■ EDITED BY

KIRK VARNEDOE

ADAM GOPNIK

THE MUSEUM OF MODERN ART

NEW YORK

HARRY N. ABRAMS, INC.

PUBLISHERS, NEW YORK

■ WITH ESSAYS BY

JOHN E. BOWLT

LYNNE COOKE

LORENZ EITNER

IRVING LAVIN

PETER PLAGENS

ROBERT ROSENBLUM

ROGER SHATTUCK

ROBERT STORR

JEFFREY S. WEISS

Editor: Mark Greenberg
Designer: Elissa Ichiyasu
Photo Researcher: Joan Pachner

Published in conjunction with the exhibition *High and Low: Modern Art and Popular Culture,* organized by Kirk Varnedoe, Director, Department of Painting and Sculpture, The Museum of Modern Art, New York, and Adam Gopnik, Art Critic, *The New Yorker* magazine, and shown at the Museum October 7, 1990–January 15, 1991. The exhibition is sponsored by AT&T.

Library of Congress Cataloging-in-Publication Data
Modern art and popular culture : readings in high and low / edited by Kirk Varnedoe and Adam Gopnik.
p. cm.
Includes index.
Contents: High and Low before their time / Irving Lavin—Subjects from common life in the real language of men / Lorenz Eitner—Picasso, collage, and the music hall / Jeffrey S. Weiss—Cubism as pop art / Robert Rosenblum—A brazen Can-Can in the temple of art / John E. Bowlt—No joy in Mudville / Robert Storr—The independent group / Lynne Cooke—Golden days / Peter Plagens—The last cause / Roger Shattuck.
ISBN 0–8109–2466–8 (Abrams: pbk.).—ISBN 0–87070–356–0 (Museum of Modern Art: pbk.)
1. Art, Modern—19th century—Themes, motives.
2. Art, Modern—20th century—Themes, motives.
3. Popular culture.
I. Varnedoe, Kirk, 1946–
II. Gopnik, Adam.
III. Museum of Modern Art (New York, N.Y.)
N6447.M63 1991
700'.9'04—dc20 89–61091
CIP

Published in 1990 by
Harry N. Abrams, Inc.
A Times Mirror Company
100 Fifth Avenue
New York, N.Y. 10011
and
The Museum of Modern Art
11 West 53 Street
New York, N.Y. 10019

Distributed in the United Kingdom, Europe, and the British Commonwealth by Thames and Hudson, Ltd, London

Printed and bound in the United States of America

On the cover:
Gerald Murphy
Razor, 1924
Oil on canvas, 32⅝ × 36½" (82.9 × 91.4 cm)
Dallas Museum of Art, Foundation for the Arts Collection; gift of the artist

MODERN ART
AND
POPULAR
CULTURE
READINGS IN
HIGH & LOW
.

MODERN ART AND POPULAR CULTURE

READINGS IN

HIGH & LOW

CONTENTS

ACKNOWLEDGMENTS

This book resulted from a joint effort of The Museum of Modern Art and Harry N. Abrams, Inc., and we are grateful to many people on both sides for their contributions of talent and hard work. At the Museum, Ellen Harris, Deputy Director, Finance and Auxiliary Activities, was instrumental in furthering the arrangements for the publication; and Paul Gottlieb, President of Harry N. Abrams, Inc., was tremendously supportive in the project, which he helped to bring to fruition despite the demands of a shortened production schedule.

Harriet Bee, Managing Editor in the Department of Publications at the Museum, aided in select ways with the editing and organization of the texts. The principal work of reviewing, coordinating, and editing the texts was undertaken, though, by Mark Greenberg of Abrams, and we are very grateful for his thoroughness and sensitivity in this task. The book was designed by Elissa Ichiyasu, to whom we owe a great debt of thanks for responding with grace to the constraints imposed both by the schedule and by the diversity of demands the different essays posed.

Mary Beth Smalley, Curatorial Assistant in the Department of Painting and Sculpture at the Museum, helped receive and coordinate the manuscripts and illustrations. With regard to the final labor of searching out illustrations, compiling the captions, and organizing with all the authors the technical changes made in the texts, a very special expression of gratitude is owed to Joan Pachner, doctoral candidate at the Institute of Fine Arts, New York University, who stepped in at a crucial moment and—by dint of terrific resourcefulness—saved the book from crippling delays.

Finally, we wish to thank, with great warmth, the authors whose essays appear here, for their willingness to participate, for the pleasure of working with each of them, and for the quality of their work.

For the model he provided in his engagement with modern popular culture, and with admiration for his work, we dedicate this volume to the memory of Reyner Banham.

Kirk Varnedoe
Adam Gopnik

CONTRIBUTORS

JOHN E. BOWLT is Professor of Russian Art and Language in the Department of Slavic Languages and Literature at the University of Southern California, Los Angeles. Educated in Great Britain and the Soviet Union, he received his Ph.D. in Russian literature and art from the University of St. Andrews, Scotland, in 1971. Among his many books and articles, Dr. Bowlt has published the only major documentary source book in English on Russian revolutionary art, *Russian Art of the Avant-Garde: Theory and Criticism, 1902–1934*, as well as the catalogue for a retrospective exhibition of Pavel Mansurov.

LYNNE COOKE received her doctorate from the University of London in 1989. Since 1979 she has been a lecturer in the History of Art Department at University College, University of London. In addition to articles for *Parkett*, *Art in America*, and *Burlington Magazine*, Dr. Cooke has contributed to many exhibition catalogues, including an essay titled "Between Image and Object" in *A Quiet Revolution: British Sculpture Since 1965*.

LORENZ EITNER holds the Osgood Hooker Chair in the History of Art at Stanford University, where he was Chairman of the Art Department and Director of the Art Museum from 1963 to 1989. He received his doctorate from Princeton University in 1952. Dr. Eitner has published the source book *Neoclassicism and Romanticism, 1750–1850* and *An Outline of 19th Century European Painting*, as well as *Gericault: His Life and Work*, which was awarded the Mitchell Prize in 1984 and the Rufus Morey Prize in 1985.

IRVING LAVIN is Professor of Art History at the Institute for Advanced Study in Princeton, New Jersey. His publications include *Bernini and the Unity of the Visual Arts*, which was awarded the Premio Daria Borghese in 1981. He was elected to the American Academy of Arts and Sciences and the Accademia dei Lincei, Rome, and is a former President of the International Committee for the History of Art.

PETER PLAGENS is a painter and critic. He exhibits regularly in New York and Chicago and is represented in public collections in Baltimore, Buffalo, Washington, D.C., Santa Fe, and Kyoto, Japan. He was a contributing editor to *Artforum* from 1966 to 1976. Mr. Plagens's publications include *The Sunshine Muse: Contemporary Art on the West Coast* and

Moonlight Blues: An Artist's Art Criticism. He is currently the art critic for *Newsweek* magazine.

ROBERT ROSENBLUM teaches at New York University, where he is the Henry Ittleson Jr. Professor of Modern European Art at the Institute of Fine Arts and a Professor of Fine Arts at the College of Arts and Sciences. Professor Rosenblum's many articles and books include *Cubism and Twentieth Century Art,* "The Typography of Cubism" (in *Picasso in Retrospect,* edited by John Golding), *Transformations in Late Eighteenth Century Art, Modern Painting and the Northern Romantic Tradition: Friedrich to Rothko,* as well as *The Dog in Art from Rococo to Post-Modernism* and *The Romantic Child from Runge to Sendak.* His *Paintings in the Musée d'Orsay* was published in 1989.

ROGER SHATTUCK is University Professor and Professor of Modern Foreign Languages at Boston University. His many books include *The Banquet Years,* an introduction to Marcel Proust, and *The Innocent Eye.* Professor Shattuck was the recipient of the Literary Award from the American Academy of Arts and Sciences in 1987.

ROBERT STORR is an artist and writer. He is a Contributing Editor to *Art in America* and publishes regularly in *Art/Press* and *Parkett.* Mr. Storr's interviews with Robert Ryman, Robert Mangold, and Brice Marden appeared in *Abstract Painting of America and Europe,* and his monograph on Philip Guston appeared in 1986.

JEFFREY S. WEISS is completing his doctoral dissertation on Pablo Picasso and Marcel Duchamp during the years 1912 to 1917 for the Institute of Fine Arts, New York University. Mr. Weiss has written on the work of Vasily Kandinsky and Paul Klee, as well as an article titled "Science and Primitivism: A Fearful Symmetry in the Early New York School" in *Arts* magazine in 1983.

■ INTRODUCTION ■

This book was conceived as a part of the preparation for the exhibition "High and Low: Modern Art and Popular Culture," held at The Museum of Modern Art, New York, in the autumn of 1990 (and at The Art Institute of Chicago and the Museum of Contemporary Art, Los Angeles, in the spring and summer of 1991, respectively). That exhibition had two purposes. First, and most simply, its aim was to bring together as many as possible of the modernist masterpieces—from Picasso's and Braque's collages with their fragments from the daily newspapers to the paintings of Elizabeth Murray with their inspirations from cartoon styles—that had expanded the language of art in this century by drawing on contemporary vernacular sources. But we hoped that the rewards of the exhibition would be intellectual as well as sensual. We wanted not just to chronicle and celebrate but also to understand in greater depth the dialogue between high modern art and certain aspects of popular culture, such as advertising, graffiti, comics, and caricature—to grasp the origins of that interchange, its development, and its recurring structures, in order to see what that history might tell us about modern life.

Although an enormous body of writing about "mass culture" and the avant-garde already existed, this corpus seemed disproportionately weighted by the work of commissars and scholiasts. The pronouncements of the theorists appeared all too frequently to be engaged, at best, in the skillful juggling of abstract concepts; and seemed, at worst, to insist on imposing dogmatic, narrow, and historically untenable (not to say untestable) categories on the complex realities of modern history. We felt that most of this literature—despite its claims to be engaged with "modernism" as a historical project—was depressingly unconcerned with the basic stuff of history: the particular facts of how modern paintings, sculptures, and drawings actually got made, the individual people who made them, and the similarly complex circumstances and personalities involved in shaping popular culture in areas such as the comics and advertising.

We felt that another and a better way of looking at these issues could be found in the work of certain scholars and critics, young and old, who (almost of necessity) form no coherent school and advance no all-purpose theory, but whose work offers an original sense of the shape of particular things and moments. These authors provided what we were hungry for: informed history, written in a clear fashion, free from jargon or pedantry. We felt that the framework of this alternative, antiauthoritarian tradition of approach to the subject could be found both in scholarly practice—exemplified by such seminal works as Meyer Schapiro's essay "Courbet and Popular Imagery"— and in a humane critical tradition embodied in figures like the poets Baudelaire and Apollinaire and the architectural historian Reyner Banham. A sense of history in all its peculiarity, a respect for vernacular art that did not

KIRK VARNEDOE AND ADAM GOPNIK
■

spill over into perverse pop worship, above all a feeling for detail, for the irreducible acts, decisions, and creative misunderstandings of a particular moment — these elements seemed to us the distinguishing marks of the kind of scholarship and criticism that we wanted to emulate and, if possible, to stimulate.

Acutely aware of the necessary gaps, blind spots, and telegraphic condensations within the long synoptic chronicle of modern art and popular culture that we had ourselves undertaken in the catalogue of the exhibition (*High and Low: Modern Art and Popular Culture*. New York: The Museum of Modern Art, 1990), we set out to assemble a complementary anthology of readings on the subject by writers we admired. Each contributor agreed to take up a focused moment in either the origins or the development of modern art's engagement with popular culture — with an eye, always, toward a larger understanding of how the dialogue between private imaginations and public codes had affected the world we live in and the way we live in it.

This book is the consequence of that ambition. Three of the essays it contains represent a summing up or a recapitulation of seminal investigations by a well-established scholar. Irving Lavin's "High and Low Before Their Time: Bernini and the Art of Social Satire" is a revised version of his essay on Bernini and the invention of caricature, previously available only in an exhibition catalogue. Against the stereotyped view that still sees low satiric imagery as the historical opposite of high ceremonial and aristocratic art, Lavin demonstrates that caricature — for centuries the Western "low" form par excellence — emerged originally only in the most refined circles of the high Baroque. He shows, too, how caricature assumed a new equality between artist and patron and reflected an extreme self-consciousness about styles, as well as a sophisticated set of arguments about the nature of representation. Lavin's essay, in effect, is the Genesis story of discrete "high" and "low" categories in Western art; and, far from narrating the first stirrings of a battle between opposed or alien realms, it shows us that from its very beginnings these categories were provisional, mutable positions within a large circle of creation. Lavin shows not only that "low" art as a separate, identifiable realm could be defined only against the example of a secure fine-art tradition, but that the high tradition was itself the begetter of that low tradition; high needs low, as Lear needs his Fool. From the beginning, Lavin demonstrates, the relationship between high and low has been one of dance and dialogue rather than one of opposition and contamination. As a consequence, what look to us like bold modernist transgressions of the familiar decorum of high and low often turn out to represent the long-postponed repossession of forms and visual strategies that had belonged to the high-art tradition all along. What may seem the invasion of an alien visitor can often turn out to be the return of a prodigal.

Lorenz Eitner's essay on popular imagery in nineteenth-century art is in part a summary and critical evaluation of the flood tide of scholarship that has illuminated this subject since Meyer Schapiro's famous essay on the source of Courbet's compositional ideas in popular prints—the *images d'Épinal*. Eitner, however, wants to draw our attention not just to discrete moments of influence and stylistic borrowing, but to the nineteenth-century inventions of larger transforming patterns of creation. He emphasizes, for example, the generative role of parody in making art modern. The familiar low-comic form of the high-art pastiche, Eitner points out, became in the hands of Daumier and Manet the means toward a profound imaginative revolution in style. When Daumier sends up the idealizing pretensions of the academic nude, or when Manet parodies the Titianesque nude in his *Olympia*, both artists reclaim the ossified energies of a motif or style through an affectionate and revivifying satire; by mocking the decadent form of an entrenched motif, we reinvoke its original vitality. Such gambits of humor in modern art, Eitner suggests, play a role like that of "parodic" recycling of motifs in Renaissance and Baroque musical composition, where the parsimonious transposition and reuse of familiar motifs and themes always become the engine of new invention. If Lavin shows that "low" has often been in some way a subset of "high," Eitner shows that the artificial separation of styles could itself, through parodic juxtapositions, generate a kind of magnetic field in which new creation takes place.

Robert Rosenblum's "Cubism as Pop Art" is an extension and revision of his seminal 1973 essay on the meanings of popular imagery, and particularly of typographic fragmented headlines, in Cubist collage. The force of Rosenblum's argument transcends his discovery of puns and rebuses in these images, important as that discovery was. If Eitner's high and low interchanges recall the Bach who used parody as a way of making new and serious things, Rosenblum's story (which begins with the stenciled name BACH on a Braque canvas) recalls instead the Bach of *The Art of Fugue*. Cubism, Rosenblum shows us, invented a new tempering for modern art, as potent for its time as linear perspective had been in the quattrocento, and created a counterpoint between high metaphysics and punning mischief. The Cubist grid, as Rosenblum reveals it, was less the grill on which representation was martyred and more like a net stretched taut between the world and sight, catching the heraldry of modern existence—a seine which captured news of distant wars and ads for ladies' lingerie side by side.

Rosenblum's essay is also, self-declaredly, a document in the history of taste. It was the experience of American Pop art of the sixties that made Rosenblum look again at what Picasso and Braque had done half a century before, and reconsider that Adamic style not just as a step on the path toward abstraction but as a complex, multipart system of many-voiced reference. But if Pop brought Rosenblum back to Cubism, the spiraling

movement of his scholarship led him not merely to some voguish rein-terpretation of the familiar forms but instead to a set of precise, empirical questions about objects he had looked at so often before: Why these particular words, why these headlines, and why these juxtapositions? An-swering those questions led him to real and inarguable discoveries about the original intentions of Braque and Picasso. Rosenblum's Cubism had always been available to be seen, but it required the impetus of a new engagement with popular culture in contemporary art to become articulated. His influential essay, here revised to address two decades of subsequent re-search, reminds us that for scholars as much as for artists, new ideas come into being by paying attention to things that a moment before seemed almost too familiar.

The essays by Jeffrey Weiss, on Cubism and the cabaret and music hall revue, and by John Bowlt, on popular imagery and the Russian avant-garde, both extend the new attention to popular culture in early modern art that Rosenblum pioneered. The Russian story is, inevitably, different from all the others, for it takes place not as a series of responses to the forces of modernization but as a heroic attempt by artists to create those forces almost out of thin air. Like the Marx Brothers Groucho and Chico searching for a stolen painting in their film *Animal Crackers* (Groucho: "Suppose nobody in the house took the painting?" Chico: "Go to the house next door." Groucho: "That's great. Suppose there isn't any house next door?" Chico: "Well, then of course we gotta build one."), the Russian avant-garde had to construct a modern culture in order to have a habitation in which to make modern art. As Bowlt shows, they used the indigenous folk-art stylizations of shop signs as replacements for the Cubist headlines and ads. The Russian story, as Bowlt chronicles it, suggests that the attention to popular culture that filled early modern painting was less the reflexive response to an unavoidable new thing than a complex structure of inven-tion, which searched for those new things as necessary elements of style.

In the "High and Low" exhibition we tried to focus on the passage from like to like, showing for example how popular graphic and painterly and poster styles passed into high painting. But we recognize as well that another kind of inquiry might ask about the dialogues between, say, dra-matic or theatrical art and modern painting and assemblage. In the past, such inquiries have tended to the hopelessly vague or undemonstrable; but Jeffrey Weiss makes this approach credible by looking at a specific ex-change, between Cubist collage and the satirical revues of the Parisian music halls. Weiss shows us that the revues had already on hand a series of satiric devices—the punning occlusions of headlines, the absurdist mix of dire daily news and farcical trivia—that, passing into the hands of Picasso and Braque, could become the means toward avant-garde advance. Here, as so often elsewhere, jokes became elegies—a structure of entertainment

was made into the template for a new kind of expressive lyricism and hermetic poetry. By recognizing the convergence of the worlds proposed by the music hall revue and the collage, Weiss also asks us to reconsider the origins of Cubist innovations, not in a narrow or pseudo-technical response to semiological problems in representation, but as a living response, formed in the crucible of popular culture, to a new world. Weiss, beginning from Rosenblum's original insight about the ludic nature of Cubist collage, shows that the particular kind of games that Picasso and Braque were playing were already available as a fully developed language in popular entertainment — and that the artists' act of genius was to pay attention to it and to see its possibilities as a form of lyric expression.

If Weiss's essay, and those of Lavin, Eitner, and Rosenblum, represents the extension and critique of the tradition of Schapiro, the essays by Robert Storr and Peter Plagens extend the critic's inspection of pop culture that began with Baudelaire. Storr addresses Clement Greenberg's 1939 essay "Avant-Garde and Kitsch," from which many automatic assumptions about the nature of popular culture and modern art continue to flow. Storr offers a detailed reconstruction of the background of that essay, both within Greenberg's own work and within the broader debates of the art world in its time. He examines the sources of its extraordinary polemical force — and also demonstrates its reliance on what was at best an innocently ill-informed, and at worst a purposefully incurious, reading both of the history of modern art and of the art of Greenberg's own time. Greenberg's terms turn out to be arbitrary constructions of a moment's need. They served a combative purpose that enriched and helped to fortify a great moment in modern art but were nonetheless built atop a dubious vision of history and were propelled by mandarin forms of arbitrary judgment. Exploding the flawed "dialectic" of high and low, Storr offers in the end a series of reflections that ask us to transcend the absurdity of authoritarian criticism on art and to put in its place not a nihilism but a genuine engagement with the particulars of history and the contradictions of modern experience.

Peter Plagens's essay on California Pop is different in kind from all the other contributions. It is a first-person account of things seen and experienced at a crucial moment, in a special locale, in the development of American art. Plagens asks us to look at the work of Ed Ruscha and other Los Angeles artists who emerged during the sixties in a new way, not as a pendant of New York Pop but as a separate activity with an original aesthetic. But he asks us also to broaden our sense of vernacular elements in contemporary art, so that the Zen purity of abstract artists like Larry Bell and John McCracken can also be seen as responses to the pop culture that surrounded them, in areas like the exquisite lacquering of custom cars.

Lynne Cooke also concentrates on the sharply different inflections derived from popular culture in the contexts of different cities and countries,

comparing the origins and expressions of an engagement with similar sources — advertising, commercial packaging, pulp magazines, and so on — in British art of the 1950s and 1960s and in American art of the same period. Cooke helps us to understand the complex nature of transatlantic interchanges in the domains of both high and low culture during the formative period of postwar art; and she opens a window onto the contentious internal dynamics of a British art scene in the 1950s that is too often treated by American writers as a mere training ground for the Pop sensibility. The differing visions of the modernist tradition, and of the potentials to be found in the languages of pulp magazines, car reviews, and comic books, are here examined in the light of the special circumstances of both the British art world and British politics at a key moment when a younger generation broke with the modern establishment and found its tongue in the slang of a new consumer society.

The innovation of these essays, taken all together, may paradoxically involve a recuperation of ideas long extant. "Back to Baudelaire" is the cry, in effect, at the end of Storr's essay — back, that is, to a critical approach which surrenders ambitions for historical system-plotting and claims to final authority, and which instead "enters modernity in all its enduring ambiguity." And if this is the critic's lesson, it might be supplemented by a historical approach almost as venerable, and similarly misunderstood in recent years — the investigation of iconography imagined originally by Aby Warburg, which has so often been caricatured or degraded into the mere decoding of visual allegories. Warburg proposed to follow the transmission of symbolic motifs and stylistic habits through history, as the unfolding of tropes and props that somehow seemed necessary to the imagination, but which migrated from social place to place, from antique sarcophagi to Renaissance portraits to contemporary advertisements, to be used — like the system of numbers or any other rich structural system — in new ways in new places. The story of high and low might be seen as only an aspect of the larger, authentically Warburgian vista of art history — an art history that begins with the close study of motifs and structures, and follows their evolution and reuse without surrendering either to a narrow social determinism or to a metaphysical idealism. The changing force and meaning of shop signs, or puns made from occluded headlines, demonstrate the ways in which our culture's language of images operates truly as all languages are empowered to do — that is, not just as imprisoning structures, but as all-purpose codes that have no essence and are constantly and unpredictably kept in play to reveal new possibilities and new uses.

If the parental figures of this enterprise are found predominantly in the lineage from Baudelaire to Banham, of astute observers of imagery and styles, historians of books and ideas are equally crucial. Roger Shattuck — to choose an example immediately at hand — has been concerned for his entire

career with describing the choreography that governs the endless circular pavane between the elements of our culture. The modernism he has mapped for us is conceived not as the inexorable march toward a fixed goal, or as a set of exclusions and prohibitions, but as the complicated branching relationship of acts and clubs and activities, where burlesque banquets produce profound cultural seismic shifts. Shattuck supplies here a coda for the whole enterprise of "High and Low: Modern Art and Popular Culture" — appropriately, in the dual form of an entertainment and of a critical response to it. Shattuck offers an imaginary review of an imaginary play — almost, a kind of revue — in which many of the actors of the modernist drama, artists and writers, high and low, appear. Their farcical and at times poignant bumps and collisions and misunderstandings offer a poetic vision of the interweavings of seemingly disparate strains of modern experience. Harpo Marx and Tristan Tzara, Marcel Duchamp and Ring Lardner — modern art in all its complexity and popular culture in all its vitality — suggest for Shattuck a world like that found in a French boulevard farce, a comedy of mistaken identities (which lead to the discovery of real lost brothers), misunderstandings, suddenly pledged oaths of permanent friendships, episodes of high dudgeon, and other moments of common recognition and soft-shoe amiability. The play ends, Shattuck tells us, unresolved. Perhaps, indeed, the lack of a final reconciliation is just what such a comedy thrives on. The possibilities for near-misses, strange alliances, and odd bedfellows are not yet exhausted, and this nagging open-endedness with its lure of surprise will keep drawing us, the audience, back to our grumbling, and befuddlement, and criticism — and pleasure — when the curtain goes up and the action resumes this evening.

HIGH AND LOW BEFORE
THEIR TIME: BERNINI AND THE
ART OF SOCIAL SATIRE ▪

Modernism nowadays is so closely identified with formalism that a new social awareness, which was a fundamental aspect of the modernist movement since the late nineteenth century, is often forgotten. This new social concern, in turn, engendered a new appreciation of popular culture, and of unsophisticated culture generally in all its manifestations. The thoroughness of modernism's rejection of traditional cultural values, and the intimacy of the association modernism established between that rejection and social reform, were unprecedented since the coming of Christianity. The association, however, had a long prehistory to which the modern movement was deeply indebted, but which we tend to overlook. We tend, instead, to think of the development of culture in Darwinian terms, as a progressive evolution leading inexorably if not necessarily to improvement then at least to increased sophistication and facility. The exceptions to this principle are just that, exceptions—cases in which, owing to special circumstances, a primitive cultural state is preserved accidentally, as in certain "remote" corners of the globe; or perseveres incidentally within the domain of high culture in certain extra-, preter-, or noncultural contexts, as in the art of the untutored (popular and folk, including graffiti), of children, of the insane.[1]

Without presuming to challenge the biological theory of evolution as such, my view of the matter in art-historical terms is quite different. I would argue that man has what might be described as an "unartistic" heritage that persists, whether recognized or not, alongside and notwithstanding all developments to the contrary. "High" and "low," the sophisticated and the naive, are always present as cultural alternatives—in all societies, even "primitive" ones—exerting opposite and equal thrusts in the history of human awareness and self-revelation. They may appear to exist, develop, and function independently, but in fact they are perennial alter egos, which at times interact directly. High and low art, like Beauty and the Beast, go hand in hand.

A striking and surprising case in point is offered by a series of mosaic pavements found in a great and lavishly decorated house at Olynthus in Greece, dating from the early fourth century B.C.[2] Here the figural compositions with concentric borders display all the order and discipline we normally associate with Greek thought (fig. 1). Traces of this rationality are discernible in certain of the floors where large geometric motifs are placed in the center, above finely lettered augural inscriptions, such as "Good Fortune" or "Lady Luck," while various crudely drawn apotropaic symbols—circles, spirals, swastikas, zigzags—appear here and there in the background (fig. 2). Finally, the entire composition may be dissolved in an amorphous chaos from which the magical signs shine forth mysteriously helter-skelter, like stars in the firmament—the random arrangement is as deliberate and significant as the signs themselves (fig. 3). The entire gamut of expressive form and meaningful thought seems here encapsulated, at the very apogee of the classical

IRVING
LAVIN
■

period in Greece, when the great tradition of European high art was inaugurated. The Olynthus mosaics reveal the common ground—man's sense of the supernatural—that lies between the extremes of high and low to which we give terms like "mythology" and "superstition."

The subsequent development of Greco-Roman art also abounds in various kinds and phases of radical retrospectivity—Neo-Attic, Archaistic, Egyptianizing—in which the naturalistic ideals of classical style were thoroughly expunged. Virtuoso performances by artists of exquisite taste and refined technique recaptured the awkward grace and innocent charm of a distant and venerable past. The retrospective mode might even be adopted in direct apposition to the classical style, as in the reliefs of a late-fourth-century altar from Epidaurus, where the archaistic design of the figure on the side contrasts with the contemporary forms of those on the front (figs. 4 and 5).[3]

A conspicuous and historically crucial instance of such a coincidence of artistic opposites occurred at the end of classical antiquity, in the arch in Rome dedicated in A.D. 315 to celebrate the emperor Constantine's victory over his rival, Maxentius. Parts of earlier monuments celebrating the emperors Trajan, Hadrian, and Marcus Aurelius were incorporated in the sculptural decorations of the arch, along with contemporary reliefs portraying the actions of Constantine himself (fig. 6). The rondels display all the nobility and grace of the classical tradition, while the friezes below seem rigid, rough, and ungainly, culturally impoverished. It used to be thought that the arch was a monument of decadence, a mere pastiche in which Constantine's craftsmen salvaged what they could of the high style art of their predecessors, using their own inadequate handiwork only when necessary. In fact, there is ample evidence to show that the juxtaposition was deliberate, intended to create a complementary contrast that would illustrate Constantine's intention to incorporate the grandeur of the Empire at the height of its power with the humble spirituality of the new Christian ideal of dominion. The latter mode may be understood partly in contemporary terms, as an elevation to the highest level of imperial patronage of "vulgar" forms, whether native to the indigenous populace of Rome or imported from the provinces.[4] It has been suggested, however, that the vulgar style, which was destined to play a seminal role in the development of medieval art, was also a conscious evocation of Rome's remote, archaic past, when simplicity, austerity, and self-sacrifice had first laid the foundation of a new world order.[5]

An analogous phenomenon has been observed in the context of medieval art itself, at the height of the Romanesque period. Many churches of the eleventh and twelfth centuries, including some of the most illustrious, display more or less isolated reliefs executed in a crude, "infantile" manner and illustrating grotesque or uncouth subjects (fig. 7).[6] Although they were

formerly dismissed as reused "debris" from a much earlier, pre-Romanesque period, recent study has shown that such works are in fact contemporary with, often part of the very fabric of the buildings they adorn. They might even proudly display the inscribed signature of the sculptor, and the bold suggestion has been made that the same artist may also have been responsible for the more familiar and more sophisticated parts of the decoration. Such stylistic and thematic interjections must be meaningful, especially since they inevitably recall the real spolia, bits and pieces of ancient monuments, with which many medieval churches are replete. These deliberately retrieved fragments, often discordantly incorporated into the new masonry, bore physical witness to the supersession of paganism by Christianity. Perhaps the substandard Romanesque reliefs express a similar idea in contemporary terms.

The particular subject of this paper may thus quite properly be viewed as one episode in the general history of the phenomenon of cultural extremes that sometimes touch. The episode, however, is an important one in the development of European culture because, despite the many antecedents, something new happened in the Renaissance. The classical ideals of naturalism and high culture were not only retrieved, they were also revived, refined, regularized, and embedded in a theoretical framework. This philosophical, mathematical, even theological structure, which culminated toward the end of the sixteenth century in a treatise by Gian Paolo Lomazzo with the significant title *L'idea del tempio della pittura* (1590), served not only to explain and justify the classical values themselves; it also raised their practitioners to the level of liberal, and therefore noble artists. The classical ideals, albeit in many variations, were thus enshrined in a code of visual behavior, as it were, that had every bit the force of—indeed, it was often directly linked to—a code of personal behavior in social terms. To this unprecedented idea of a pure, high art, elevated to the apex of an explicit theoretical and social scale of values, there was an equal and opposite reaction, on the same terms. One of the products of this reaction was the creation of caricature, an art form that we still today think of as peculiarly modern.

Bernini's caricature of Pope Innocent XI (fig. 8) is one of the few traces of the artist's handiwork that have come down to us from the very last years of his life. Bernini was seventy-eight and had only four years to live when Benedetto Odescalchi was elected pope, at the age of sixty-five, in 1676. As a work of art, the drawing is slight enough—a few tremulous, if devastating, pen lines sketched in a moment of diversion on a wisp of paper measuring barely four and a half by seven inches.[7] Despite its modest pretensions—in part actually because of them, as we shall see—the work represents a monumental watershed in the history of art: it is the first true caricature that has come down to us of so exalted a personage as a pope. Signifying as it does that *no one* is beyond ridicule, it marks a critical step in the develop-

ment, perhaps the beginning, of what can properly be called the art of social satire, a new form of visual expression in which the noblest traditions of European art and society are called into question. The forces here unleashed would ultimately, in the modern period, challenge the notion of tradition itself.

By and large, before Bernini there were two chief methods of ridiculing people in a work of art. The artist might poke fun at a particular individual, independently of any setting or ideological context, if the victim occupied a relatively modest station in life. Such, evidently, were the informal little comic sketches of friends and relatives by Agostino and Annibale Carracci, described in the sources but now lost. These *ritrattini carichi,* or "charged portraits," as the Carracci called them, were certainly among the primary inspirations of Bernini's caricatures (fig. 9). Alternatively, the victim might be grand, and he would be represented in a context that reflected his position in society. The artists of the Reformation, for example, had made almost a specialty of satirizing the popes as representatives of a hated institution and its vices (fig. 10). In the former case the individuality of the victim was important, but *he* was not; in the latter case the opposite was true.[8]

The differences between Bernini's drawing and these antecedents have to do, on the one hand, with the form of the work—a particular kind of drawing that we immediately recognize and refer to as a caricature—and, on the other, with its content—the peculiar appearance and character of a specific individual who might even be the Supreme Pontiff of the Roman Catholic Church. I shall offer my remarks under those general headings.[9]

Much of what I shall have to say was already said, at least implicitly, in the accounts of Bernini's caricatures given by his early biographers, who were well aware of the significance of his achievement in this domain. Filippo Baldinucci reports that Bernini's "boldness of touch" (*franchezza di tocco*) in drawing was

truly miraculous; and I could not say who in his time was his equal in this ability. An effect of this boldness was his singular work in the kind of drawing we call caricature, or exaggerated sketches, wittily malicious deformations of people's appearance, which do not destroy their resemblance or dignity, though often they were great princes who enjoyed the joke with him, even regarding their own faces, and showed the drawings to others of equal rank.[10]

Domenico Bernini, the artist's son, gives the following formulation:

at that time [under Urban VIII] and afterwards he worked singularly in the kind of drawing commonly referred to as caricature. This was a singular effect of his spirit, in which as a joke he deformed some natural defect in people's appearance, without destroying the resemblance, recording them on paper as they were in substance,

although in part obviously altered. The invention was rarely practiced by other artists, it being no easy matter to derive beauty from the deformed, symmetry from the ill-proportioned. He made many such drawings, and he mostly took pleasure in exaggerating the features of princes and important personages, since they in turn enjoyed recognizing themselves and others, admiring the great inventiveness of the artist and enjoying the game.[11]

The explicit definition of caricature given in these passages — a comic exaggeration of the natural defects of the sitter's features — focuses on what might be called the mimetic nature of the genre. It is essential that an individual, preferably of high rank, be represented, and that with all the distortion he remain individually identifiable. The formal qualities are expressed implicitly: the drawings were independent works of art, conceived as ends in themselves and appreciated as such; they were also true or pure portraits, in that they depicted a single individual, isolated from any setting or narrative context; and they were graphically distinctive, in that they were drawn in a singular manner (reflecting Bernini's *franchezza di tocco*), specifically adapted to their purpose.[12]

On all these counts Bernini's drawings are sharply distinguished from the tradition most often cited in the prehistory of caricature, physiognomics. The scientific or pseudoscientific investigation of ideal types as they relate to moral and psychological categories originated in antiquity and enjoyed a great florescence in the Renaissance. Leonardo's studies of grotesque heads as expressions of the aesthetic notion of perfect or beautiful ugliness (fig. 11) are one familiar case in point. Another major aspect of the tradition was the comparison of human and animal features, on the theory that the analogies revealed common psychological qualities: human facial traits were assimilated to those of various animal species to bring out the supposed characterological resemblances. The first comprehensive tract on the subject was published in 1586 by Giambattista della Porta (fig. 12).[13] Bernini was certainly aware of the physiognomical tradition, both the association between exaggeration and character analysis and the link between human and animal types. Yet, such studies never portrayed specific individuals, they were never drawn in any special style of their own, and they were never sufficient unto themselves as works of art.

It is well known that in the course of the sixteenth century drawing had achieved the status of an independent art — that is, serving neither as an exercise, nor a documentary record, nor a preparatory design — in a limited variety of forms. One was what may be called the presentation drawing, which the artist prepared expressly for a given person or occasion. Michelangelo's drawings for his friend Tommaso Cavalieri are among the earliest such works that have come down to us (fig. 13).[14] Another category, especially relevant in our context, was the portrait drawing, which by

Bernini's time had also become a distinct genre. In the early seventeenth century there was a specialist in this field in Rome, Ottavio Leoni; he portrayed many notables of the period, including Bernini himself (fig. 14), who also made "regular" portrait drawings of this sort (cf. fig. 17).[15] (In Bernini's case the complementarity and contrast between the two independent graphic forms extend even to the identifying inscriptions: on the caricatures, a coarse scrawl with the name and professional qualification in the vulgar language; on the formal portrait, a humanistic Latin epigraph in calligraphic minuscules, but not the noble majuscules of classical epigraphy.) A common characteristic of these early autonomous drawings is that they were highly finished, and the draftsman tended to invent or adopt special devices which distinguish them from other kinds of drawings[16]: Michelangelo's famous stippling and rubbing is one example, Leoni's mixture of colored chalks is another. These works are carefully executed, rich in detail, and complex in technique. The artist, in one way or another, created an independent form midway between a sketch and a painting or sculpture. We shall explore the peculiar graphic qualities of Bernini's caricatures presently. For the moment it is important to note that they incorporate two interrelated innovations with respect to this prior history of drawing as an end in itself. Bernini's are the first such independent drawings in which the technique is purely graphic, i.e., the medium is exclusively pen and ink, the forms being outlined without internal modeling; and in them the rapidity, freshness, and spontaneity usually associated with the informal sketch become an essential feature of the final work of art.[17]

Within the specific context of the autonomous portrait drawing, Bernini's caricatures also stand apart. The prevalent convention in this genre, and indeed in that of the painted portrait generally since the early Renaissance, was to show the sitter in three-quarter views, whereas Bernini's caricatures are invariably either full-face or profile (figs. 15 and 16). The effect seems deliberately archaic, but his preference may also be seen in the light of another, equally striking fact: among Bernini's own portrait drawings (other than caricatures) those that are independent are three-quarter views (fig. 17), while those that can be identified as studies for sculptured portraits are in strict profile (fig. 18).[18] We know that the very first studies he made from life for the famous bust of Louis XIV were two drawings, one full-face, the other in profile.[19] Bernini, of course, astonished his contemporaries by also making many sketches of the sitter moving and talking, and these must have been extremely various.[20] In actually preparing the sculpture, however, the full-face and profile were evidently primary, perhaps because the sculptor began by tracing them on the sides and front of the block.[21] We shall see that other factors were involved as well, but it seems clear that in this respect Bernini's caricatures transfer to the final work conventions proper to a preliminary stage.

Bernini's caricatures have a distinct graphic style that marks them as caricatures quite apart from what they represent. They consist, as we have noted, entirely of outlines, from which hatching, shading, and modeling have been eliminated in favor of an extreme, even exaggerated simplicity. The lines are also often patently inept, suggesting either bold, muscle-bound attacks on the paper, or a tremulous hesitancy. In other words, Bernini adopted (or rather created) a kind of lowbrow or everyman's graphic mode in which traditional methods of sophisticated draftsmanship are travestied just as are the sitters themselves.[22]

If one speculates on possible antecedents of Bernini's caricature technique, two art forms — if they can be called that — immediately spring to mind, in which the inept and untutored form part of the timeless and anonymous heritage of human creativity: children's drawings and graffiti. It is not altogether far-fetched to imagine that Bernini might have taken such things seriously, as it were, in making his comic drawings, for he would certainly not have been the first to do so. Albrecht Dürer drew a deliberately crude and childish sketch of a woman with scraggly hair and prominent nose in a letter he wrote from Venice in 1506 to his friend Willibald Pirckheimer (fig. 19). The drawing illustrates a famous passage in which Dürer describes the Italians' favorable reaction to his *Rosenkranz Madonna*. He reports that the new picture had silenced all the painters who admired his graphic work but said he could not handle colors.[23] The clumsy-looking sketch is thus an ironic response to his critics, as if to say, "Here is my Madonna, reduced to the form these fools can appreciate."

Something similar appears in certain manuscripts of Dürer's friend and admirer Erasmus of Rotterdam (fig. 20). Here and there he introduced sketches — one might almost call them doodles, except they are much too self-conscious — that include repeated portrayals of himself with exaggerated features, in what Panofsky described as the sharply observant, humorous spirit that animated his *Praise of Folly*.[24] It might be added that the crude style of the drawings also matches the ironic exaltation of ignorance that is the fundamental theme of *Praise of Folly*. Although Erasmus was an amateur, it should not be assumed that the sketches are simply inept. He did know better, for he had practiced painting in his youth, and he had a discriminating art-historical eye that even encompassed what he called a "rustic" style, which he associated with early medieval art.[25] On the back of a Leonardesque drawing from this same period, a deliberate graphic antithesis occurs in which a wildly expressive head is redrawn as a witty, schoolboyish persiflage (fig. 21).

A child's drawing plays a leading role in a portrait by the mid-sixteenth-century Veronese painter Giovanni Francesco Caroto (fig. 22).[26] Perhaps the drawing is the work of the young man who shows it to the spectator. He seems rather too old, however, and a much more correctly drawn eye (the

eye of the painter?) appears at the lower right of the sheet.[27] The suggestive smile and glance with which the youth confronts the viewer certainly convey a deeper sense of the ironic contrast between the drawing and the painting itself.[28]

Graffiti have a particular relevance to our context because while their stylistic naïveté may be constant, the sorts of things they represent are not. Historically speaking, portrait graffiti are far rarer than one might suppose. Considering the role of "proper" portraiture in classical times, it is certainly significant that ancient draftsmen also inscribed many comic graffiti portraying real individuals—often identified by name—on the walls of Roman buildings at Pompeii and Rome (fig. 23).[29] I feel sure Bernini was aware of such drawings, if only because we know he was acutely aware of the wall as a graphic field. It was his habit, he said, to stroll about the gallery of his house while excogitating his first ideas for a project, tracing them upon the wall with charcoal.[30] Two extant wall compositions by him, though not preliminary sketches, are in fact drawings (fig. 24).[31]

The term "graffito," of course, refers etymologically to the technique of incised drawing. The beginning of its modern association with popular satirical representations can be traced to the Renaissance, notably to Vasari's time when sgraffito was used for a kind of mural decoration that often included grotesque and chimeric forms with amusing distortions and transformations of nature, based on classical models (fig. 25).[32]

It is also in the Renaissance that we begin to find allusions to popular mural art by sophisticated artists. Michelangelo, who was full of references, serious as well as ironic, to the relations among various kinds of art, was a key figure in this development. By way of illustrating Michelangelo's prodigious visual memory, Vasari tells an anecdote that also sheds light on this neglected aspect of the master's stylistic sensibility. On an occasion during his youth, when Michelangelo was dining with some of his colleagues, they held an informal contest to see who could "best" draw a figure without design—as awkward, Vasari says, as the doll-like creatures (fantocci) made by the ignorant who deface the walls of buildings. Michelangelo won the game by reproducing, as if it were still before him, such a scrawl (gofferia), which he had seen long before. Vasari's comment—that this was a difficult achievement for one of discriminating taste and steeped in design—shows that he was well aware of the underlying significance of such an interplay between high and low style.[33] Juxtapositions of this kind may actually be seen among the spectacular series of charcoal sketches attributed to Michelangelo and his assistants, discovered a few years ago on the walls of chambers adjacent to and beneath the Medici Chapel in Florence (fig. 26).[34]

An even more remarkable instance—and, as it happens, almost exactly contemporary with the Dürer letter—involves one of Michelangelo's early

sonnets (fig. 27). The poem parodies Michelangelo's own work on the Sistine ceiling, its gist being that the agonizing physical conditions of the work impair his judgment (*giudizio*), that is, the noblest part of art, so that he is not a true painter, and he begs indulgence:

My belly's pushed by force beneath my chin.
. .
My brush, above my face continually,
Makes it a splendid floor by dripping down.
. .
And I am bending like a Syrian bow.
 And judgment, hence, must grow,
Borne in mind, peculiar and untrue;
You cannot shoot well when the gun's askew.
 John, come to the rescue
Of my dead painting now, and of my honor;
I'm not in a good place, and I'm no painter.[35]

In the margin of the manuscript page he drew a sketch depicting his twisted body as the bow, his right arm holding the brush as the arrow, and a figure on the ceiling as the target. Of particular interest in our context is the striking contrast in style between the two parts of the sketch: the figure of the artist is contorted but elegantly drawn in a normal way; that on the ceiling is grotesquely deformed and drawn with amateurish, even childlike crudity. Michelangelo transforms the Sistine ceiling itself into a kind of graffito, deliberately adopting a subnormal mode to satirize high art—in this case his own. If, as I suspect, the grotesque figure on the vault alludes to God the Father (fig. 28), Michelangelo's thought may reach further still: the graffito style would express the artist's sense of inadequacy in portraying the Supreme Creator, and unworthiness in the traditional analogy between the artist's creation and God's.[36]

Two further examples bring us to Bernini's own time. In a view of the interior of a church in Utrecht by the great Dutch architectural painter Pieter Saenredam, a graffito of four men wearing curious armor and riding a horse appears conspicuously on a pier at the lower right (figs. 29 and 30).[37] The drawing represents a well-known episode from a medieval French romance, which had a wide popular appeal. Although the meaning of the subject in the context of Saenredam's picture is unclear, the style of the drawing may have been intended not only to suggest the hand of an untrained graffito artist generally; it may also be a deliberate archaism to evoke the medieval origin of the story and, incidentally, of the building itself. Perhaps the boy standing nearby and about to draw on the wall refers ironically to Saenredam himself; perhaps the companion group, a boy seated with a

schoolchild's box at his side and teaching a dog to sit up, refers to the mastery of art achieved by instruction and practice. In any event, the drawing must have had a special significance for Saenredam, since he added his own signature and the date immediately below.[38]

Our final example is from Rome, in the form of a drawing by Pieter van Laer, nicknamed "il Bamboccio." He was the physically deformed leader of a notorious group of Flemish artists in Rome in the seventeenth century called *i bamboccianti* (the "painters of dolls"), a contemporary term that refers derisively to the awkward figures and lowlife subject matter of their paintings. The members of the group formed a loose-knit organization, the Bentvueghel, and were notorious for their unruly lifestyle, which made a mockery of the noble Renaissance ideal of the gentleman artist. The drawing (fig. 31) shows the interior of a tavern filled with carousing patrons; the back wall is covered with all manner of crude and grotesque designs, including a caricature-like head shown in profile.[39] Many works by the *bamboccianti* are reflections on the nature of art, both in theory and practice, and Van Laer's drawing is surely also an ironic exaltation of the kind of satirical and popular art held in contempt by the grand and often grandiloquent humanist tradition. We are invited to contemplate this irony by the figures who draw attention to the word "Bamboo[ts]" scrawled beneath a doll-like figure, seen from behind, and the profile head — the latter certainly a self-portrait of Van Laer. The subtlety of the conceit may be inferred from the fact that *bamboccio,* like its synonym *fantoccio* used by Vasari in the anecdote about Michelangelo, was specifically applied to the crude mural drawings of the inept.[40]

One point emerges clearly from our consideration of the prehistory of Bernini's deliberate and explicit exploitation of aesthetic vulgarity. The artists who displayed this unexpected sensibility generally did so in order to make some statement about the nature of art or of their profession. The statements were, in the end, deeply personal and had to do with the relation between ordinary or common creativity and what is usually called art. No doubt there is an art-theoretical, or even art-philosophical element in Bernini's attitude, as well, but with him the emphasis shifts. His everyman's style is not a vehicle for comment about art or being an artist, but about people, or rather being a person. His visual lampoons are strictly *ad hominem,* and it is for this reason, I think, that in the case of Bernini one can speak for the first time of caricature drawing not only as art, but as an art of social satire.

With respect to the context of Bernini's caricatures outside the visual arts, it is important to note that we can date the beginning of his production as a caricaturist fairly precisely. It must have coincided with the earliest datable example that has come down to us, the famous drawing of Cardinal Scipione Borghese, nephew of Pope Paul V and Bernini's greatest early patron (see fig. 15). A terminus ante quem is provided by Scipione's death at

age fifty-seven on October 2, 1633, but most likely the sketch was made during the sittings for the even more famous pair of marble portrait busts of the cardinal that are known to have been executed in the summer of 1632 (fig. 32).[41] It can scarcely be coincidental, moreover, that probably in November of the same year Lelio Guidiccioni, one of Rome's literary lights and a close friend and admirer of Bernini, acquired an important album of drawings of genre figures, now lost, by Annibale Carracci.[42]

What especially suggests that Bernini started making caricatures at this time is the fact that he then also developed a passionate interest in the comic theater. Beginning in February 1633, and very frequently thereafter at carnival time, he would produce a comedy of his own invention, often in an improvised theater in his own house, with himself, his family, and his studio assistants as the performers.[43] His plays were extremely successful, and we have many references to them in the early biographies and contemporary sources, which report that the audiences included some of the highest members of Roman society. The significance of this parallel with the theater is not simply that Bernini's interest in caricature and comedy coincided, for it is evident from what we learn about his plays that their relationship to their predecessors was analogous to that of his caricatures to theirs.

Bernini's comedies stemmed largely from the popular tradition of the commedia dell'arte, in which troupes of professional actors assumed stock character roles and performed largely conventional plots. The comic effect depended heavily on the contrast of social strata achieved through the interplay of representative types, portrayed through stereotyped costumes, gestures, and dialects. The actors were so versed in their craft, and its conventions were so ingrained, that the plays were recorded only in the form of brief plot summaries. The recitations were thus extemporaneous, but bound to a tradition of virtuosity born of familiarity and repetition.

By way of contrast, I shall quote first Domenico Bernini's account of Bernini's plays, and then just one contemporary description.[44] Domenico says:

The beauty and wonder [of his comedies] consisted for the greatest and best part in the facetious and satiric jokes, and in the scenic inventions: the former were so meaningful [*significanti*], spirited and close to the truth [*fondati sul vero*], that many experts attributed the plays to Plautus or Terence or other writers, whom the cavalier had never read, but did them all by sheer force of wit. A most remarkable thing is that each night the theater was filled with the highest nobility of Rome, ecclesiastic as well as secular, and those who were targets of his jibes not only took no offense but, considering their truth and honesty, almost took pride in being subjected to Bernini's acute and ingenious remarks. These then circulated throughout Rome and often the same evening reached even the ears of the pope, who seeing Bernini the next day took pleasure in having him repeat them. Bernini not only labored to compose them,

but also took great pains to see that the actors, who were mostly members of his entourage and not experienced in the theater, would give natural and lively performances. In so doing, he served as everyone's teacher and the result was that they performed like long-time professionals in the art.[45]

To savor the description that follows, which dates from February 1634, it must be understood that Cardinal Gaspare Borgia was the Spanish ambassador to the Holy See, that his coat of arms included a striding bull, and that he was notoriously overbearing and tactless in pursuing his country's interests at the court of Urban VIII, who was strongly pro-French.[46]

Borgia is absolutely furious because, to everyone's delight, Bernini in his comedy introduced a bull being beaten on the stage; he is quite aware it referred to him since he was a bull in arms and was called that by the pope. Borgia was also upset because elsewhere in the comedy a Spaniard argues with a servant who, having been told by a Frenchman not to let himself be bullied, beats up the Spaniard to the amusement of all. Borgia, who understands without gloss the recondite meanings of the actions and words, considers the king and the whole Spanish nation offended by the pope himself, who knows perfectly well all the scenes of the comedy before they are performed. Borgia is also angry about other jibes, though these are the worst, and heaven protect Bernini from a bitter penance in the future, for Borgia is not one easily to forget offenses.[47]

It is clear that Bernini's plays broke with the commedia dell'arte conventions in various ways, of which three are especially important here. One is that Bernini introduced all sorts of illusionistic tricks — houses collapse, the theater threatens to catch fire, the audience is almost inundated — tricks that not only added a kind of visual scenographic interest that had been confined mainly to court spectacles, but also communicated with the spectator directly and in a way that seemed, at least at first glance, quite *un*contrived. Furthermore, Bernini's comedies were not enacted extemporaneously by professional actors but by amateurs who had been carefully instructed and mercilessly rehearsed and who recited parts that — as we know from the manuscript of one of his plays that has come down to us — might be completely written out, as in the regular theater. His productions combined the technique of raw talent with the conception of high art. Finally, Bernini introduced topical allusions to current events and real people; with unexampled boldness, he poked fun at some of the highest members of Roman society, who might even be present in the audience. Bernini's comedies thus included what can only be described as "living caricatures," witty distortions of the political allegiance or moral character of individuals, who remain readily identifiable. In general, his plays may be said to have involved a dual breach of decorum, treating low comedy performed by amateurs as if it

were legitimate theater, and treating exalted personages as if they were ordinary people.

Although Bernini may be said to have introduced an element of social satire to the stage, there was one literary tradition in Rome to which it was, so to speak, endemic. This was the so-called pasquinade, or satire in verse or prose, which poked fun, often in very bitter terms, at the religious and civic authorities for their personal foibles or for whatever of the city's current ills could be attributed to their greed or ineptitude. The diatribes were occasionally gathered together and published, so that the pasquinade became a veritable genre of popular literary satire. It was the custom to write a pasquinade in Latin or Italian on a scrap of paper and attach it to one of several more or less fragmentary ancient statues that were to be seen about town. These "talking statues," as they were sometimes called, became the loudspeaker through which the vox populi expressed its wit and discontent. The genre derives its name from the most infamous of the sculptures (fig. 33), nicknamed Pasquino—according to one version of the legend, after a clever and malicious hunchbacked tailor who lived nearby in the Piazza Orsini, considered the heart of Rome, and who started the custom early in the sixteenth century.[48] It is no accident, of course, that the speaking statues of Rome were all antiques. From biblical times the issue of idolatry was focused chiefly on sculpture, the three-dimensionality of which gave it special status in the hierarchy of representation. The early Christians regarded pagan statuary as literally the work of the devil and endowed with demonic powers, notably the power of speech. Indeed, Pasquino's irreverent and malicious comments were often downright diabolic.

As a literary genre the pasquinade might well be described as something like a verbal graffito in that, by contrast with the high art of satire, it tended to be more topical in content and more informal in style and, though well-known writers such as Pietro Aretino often joined in the sport, it was characteristically anonymous. Indeed, this popular and rather underprivileged element lies at the very heart of the tradition, for there is a remarkable and surely not accidental consonance between the character of Pasquino the tailor, a lowly artisan and man of the people, grotesquely deformed yet pungently articulate, and the character of the sculpture itself—pathetically worn and mutilated, yet also pathetically expressive. The fundamental irony of the group's brutish appearance and caustic eloquence was perfectly explicit: in the eloquent engraving of the group signed and dated 1550 by Antonio Lafreri (fig. 34), Pasquino says of himself:

I am not, though I seem so, a mutilated Baboon, without feet and hands . . . but rather that famous Pasquino who terrifies the most powerful . . . when I compose in Italian or Latin. I owe my physique to the blows of those whose faults I faithfully recount.[49]

If the pasquinade is something like a verbal graffito, Bernini's caricatures can be thought of as visual pasquinades, almost literally so if one considers Bernini's very special relationship to the statue itself. The group is mentioned in the biographies as well as in Chantelou's diary, always with the same point illustrated by an anecdote: Asked by a cardinal which was his favorite ancient statue, Bernini named the *Pasquino,* of which he said that "mutilated and ruined as it is, the remnant of beauty it embodies is perceptible only to those knowledgeable in design."[50] Indeed, he regarded it as a work of Phidias or Praxiteles. The cardinal thought his leg was being pulled and was infuriated. Bernini was said to have been the first to place the highest value on the *Pasquino* as a work of art.[51] The appreciation of antique fragments was by now nothing new, so that whether true or not, the claim—and likewise the cardinal's anger—only makes sense in view of the satirical tradition with which the *Pasquino* was primarily associated; Bernini even said that one must disregard what had been written about the sculpture. No less remarkable is the reason he gave for his esteem—that the work contains "the highest perfection of nature *without the affectation of art*" [italics mine].

The drawing of Innocent XI is unique among the preserved caricatures by Bernini because it is the only one datable to the very end of his life, and because it represents the most exalted personage of all. The skeletal figure with gargantuan nose and cavernous eyes is immediately recognizable (cf. figs. 8 and 35).[52] What makes the characterization so trenchant, however, is not only the treatment of the pope's physical features, but also the fact that he is shown incongruously wearing the regalia of the bishop of Rome and bestowing his blessing while reclining in bed, propped up by huge pillows. The pope is thus ridiculed on two levels at once, both of which reflect aspects of his personality and conduct that were notorious.[53] This remarkable man was by far the most irascible and ascetic individual to occupy the papal throne since the heyday of the Counter Reformation a century before. He was utterly indifferent to the amenities of life himself and lived in monastic austerity. He was indefatigable in his efforts to purify the Church of its abuses, the boldest and best known of which was his war on nepotism. He rigorously excluded his family from Church affairs and sought to ensure that his successors would do likewise. He was equally staunch in his defense of the Church against heretics and against attempts to curtail the prerogatives of the Holy See. His financial contributions to the war against the Turks, made possible by a fiscal policy of absolute parsimony, were a major factor in the victory at Vienna in 1683 that saved Europe from the infidel. The process of sanctification was initiated soon after his death and is still in progress; he was beatified in 1953.

Although his virtues may indeed have been heroic, Innocent XI was not without his faults. He demanded the same kind of austerity from his subjects

that he practiced himself. Public entertainments were banned, and with edict after edict he sought to rule the lives of his people down to the pettiest details of personal dress and conduct. He suffered the consequences of his disagreeableness, which won him the epithet The Big No Pope (*Papa Mingone*, from the word *minga*, meaning "no" in his native Lombard dialect). A notice of 1679 reports that several people were jailed for circulating a manifesto with the punning and alliterative title, *Roma assassinata dalla Santità* ("Rome Assassinated by Sanctity" — *santità* in Italian means both "holiness" and "His Holiness").[54]

In addition, Innocent XI was a sick man, plagued by gout and gallstones.[55] These sufferings — real and imagined, for he was certainly a hypochondriac — must have exacerbated the harshness of an inherently acerbic personality. His ailments often conspired with a natural tendency to reclusiveness to keep the pope confined to his room and to his bed. For days, weeks, months on end he would remain closeted, refusing to see anyone and procrastinating in matters of state — conduct that elicited a brilliant pasquinade, reported in July 1677:

Saturday night there was attached to Pasquino a beautiful placard with a painted poppy [*papavero* in Italian — the opium flower] and the following legend [like a medicinal prescription] beneath: *Papa Vero = Per dormire* [true Pope = to sleep]; next morning it provided a field day for the wags, including the whole court, which is fed up with the current delays and cannot bear such irresolution.[56]

On rare occasions during these periods, when the pope's condition improved or in matters of special importance, visitors might be admitted to his chamber, where he received them in bed. Bernini's drawing captures the irony of this spectacle of the Supreme Roman Pontiff conducting the most dignified affairs of state in most undignified circumstances.

The character of the portrait itself has no less significant implications than its appurtenances. In a quite remarkable way, as we know from many descriptions and other depictions, the pope's appearance matched his personality. He was exceedingly tall and gaunt, with a huge aquiline nose and protruding chin. These features are glossed over in many "straight" portraits of Innocent, but we have a drawing, perhaps by Bernini himself, in which his crabbed and rather chilling aspect appears unmitigated (fig. 35). The profile of the pope, also wearing the bishop's miter, may have been in preparation for a sculptured portrait, and the caricature may have originated in one of Bernini's sessions sketching the man in action — repeating the process we suggested in connection with the Scipione Borghese portraits done nearly fifty years earlier.[57]

Bernini certainly had reason enough to take an unsympathetic view of the pope, whose indifference, if not actual hostility, to art was notorious. It was

Innocent who in January 1679 refused to permit the execution of the final block of the portico in front of Saint Peter's, thus dooming to incompletion the greatest architectural project of Bernini's life. It was he who prudishly forced the artist to cover the bosom of the figure of Truth on the tomb of Alexander VII. It was Innocent who ordered an inquiry into the stability of the dome of Saint Peter's where cracks had appeared, which some of Bernini's critics falsely attributed to his work on the supporting piers many years before.[58]

It would be a mistake, however, to think of the drawing simply as an exercise of Bernini's spleen upon Innocent's character and appearance. The basic design and the specific deformations it embodies are rife with reminiscences and allusions that augment its meaning. The reclining figure performing an official act recalls those most peculiar and regal ceremonies Bernini must have become aware of on his visit to the court of Louis XIV in 1665, the *lit de justice* and the *lever* and *coucher du roi,* in which the Sun King received homage as he rose in the morning and retired in the evening.[59] The image also reflects the tradition of the reclining effigy on tomb monuments and the reclining Moriens in the innumerable illustrated versions of the *Ars Moriendi* ("The Art of Dying Well") (fig. 36); the latter genre had an important role in the devotions of the Confraternity of the Bona Mors at the Gesù, in which Bernini and the pope himself, when he was cardinal, participated regularly.[60] Bernini had only recently adapted this convention for his portrayal of Blessed Lodovica Albertoni in a state of ecstatic expiration in her burial chapel in San Francesco a Ripa in Rome (fig. 37). He may even have recalled a sixteenth-century Flemish tomb, an engraving of which there are other reasons to suppose he knew, where a beckoning skeleton replaced the figure of the deceased (fig. 38).[61] The somewhat lugubrious irony of this conflation of regal pomp and funereal decrepitude was surely deliberate.

So, too, were aspects of the rendering of the pope's physiognomy and gesture. Innocent followed like a chill wind after the florid exuberance of the long, Baroque summer of the Church Triumphant. He was, as we have noted, a veritable throwback to the rigorous pietism of the Counter Reformation, and quite consciously so, for he took as the model for all his actions the most austere pontiff of that whole period, Pius V (1566–1572), who had also been unrelenting in his zeal to cleanse the Church of its vices, including nepotism, and protect it from its enemies (the Turks were defeated in the momentous naval battle at Lepanto during his reign).[62] He had been beatified in 1672, shortly before Innocent XI took office, and was canonized in 1712. It happened that Innocent also bore a striking physical resemblance to Pius, whose desiccated and otherworldly features seem perfectly to embody the spiritual fervor of his time. Innocent actually had himself depicted as a kind of reincarnation of his saintly idol on a very unusual medal where portraits of the two men appear on the two faces (fig. 39).[63] Bernini must

have had the analogy in mind when drawing the caricature: the emaciated figure with spidery hand raised in blessing distinctly recalls a particular medallic image issued by Pius himself, which is one of the most penetrating of all the portrayals of the great reformer (fig. 40).[64] In this way Bernini assimilated both Innocent and his prototype into a composite image of the pontifical arch zealot.

In some respects the drawing of Innocent reaches beyond the limits of portraiture; the exaggeration is so extreme that the figure scarcely resembles a human being at all, but rather some monstrous insect, with pillows for wings and bishop's miter for antennae, masquerading as a person. Again, I doubt that the analogy is fortuitous. To be sure, insects in general were not a very important part of the physiognomical tradition discussed earlier, but one insect in particular, or at least the name of it, played a considerable role in the history of comic monstrosities in Western art — namely, the cricket. In a famous passage Pliny says that the Greek artist Antiphilos established a new genre of painting by a comic portrayal of a man called Gryllos in a ridiculous costume, from which, Pliny says, all such pictures are called *grylloi*.[65] Although the exact meaning of the passage is in dispute, it is generally agreed that Pliny must be referring to amusing depictions of cavorting dwarfs and hybrid and humanoid creatures, of which numerous examples are known. No doubt this interpretation dates from the Renaissance and is based in part on the happenstance that the word, when spelled with a lambda in Greek, means "pig," and with two l's in Latin means "cricket."[66] As early as the mid-sixteenth century the works of Hieronymus Bosch, which contain all manner of mixed human and animal forms, were called *grylloi* (fig. 41); so, too, were Arcimboldo's polymorphous transmutations of traditional frontal and profile portrait types.[67] Bernini's caricature of Innocent looks like nothing so much as a great cricket, and I have no doubt that this novel assimilation of insect and human likenesses was made in deliberate reference to, and emulation of, the new art of comic portraiture invented by the ancient master.

I suspect, moreover, that the analogy reached beyond physical appearances to a moral and psychological level as well, through another remarkable wordplay of the sort that always fascinated Bernini. In Italian *grillo* would refer not only to the classical prototype of the comic portrait, but also to the character or personality of the insect itself. Owing to the creature's peculiar life-style, the word *grillo* has a meaning roughly equivalent to "whim" or "caprice" in English. The term appears frequently in the art literature of the period in reference to the artist's inventiveness or even his personal stylistic idiosyncrasies.[68] More generally, to "have a cricket in one's head" (*avere un grillo in testa*) is to "have a bee in one's bonnet" — an expression that seems to suit Innocent XI as if it were tailored for him. In Bernini's sketch, the pope's appearance and character merged with the

invention of comic portraiture in a grandiose pun linking antiquity to the present under the aspect of satire.

The chain turns full circle, as it were, when two additional links are added that pertain to the *Pasquino*. In the early sixteenth century there had been a one-eyed barber named Grillo who had written pasquinades that were actually called *grilli,* which he was said to have had in his head. The frontispiece of a volume of the poems he attached to the *Pasquino* shows him chasing after crickets in the field (fig. 42).[69] Perhaps Grillo's memory was still alive in Bernini's time. In any case, Bernini seems not to have been the only one to apply an image of this sort to Innocent. One is tempted to imagine that his drawing may have inspired the following verses from a vicious pasquinade occasioned by the pope's death in 1689:

I've not found in the annals of ancient things
A worst beast, who beneath hypocrisy clings
And tinges in others' blood his beak and wings.[70]

I have so far discussed rather specific aspects of the form, sources, and significance of Bernini's caricatures. Insofar as they are documents of social comment, however, certain more general features of the context in which they were produced must also be considered. With hindsight it seems inevitable that the true caricature should have emerged in Rome and nowhere else.[71] Rome was then, as it still is, unlike any other major European city in that, from the point of view of commerce and industry, it was insignificant; its only reasons for being were administrative and symbolic. It was the capital of a great state, which, though of diminished political and military importance, retained a spiritual force that made it a focal point of international relations, secular as well as ecclesiastical. There was nothing in Rome to match the growth of the bourgeoisie in the urban centers of the north, but in the bosom of the Church men could, and very often did, rise from the humblest circumstances to the heights of power and wealth. As the headquarters of the Catholic hierarchy, and especially of the religious orders, the city was filled with people who, like Bernini, had broken through the barriers of traditional class hierarchy. Social irony was almost a natural by-product of this extraordinary environment, wherein moral pretense and cosmopolitan reality were extremes that touched.

The birth of caricature was also related to the rise in status for which artists had been struggling since the Renaissance, and of which Bernini was in some respects the epitome. A major theme of the biographies by Baldinucci (written at the behest of Bernini's close friend, Queen Christina of Sweden) and by his son Domenico was precisely his acceptance by the great people of his day, even at a certain risk to themselves. This could easily be dismissed as mere propaganda, but I think their wonderment at Bernini's

social achievement was genuine. The point is vividly illustrated in the matter of caricature by a satirical poem published in 1648 by the duke of Bracciano, one of the leading figures of the day, of whom Bernini did a bust, preserved in a marble copy, that some critics have regarded as a sort of formal caricature (fig. 43).[72] The duke describes a merry gathering at his villa at Bracciano of the cream of Roman nobility, at which he and Bernini, whom he lists among the guests as "animator of marbles," joined in making comic drawings of the participants.[73] In 1665, during his visit to Paris to design the Louvre, Bernini introduced the concept and example of his persiflages to Louis XIV and his court, who were greatly amused.[74]

Bernini's career, in fact, would indeed be difficult to match by that of any other artist—not Velásquez, whose aspiration to nobility was a central factor in his life; not Rubens, whose position in the world was inseparable from his activity as a diplomat. Bernini never lost touch with the humble craft origins of his profession. He became early on a member of the marble workers' guild, to which he remained very attached and contributed generously later in life;[75] and although much indebted to the humanist tradition, he laid no claim to recondite learning or theoretical speculation. His freedom of wit and satire and his ability to consort on equal terms with the high and mighty were based solely on the quality of his mind and art. In this sense he fulfilled the Renaissance ideal, while helping to create a new role for the artist in society.

In the end, however, the caricatures must be thought of as a deeply personal expression of Bernini's creative genius, for two reasons in particular. One is that—and this is true of his comedies as well—although he circulated them among his friends, there is no evidence he ever intended to publish his drawings in the form of prints. We owe the caricature as an instrument of social reform in this sense to eighteenth-century England. Bernini's little lampoons sprang from a deep well within, however, and were far from mere trifles to him. Both points emerge from the last document I shall quote, a charming letter Bernini wrote to a friend named Bonaventura ("Good Fortune" in Italian) accompanying two such sketches, now lost:

As a cavalier, I swear I'll never send you any more drawings because having these two portraits you can say you have all that bumbler Bernini can do. But since I doubt your dim wit can recognize them I'll tell you the longer one is Don Giberti and the shorter one is Bona Ventura. Believe me, you've had Good Fortune, because I've never had greater satisfaction than in these two caricatures, and I've made them with my heart. When I visit you I'll see if you appreciate them.

> Rome, 15 March 1652.
> Your True Friend
> G. L. Bern.

This is, incidentally, the first time the word "caricature" is used as we use it today, as the name for a certain class of drawings.[76]

NOTES

■ An earlier version of this essay appeared in Lavin et al. (1981) pp. 25–54. Since the original publication, Professor Dieter Wuttke of Bamberg has kindly brought to my attention an important article by Arndt (1970), in which several of the points dealt with here are anticipated. In particular, Arndt suggests (p. 272) a similar interpretation of the sketch by Dürer discussed below. On later appreciation of children's drawings, see Georgel (1980). Also, my colleague John Elliott acquainted me with a remarkable sketch in which Philip IV of Spain and his minister Olivares are crudely portrayed as Don Quixote and Sancho Panza; but the drawing is not independent and is clearly much later than the manuscript, dated 1641, to which it was added along with a postscript (on this point I am indebted to Sandra Sider of the Hispanic Society of America). See Elliott (1964, plate 19 opposite p. 344).

1. Insofar as the notion of "high/low" includes that of primitivism, there is a substantial bibliography, beginning with the classic work of Lovejoy and Boas (1935); more recent literature on primitivism in art will be found in *Encyclopedia* (1959–87, vol. 11, columns 704–17), to which should be added Gombrich ([1960], 1985), and, for the modern period, Rubin, ed., 1985. Further discussion of some aspects of the problem will be found in an essay on Picasso's lithographic series *The Bull*, in a volume of my essays to be published by the University of California Press (1991). If one includes related domains, such as popular art, the art of children and the insane — what I have elsewhere called "art without history" — the subject of their relations to sophisticated art has yet to receive a general treatment. The development of interest in the art of the insane, in particular, has now been studied in an exemplary fashion by MacGregor (1989).

2. On the Olynthus mosaics, see Salzmann (1982, pp. 100ff.).

3. Cited in Hadzi (1982, p. 312).

4. See the exemplary discussion of the arch in Kitzinger (1977, pp. 7ff.).

5. This last is the luminous suggestion of Tronzo (1986). For the parameters of this idea in terms of classical literary style, see Gombrich (1966[1]).

6. On these works see Schmitt (1980); the fundamental importance of Schmitt's study for our understanding of medieval art has yet to be fully grasped.

7. For a description and bibliography, see Lavin et al. (1981, catalogue number 99, pp. 336–37). Traces of further drawing appear at the upper right. Bernini evidently cut off a portion of a larger sheet in order to make the caricature, which he may have drawn for his personal satisfaction and kept for himself. Twenty-five caricatures are mentioned in a 1706 inventory of Bernini's household; Fraschetti (1900, p. 247).

8. For a general account of social criticism in postmedieval art, see Shikes (1969). A fine analysis of the nature of the Carraccis' *ritrattini carichi*, with the attribution to Annibale of the drawing reproduced here, will be found in Posner (1971, pp. 65–70, fig. 59; and cf. fig. 60, certainly cut from a larger sheet), but see also Bohlin (1979, pp. 48, 67, nn. 83f.); so far as can be determined, Annibale's drawings displayed neither the social content nor the distinctive draftsmanship of Bernini's caricatures, nor is it clear that they were autonomous sheets. On the papal

satires of the Reformation, see Grisar and Heege (1921–23); Koepplin and Falk (1974–76, vol. 2, pp. 498–522).

9. For caricature generally, and for bibliography, see *Encyclopedia* (1959–87, vol. 3, columns 734–35). For a useful recent survey of caricature since the Renaissance, see *Caricature* (1971). On the development in Italy, the fundamental treatment is that of Juynboll (1934); important observations will be found in a chapter by E. Kris and E. H. Gombrich in Kris (1952, pp. 189–203), and in Gombrich (1972, pp. 330ff). The pages on Bernini's caricatures in Brauer and Wittkower (1931, pp. 180–84), remain unsurpassed; but see also Boeck (1949), Harris (1975, p. 158), and Harris (1977, p. xviii, numbers 40, 41). The latter has questioned whether the caricatures in the Vatican Library and the Gabinetto Nazionale delle Stampe in Rome, attributed to Bernini by Brauer and Wittkower, are autographs or close copies; however, the issue does not affect the general argument presented here. Caricature drawings attributed to Bernini other than those noted by Brauer and Wittkower and by Harris (1977) will be found in Cooke (1955); Sotheby (1963, Lot 18); Stampfle and Bean (1967, vol. 2, pp. 54f.).

10. In Bernini's drawings, "si scorge simmetria maravigliosa, maestà grande, e una tal franchezza di tocco, che è propriamente un miracolo; ed io non saprei dire chi mai nel suo tempo gli fusse stato equale in tal facoltà. Effetto di questa franchezza è stato l'aver egli operato singolarmente in quella sorte di disegno, che noi diciamo caricatura o di colpi caricati, deformando per ischerzo a mal modo l'effigie altrui, senza togliere loro la somiglianza, e la maestà, se talvolta eran principi grandi, come bene spesso accadeva per lo gusto, che avevano tali personaggi di sollazzarsi con lui in si fatto trattenimento, anche intorno a'propri volti, dando poi a vedere i disegni ad altri di non minore affare." Baldinucci ([1682] 1948, p. 140).

11. "Ne devesi passar sotto silenzio l'havere ei in quel tempo & appresso ancora, singolarmente operato in quella sorte di Disegno, che communemente chiamasi col nome di *Caricatura*. Fù questo un'effetto singolare del suo spirito, poichè in essi veniva a deformare, come per ischerzo, l'altrui effigie in quelle parti però, dove la natura haveva in qualche modo difettato, e senza togliere loro la somiglianza, li rendeva su le Carte similissimi, e quali in sostanza essi erano, benche se ne scorgesse notabilmente alterata, e caricata una parte; Invenzione rare volte praticata da altri Artefici, non essendo giuoco da tutti, ricavare il bello dal deforme, e dalla sproporzione la simetria. Ne fece egli dunque parecchi, e per lo più si dilettava di caricare l'effigie de' Principi, e Personaggi grandi, per lo gusto, che essi poi ne ricevevono in rimirarsi que' medesimi, pur d'essi, e non essi, ammirando eglino in un tempo l'Ingegno grande dell'Artefice, e solazzandosi con si fatto trattenimento." Bernini (1713, p. 28).

12. For the foregoing, see Lavin (1970, p. 144 n. 75).

13. Della Porta ([1586] 1650, pp. 116f.). For general bibliography on physiognomics, see *Encyclopedia* (1959–68, vol. 3, columns 380f.).

14. Cf. Wilde (1978, pp. 147ff.).

15. For portrait drawing generally, see Meder (1978, pp. 335ff.); for drawings by Leoni, see Kruft (1969).

16. It is interesting that in both cases contemporaries were already aware of the distinctive techniques used in these drawings; for Michelangelo, see Vasari ([1550, 1568] 1962, vol. 1, pp. 118, 121f.; vol. 4, pp. 1,898ff.); for the colored chalks and pencils of Leoni and Bernini, see Baglione ([1642] 1935, p. 321) and Stampfle and Bean (1967, pp. 52f.).

17. There was one class of sixteenth-century works, incidentally, in which the loose sketch might become a sort of presentation drawing, namely, the German autograph album (*album amicorum* or *Stammbuch*); see, for example, Thöne (1940, pp. 55f., figs. 17–19) and *Drawings* (1964, p. 23, numbers 33, 35).

18. For Bernini's portrait drawings generally, see Brauer and Wittkower (1931, pp. 11, 15, 29f., 156f.) and Harris (1977, *passim*.). It happens that the two preserved and certainly authentic profile drawings by Bernini represent sitters of whom he also made sculptured portraits, i.e.,

Scipione Borghese (fig. 18) and Pope Clement X [see Lavin et al. (1981, catalogue number 83, pp. 294–99, 375)]. Conversely, there are no recorded portrait sculptures of the sitters of whom Bernini made drawings in three-quarter view. It is interesting in this context to compare the triple views provided to Bernini by painters for four sculptured busts to be executed *in absentia* — by Van Dyck for portraits of Charles I and Henrietta Maria, by Philippe de Champaigne for Richelieu, and by Sustermans and Boulanger for Francesco I of Modena; cf. Wittkower (1966, pp. 207f., 209f., 224):

			VIEW	
Subject	*Right profile*	*Full-face*	*Three-quarter–to–left profile*	*Left profile*
Charles I	X	X	X	
Henrietta Maria	X	X		X
Richelieu	X		X	X
Francesco I	X	X		X

All four include the right profile, all but the third the full face, and all but the first the left profile; only the first and third show the head turned three quarters (to the left). "Portraits," otherwise unspecified, were also sent from Paris to Bernini in Rome for the equestrian statue of Louis XIV; see Wittkower (1961, p. 525, number 47).

19. The first studies for the bust are mentioned in Chantelou's diary, June 23, 1665: "Le Cavalier a dessiné d'après le Roi une tête de face, une de profil" (Chantelou, p. 37); cf. a letter of 26 June from Paris by Bernini's assistant Mattia de' Rossi, "doppo che hebbe fenito il retratto in faccia, lo fece in profilo," Mirot (1904, p. 218n), and the remark of Domenico Bernini (1713, p. 133), "Onde a S. Germano fè ritorno per retrarre in disegno la Regia effigie, e due formònne, una di profilo, l'altro in faccia." Charles Perrault in his *Mémoires* of 1669 also mentions Bernini's profile sketches of the king: "[Bernini] se contenta de dessiner en pastel deux ou trois profils du visage du Roi" (Perrault, p. 61).

20. For the references to this aspect of Bernini's procedure, see Brauer and Wittkower (1931, p. 29), and Wittkower (1951).

21. Interesting in this context are Michelangelo's frontal and profile sketches for the marble block of one of the Medici Chapel river gods; see De Tolnay (1943–60, vol. 3, plate 131). Cellini (1971, p. 789), speaks of Michelangelo's method of drawing the principal view on the block and commencing carving on that side.

22. It is significant that Bernini employed a comparable technique when he portrayed nature in what might be called a "primitive" or formless state, as in the sketches for fireworks [Lavin et al. (1981, catalogue numbers 56–58, pp. 219–27)] or a project for a fountain with a great display of gushing water [Brauer and Wittkower (1931, plate 101a); cf. Harris (1977, p. xxi, number 70)].

23. Cf. Rupprich (1956–69, vol. 1, pp. 54f.). The passage (my own translation) reads as follows:
"Know that my picture says it would give a ducat for you to see it; it is good and beautifully coloured. I have earned great praise for it, but little profit. I could well have earned 200 ducats in the time and have refused much work, so that I may come home. I have also silenced all the painters who said I was good at engraving, but that in painting I did not know how to handle colors. Now they all say they have never seen more beautiful colors." Dürer made the drawing immediately before he wrote this passage, which surrounds the figure. Lange and Fuhse (1893, p. 35 n. 1) noted long ago that the sketch must refer to this, rather than the preceding portion of the letter.

24. Panofsky (1969, p. 203). On Erasmus's self-mocking sketches, see Heckscher (1967, pp. 135f. n. 23) and the bibliography cited there.

25. Erasmus speaks of marveling and laughing at the extreme crudity of artists a century or two earlier ("admiraberis et ridebis nimiam artificum rusticitatem"); see Panofsky (1969, pp. 200, 202f.), who also discusses Erasmus's early interest in and practice of painting and drawing.

26. Franco Fiorio (1971, pp. 47f., 100); for suggestive analysis of the painting, see Almgren (1971, pp. 71–73).

27. On the eye of Painting, see Posner (1967, pp. 201f.).

28. What may be a deliberately crude head appears among the test drawings and scratches on the back of one of Annibale Carracci's engraved plates; Posner (1971, p. 70, fig. 68); and Bohlin (1979, p. 437).

29. Both ancient graffiti and *grylloi* (discussed below) are often considered in the literature on comic art, e.g., Champfleury (1865, pp. 57–65, 186–203), but I am not aware that they have hitherto been treated seriously as specific progenitors of the modern caricature. For ancient graffiti generally, see *Enciclopedia* (1958–66, vol. 3, pp. 995f.). For a recent survey of the figural graffiti at Pompeii, see Cèbe (1966, pp. 375f.); for those on the Palatine in Rome, see Väänänen (1966, 1970).

30. "Il m'a dit qu'à Rome il en avait une [a gallery] dans sa maison, laquelle est presque toute pareille; que c'est là qu'il fait, en se promenant, la plupart de ses compositions; qu'il marquait sur la muraille, avec du charbon, les idées des choses à mesure qu'elles lui venaient dans l'esprit" (Chantelou, p. 19). The idea recalls the ancient tales of the invention of painting by tracing shadows cast on the wall; see Kris and Kurz (1979, p. 74 and n. 10).

31. I refer to the well-known *Saint Joseph Holding the Christ Child* at Ariccia [Brauer and Wittkower (1931, pp. 154–56, plate 115)], and a (much restored) portrait of Urban VIII in black and red chalk, in the Villa La Maddelena of Cardinal Giori, Bernini's friend and patron, at Muccia near Camerino (fig. 24). The attribution of the latter work, reproduced here for the first time, I believe, stems from an inventory of 1712; Brauer and Wittkower (1931, p. 151); cf. Feliciangeli (1917, pp. 9f.). I am indebted to Professors Italo Faldi and Oreste Ferrari for their assistance in obtaining photographs. Cf. also a portrait drawing in black and red chalk in the Chigi palace at Formello; Martinelli (1950, p. 182, fig. 193).

32. The association between *sgraffiti* and *grotteschi* is clear from Vasari's description and account of their invention; see Vasari ([1550, 1568] 1966ff., vol. 1, *Testo*, pp. 142–45, *Commento*, p. 212, vol. 4, *Testo*, pp. 517–23); cf. Maclehose and Brown (1960, pp. 243–45, 298–303). On *sgraffiti* and *grotteschi*, see Thiem (1964) and Dacos (1969).

33. "E stato Michelagnolo di una tenace e profonda memoria, che nel vedere le cose altrui una sol volta l'ha ritenute si fattamente e servitosene in una maniera che nessuno se n'è mai quasi accorto; né ha mai fatto cosa nessuna delle sue che riscontri l'una con l'altra, perché si ricordava di tutto quello che aveva fatto. Nella sua gioventù, sendo con gli amici sua pittori, giucorno una cena a chi faceva una figura che non avessi niente di disegno, che fussi goffa, simile a que' fantocci che fanno coloro che non sanno e imbrattano le mura. Qui si valse della memoria; perché, ricordatosi aver visto in un muro una di queste gofferie, la fece come se l'avessi avuta dinanzi du tutto punto, e superò tutti que'pittori: cosa dificile in uno uomo tanto pieno di disegno, avvezzo a cose scelte, che no potessi uscir netto." Vasari ([1550, 1558] 1962, vol. I, p. 124; see also vol. 4, pp. 2,074f.).

34. Dal Poggetto (1979, p. 267, no. 71, and p. 272, nos. 154, 156). A remarkable precedent for these drawings are those attributed to Mino da Fiesole, discovered on a wall in his house in Florence; see Sciolla (1970, p. 113 with bibliography).

35. c'a forza 'l ventre appicca sotto 'l mento.
. .
e 'l pennel sopra 'l viso tuttavia
mel fa, gocciando, un ricco pavimento.
. .
e tendomi come arco sorïano.
 Però fallace e strano
surge il iudizio che la mente porta,
chè mal si tra' per cerbottana torta.

La mia pittura morta
difendi orma', Giovanni, e 'l mio onore
non sendo in loco bon, nè io pittore.

Girardi (1960, pp. 4f.); trans. from Gilbert and Linscott (1963, pp. 5f.). The sheet has most recently been dated 1511–12 by De Tolnay (1975–80, vol. I, p. 126), who also notes the disjunction between the two parts of the drawing.

36. On the analogy, cf. Lavin (1980, p. 156).

37. A similarly crude drawing in white of a woman appears on the adjacent face of the pier.

38. The inscription, in white except for the artist's signature, which is in black, reads: "de buer Kerck binnen utrecht / aldus geschildert int iaer 1644 / van / Pieter Saenredam" ("the Buur church in Utrecht thus painted in the year 1644 by Pieter Saenredam"). Cf. Maclaren (1960, pp. 379–81); *Catalogue* (1961, pp. 185f.). For assistance in identifying the object at the seated boy's side, I am indebted to Dr. Jean Fraikin, Curator of the Musée de la Vie Wallone at Liège, who cites the following bibliography on children's school boxes: Dewez (1956, pp. 362–71); *L'Art* (1970, pp. 372ff.). Crude drawings—two women (one of them virtually identical with the one mentioned above), a tree, and a bird—also appear on a pier at the right, surrounding an inscription with the artist's signature and the date 1641, in one of Saenredam's views of the Mariakerk at Utrecht; *Catalogue* (1961, pp. 212f.). On this painting see Schwartz (1966–67), who notes the association between such drawings and the artist's signature (p. 91 n. 43). Saenredam's sensitivity to and deliberate manipulation of stylistic differences are evident in the relationship between Gothic and Roman architecture in his paintings, for which see now the thoughtful article by Connell (1980).

39. For this drawing, see Janeck (1968, pp. 122f.). The figure shown from the back on the wall recurs among other graffiti in a painting attributed to Van Laer in Munich; Janeck (1968, pp. 137f.); see also Kren (1980, p. 68).

40. Cf. Malvasia (1841, vol. 2, p. 67), with regard to the youthful wall scribblings of the painter Mastelletta. For this reference I am indebted to David Levine, whose Princeton dissertation on the *bamboccianti* (1984) deals with their art-theoretical paintings and the Berlin drawing.

41. The precise dating of the Borghese busts emerges from a letter of the following year written by Lelio Guidiccioni [cf. D'Onofrio (1967, pp. 381–86)]. I plan to discuss the letter at greater length in another context.

42. On this and the following point, see Lavin (1970, p. 144 n. 75).

43. On Bernini and the theater, see Lavin (1980, pp. 145–57).

44. A convenient, but not complete, collection of early sources on Bernini's theatrical activities will be found in D'Onofrio (1963, pp. 91–110).

45. Bernini (1713, pp. 54f.).

46. On Borgia, see Pastor (1894–1953, vol. 28, pp. 281–94), for example.

47. Letter to the duke of Modena from his agent in Rome, 23 February 1634 [Fraschetti (1900, pp. 261f., n. 4; see also the description of comedies in 1638, pp. 264f., and 1646, pp. 268–70)].

48. The bibliography on Pasquino and the pasquinade is vast. For a recent survey, see Silenzi (1968). The best orientation within the literary context remains that of Cian (1945, vol. 2, pp. 81–107, 321–37). On the sculpture, see now Haskell and Penny (1981, pp. 291–96). For a valuable study of the "high" and "low" traditions of satire with respect to Bernini's rival, Salvator Rosa, see Roworth (1977).

49. From the inscription on the base:

Io non son (come paio) un Babbuino
 stroppiato, senz piedi, et senza mani,
. .
Ma son quel famosissimo Pasquino
 Che tremar faccio i Signor piu soprani,
. .
 Quando compongo in volgare, o in latino.
La mia persona è fatta in tal maniera
 Per i colpi ch'hor questo hor quel m'accocca
Per ch'io dico i lor falli a buona cera.

Our transcription is based on a corrected but unsigned and undated version of the print in a copy of Lafreri in the Marquand Library, Princeton University: fig. 34 is reproduced from Lafreri (1575), Beinecke Library, Yale University.

50. It is especially interesting that Bernini distinguished between complete and incomplete statues, and among the latter noted the subtle differences between the Belvedere torso and the *Pasquino*, ranking the *Pasquino* highest of all. The passages referred to are:

M. le nonce, changeant de matière, a demandé au Cavalier laquelle des figures antiques il estimait devantage. Il a dit que c'était le *Pasquin*, et qu'un cardinal lui ayant un jour fait la même demande, il lui avait répondu la même chose, ce qu'il avait pris pour une raillerie qu'il faisait de lui et s'en était faché; qu'il fallait bien qu'il n'eut pas lu ce qu'on en avait écrit, et que le *Pasquin* était une figure de Phidias ou de Praxitèle et représentait le serviteur d'Alexandre, le soutenant quand il reçut un coup de flèche au siège de Tyr; qu'à la vérité, mutilée et ruinée comme est cette figure, le reste de beauté qui y est n'est connu que des savants dans le dessin. (Chantelou, pp. 25f.)

Diceva che il Laocoonte e il Pasquino nell'antico avevano in sé tutto il buono dell'arte, perché vi si scorgeva imitato tutto il più perfetto della natura, senza affettazione dell'arte. Che le più belle statue che fussero in Roma eran quelle di Belvedere e fra quelle dico fra le intere, il Laocoonte per l'espressione dell'affetto, ed in particolare per l'intelligenza che si scorge in quella gamba, la quale per esserve già arrivato il veleno, apparisce intirizzita; diceva però, che il Torso ed il Pasquino gli parevano di più perfetta maniera del Laocoonte stesso, ma che questo era intero e gli altri no. Fra il Pasquino ed il Torso esser la differenza quasi impercettibile, né potersi ravvisare se non da uomo grande e più tosto migliore essere il Pasquino. Fu il primo il Bernino che mettesse questa statua in altissimo credito in Roma e raccontasi che essendogli una volta stato domandato da un oltramontano qual fusse la più bella statua di quella città e respondendo che il Pasquino, il forestiero che si credette burlato fu per venir con lui a cimento. [Baldinucci ([1682] 1948, p. 146).]

Con uguale attenzione pose il suo studio ancora in ammirar le parti di quei due celebri Torsi di Hercole, e di Pasquino, quegli riconosciuto per suo Maestro dal Buonarota, questi dal Bernino, che fù il primo, che ponesse in alto concetto in Roma questa nobilissima Statua; Anzi avvenne, che richiesto una volta da un Nobile forastiere Oltramontano, *Quale fosse la Statua più riguardevole in Roma?* e rispostogli, *Che il Pasquino*, quello diè sù le furie, stimandosi burlato, e poco mancò, che non ne venisse a cimento con lui; E di questi due Torsi era solito dire, che contenevano in se tutto il più perfetto della Natura senza affettazione dell'Arte. [Bernini (1713, pp. 13f.).]

51. The *Pasquino* had long been esteemed, cf. Haskell and Penny (1981, p. 292), but I have not found precedent for Bernini's placing it foremost.

52. A photograph of Innocent's death mask will be found in Lippi (1889, frontispiece).

53. For Innocent generally, and bibliography, see *Bibliotheca* (1961–69, vol. 7, columns 848–56); for most of what follows, see Pastor (1894–1953, vol. 32, pp. 13–37, 153–67).

54. "E poi stato mandato in Galera quel libraro francese Bernardoni che faceva venir libri contro

cardinale e ministri della chiesa sendo anco stati carcerati alcuni copisti per essersi veduto un Manifesto intitolato; Roma assassinata dalla santità." Unpublished *avviso di Roma,* July 8, 1679, Vatican Library, MS Barb. lat. 6838, fol. 154 v. For collections of pasquinades on Innocent XI, see Lafon (1876, p. 287); Pastor (1894–1953, vol. 32, p. 30 n. 8); Besso (1904, p. 308); Romano (1932, pp. 72–74); Silenzi (1933, pp. 251f.) [reprinted in Silenzi (1968), pp. 278f.]; Cian (1945, vol. 2, pp. 260f., 516, n. 228–30).

55. On the pope's health, see Pastor (1894–1953, vol. 32, pp. 515–19); Michaud (1882–83, vol. 1, pp. 158f.).

56. "Sabbato à notte fu fatto a Pasquino un bellissimo Cartello con un Papauero dipinto, e sotto la presente Inscrittione = *Papa Vero* = *Per dormire,* il che la mattina non pochi motivi di discorso diede à gli otiosi, nel cui numero vi si comprende la corte tutta, la quale attediata dalle lunchezze correnti non può soffrire tante irresolutioni." Unpublished *avviso di Roma,* July 5, 1677, Vatican Library, MS Barb. lat. 6384, fol. 200.

57. The drawing, in red chalk, conforms in type to Bernini's studies for sculptured portraits (see above, p. 21), and its plastic modeling led Brauer and Wittkower (1931, p. 157) to consider it a copy after a lost original; I suspect it is original, overworked by another hand. No sculptured portrait of Innocent by Bernini is recorded, unless he made the model for a bronze, datable 1678, by a certain Travani, once in S. Maria in Montesanto, Rome; see Martinelli (1956, p. 47 n. 95).

58. On the foregoing, see Pastor (1894–1953, vol. 32, p. 35); Wittkower (1981, p. 260).

59. See the classic study by Kantorowicz (1963, pp. 162–77).

60. For Bernini and the *Ars Moriendi,* see Lavin (1972, pp. 159–71); on Innocent and the Bona Mors, see Pastor (1894–1953, vol. 32, p. 14).

61. For this tomb, cf. Lavin (1980, p. 136 n. 10) and Lavin et al. (1981, catalogue numbers 2–5, n. 13).

62. For Pius V, see *Bibliotheca* (1961–69, vol. 10, columns 883–901). Innocent's emulation of Pius is attested in the sources, e.g., a letter to Paris from the French agent in Rome, May 11, 1678: "On travaille icy en bon lieu pour inspirer le dessein au pape de proffiter de sa fortune en imitant seulement Pie V que Saintété paroit s'estre proposée pour le modèle de ses actions." Paris, Ministère des affaires étrangères, Correspondance de Rome, vol. 256, fol. 141 (modern foliation), quoted in part by Michaud (1882–83, vol. 1, pp. 152f.); cf. Pastor (1894–1953, vol. 32, pp. 184, 518, 523).

63. Cf. *Trésor* (1834–58, vol. 6, p. 38 and plate xxxvi, number 8); Patrignani (1953, p. 78, number 2). There are also plaques on which the two popes' portraits are paired, and Innocent struck a medal and coins to celebrate the victory at Vienna with the same inscription used by Pius on a medal celebrating the victory at Lepanto; cf. Hiesinger and Percy (1980, pp. 130f.); Venuti (1744, pp. 125f., number VII, p. 299, number XXVIII); Serafini (1964–65, vol. 2, pp. 298f.).

64. Venuti (1744, p. 125, numbers V, VI).

65. "Idem iocosis nomine Gryllum deridiculi habitus pinxit, unde id genus picturae grylli vocantur." Jex-Blake and Sellers (1975, pp. 146f.) For the ancient genre, see *Enciclopedia* (1958–66, vol. 3, pp. 1,065f.).

66. On the modern use of the term, see the basic contributions in the journal *Proef* (1974) by Miedema, Bruyn, and Ruurs (kindly called to my attention by David Levine); cf. Alpers (1975– 76, p. 119 and n. 15); Miedema (1977, p. 211 n. 29). See further, Wind (1974, pp. 28f.) and the references given in the next footnote.

67. For Bosch, see the remarks by Felipe de Guevara, trans. in De Tolnay (1966, p. 401); cf. Gombrich (1966², pp. 113, 115 n. 30); Posner (1971, pp. 69, 164 n. 94). For Arcimboldo, see Kaufmann (1975, pp. 280–82). The word was also applied by Lomazzo ([1584] 1973–74, p. 367) and Tesauro ([1670] 1968, p. 85) to the kind of grotesque decorations discussed above.

68. See the passages noted in the index to Lomazzo ([1584] 1973–74, p. 672, s.v. "Grillo").

69. Silenzi (1933, pp. 17, illustrated opposite p. 100, 339f., 343).

70. Io non retrovo ancor nei vecchi annali
 Bestia peggior, che sotto hipocrasia
 Col sangue altrui tingesse e 'l becco e l'ali

Silenzi (1968, p. 279).

71. There is no comprehensive social history of Rome at this period. For a recent general survey with useful bibliographical indications, see Petrocchi (1975).

72. On the portrait, see Wittkower (1966, p. 204ff). A document recently published by Rubsamen (1980, p. 45, number 72), makes it clear that this bust is a copy after a (lost) model by Bernini, as had been suggested by Martinelli.

73. Frà questi v'è Paol' Emilio Orsino,
 Il Duca Sforza & ambi i Mignanelli
 Animator di marmi euui il Bernino,
 .
 Hor mentre battagliauano costoro,
 Bernino, & io sopra un buffetto à parte
 Presemo à caricare alcun di loro.
 .

 Orsini (1648, pp. 63, 65); first published by Muñoz (1919, pp. 369f.).

74. Caricatures are mentioned in two sharp and revealing passages in the diary of Bernini's visit kept by Chantelou (1885, pp. 106, 151; interestingly enough, Chantelou uses the phrase attributed to the Carracci, "charged portraits"). During an audience with the king, ". . . le Cavalier a dit en riant: 'Ces messieurs'ci ont le Roi à leur gré toute la journée et ne veulent pas me le laisser seulement une demiheure; je suis tenté d'en faire de quelqu'un le portrait chargé.' Personne n'entendait cela; j'ai dit au Roi que c'étaient des portraits que l'on faisait ressembler dans le laid et le ridicule. L'Abbé Butti a pris la parole et a dit que le Cavalier était admirable dans ces sortes de portraits, qu'il faudrait en faire voir quelqu'un à Sa Majesté, et comme l'on a parlé de quelqu'un de femme, le Cavalier a dit que *Non bisognava caricar le donne che da notte.*" Subsequently, Butti was himself the victim ". . . quelqu'un parlant d'un portrait chargé, le Cavalier a dit qu'il avait fait celui de l'abbé Butti, lequel il a cherché pour le faire voir à Sa Majesté, et, ne l'ayant pas trouvé, il a demandé du crayon et du papier et l'a refait en trois coups devant le Roi qui a pris plaisir à le voir, comme a fait aussi Monsieur et les autres, tant ceux qui étaient entrés que ceux qui étaient à la porte."

75. See Lavin (1968, pp. 236f.).

76. . . . mio sig——re

Da chavaliere vi giuro di non mandarvi più disegni perchè avendo voi questi dui ritratti potete dire d'avere tutto quel che può fare quel baldino di bernino, ma perchè dubito che il Vostro corto ingegno non sapia conoscerli per non vi fare arrossire vi dico che quel più lungo è Don Ghiberti e quel più basso è Bona Ventura. Credetemi che a voi e toccato aver la buona Ventura perchè mai mi sono più sodisfatto che in queste due caricature e lo fatte di cuore. Quando verrò costì vedrò se ne tenete conto. Roma li 15 Marzo 1652.

<div align="right">Vero Amico
G. L. Bern.</div>

Ozzola (1906, p. 205); cf. Lavin (1970, p. 144 n. 75). Ozzola guessed from the letter itself that the addressee might have been named Bonaventura. I have no doubt that the fortunate recipient was, in fact, the Bolognese painter and Franciscan friar Bonaventura Bisi. Bisi was a friend and correspondent of Guercino, who also made a caricature of him, datable 1657–59, with an inscription punning on his last name (cf. Galleni, 1975).

BIBLIOGRAPHY

Amgren, A. *Die umgekehrte Perspektive und die Fluchtachsenperspektive.* Uppsala, 1971.

Alpers, S. "Realism as a Comic Mode. Low-Life Painting Seen through Bredero's Eyes." *Simiolus,* vol. 8 (1975–76), pp. 115–44.

Arndt, H. *"Johannes est stultus, amen.* Kinderzeichnungen eines lateinschuler aus den Tagen des Erasmus." In M. Gosebruch and L. Dittmann, eds., *Argos—Festschrift für Kurt Badt,* pp. 261–76. Cologne, 1970.

L'Art populaire en Wallonie, Liège, 1970.

Baglione, G. *Le vite de' pittori* [1935] *scultori et architetti dal pontificato di Gregorio XIII. del 1572. in fino a'tempi di Papa Urbino Ottavo nel 1642.* Rome, 1642; ed. V. Mariani, Rome, 1935.

Baldinucci, F. *Vita del Cavaliere Gio. Lorenzo Bernino scultore, architetto, e pittore.* Rome, 1682; ed. S. S. Ludovici, Milan, 1948.

Bernini, D. *Vita del Cavalier Gio. Lorenzo Bernino.* Rome, 1713.

Besso, M. *Roma e il papa nei proverbi e nei modi di dire.* Rome, 1904.

Bibliotheca sanctorum. 12 vols. Rome, 1961–69.

Boeck, W. "Bernini und die Erfindung der Bildniskarikatur." *Das goldene Tor,* vol. 4 (1949), pp. 294–99.

Bohlin, D. D. *Prints and Related Drawings by the Carracci Family.* Washington, D.C., 1975.

Boissard, J. J. *Romanae urbis topographiae et antiquitatum.* 2 vols. Frankfurt, 1597–1602.

Brauer, H. and R. Wittkower. *Die Zeichnungen des Gianlorenzo Bernini,* Berlin, 1931.

Bruyn, J. "Problemen bij grillen." *Proef,* vol. 3 (1974), pp. 82–84.

Caricature and Its Role in Graphic Satire (exh. cat.). Providence, R.I., 1971.

Catalogue Raisonné of the Works by Pieter Jansz. Saenredam (exh. cat.). Utrecht, 1961.

Cèbe, J.-P. *La Caricature et la parodie dans le monde romain antique des origines a Juvénal.* Paris, 1966.

Cellini, B. *Opere.* Ed. G. G. Ferrero. Turin, 1971.

Champfleury [J. Fleury-Husson], *Histoire de la caricature antique.* Paris, 1865.

Chantelou, P. Fréart de. *Journal du Cavalier Bernin en France.* Ed. L. Lalanne. Paris, 1885.

Cian, V. *La satira.* 2 vols. Milan, 1945.

Connell, E. J. "The Romanization of the Gothic Arch in Some Paintings by Pieter Saenredam. Catholic and Protestant Implications." *The Rutgers Art Review,* vol. 1 (1980), pp. 17–35.

Cooke, H. L. "Three Unknown Drawings by G. L. Bernini." *Burlington Magazine,* vol. 97 (1955), pp. 320–23.

Dacos, N. *La Découverte de la Domus Aureus et la formation des grotesques à la Renaissance.* London–Leiden, 1969.

Dal Poggetto, P. *I disegni murali di Michelangiolo e della sua scuola nella Sagrestia Nuova di San Lorenzo.* Florence, 1979.

De la Vigne, D. *Spiegel van een saalighe Doodt.* Antwerp, 1673 (?).

Della Porta, G. B. *De humana physiognomonia.* Vico Equense, 1586; ed. Rouen, 1650.

De Tolnay, C. *Michelangelo.* Princeton, 1943–60.

De Tolnay, C. *Hieronymus Bosch.* New York, 1966.

De Tolnay, C. *Corpus dei disegni di Michelangelo.* Novara, 1975ff.

Dewez, L. "L'Ecole. Les boîtes d'écolier." *Enquêtes du Musée de la Vie Wallone,* vol. 7 (1956), pp. 362–71.

D'Onofrio, C. *Gian Lorenzo Bernini. Fontana di Trevi. Commedia inedita.* Rome, 1963.

D'Onofrio, C. *Roma vista da Roma.* Rome, 1967.

Drawings of the 15th and 16th Centuries from the Wallraf-Richartz–Museum in Cologne. Circulated by the American Federation of Arts 1964–65 (exh. cat.). Berlin, 1964.

Elliott, J. H. *Imperial Spain 1496–1716.* New York, 1964.

Enciclopedia dell'arte antica, classica e orientale. 7 vols. Rome, 1958–66.

Encyclopedia of World Art. 17 vols. London, 1959–87.

Fagiolo dell'Arco, M. and M. *Bernini. Una introduzione al gran teatro del barocco.* Rome, 1967.

Feliciangeli, B. *Il cardinale Angelo Giori da Camerino e Gianlorenzo Bernini.* Sanseverino-Marche, 1917.

Franco Fiorio, M. T. *Giovan Francesco Caroto.* Verona, 1971.

Fraschetti, S. *Il Bernini. La sua vita, la sua opera, il suo tempo.* Milan, 1900.

Galleni, R. "Bonaventura Bisi e il Guercino." *Paragone,* vol. 26, no. 307 (1975), pp. 80–82.

Georgel, P. "L'Enfant au Bonhomme." In K. Gallwitz and K. Herding, eds., *Malerei und Theorie. Das Courbet-Colloquium 1979,* pp. 105–15. Frankfurt, 1980.

Gilbert, C. (trans.), and Linscott, R. N. (ed.). *Complete Poems and Selected Letters of Michelangelo,* New York, 1963.

Girardi, E. N. *Michelangiolo Buonarroti. Rime.* Bari, 1960.

Gombrich, E. H. "The Debate on Primitivism in Ancient Rhetoric." *Journal of the Warburg and Courtauld Institutes,* vol. 29 (1966[1]), pp. 24–38.

Gombrich, E. H. *Norm and Form.* London, 1966[2].

Gombrich, E. H. *Art and Illusion,* Princeton, 1972.

Gombrich, E. H. *Il gusto dei primitivi. Le radici della rebellione.* Naples, 1985.

Grisar, H., and F. Heege. *Luthers Kampfbilder.* 4 vols. Freiburg im Breisgau, 1921–23.

Hadzi, M.L. In P. W. Lehman and D. Spittle, *Samothrace. The Temenos.* Princeton, 1982.

Harris, A. S. "Angelo de' Rossi, Bernini and the Art of Caricature." *Master Drawings,* vol. 13 (1975), pp. 158–60.

Harris, A. S. *Selected Drawings of Gian Lorenzo Bernini.* New York, 1977.

Haskell, F., and N. Penny. *Taste and the Antique: The Lure of Classical Sculpture 1500–1900.* New Haven and London, 1981.

Heckscher, W. S. "Reflections on Seeing Holbein's Portrait of Erasmus at Longford Castle." In D. Fraser, H. Hibbard, M. J. Lewine, eds., *Essays in the History of Art Presented to Rudolf Wittkower,* pp. 128–48. London, 1967.

Hiesinger, U. W., and A. Percy. *A Scholar Collects: Selections from the Anthony Morris Clark Bequest.* Philadelphia, 1980.

Janeck, A. "Untersuchung über den Holländischen Maler Pieter van Laer, genannt Bamboccio," Ph.D. diss., Würzburg, 1968.

Jex-Blake, K., and E. Sellers. *The Elder Pliny's Chapters on the History of Art.* Chicago, 1975.

Juynboll, W. R. *Het komische genre in de Italiaansche schilderkunst gedurende de zeventiende en de achttiende eeuw. Bijdrage tot de geschiedenis van de caricatur.* Leyden, 1934.

Kantorowicz, E. H. "Oriens augusti — Lever du roi," *Dumbarton Oaks Papers*, vol. 17 (1963), pp. 117–77.

Kaufmann, T. D. "Arcimboldo's Imperial Allegories. G. B. Fonteo and the Interpretation of Arcimboldo's Painting." *Zeitschrift für Kunstgeschichte*, vol. 39 (1975), pp. 275–96.

Kitzinger, E. *Byzantine Art in the Making. Main Lines of Stylistic Development in Mediterranean Art. 3rd–7th Century.* Cambridge, Mass., 1977.

Koepplin, D., and T. Falk. *Lukas Cranach. Gemälde, Zeichnungen, Druckgraphik.* 2 vols. Stuttgart, 1974–76.

Kren, T. "Chi non vuol Baccho. Roeland van Laer's Burlesque Painting about Dutch Artists in Rome." *Simiolus*, vol. 11 (1980), pp. 63–80.

Kris, E. *Psychoanalytic Explorations in Art.* New York, 1952.

Kris, E., and O. Kurz. *Legend, Myth, and Magic in the Image of the Artist. A Historical Experiment.* New Haven and London, 1979.

Kruft, H.-W. "Ein Album mit Porträtzeichnungen Ottavio Leonis." *Storia dell'Arte*, 1969, pp. 447–58.

Lafon, M. *Pasquino et Marforio. Les bouches de marbre de Rome.* Paris, 1876.

Lafreri, A. *Speculum romanae magnificentiae.* Rome, 1575.

Lange, K., and F. Fuhse. *Dürers schriftlicher Nachlass.* Halle, 1893.

Lavin, I. "Five New Youthful Sculptures by Gianlorenzo Bernini and a Revised Chronology of His Early Work." *The Art Bulletin*, vol. 50 (1968), pp. 223–48.

Lavin, I., with the collaboration of M. Aronberg Lavin. "Duquesnoy's 'Nano di Créqui' and Two Busts by Francesco Mochi." *The Art Bulletin*, vol. 52 (1970), pp. 132–49.

Lavin, I. "Bernini's Death." *The Art Bulletin*, vol. 54 (1972), pp. 159–86.

Lavin, I. *Bernini and the Unity of the Visual Arts.* New York–London, 1980.

Lavin, I., et al. *Drawings by Gianlorenzo Bernini from the Museum der bildenden Künste, Leipzig* (exh. cat.). Princeton, 1981.

Lavin, I. *History as a Visual Figure of Speech. Uses of the Past in Art From Donatello to Picasso* Berkeley, to be published in 1991.

Levine, D. "The Art of the Bamboccianti." Ph.D. diss., Princeton University, 1984.

Lippi, M. G. *Vita di Papa XI.* Ed. G. Berthier. Rome, 1889.

Lomazzo, G. P. *Idea del tempio della pittura.* Milan, 1590; *Trattato dell'arte della pittura.* Milan, 1584. *Gian Paolo Lomazzo. Scritti sulle arti.* Ed. R. P. Ciardi. 2 vols. Florence, 1973–74.

MacGregor, J. M. *The Discovery of the Art of the Insane.* Princeton, 1989.

Maclaren, N. *National Gallery Catalogues. The Dutch School.* London, 1960.

Maclehose, L. S., and G. B. Brown. *Vasari on Technique.* New York, 1960.

Malvasia, C. E. *Felsina pittrice. Vite de' pittori bolognesi.* Ed. G. Zanotti. 2 vols. Bologna, 1841.

Martinelli, V. "I disegni del Bernini." *Commentari*, vol. 1 (1950), pp. 172–86.

Martinelli, V. *I ritratti di pontefici di G. L. Bernini.* Rome, 1956.

Meder, J. *The Mastery of Drawing.* Translated and revised by W. Ames. New York, 1978.

Michaud, E., *Louis XIV et Innocent XI,* 4 vols., Paris, 1882–83.

Miedema, H. "De grillen." *Proef*, vol. 3 (1974), pp. 84–86.

Miedema, H. "Grillen van Rembrandt." *Proef,* vol. 3 (1974), p. 74f.

Miedema, H. "Realism and Comic Mode. The Peasant." *Simiolus,* vol. 9 (1977), pp. 205–19.

Mirot, L. "Le Bernin en France. Les travaux du Louvre et les statues de Louis XIV." *Mémoires de la société de l'histoire de Paris et de l'Ile-de-France,* vol. 31 (1904), pp. 161–288.

Muñoz, A. *Roma barocca.* Rome, 1919.

Orsini, P. G., duke of Bracciano. *Parallelo fra la città e la villa. Satire undici.* Bracciano, 1648.

Ozzola, L. "Tre lettere inedite riguardanti il Bernini." *L'Arte,* vol. 9 (1906), p. 205.

Panofsky, E. "Erasmus and the Visual Arts." *Journal of the Warburg and Courtauld Institutes,* vol. 32 (1969), pp. 200–27.

Passional Christi und Antichristi. Ed. D. G. Kawerau. Berlin, 1885.

Pastor, L. von. *The History of the Popes.* 40 vols. St. Louis, 1894–1953.

Patrignani, A. "Le medaglie papali del periodo neoclassico (1605–1730). Seconda parte: Da Clemente X (1670) a Benedetto XIII (1730)." *Bollettino del circolo numismatico napolitano,* vol. 38 (1953), pp. 65–110.

Perrault, C. *Mémoires de ma vie par Charles Perrault. Voyage à Bordeaux (1669) par Claude Perrault.* Ed. P. Bonnefon. Paris, 1909.

Petrocchi, M. *Roma nel seicento.* Bologna, 1975.

Posner, D. "The Picture of Painting in Poussin's *Self-Portrait.*" In D. Fraser, H. Hibbard, M. J. Lewine, eds., *Essays in the History of Art Presented to Rudolf Wittkower,* pp. 200–203. London, 1967.

Posner, D. *Annibale Carracci: A Study in the Reform of Italian Painting around 1590.* London, 1971.

Robinson, D. M. "The Villa of Good Fortune at Olynthus." *American Journal of Archaeology,* vol. 38 (1934), pp. 501–10.

Romano, P. *Pasquino e la satira in Roma.* Rome, 1932.

Roworth, W. W. "Pictor Succensor. A Study of Salvator Rosa as Satirist, Cynic, and Painter." diss., Bryn Mawr College, 1977.

Rubin, W., ed., *"Primitivism" in 20th Century Art,* 2 vols. New York, 1984.

Rubsamen, G. *The Orsini Inventories.* Malibu, Calif., 1980.

Rupprich, H. *Dürer: schriftlicher Nachlass.* 3 vols. Berlin, 1956–69.

Rurrs, R. "Adrianus Brouwer gryllorum pictor." *Proef,* vol. 3 (1974), p. 87f.

Salzmann, D. *Untersuchungen zu den antiken Kieselmosaiken.* Berlin, 1982.

Schmitt, M. " 'Random' Reliefs and 'Primitive' Friezes. Reused Sources of Romanesque Sculpture?" *Viator,* vol. 11 (1980), pp. 123–45.

Schwartz, G. "Saenredam, Huygens and the Utrecht Bull." *Simiolus,* vol. 1 (1966–67), pp. 69–93.

Sciolla, G. C. *La scultura di Mino da Fiesole.* Torino, 1970.

Serafini, C. *Le monete e le bolle plumbee pontificie del medagliere vaticano.* 4 vols. Bologna, 1964–65.

Shikes, R. E. *The Indignant Eye: The Artist as Social Critic in Prints and Drawings from the Fifteenth Century to Picasso.* Boston, Mass., 1969.

Silenzi, F. and R. *Pasquino. Cinquecento Pasquinate.* Milan, 1933.

Silenzi, F. and R. *Pasquino. Quattro secoli di satira romana.* Florence, 1968.

Sotheby & Co., *Catalogue of Old Master Drawings, May 21, 1963.*

Stampfle, F. and J. Bean. *Drawings from New York Collections.* Vol. 2: *The Seventeenth Century.* New York, 1967.

Tesauro, E. *Il cannocchiale aristotelico.* Turin, 1670. Ed. A. Buck. Bad Homburg, etc., 1968.

Thiem, G. and C. *Toskanische Fassaden-Dekoration.* Munich, 1964.

Thöne, F. "Caspar Freisingers Zeichnungen." *Zeitschrift des deutschen Vereins für Kunstwissenschaft,* vol. 7 (1940), pp. 39–63.

Trésor de numismatique et de glyptique. Ed. P. Delaroche, H. Dupont, C. Lenormant. 20 vols. Paris, 1834–58.

Tronzo, W. *The Via Latina Catacomb: Imitation and Discontinuity in Fourth-Century Roman Painting.* University Park and London, 1986.

Väänänen, V., ed., *Graffiti del Palatino.* Vol. 1: *Paedagogium.* Helsinki, 1966. Vol. 2: *Domus Tiberiana.* Helsinki, 1970.

Vasari, G. *La vita di Michelangelo nelle redazioni del 1550 e del 1568.* Ed. P. Barocchi. 5 vols. Milan and Naples, 1962.

Vasari, G. *Le vite de' più eccellenti pittori scultori e architettori nelle redazioni del 1550 e 1568.* Ed R. Bettarini, P. Barrocchi. Florence, 1966ff.

Venuti, R. *Numismata romanorum pontificum praestantoria a Martinus V ad Benedictum XIV.* Rome, 1744.

Wilde, J. *Michelangelo.* Oxford, 1978.

Wind, B. "Pitture Ridicole: Some Late Cinquecento Comic Genre Paintings." *Storia dell'arte,* no. 20 (1974), pp. 25–35.

Wittkower, R. *Bernini's Bust of Louis XIV.* London, etc., 1951.

Wittkower, R. "The Vicissitudes of a Dynastic Monument. Bernini's Equestrian Statue of Louis XIV." In *De artibus opuscula XL: Essays in Honor of Erwin Panofsky,* pp. 497–531. Ed. M. Meiss. New York, 1961.

Wittkower, R. *Gian Lorenzo Bernini. The Sculptor of the Roman Baroque,* London, 1981.

■ SUBJECTS FROM COMMON

LIFE IN THE REAL LANGUAGE

OF MEN: POPULAR ART

AND MODERN TRADITION

IN NINETEENTH-CENTURY

FRENCH PAINTING ■

LORENZ EITNER

■

The belief that art and literature are products of acquired knowledge and skill, i.e. of civilization, was attacked in the latter half of the eighteenth century by thinkers who, reacting against Enlightenment rationalism, attributed creativity to irresistible emotional forces, natural rather than cultural in origin: the true artist, compelled by inner necessity, creates as a tree bears fruit, regardless of rules or of external demands. The vital energy that is expressed in art is not the product of education or of imitation, but comes from nature itself. "An Original may be said to be of *vegetable* nature; it rises spontaneously from the vital root of genius; it grows, it is not made," wrote Edward Young (1759),[1] and Rousseau denounced culture as an evil, a sin against nature and hence an enemy to art: "Everything is good as it comes from the hands of the Author of Nature, everything degenerates in the hands of man" (1762).[2] Herder and the youthful polemicists of the German Storm and Stress Movement gave a particular turn to Rousseauistic thought, opposing to the sterility and rootlessness of cosmopolitan culture the ideal of a return to the origins of human development, to the natural sources of self-expression in childhood, in primitive ethnicity, and in folk tradition.

The counter-aesthetic that developed from these ideas in the last decade of the eighteenth century was influential chiefly on literature but also had some effect on art. It discounted technical routine and sophisticated refinements as symptoms of decadence, and in their stead extolled the naive sincerity of "unspoiled children, women, people of good common sense, formed by activity rather than speculation" (1771).[3] The authentic expression of feeling was more likely to be encountered among the illiterate peasants of the village than among the faculty of the academy. Notions such as these found their way into the programs that some artists and poets set themselves. "We must become children again if we want to attain the best,"[4] wrote the painter Philipp Otto Runge in 1802, in a letter in which he denounced the futility of conventional art study. And Wordsworth, explaining in his Preface to *Lyrical Ballads* (1800) "why I have chosen subjects from common life, and endeavored to bring my language near to the real language of men," defined poetry as the "spontaneous overflow of powerful feelings."[5] Relics of bardic poetry, fairy tales and folk songs, and the eloquent simplicity of early art now took on a new, urgent interest, as examples of a vigorous natural creativity that stood in sharp contrast to the sickly artifices of modern culture.

The discontent with the entrenched establishments of art that surfaced toward the end of the eighteenth century set the pattern for a succession of similar episodes of dissidence that were to occur periodically throughout the nineteenth century. All had the same main tendency: that of opposing the dominant direction of "high" art with a plea for a return to healthy origins — in the primitive past before mankind fell into the trap of civilization, in the

innocence of childhood, or in the uncorrupted soundness of the common people. All shared, to some degree, an aversion to academicism or even intellectuality, and a tolerance or positive liking for naïveté of expression, awkwardness of execution, and quaintness of shape, considering them signs of genuineness. The impact of these attitudes on popular literature and public taste was first felt around 1800. Their immediate effect on the arts was relatively slight, save for a passing infatuation with Ossianic subjects and primitivist mannerisms. The ferment did, however, seep into the teaching studios, causing confusion among the students and giving them a chance to question the curriculum and annoy their professors. Among David's pupils, a small group of dissidents rejected the classicism of their master as tepid and insufficiently "pure" and opposed to it an ideal of primordial primitive grandeur, derived from their own readings in Homer, the Bible, and most particularly, the poems of "Ossian." Not content with introducing archaisms into their work, the more zealous of these young artists, nicknamed *Primitifs* or *Penseurs,* applied the ethic of extreme simplicity and purity to their personal lives, and walked about the streets of Paris in antique Greek costume to demonstrate their independence of the affected and hypocritical ways of modern society. To keep debased art from further corrupting the public, they advocated setting fire to the museum, sparing only three or four antique statues and no more than a dozen paintings.[6]

The outbreak of youthful anarchism and iconoclasm was itself of little consequence. David, most conservative of revolutionaries, soon reestablished order in his studio, but this moment of turbulence is of some significance as the first, faint appearance of a split between the broad mainstream and a gradually widening fringe of dissenting and independent artists, the beginning of the avant-garde. The early symptoms of this rift were felt in the educational establishment: a growing number of young artists, from about 1815 onward, questioned the value of the prevailing models of formal instruction and chose to be their own teachers. The tendency toward self-development produced a steady pressure on the boundaries that had traditionally defined the high arts. Reacting against the boredom of conventions and the staleness of received notions of beauty and significance, the hollow claptrap of art theory, young artists needing open space and fresh air began to strike out on their own and to discover an invigorating savor in work outside the narrow confinement of recognized art — in the neglected periods of the past, in exotic traditions, and in the underworld of the primitive, infantile, and vulgar.

■ Théodore Géricault was among the first of the new breed of artists to distance himself from the professional establishment. Financial independence, openness of mind, and a somewhat cavalier amateurism — he liked to

call himself *propriétaire*, rather than "artist," on official occasions[7] — predisposed him to free experimentation. After a brief and fruitless period of study with two unlikely mentors, Carle Vernet and Pierre Guérin, he became his own teacher. Copying the masters at the Louvre, he gradually defined and developed his individuality through an unorthodox choice of models and a highly personal manner of execution. But while training his eye and hand in the intimate study of masterworks, he also copied reproductive engravings, and in his use of this second-hand, and often very second-rate, material showed himself to be soberly practical and goal directed. He used prints, regardless of their quality, to stock his mind with figural motifs and compositional arrangements and, in the act of copying, did not hesitate to distort his models to make them fit his purpose.[8] In his maturity, he continued to use this method of appropriation and adaptation, as an aid in the difficult initial visualization of his subject. When, in the later stages of the work, the image had begun to take shape, these early borrowings gradually disappeared, absorbed by the composition to which they had contributed. Hardly noticeable in the finished works, they only appear, as fleeting influences, in the sequence of preparatory studies.

The sources on which Géricault drew were extraordinarily diverse. Of popular art there are few traces among the outright copies, aside from some equestrian subjects taken from prints by Carle Vernet, but there is some evidence that he took an interest in the outpouring of military broadsheets occasioned by the wars of the declining Empire. Some of his paintings of those years are close enough to colored prints of the period to suggest that these played some part in their development. The early version of the *Charging Chasseur* (fig. 44), his Salon debut of 1812, bears a marked resemblance, even in its awkward presentation of horse and rider, to certain engravings of the time (see fig. 45).[9] It is probable that these fairly crude prints, published in large editions, had some bearing on Géricault's initial ideas for the subject, though their influence soon gave way to the much more sophisticated and original conception of the *Chasseur*'s final version. Not long after this first appearance at the Salon, he made his debut in the street with the *Signboard of a Farrier*, c. 1814 (fig. 46), painted on rough boards for a blacksmith of his acquaintance, a vernacular counterpart to the heroic *Chasseur.*[10]

Some years later, in the early spring of 1818, when he was about to start work on the *Raft of the Medusa* and was deeply engrossed in sensational material from the daily press, he was briefly tempted to experiment with a subject of the kind normally left to the lowest form of pictorial journalism, that of the *canards*, popular broadsheets dealing with crimes and executions. In the southern town of Rodez, a formerly Bonapartist official by the name of Fualdes, recently sacked by the Bourbon government, was attacked at night, dragged into a house of ill repute, robbed, and slaughtered in a

particularly repulsive manner. The affair was given a political turn by planted rumors that Fualdes was the victim of royalist revenge. Newspapers, pamphlets, and lithographic prints dwelt in detail on the picturesque horrors of the crime. Géricault was sufficiently impressed to draw a series of compositions (fig. 47), based on newspaper reports, in which he dissected the event into its successive episodes: the plotters conspiring; Fualdes abducted; Fualdes murdered; his body carried to the river; the assassins exulting over their crime, and escaping after disposing of the body.[11] His method recalls the serial narratives of popular imagery, and several of his compositions resemble published lithographs of the murder, but Géricault seems to have had a more ambitious purpose. According to his biographer, Charles Clément, he toyed with the idea of developing one or the other of these episodes into a major painting in an elevated, "antique" style,[12] and the preserved drawings do show that he hesitated between grandly artistic conceptions of the subject, resonant with echoes of Raphael, and rather more plainly realistic ones. In the end, he appears to have abandoned the project after having seen penny prints of the murder that he found better than his own designs. The abortive Fualdes project offers, if the accounts of it can be trusted, a very early instance — perhaps the earliest — of an effort to treat a subject associated with the most tawdry popular imagery on a scale and in a style normally reserved for "high" art. The significance of this episode lies not only in Géricault's choice of such a subject but in what it reveals of his interest in enlarging the boundaries of "high" art. In this light, the Fualdes drawings seem like a first, small start toward the great achievement of the *Medusa* — the translation into epic form of a newspaper story that according to the conventions of the period deserved nothing more than the modest dimensions and unpretending style of ordinary genre.

That Géricault at the same time did not disdain the actual formats and media of vernacular art is proven by his own lithographic essays of 1818–19,[13] which are of definitely popular character, though they share neither the technical crudities nor the primitive messages of humble mass productions. These were the years of lithography's early triumph, when the novelty of the process brought high and low artists together into a democracy of experimentation. Introduced to lithography by Horace Vernet, Géricault participated in the vogue for reminiscences of the Napoleonic glory, articles of secular devotion for the middle class, that Vernet had pioneered and that Charlet was to bring to a kind of perfection. The handful of military subjects that he drew at the time — *Cart Loaded with Wounded Soldiers, Return from Russia, Horse Artillery Changing Position* (fig. 49) — are essays in a form of national imagery for which there was a large commercial demand during the early years of the Restoration. Géricault's relatively few works in this vein stand out by virtue of their avoidance of patriotic rant, their noble reticence, their genuine pathos, and their powerful drawing. True experiments, rather

than works for the market, these lithographs were published in small editions and are, in that sense, not "popular," but works of high art in a popular format and on popular themes.

Géricault was, however, neither unaware of, nor indifferent to, the possibilities of commercial exploitation of works whose appeal to large audiences he well understood. After the half-failure of the *Medusa* at the Salon of 1819, he had the flexibility of mind to take his picture to London, to be exhibited to the paying public as the record of a famous shipwreck — a monumental *canard* accompanied by a *complainte,* or explanatory text, in the form of a pamphlet describing the disaster.[14] The speculation proved profitable beyond his expectations. Exhausted from his long labor over the *Medusa* and disillusioned for the time being with high art, he resolved during his stay in England to give up monumental painting, "employment for starving beggars," as he wrote to a friend, and to devote himself to money-making work of a popular sort: "*J'abdique le cothurne et la sainte Ecriture pour me renfermer dans l'écurie, dont je ne sortirai que cousu d'or.*"[15] Sporting art, horse portraiture, and low-life genre were English specialties held in fairly low esteem by French artists, and perhaps even by Géricault himself, but he was tempted to compete with the English on their own turf. He contracted with a London firm of lithographic publishers to undertake a series of English subjects.[16] The preparatory studies for these, as well as the twelve prints ultimately published, *Various Subjects Drawn from Life and on Stone* (1821), account for most of his English work. Horses, both of the aristocratic and the laboring kind, mainly occupied him, but he also recorded the life of the metropolis with something of a reporter's inquisitiveness, free from any aesthetic or sentimental bias. His drawings and lithographs of London street characters are marked by an acuteness of social observation that has no close parallel in English or French art of the time. The most powerful and original of these works, the lithographs of the *Piper* (fig. 50), the *Paralytic Woman,* and the *Beggar at the Bakery Window,* deal with the spectacle of urban poverty in closely observed London settings.[17] They are "popular" subjects, derived from personal experience rather than from sources in popular art. In these prints commercially produced for an English middle-class audience of 1821, Géricault anticipates, and in immediacy of observation surpasses, the social realism of French artists working after 1848. But though their matter is popular and English, their style has an expressive power and weight that take them out of the realm of common realism or popular genre. There can be little doubt that, despite his expressed appreciation of English art and his admonition to French painters to heed the English example,[18] he held fast to his initial reaction to the English school, namely that it excelled only in genre, landscape, portraiture, and animal painting, in other words, in the lesser specialties. Nor is it doubtful that he continued to think of himself as a painter of the French school,

superior to the English in the higher reaches of art, that is, in history painting. His retreat to the stables was to be a temporary episode. Though in his openness to new impressions he was stimulated by English popular art, he took from it only what suited him. He did not imitate, he adapted elements of English art — much of its subject matter and something of its empiricism, but very little of its stylistic conventions.

The great exception is the *Epsom Downs Derby* (fig. 51),[19] the only major oil painting of Géricault's English stay and the most "English" of his works — a deliberate imitation of English sporting art, executed in an English manner. Painted for his London landlord, the horse dealer A. Elmore, the picture probably represents a particular race, the Derby run on June 7, 1821 in which Elmore may have had a stake. It is possible that Géricault had witnessed this event, and that he aimed at a degree of historical accuracy in his picture. But this does not mean that he painted simply what he had seen at Epsom: steeped as he was in English art at the time, it is unlikely that his eyes had become so anglicized as to make him see reality itself through the artificial stereotypes of sporting art (see, for example, fig. 52). The *Epsom Downs Derby* is not merely a picture influenced by English racing imagery, it is a deliberate imitation — or parody — of the type in all its most telling features, and one in which it is possible to specify a fashionable contemporary practitioner of the genre, Henry Alken, as Géricault's most likely model. As a feat of stylistic simulation it is exceptional in his work, both for its self-denying mimicry and for its condescension to what must have seemed to him a "low" popular model. To grasp the significance of the *Epsom Downs Derby* as a — passing — renunciation of his aspirations to an elevated style, it is useful to compare it to his 1817 painting of a race, *The Start of the Barberi Race* (fig. 53), the crowning work of his Roman period. Begun in observations of modern Italian street life — a scene of the Roman carnival — the *Barberi Race* had gradually evolved into an image of heroic conflict, divested of all traces of modernity, and reminiscent of Raphael and the Parthenon. The contrast between the high pathos and statuesque muscularity of that Roman *Race* and the flat brilliance and flowing speed of the *Epsom Downs Derby* marks opposite poles in Géricault's work, the tension between grand tradition and popular modernity. In painting the *Derby,* perhaps to please Mr. Elmore with a bit of familiar Englishness, he may also have intended to comment ironically on his earlier grand manner and his recent descent from the *cothurne*.

■ Traditional folk art, which had been a living presence in the European countrysides and villages to the end of the eighteenth century, died in the early decades of the nineteenth and became a collector's hobby and the object of antiquarian study. Homecraft and amateur painting flourished,

then as now, carried on by individual lay artists scarcely visible beyond their immediate circle in their time and almost entirely forgotten since. The marginal professionals of provincial portraiture and the painters of shutters and shop signs remained almost equally obscure, though signboards sometimes tempted highly competent artists to try their hand at the craft—Géricault for fun, young Renoir for money, and Toulouse-Lautrec for some of both. The most significant and influential form of popular art in nineteenth-century France, however, was the commercial production of pictures for the publishing trade, an enormous enterprise, comparable in reach and impact to the visual media of our time.[20] It extended over a wide array of fields and occupied technicians and artists of every degree of skill, originality, and prestige, from the mass producers of crude broadsheets at the lower end to the designers of book illustrations and the stars of the fashionable illustrated periodicals at the top. Soon after 1850, photography joined the popular graphic media, and toward the century's end it began to replace them.

While in its higher reaches picture publishing catered to a social elite and reached into the sphere of serious art, it provided, at its humblest level, the simple icons of the uneducated poor—woodcut broadsheets that were bought for a sou to decorate the bedrooms and kitchens of villagers and lower-class town dwellers. It was to these images that the term "popular" was originally applied by their discoverers and collectors, as well as amateur ethnologists such as Champfleury, the author of realist novels and Courbet's friend, whose *Histoire de l'imagerie populaire* (1869) helped to initiate the serious study of their subject matter.[21] As used by Champfleury, "popular" meant "folk" and referred to the common people, the gradually vanishing remnant of the original stock of the nation, still attached to local customs and as yet little affected by modern schooling and the civilization of the city. Popular imagery, the garishly colored woodcuts held in contempt by the educated middle class, seemed to Champfleury the precious document of an authentic culture, the primitive, sincere expression of the beliefs and feelings of the people: "*L'imagerie, par cela qu'elle plut longtemps au peuple, dévoile la nature du peuple.*"[22] Aside from their social utility (according to Champfleury, the teaching of a simple morality and the inculcation of a spirit of resignation in the disadvantaged), he found aesthetic qualities in the rudest of broadsheets that, to his eyes, gave them an advantage over the mediocrities of the Salon. He savored the energy and austerity of the woodcuts, their beauty born of poverty, "their artistic awkwardness which is closer to the work of genius than those wishy-washy confections that come out of schools and sham traditions."[23] Very much in the spirit of Rousseau and of the primitivists of an earlier generation, he was moved to reflect on precultural creativity: "I contend that an idol carved out of a tree trunk by savages comes closer to Michelangelo's *Moses* than a good many of the sculptures in our yearly Salons."[24]

The mass manufacture of cheap printed images in France had had its beginnings in Paris, in the sixteenth century, and had gradually spread to other towns as the Paris market became less profitable. By the mid-seventeenth century, manufactures had sprung up in several provincial centers, in Chartres, Troyes, Orléans, Lille, Toulouse, and others, all of them sizable towns. Among the most productive workshops were those of Epinal, in Lorraine, which after 1800 grew into a large establishment that dominated the trade throughout the century and gave its name to the product: popular woodcuts, whatever their origin, came to be called *Images d'Epinal*. Under the energetic direction of several generations of the Pellerin family, the presses of Epinal achieved an astonishing volume of production — no fewer than about 970,000 hand-colored prints in 1822, the factory's banner year, declining to about 30,000 in lean times (1830), and rising again, in the 1840s, to very respectable figures: approximately 215,000 in 1841, 875,000 in 1842, and 420,000 in 1843.[25] An average of ninety workers were employed at the presses and in the coloring rooms, many of them children. Still others handled the shipments to distribution centers throughout France, where the prints were sold in batches to the chapmen who hawked them up and down the countryside and in the towns. Similar establishments, none as large as the firm of Pellerin, operated in other centers, their production by no means limited to *images,* but including a variety of printed materials, from playing cards to wallpaper.

Altogether, the impression given by the manufacture of *images populaires* is that of an industry, small, no doubt, compared to coal mining and railway building, but perhaps more closely related to them than to Champfleury's savages carving idols out of tree trunks. Nor, perhaps, were the products of these print factories quite so genuinely expressive of the thought and feeling of the people as Champfleury believed. Some 75 percent of the images were of traditional religious subjects, the remainder consisted of a broad miscellany of standard topics — favorite moral fables, like those of the Bonhomme Misère and the Wandering Jew; humdrum allegories; portraits of monarchs; news of disasters; Napoleonic and other battles; and such ageless chestnuts as Crédit est mort and Degrés des ages, for which there seems to have been an inexhaustible demand.[26] Scenes from ordinary life were of the greatest rarity; realism, either of content or of style, was clearly not wanted by the public for whom these images were made.[27]

Skilled woodcutters, many of whom were in the habit of signing their work, executed the blocks, generally copying earlier prints. Theirs was a highly disciplined and conservative craft, governed by formulas, passed on from generation to generation, which gave their work its characteristic Byzantine rigidity. What seems "primitive" in their designs was not an instinctive naïveté of expression, but a deliberate use of conventional simplifications, a form of shorthand. Taking their imagery from models belong-

ing to the traditions of high art, they translated these models into their own graphic language, a patois suited to their rustic audience. Within the conventions of this language, there was room for stylistic differences and refinements. Beneath the seeming uniformity of the prints, there are gradations of quality that range from the schematic crudity of the routine output to a marked, slightly mannerist sophistication in the work of certain woodcutters.

By the time Champfleury wrote his *Histoire* in the 1860s, the art of the *image populaire* was in rapid decline, having lost much of its public and having fallen victim, where it was still practiced, to efforts at modernization and the improvement of taste. What was genuinely "popular" (i.e., of the people) in the *images* did not depend so much on the way they were made as on the clientele for whom they were destined and whose tastes and habits they reflected. Champfleury and other enemies of the rootless art of the Salons reacted with nostalgic pleasure to the pungent rusticity of the old-fashioned penny prints. But in attributing this quality to a rather more profound originality and primitiveness than these mass products actually possessed, they were misled by a romantic illusion not unlike that which had caused their fathers to admire the poems of Ossian as works of original genius.

Courbet, in the early years of their association, shared Champfleury's ideas and tastes. He was undoubtedly familiar with the tradition of the *image populaire* either through exposure at home—though his family of striving rural capitalists did not belong to the class for which these prints were made—or through Champfleury's collecting, which had begun by the time of their first acquaintance. It is therefore tempting to search Courbet's paintings for traces of their influence. Champfleury himself, on coming upon Courbet's *Burial at Ornans* (fig. 54) at the Salon of 1851, was struck by what he thought was its resemblance to a popular print: "On entering, one sees the *Burial* at a distance, framed by the doorway. Everybody is surprised by the simplicity of this painting, so much like the naive woodcuts, awkwardly carved, that decorate the tops of murder broadsheets of the kind published in the Rue Gît-le-Coeur. The effect is the same, because the execution is equally simple: masterly art has found the accent of naive art."[28] Coming from Champfleury, this was high praise, but it was also the expression of an ideological partisanship that predisposed him to associate artistic merit with popular roots. Other critics, less friendly, used the same comparison to blame Courbet for having brought painting down to the level of the penny-broadsheet industry. *Image d'Epinal* was, in fact, a fairly common term of abuse or ridicule in the critical vocabulary of the time, used indiscriminately of paintings that did not meet the reviewer's expectations of eloquent gesture and agreeable finish.[29]

In a famous essay titled "Courbet and Popular Imagery" (1941), Meyer

Schapiro found these comparisons significant in the case of Courbet.[30] They pointed, he believed, to qualities that actually exist in his paintings, "unmistakable tendencies toward a more primitive form," that link them with the prints. And he went beyond these general affinities to suggest quite specific relationships of content as well. Thus he compared a preliminary drawing for the *Burial* to a woodcut broadsheet of around 1830, *Souvenir mortuaire,* and saw a connection in composition and meaning between the picture's final version and traditional woodcuts of Les Degrés des ages (fig. 55) in which youthful couples are shown ascending and paired elders descending the steps of an arched bridge, beneath which appears—in rather rare examples of the type—the small scene of a funeral.[31] In other works by Courbet, Schapiro found further suggestive resemblances to the art of the *imagiers.* Courbet's lithograph *The Apostle Jean Journet* (fig. 56), the copy of a lost portrait of the self-ordained social missionary, is itself conceived in the format of popular broadsheets, complete with rhymed text, and bears some resemblance to the very common image type of the Wandering Jew.[32] Finally, Courbet's paintings of men or women at work— the *Knife Grinders,* the *Tinker,* the *Stone Breakers,* and the *Winnowers*— repeat in monumental form "a common theme of popular art."[33] But having pointed to these correspondences, Schapiro concluded that it is difficult to prove that Courbet ever actually copied particular images.[34]

The purely visual parallels are, in fact, very slight, a matter of general character and flavor rather than of style or motif. Courbet's paintings of rural subjects share with popular imagery a provincial plainness that in the settings of the Salons, and in the provocative monumentality he gave them, produced a striking dissonance that delighted supporters such as Champfleury by what seemed to them a wholesome naïveté and simplicity, while it enraged ordinary critics and grated on Baudelaire's nerves—he called it *"Réalisme, villageois, grossier, et même rustre, malhonnête."*[35] Courbet's painterly instincts, his love of substance, the portrait character of his realism were antithetical to the linearity and schematic abstraction of the popular woodcuts. What interest he had in popular art and its deeply conservative traditions stemmed from his strong attachment to popular roots, his village patriotism, his self-identification with the people of his province, but it did not have a strong effect on his manner of painting nor, except for a brief period, on his choice of subjects.

The single instance of a possible imitation by Courbet of a particular motif from the tradition of the *image populaire* is the lithograph of *The Apostle Jean Journet Setting Out on the Conquest of Universal Harmony* (1850), which Meyer Schapiro compared in passing to popular representations of the Wandering Jew.[36] The fact that in Courbet's print the image is surrounded by an explanatory text in verse, a *complainte* such as often accompanies the Wandering Jew of the broadsheets, heightens the resemblance,

though the likelihood of a derivation from this source is rather lessened by the fact that the print's immediate model was Courbet's own painted portrait of Jean Journet (now lost). It is perhaps significant that there exist other graphic portraits of vagabond philosophers resembling Courbet's *Jean Journet* at least as closely as does the Wandering Jew of the popular woodcuts—Traviès' 1834 *Liard, the Philosophical Rag Picker* (fig. 57) is one of these.[37] Champfleury, who shared ideas with Courbet, devoted a chapter of his *Histoire de l'imagerie populaire* (1869) to the iconography of the Wandering Jew and chose a small reproduction of such a woodcut for the frontispiece of his book (fig. 58).[38] In her ingenious article on the subject, Linda Nochlin has argued that this particular image was "doubtless known both to Champfleury and Courbet" long before 1869, and that a detail of it—the three diminutive figures at its lower left, inscribed "*Les Bourgeois de la Ville parlant au Juif errant*"—made so deep an impression on Courbet that he used it as the basis for the large painting of *The Meeting* (1854) (fig. 59), assigning to himself the character of the Wandering Jew.[39] The process of pictorial transformation that this assumes rather strains probability, and so does the metamorphosis of the Wandering Jew of the popular images from a penitent, condemned to eternal, aimless wandering for an act of cruelty and uncharitableness, into the liberated and confident artist of Courbet's self-portrait.[40]

Tempting as it is to look into popular imagery of the years around 1848 for traces of a political awakening and ideas that might have attracted an artist of liberal views, there is virtually nothing in this vast material that answers these expectations. The dominant character of the broadsheets and their legends is one of deep traditionalism and conservatism, reflecting the sentiments of their rural or petit-bourgeois clientele. Champfleury, a chronic waverer between progressive and reactionary impulses, began to take a serious interest in popular imagery at about the time of the Revolution of 1848, in a spirit of nervous disillusionment with revolutionary politics. In the preface to his *Histoire,* he mentions that the bloody uprising in June 1848 first caused him to reflect on the use that could be made of the broadsheets and their legends of the Wandering Jew and Bonhomme Misère to calm the people and combat insurrectional violence.[41] This very point is made by a cartoon of the time, in a journal that did not share Champfleury's antirevolutionary views. It shows the personification of reactionary propaganda, "Mossieu Réac" (fig. 60), using an *image populaire* on a peasant—not to calm him, but to frighten him into a properly conservative mood.[42]

■ While the provincial manufacture of woodcut broadsheets remained bound to old, barely changing traditions, the pictorial press of Paris reflected, propagated, and in many ways created the transient modernity of

its time. From the end of the Napoleonic wars, its production of cartoons, albums, pictorial weeklies, and illustrated books increased enormously year by year, reaching a vast public mainly of the urban middle class, but intricately variegated in its social and intellectual composition, and encompassing a wide range of tastes and interests. The development of new techniques for the printing of pictures, by the lithographic process from 1816, by wood engraving from about 1830, promoted speed, economy, and quantity of output. The public's eager demand for illustrated periodicals and books made for intense competition among publishers to outdo one another in the novelty and lavishness of their illustrations. It also created a new class of artists who specialized in a rapid, quasi-journalistic form of draftsmanship—a class difficult to fit into the old artistic hierarchies, and extremely diverse in quality, ambition, and taste, but united in its concentration on subjects from the contemporary world.

It was not by chance that Baudelaire chose Constantin Guys (see fig. 61), a pictorial journalist, as his ideal "Painter of Modern Life" (1860), investing this exemplar of an art of the future with qualities that were to set him apart from the conventional artists of his time.[43] In an earlier essay, "The Heroism of Modern Life," which he included in his review of the Salon of 1846,[44] Baudelaire had sketched his first—still romantic—vision of a new art that, freed from the weight of the grand tradition, would seek its subject matter in the drama of the modern city. This art would distill its poetry from the stuff newspapers were made of—the excitement of political struggle, the spectacular vices of criminals and prostitutes, and the bravado of murderers facing the guillotine. Modern Paris, as rich in marvels as the ancient world, could, he believed, provide substitutes for many worthwhile conventions of traditional art: that of the nude, for instance, which in order to be revived need only to be transposed to its proper modern settings—the bed, the bath, and the dissecting room. In its youthful zest for the macabre, Baudelaire's program seems like a reflection of Géricault's interest in crime, disaster, and the morgue; it also recalls the popular woodcut broadsheets, the *canards,* with their celebrations of homicides and executions.

Some fourteen years later, Baudelaire gave a rather less hectic account of the modern artist, whom he now no longer imagined, but drew from life. Constantin Guys, as he described him,[45] had some of the qualities that writers of an earlier time—Rousseau, Wordsworth, and Runge, for example—had claimed for the child and for "natural" genius. Baudelaire found in him the clear vision of a child who has not yet been crippled by education and habit and has the ability to respond to fresh experience with "animal ecstasy." Self-taught, Guys had run through the stages from "initial barbarity" to mastery without losing his original naïveté and sincerity, proving that *"le génie n'est que l'enfance retrouvé."* Spurning professionalism, Guys appeared to Baudelaire as a man of the world, rather

than a mere artist—a traveler, cosmopolite, flaneur, and dandy. "*La foule est sa domaine*," but from within the crowd he contemplated society as a spectacle, with the detachment of an alien.[46] Indifferent to morality and causes, a pure observer rather than a critic, Guys—the Painter of Modern Life—concentrated on the picturesque in manners and fashions, "*la méta-morphose journalière des choses extérieures*," and recorded with steno-graphic speed the important superficialities that are the essence of modernity.

He admires the timeless beauty and the amazing harmony of life in the capitals, a harmony so providentially maintained amidst the turbulence of human freedom. He contemplates the landscape of the great cities . . . He delights in the fine carriages and proud horses, the dazzling spit-and-polish of the grooms, the elegant skill of the footmen, the flowing grace of the women, the beautiful children, happy to be alive and to be nicely dressed—in a word, he delights in life in general. If some fashion, the cut of a costume, has been slightly modified, if knots, ribbons and bows have been replaced by cockades, if bonnets have been enlarged and chignons made to drop ever so slightly toward the nape of the neck, if waists have been raised and skirts made fuller, you may be sure that his *eagle eye* will already have spotted it from far away.[47]

The modernity that Baudelaire in 1860 ascribed to Guys, and that was undoubtedly in part a projection of his own sense of the modern, centered on the study of visual appearance and stylistic nuance, a form of sartorial connoisseurship far removed from his earlier interest in strong subject matter and the romantic notion of heroic modernity that he had expressed in 1846.[48] For all their verbal brilliance, his descriptions of Guys's work do not actually render the character of the drawings, much rougher in their graphic shorthand, and less nervously impressionist than Baudelaire's language. Why did he choose Guys to exemplify the modern painter—a graphic artist working for the press, who was not, strictly speaking, a painter at all? It may be that, needing a peg on which to hang his own ideas about modernity, he found the obsessively modest and reclusive Guys convenient for his purpose. But it was probably also the sheer novelty of the type of artist Guys represented that attracted Baudelaire, aside from the admiration he felt for him and his work. For here was an observer who did not bury himself in the studio but took notes on battlefields, at parades and public executions, in drawing rooms and bordellos, and one who sent his work to the *London Illustrated News* rather than the Salon. An independent of sharp and rapid intelligence, not an ideological Realist, Guys had no pretensions to stardom and was content to take his place as an anonymous worker in the new picture-publishing industry, differing in his avoidance of rhetoric and self-exposure from Géricault, whom in other ways he resembled. It is under-

standable that Baudelaire should have seen in him a harbinger of the future, unaware that, even while he wrote, photography was about to render obsolete the Painter of Modern Life.

A fascination with pictures on the page, that "*culte des images*" which Baudelaire called "*ma grande, mon unique, ma primitive passion,*"[49] persisted among the French public through the early decades of the century and produced an unprecedented outpouring of graphic publications, beginning with the vogue for lithographic series in which Géricault had a part, and rising to a crescendo in the 1830s and 1840s with the advent of a multitude of albums, comic journals, illustrated newspapers, and books overflowing with hundreds of vignettes and wood-engraved plates (see fig. 62). The demand was mainly for pictures from modern life, a minor genre in high art, and one that offered the illustrators a great scope for innovation and experiment. One novelty that they brought to the well-trodden field of genre was a spirit of systematic inquiry into the behavior and appearance of the various classes that made up the urban population. The most telling products of this perhaps typically middle-class inquisitiveness about the details of ordinary lives were the innumerable caricatural studies of social types, the so-called *physiologies,* and the lavishly illustrated collections of essays—such as Paul de Kock's *La grande ville* (1842–43),[50] the encyclopedic *Le Diable à Paris* (1845–46),[51] and the nine-volume compendium *Les Français peints par eux-mêmes* (1841)[52]—that analyzed with semipedantic, semihumorous thoroughness the typical appearance, manners, tastes, and eccentricities of the multitude of subgroups that composed the population of France. The wealth of this pictorial literature of social observation, produced for the vigorously acquisitive bourgeoisie of the July Monarchy—well before the advent of programmatic social realism in the work of Courbet, Millet, and their followers—proves that an interest in the realities of modern life, including its ragged edges of beggary and crime, was by no means confined to a small, socially aware avant-garde, but basically expressed the unromantic positivism of the middle class—not unlike the statistical tables and economic surveys that are sometimes included in these books, where they look odd beside Gavarni's carnival dancers and Bertall's sardonic vignettes.

The small army of draftsmen who collaborated in this immense self-portrait of French society—nonacademics, for the most part, often of irregular training, but in no sense naive or primitivist—formed a distinct class, somewhat below that of the painters who starred at the Salons, though several—Monnier, Grandville, Daumier, Gavarni—achieved celebrity and were better known to the public than most Salon painters. A conspicuously large number of them bore aristocratic names, or hid them under pseudonyms.[53] Their work was "popular" in the sense that it reached and pleased large audiences and dealt with subjects of general interest: every-

day life, social or political satire, and nudity in bed or bath, according to Baudelaire's prescription. It did not cohere around any particular ideology or artistic tendency but was, on the contrary, extremely diverse. The sheer quantity and availability of their production assured it of visibility and influence, their freedom from the constraints of high art enabled them to move easily from topic to topic, regardless of rules of beauty, propriety, or indeed of art itself. Appreciated in its place, in the modest formats of the cartoon or the illustrated page, their work became controversial when it aspired to the status of serious art, though in its flexibility and informality it often foreshadowed developments in the more traditional fields.

To artists of the younger generation, particularly those who tended toward modernity and realism, the vernacular of the illustrated press was the perfect antidote to the academic repertory. All artists whose youth fell into the decades of the 1830s or 1840s were inevitably exposed to it. Those who were headed for the mainstream sought to avoid its taint; the modern-minded allowed themselves to be influenced. The illustrators had a twenty-year headstart on the realist painters and had touched on every conceivable aspect of modern life, leaving little scope for absolute novelty to the artists of the 1850s and 1860s. It is not surprising, therefore, that certain paintings by Courbet or Manet should bear a resemblance to earlier prints from the popular media, and the temptation is strong in such cases to assume a connection. But the number of parallels is so very large that it casts doubt on the significance, in specific cases, of even quite striking resemblances. Thus, merely to cite random examples, an anonymous engraving, of around 1840, *Two Nude Women Asleep* (fig. 63), a rare subject, is close in general effect to Courbet's *The Sleepers* (1866) (fig. 64), but that hardly justifies considering it a possible source. The same can be said for Gustave Doré's *Afternoon in the Garden of the Tuileries* (1849) (fig. 65), which resembles Manet's *Music in the Tuileries* (1862) (fig. 66) no less than certain other illustrations that have been proposed as influences.[54]

Manet has been singled out by recent scholarship as the artist whose commitment to modernity brought him into particularly close touch with the popular media of his time. The many correspondences between his paintings and the imagery of the illustrators indicate beyond doubt that he was familiar with this vast resource and responsive to its suggestions. But that he actually borrowed particular ideas and motifs from it has turned out to be difficult to prove, despite vigorous efforts to identify his sources. Resemblances abound, but their very number suggests that they are a matter of Manet's involvement in widely shared interests, rather than of dependence on specific models. Certain publications, the volumes of *Les Français peints par eux-mêmes* (1841), for example, have been found to be especially rich in images that seem to foretell paintings by Manet, and it has been suggested that he must have been familiar with them.[55] This

seems highly likely, but it rather goes against the grain to imagine Manet recharging his flagging imagination by an intensive browse through the pages of a particular picture book.

What did attract Manet then to those publications that have been proposed as his sources? Since the purely visual connections are not conclusive, the likelihood of actual influence would mainly depend on the general aesthetic and social character of the publications in question, on their compatibility with Manet's style of modernity. He cannot have been indiscriminately receptive to all the popular media, whose differences — stylistic, social, and generational — though no longer obvious to modern eyes, were apparent and important to contemporaries. "Modernity" had its nuances: the distinctions between the sharp, somewhat cold-blooded observation of Guys, the melancholy elegance of Gavarni, the robust humor and humanity of Daumier reflected not only the individual temperaments of these artists, but also the various publics they served. Marked differences of tone, of sensibility, of class-determined nuances of style and taste distinguish the lithographs of Gavarni from those of Beaumont, and even more from those of Grévin; the satire of Cham differs from that of Bertall; the social observation of Monnier from that of Lami; the fantasy of Grandville from that of Traviès. It is worth noting, in this connection, that the popular "sources" suggested for Manet's paintings of the 1860s date mostly from the 1840s[56] — understandably, perhaps, since that decade was the golden age of the illustrated press. But this time lapse means that when he used these borrowings they were no longer really modern; it also assumes an oddly retrospective tendency in an artist so sensitive to changes of style as Manet, to whom the outdatedness of these illustrations must have been apparent. There seem to be few, if any, borrowings in his work from popular illustrations of the 1860s and 1870s, his more immediate present, but a period in which the pictorial media were declining into banality.

Manet was, at least in his work before the 1870s, essentially a studio-bound painter and *salonnier,* in whose work observed reality played a minor part. His frequent borrowings from the old masters were deliberate quotations rather than furtive imitations. Art was his subject matter, and a shared knowledge of past art one of his links with his audience. His individuality expressed itself in the choice and interpretation of the quoted masterworks, his originality and modernity in the alterations that he introduced into them. To quote details from particular, obscure images of the kind that could be gleaned from the illustrated press would have been futile, since his reference would not have been understood. But to gather from a great variety of sources — society itself, its fashions, entertainments, and popular media — the current note of beauty and elegance, the slang of the season, the manners and corruptions of the moment, in intimate observations under-

stood by his contemporaries, and to apply these modernisms to familiar works of high art was a challenging and, as it turned out, explosively controversial project.

■ Political satire and social observation dominated the imagery of the popular press in the third and fourth decades of the nineteenth century. Artistically, the best part of this immense production was the work of the masters of lithographic caricature, one of the glories of French art of the time and certainly comparable in quality to the work of the leading painters, though it was not seen in that light then and even today is often misjudged a minor art. The forty years that Daumier spent in the service of pictorial journalism were not, as has sometimes been said, a tragic waste of genius — though he has a place among the great painters of the century, his finest work, unsurpassed in the history of its medium, was done in lithography for the pages of the weekly press. In the political battles of the post-Napoleonic era, caricature which had only a feeble tradition in France suddenly rose to the highest level it has ever attained. The great proliferation of graphic satire in the years between 1827 and 1835 was the work of a young generation of artists working for the press, many of them quite unburdened by any academic schooling, but all enthusiastically motivated by the political passions aroused by the events that surrounded the Revolution of 1830.

The press laws of September 1835 put a stop to this activity and forced the talents that had grown strong in political controversy to seek other outlets. Social and cultural criticism now replaced political combat, and the wits sharpened in attacks on king, clergy, and reaction adjusted themselves to less dangerous targets. One of these, near at hand, was the world of art itself, tempting to satirists in the pomposities and decrepitudes of its academic establishment, in the eccentricities of prominent artists and their admirers, and in the more bizarre novelties of the Salons. There was considerable piquancy in this arrogation by workers in a "low" medium of a critical function that allowed them to tease their betters, and not a few cartoonists took to this role with zest. Caricature came to be the instrument of a new, purely pictorial form of art criticism: Salon reviews without words. The illustrated journals regularly published "Comic Salons," consisting of travesties of individual paintings or of pages crowded with minuscule images that surveyed, and ridiculed, whole gallery walls (see fig. 67). Their popular draftsmen—Cham, Bertall, Nadar, Doré, and others—competed with one another in wit and malice at the expense of the exhibiting artists, but the quality of these cartoons rarely rose above that of trivial amusements, and their humor hardly transcended the platitudes of the written reviews or the philistinism of the public.

Of greater importance were those satires that took issue with the grand traditions of art and involved some of the most gifted caricaturists in an altogether more serious kind of criticism. Aimed mainly at the fading grandeurs of the classical heritage, they assumed the form of parody — paraphrasing famous works of art or evoking the heroes of classical myth and literature, only to deflate them by an abrupt confrontation with prosaic modernity.[57] The effect depended on the viewers' recognition of a grand prototype and on their acquiescence in its deflation. For artists of the popular media, there was an obvious pleasure in this invasion of Olympus and its sacred groves, at the very moment when, around 1840, a reaction favorable to classicism was evident in the Salons and the critical literature.[58] But, beside the thrill of blasphemy, there was aesthetic gratification in these games with the relics of an ancient grandeur that had not lost all its potency and that, at the very least, offered relief from the humdrum of graphic journalism. On a deeper level, parody could infuse modern feeling into subject matter grown stale, and bring fresh life — if merely through laughter — to forms of beauty that had with time hardened into stereotypes.

Grandville attempted something of the kind in *Un Autre monde* (1844), that astonishing demonstration of the powers of caricature. One of the chapters of this book describes an excursion into the land of anachronism, a country called Antiquity, in which the *Primitifs,* David's dissident students, would have felt at home.[59] It is a fantasy, perhaps a nightmare, of antiquity modernized, or modernity dressed in antique costume. "Past and present mingle here in friendly alliance. Our mission is to show . . . how old and new forms unite; we vivify the spirit of modernity through contact with the spirit of antiquity." The text that links Grandville's caricatures describes the arrival of a traveler in the city of Rheculanum and his visit to the theater, where a star of the classical stage, Mlle. Leucothoé, performing an antique version of Racine's *Phèdre* (fig. 68), is about to deliver her famous monologue:

Oui, prince, je languis, je brule pour Thésée,
Non point tel que l'ont vu souvent les boulevards . . .[60]

The parody of the text cuts three ways: it spoofs Racine's high style, it gives it an anachronistic "antique" setting, and it provides that setting with the attributes of modern Paris. Grandville's illustration of the scene is conceived in the same spirit. The modern theater, with its stage, orchestra, and loges, is represented in the linear manner of Flaxman's imitations of Greek vase painting. The action on the stage echoes Guérin's painting of *Phaedra and Hippolytus* (1802), a monument of French Neoclassicism. Modern detail pervades the classical design — Hippolytus' shotgun and dachshunds, the *togatus* training his telescope on the stage, the old musician in the orchestra, evidently Homer himself, in a Parisian frock coat, smiting an enormous lyre.

Grandville's parody appeals to the educated viewer's recognition of its (neo)classical models, rather in the manner of Salon eclecticism, only to disrupt the solemnity of these associations with its impudent modernities.

Daumier's parodies of classical subjects differ from those of Grandville in that they do not mimic classical style but are emphatically modern and personal in their energetic freedom of line and vigor of tonal contrast, the exact contrary of the Flaxmanesque abstractions that stand for classicism in Grandville's caricatures. While Grandville renders modern subjects in a pseudoclassical manner, Daumier modernizes classical subjects. His gods and heroes belong to his familiar stock of Parisian popular types, and in their immediate recognizability beneath the flimsy Greek shifts lies the joke and the shock: flat chested or potbellied, they are a very physical and earthly lot, with the gestures and expressions of the French middle class. Except for the few antique props, an occasional helmet or shield, there is little in the settings in which Daumier places them that is not modern and of the real world. The comic effect is not at the expense of classical antiquity, but of unreasonable expectations of ideal beauty that cannot meet the test of reality. "Daumier has come down brutally on antiquity," wrote Baudelaire, "on *false* antiquity — for no one has a better sense of antique grandeur."[61]

Stimulated both by the fun of blasphemy and his sense of *les grandeurs anciennes,* Daumier drew the fifty lithographs of his *Histoire ancienne* (1841–43), which, print for print, ranks among his greatest works.[62] The facetious preface of the series, perhaps written by Philipon, which compares Daumier with Ingres and celebrates him as the artist who rejuvenated Beauty's face and renewed the bond between ancient and living art, was not so absurd as its author may have intended it to be. The difficulty that faced Daumier in this ambitious project was to re-imagine fifty episodes from antiquity in terms of contemporary life and feeling, giving each a memorable pictorial form and comical charge, without falling into repetition and jocularity. The challenge drew from him some of the most beautiful, most grandly conceived, and most hilarious inventions of his career. *Pygmalion*[63] (fig. 69) stands aghast with surprise and delight as Galatea, a comely and quite modern nude that could have been posed by Victorine Meurent, comes to life and reaches down for a pinch of snuff. Penelope[64] (fig. 70), middle-aged, bony, endearingly unattractive, sits at her loom in a passionate revery, thinking of Ulysses whose portrait — echoes of Dibutade! — she has drawn on the wall.[65] A lamp in the dark above casts its light on her unquiet body and on the infantile drawing — a caricature within the caricature — of the absent hero. The scene is realized with a warmth of feeling and a poetry of light and shadow worthy of Rembrandt.

When Daumier aimed his parody at particular paintings, as he occasionally did in the period of relative press freedom after the Revolution of 1848, he quoted heroic compositions by David, Ingres, and Guérin to

comment crushingly on small political issues of the moment. His *Clytem-nestra* (1850)[66] (fig. 71) paraphrases Pierre Guérin's *Clytemnestra Contemplating the Murder of Agamemnon* (1817) (fig. 72), a famous Neoclassical *machine,* in making heavy weather of a petty intrigue of journalists that involved Dr. Véron of the Bonapartist *Constitutionnel* and Philipon of the liberal *Charivari,* Daumier's publisher. Wearing the nightcap and high choker by which cartoonists always identified him, the vengeful Véron plays Aegisthus to a reluctant Clytemnestra, who is recognizable as Véron's protegée, the actress Rachel; he urges her to administer a clyster to the unsuspecting Philipon-Agamemnon. The bathos of the classical impersonations, the contrast between the epic invocation and the paltry occasion, the hint of a pun, and the dramatic staging resonant with echoes of high art, create an interplay of associations that not only stimulated Daumier's comic verve but also appealed to his painterly instincts. His small cartoon upstages Guérin's big painting as much by its superior management of the scene as by its malicious wit.

The serious intention that guided Daumier's parodistic invasions of high art was not to devalue the great traditions, but to give them new life by freeing them from the preciousness of a mandarin culture, reanimating them with genuine feeling, and bringing them into the reality of modern experience. Developed in a field of low art, parody became in his work an effective alternative to academic eclecticism, a spur to original invention, and a useful vehicle for satire in the uneasy, half-permissive cultural atmosphere of the Second Empire. It deeply suited the temper of French society and by its vitality affected the style of the vernacular culture, which, however corrupt, was more productive of viable art than the moribund academic establishment. The criticism of modern society that Couture had attempted in his *Romans of the Decadence* (1847), in the forms of a solemn pseudoclassicism, was superseded by Offenbach's *Orphée aux enfers* (1858) and *La Belle Helène* (1864), cynical and thoroughly modern burlesques of antiquity, that raised the art of parody to its highest point.[67]

Young artists, cutting their teeth on historical subjects, seized on this alternative, not precisely in the spirit of comic parody, but in a somewhat similar vein, to preserve their work from the deadness of academic convention. Degas, wrestling with a classical subject in his *Spartan Boys and Girls Exercising* (1860–62, fig. 73), at the outset took David's *Intervention of the Sabine Women* (1799, fig. 74) as a model in arranging his composition and in conceiving his frieze of figures in a Neoclassical contour style. Dissatisfied with his first version, he laid it aside and painted a second, giving his figures sharply characterized faces and bodies, and by this striking modernization lifted the scene out of its original unreality and timelessness. Transported into a believable present, the nudity of the awkward adolescent bodies, and their strained attitudes, took on a new character. The scene acquired disturb-

ing sexual overtones that altered its meaning and have since brought it under an intense interpretative scrutiny that the earlier, more severely stylized version—had it been carried out—would probably not have attracted.[68]

Manet's early nude, the *Nymph Surprised* (c. 1861), modeled on Rubens's *Suzanna in the Bath,* produced no excitement in its time, and has been little noticed since. His *Olympia* of 1863 (fig. 75) caused an immense scandal at the Salon of 1865. The cries of outrage raised by its reviewers continue to resound to this day through the vast literature it has spawned, and they have occupied some historians as much as, or even more than, the picture itself.[69] *Olympia* is, among other things, about prostitution, though only a few of the seventy or so reviewers who condemned it made this point; but it is, first and most important, about a famous painting, Titian's 1538 *Venus of Urbino* (fig. 76). Manet clearly wanted this to be understood: it was an important part of his picture's meaning. Curiously, scarcely any of the contemporary critics remarked on its source, one of Titian's best-known works.[70] It is tempting to conclude that Manet failed to make his point, and that his picture did not compel comparison with its great model, but this would give too much significance to the reactions of the press reviewers, which were, on the whole, extremely obtuse. The critics did not see, or chose to ignore, what was plainly before them, and they made up for this by seeing much that was not in the picture at all: not a few of them dwelt on the supposed dirtiness of Olympia's hands, they saw her as a "gorilla covered in rubber," or as a "putrefying body."[71] The hysterical blindness of the reviewers, and their stampede to rush their witticisms to the public, make for enjoyable reading and good copy, and perhaps for this reason have been taken rather too seriously.

The genesis of the painting is not absolutely clear. Theodore Reff, who has made the closest study of its development,[72] believes that it underwent a lengthy and gradual evolution, in the course of which Manet experimented with different forms of the recumbent nude, taking his inspiration from a variety of sources—Goya, Ingres, Delacroix, popular lithographs, and possibly photographs—before he made the "sudden decision to base his composition on the *Venus of Urbino.*" Reff supports this view with a sequence of drawings, which, he believes, antedate this decision. It is possible to conclude, however, that this initial stage was brief, and that perhaps not all the drawings that have been proposed as preliminaries are actually directly related to *Olympia.* In either case, there arises the question of Manet's initial purpose: Did he start with the intention of painting a picture about modern prostitution and, in the course of developing his subject, arrive at Titian's *Venus* as a suitable form in which to cast his idea? Or did he begin with the plan of painting a Venus-like nude in the manner of Titian, but in a modern style, and hence requiring the plausible, modern motivation of the nude as "courtesan," which was, after all, the character in which Titian's *Venus* was

seen at the time? The latter assumption is by far the more likely, and the one most in accordance with what is known of Manet's manner of work. At any rate, the painting that resulted from the process was composed with the *Venus of Urbino* in mind: this was its model, text, and reference.

Manet's intention, however, was not to imitate and adapt, in the tradition of academic pilferage, but to appropriate and transform his model, to create an original work whose meaning would lie in the difference between itself and its model. The boldness of the challenge lay not only in the competition with a supremely great painter of the past, but also in the difficulty of transposing a perhaps excessively familiar motif from its place in history to the modernity of mid-nineteenth-century France. Baudelaire, writing in around 1859–60, had addressed this problem in an oddly prescient way: "If a patient, exact, but only moderately imaginative artist, having to paint a courtesan of today, were to take his *inspiration* . . . from a courtesan by Titian or Raphael, it is extremely probable that he would produce a false, ambiguous, and obscure work. The study of a masterwork of that time and of that kind will teach him nothing about the bearing, the look, the expression or the vital aspect of one of these creatures . . ."[73] Within its context — a discussion of modernity in its visual manifestations — the meaning of this passage is clear: it refers to the problem of realism in the representation of contemporary physiognomies, the intimate, fugitive aspect of face and body peculiar to a particular class at a particular moment in time. "Courtesans" are mentioned only as an attractively lurid instance of what Baudelaire proposes as a general rule. Nor did Manet propose to paint a realistic study of modern prostitution, or to represent a typical prostitute in the manner of the popular sociological essays of the time, the so-called *physiologies.* But he clearly wanted to give his recumbent Venus the authentic appearance of a modern woman. He painted her in the likeness of Victorine Meurent, an artist's model, not a prostitute, whose face and figure had already served him for a number of other paintings. He posed her in an attitude designed to recall Titian's *Venus,* but the physical immediacy that he introduced into his picture — Olympia's alert posture; her direct gaze, which is less dreamily absent than that of Venus; the resolute gesture of her hand firmly clasped over her sex; and the prosaic modernity of her taut, short, practical body — made this association seem blasphemous. Admirable in the remoteness of antique myth or traditional art, nudity, sexuality, and erotic license turned abominable in the near view.

Manet took pleasure in teasing the public's sensibility. *Olympia* is an impudent picture, and from its impudence derive much of its vitality, its verve of handling, and hence its aura of contemporaneity. In translating a classic composition from its aesthetic distance into the immediacy of direct experience, it functioned as parody, no less than Daumier's comic modernizations of antique gods and heroes. Manet dared to apply the device of

parodic appropriation, which had long since become a commonplace of comic popular art, to a serious work of high art, and he discovered that what caused laughter in the pages of *Charivari* or at the Bouffes-Parisiens still produced scandal at the Salon. The use of *serious* parody for the revitalization of motifs from the great tradition nevertheless remained a central part of his effort toward modernity, and it was in developing this method, rather than in his borrowings from the illustrated press, that he drew most importantly on the popular media. The irony of the situation was that Manet's concern for the values of tradition and his desire to reconcile these with the realities of modern life should have been interpreted — in his time and even today — as "an outright affront to public sensibility."[74] It was, after all, the spirit of the public, as expressed in its vernacular arts and entertainments, that Manet — like Géricault a generation before him — had absorbed and applied in his work, and had sought to bring into the sanctuary of high art, not to destroy it, but to renew its connection with the present.

NOTES

1. E. Young, *Conjectures on Original Composition* (1759); cf. M. W. Steinke, *Edward Young's "Conjectures on Original Composition" in England and Germany* (New York, 1917), pp. 45ff.

2. J. J. Rousseau, *Emile, ou de l'éducation* (1762; ed. Firmin Didot, Paris, 1851), p. 1.

3. J. G. Herder, "Auszug aus einem Briefwechsel über Ossian und die Lieder alter Völker" (1771); see B. Suphan et al., *Herders Sämtliche Werke* (Berlin, 1877–1913), vol. 5, p. 181.

4. P. O. Runge, in a letter to his brother Daniel, February 1802; see *Hinterlassene Schriften von Phillip Otto Runge* (Hamburg, 1840), vol. 1, p. 7.

5. W. Wordsworth, from the preface to *Lyrical Ballads* (1800), lines 129–30, 477–78.

6. M. E. J. Delécluze, *Louis David, son école et son temps* (Paris, 1855), p. 420. Delécluze's reminiscences of the *penseurs* or *primitifs* were first published in *Le Livre des Cent-et-Un* (Paris, 1832), vol. 7, pp. 61ff. See also G. Levitine, "The Primitifs and Their Critics in the Year 1800," in *Studies in Romanticism* (Boston University), vol. 1, no. 4 (1962), p. 209.

7. L. Eitner, *Géricault, His Life and Work* (London, 1983), p. 102.

8. Throughout his life, but particularly during the period of intensive self-training (1814–16) preceding his Italian voyage, Géricault frequently copied engravings after original works of art, partly because these often rather crude prints allowed him some freedom of self-expression in exaggerating or distorting his models. A main source for his experimental drawings of those years was the engravings in J. B. Wicar's illustrated catalogue of the Florentine art collections, *Tableaux, statues, bas-reliefs, et camées de la Galerie de Florence et du Palais Pitti* (Paris, 1789), of which he seems to have known only the first volume.

9. For example, an anonymous, handcolored engraving, part of the series *Troupes françaises*, published by the firm of Martinet, in the Rue du Coq, Paris, about 1810.

10. Eitner, *Géricault*, pp. 53ff.

11. Ibid., pp. 156–57.

12. C. Clément, *Géricault, étude biographique et critique* (Paris, 1879), p. 364; *Dessins*, no. 165.

13. Eitner, *Géricault*, pp. 151ff.

14. Ibid., pp. 209ff.

15. Ibid., pp. 216ff.

16. Ibid., pp. 228ff.

17. L. Delteil, *Géricault* (*Le Peintre-graveur illustré*, vol. 18) (Paris, 1924), nos. 30, 31, 38; cf. Eitner, *Géricault*, pp. 229–30.

18. Clément, *Géricault*, p. 199; cf. Eitner, *Géricault*, p. 218.

19. Eitner, *Géricault*, pp. 234ff.

20. See P. L. Duchartre and R. Saulnier, *L'Imagerie populaire* (Paris, 1925); J. Adhémar, *L'Imagerie populaire française* (Paris, 1968); J. M. Dumont, *Les Maîtres-graveurs populaires, 1800–1850* (Epinal, 1965). Dumont's book contains statistics concerning the work force and production at the factory in Epinal (p. 53).

21. Champfleury [Jules Fleury-Husson], *Histoire de l'imagerie populaire* (Paris, 1869; 2nd ed.,

1886). Fifty years earlier, the English bibliographer Thomas Frognall Dibdin visited the image factory of Picard-Guérin in Caen, from which "issue the thousands and tens of thousands of broadsides, chap-books, &c. &c. which inundate Normandy." He collected several prints on this occasion (1818), including "a metrical canticle of the *Prodigal Son*, with six wood cuts above the text"; see Dibdin's *A Bibliographical, Antiquarian, and Picturesque Tour in France and Germany*, 2nd ed., vol. 1 (London, 1829), p. 194.

22. Champfleury, *Histoire*, p. xii.

23. Ibid., p. xi.

24. Ibid.

25. Cf. Dumont, *Maîtres-graveurs*, p. 53.

26. On the iconography of the *images populaires*, see Champfleury, *Histoire*, pp. 1–94 (on the Wandering Jew); pp. 95–168 (on *Le Bonhomme misère*); pp. 171–89 (on *Crédit est mort*).

27. "Le peuple a toujours aimé qu'on lui représente des personnages, qu'on lui raconte des histoires qui se passent dans un monde d'autant plus attirant et séduisant qu'il lui est plus fermé. Il est logique que le peuple fuie les représentations des personnes qui l'entourent, de sa propre vie, de ses soucis, de ses misères, dont il est saturé. Il obéit à un besoin d'évasion bien naturel, qui est loin, d'ailleurs, d'être particulier aux milieux populaires. Le réalisme était rarement le fait du peuple, mais bien plutôt un merveilleux conventionnel." P. L. Duchartre and R. Saulnier, *L'Imagerie Parisienne* (Paris, 1944), pp. 7–8.

28. Quoted by Schapiro from an article in *Messager de l'Assemblé* (1851); reprinted by Champfleury in *Grandes Figures d'hier et d'aujourd'hui* (Paris, 1861), p. 244; in M. Schapiro, *Modern Art: 19th and 20th Centuries* (New York, 1978), p. 48.

29. It was, for instance, used of Manet's *Olympia*.

30. M. Schapiro, "Courbet and Popular Imagery," first published in *Journal of the Warburg and Courtauld Institutes*, vol. 4 (1941), pp. 164ff., reprinted in Schapiro, *Modern Art*, pp. 47ff.

31. Schapiro, *Modern Art*, p. 50. Both the *Souvenir mortuaire* and the particular version of *Les Degrés des ages* cited by Schapiro are evidently of great rarity. I have been unable to find another example of *Les Degrés des ages* that shows a funeral scene beneath the arch. The most common nineteenth-century version shows a Last Judgment in that space. Schapiro concludes: "That Courbet copied such images is difficult to prove, but the resemblance is evident." The visual resemblance, i.e., that which one might expect to result from copying, is in fact quite remote; the relationship between the painting and the print, if indeed there is one, is at best one of a very loose thematic analogy.

32. Schapiro, *Modern Art*, pp. 50–51.

33. Ibid.

34. Ibid.

35. In the notes for a projected article, "Puisque réalisme il y a," about Champfleury and Courbet, written in 1855; see C. Baudelaire, *Oeuvres complètes* (Paris: Bibliothèque de la Pléiade, 1961), p. 636.

36. Schapiro, *Modern Art*, pp. 50–51.

37. The lithographer Charles-Joseph Traviès de Villers (1804–1859), was one of the chief contributors to Charles Philipon's *La Caricature* and *Le Charivari*. Liard, a ragpicker who astonished passersby by quoting Greek and Latin tags to them, was an acquaintance of Traviès, who evidently had a special interest in ragpickers. The essay "Les Chiffonniers," in *Les Français peints par eux-mêmes* (Paris, 1841), vol. 3, p. 333, has a frontispiece portrait of another, elderly, ragpicker by Traviès. The author of the essay, L. A. Berthaud, describes a philosophical ragpicker,

whom he calls Christophe, a familiar figure in Paris streets and much admired by "mon
camerade Traviès. . . . On a fait son portrait, on l'a lithographié, et il s'est trouvé si ressemblant,
que tout le monde l'a reconnu" (p. 335). There is no mention of the Wandering Jew.

38. Champfleury, *Histoire*, pp. 1–94. In the catalogue of *images populaires* of the Wandering
Jew (p. 85), Champfleury names Bonnet of the Rue Saint-Jacques as the publisher, and the
Imprimerie de Chassaignon, Rue Gît-le-Coeur, as the printer of the *image populaire* that he
reproduces as his book's frontispiece. This would make the woodcut an exceptional piece, for
Parisian shops normally specialized in engravings. On p. 57, Champfleury indicates that this
(particularly naive) woodcut continued to be printed until the end of the Restoration, i.e., about
1830. It was, nevertheless, of extreme rarity at the time when Champfleury wrote, and he
makes the astonishing statement, "il n'existe à Paris aucun autre monument ancien peint ou
gravé ayant trait au Juif-Errant." This is clearly of some significance with regard to the possible
influence of this iconography on Courbet in 1850–54.

39. L. Nochlin, "Gustave Courbet's *Meeting*: A Portrait of the Artist as a Wandering Jew," *The
Art Bulletin*, vol. 49 (1967), pp. 209–22.

40. Nochlin believes ("Gustave Courbet's *Meeting*," pp. 209, 214) that Courbet's *Meeting* was
"unequivocally based upon a source in popular imagery: a portion of a broadsheet of the
Wandering Jew . . . which was later to serve as the frontispiece of Champfleury's *Histoire*" and
that this rare broadsheet, which Champfleury published in 1869, fifteen years after Courbet's
painting, was "doubtless known both to Champfleury and Courbet long before that time."
Champfleury had indeed begun to interest himself in the legend of the Wandering Jew by
about 1848, and may have started his cataloguing of broadsheets then, but there is nothing in
his book to indicate that he had known this particular broadsheet and shared it with Courbet by
1854, in time for its small marginal image to inspire the large canvas that Courbet painted in
Montpellier that year. Champfleury's own account (*Histoire*, p. xli) rather suggests a long
collecting effort; of the twenty-nine broadsheets that he catalogued in 1869, more than half
date from after 1850 (and most of these from after 1860). The *image populaire* that he
reproduced in his frontispiece, which is the basis of Nochlin's theory, was a rare, if not unique,
specimen and the only one of its kind in his collection — not a common type, as Nochlin suggests
(cf. note 38 above). Acceptance of the detail in the broadsheet as the model for Courbet's
painting depends primarily on one's opinion of its visual correspondence to the painting.
Concerning the contemporary significance of the image of the Wandering Jew, and hence its
suitability for the self-portrait of the artist "as an active witness to a new social order," Nochlin
(p. 214) cites Champfleury (pp. 2–3), and concludes that by the middle of the nineteenth
century the legend of the Wandering Jew had "evolved from a simple, apocryphal story of sin,
retribution, and eternal wandering, into a socially conscious morality tale, often providing the
scaffolding, or more accurately, the pretext, for elaborate left-wing literary productions."
Actually, Champfleury's passage (pp. 2–3) rather dismissively mentions modern versions of the
traditional story and compares them unfavorably with the "simple, apocryphal story" of the folk
tradition: "Des esprits poétiques s'emparèrent de la légende pour l'approprier aux imaginations
du jour; séduits par cette conception bizarre, ils tentèrent de rajeunir le texte. . . . Les roman-
ciers voulurent goûter au festin. Le Juif servit des lors à des compositions sociales, ou furent
entassées toutes les aspirations modernes. Les peintres aussi suivirent le courant; de même que
les dramaturges de boulevard voyaient dans la personnalité d'Ahasverus un prétexte à grandes
machines, divers artistes prirent à partie la figure du Juif et pourtant n'en surent rien tirer de
particulier." A footnote mentions one such painting, exhibited at the Salon of 1863: "composi-
tion sans intérêt." Of modern versions, Champfleury cites Pierre Jean de Béranger's poem "Le
Juif errant," which Nochlin calls a "socially conscious song," but in which the sinister Jew is
presented as a warning example of the punishment awaiting those who, like himself, lack
charity and humanity. A poem by Pierre Dupont, which Champfleury scathingly compares to
the popular *complainte* and to which Nochlin refers as a "socially oriented variant," also
pictures the Jew as merciless. There remains Eugène Sue's famous, interminable *Juif errant*, in
which the spectral figure of Ahasverus functions as link for the separate strands of a wildly

ramified plot — a reformed sinner, but hardly a character who would tempt a socially conscious artist to wholehearted self-identification. Champfleury, who does not mention Sue, but may have had him in mind in his reference to "romanciers," does not support the claim that there existed "many contemporary variants of the legend" that transformed the Wandering Jew "from a helpless victim into an active witness to a new social order," nor does Nochlin herself adduce any further examples. Champfleury, on the contrary, expresses a strong preference for the traditional image. If Courbet indeed saw himself in the character of a benign Ahasverus, he is not likely to have received this notion from his friend.

41. Champfleury, *Histoire*, p. xlii.

42. *La Revue comique* (Paris, May 1849), p. 8. The cartoon is probably by Nadar.

43. Baudelaire, *Oeuvres complètes*, Bibliothèque de la Pléiade, Paris, 1968, pp. 1,152ff. "Le Peintre de la vie moderne" was written in the winter of 1859–60 and first published in *Le Figaro*.

44. *Salon de 1846*, "XVII. De l'héroisme de la vie moderne," in Baudelaire, *op.cit.*, pp. 949ff.

45. *Le Peintre de la vie moderne*, "III. L'Artiste, homme du monde, homme des foules et enfant," in Baudelaire, *op.cit.*, pp. 1,157–59.

46. Baudelaire, *op.cit.*, p. 1,160.

47. Ibid., p. 1,161.

48. *Salon de 1846*, "XVIII. De l'héroisme de la vie moderne," in Baudelaire, *op. cit.*, pp. 951–52.

49. *Mon Coeur mis a nu*, c. 1863, in Baudelaire, *op.cit.*, p. 1,295.

50. P. de Kock, *La Grande Ville: Nouveau Tableau de Paris*, 2 vols. (Paris, 1842–43), with texts by such writers as Balzac, Dumas, and Ourliac and illustrations by Daumier, Gavarni, Daubigny, Traviès, Monnier, and others.

51. *Le Diable à Paris: Moeurs et coutumes, caractères et portraits des habitants de Paris*, 2 vols. (Paris, 1845–46), with texts by such writers as Balzac, George Sand, Musset, and Nodier and illustrations by Gavarni, Daubigny, Français, Bertall, and others.

52. *Les Français peints par eux-mêmes. Encyclopédie morale du XIXe siècle*, 9 vols. (including *Le Prisme*) (Paris, 1841), with essays by many authors and illustrations by Gavarni, Daumier, Grandville, Meissonier, Charlet, Traviès, Monnier, and others. A second edition appeared in 1876–78 with many new illustrations.

53. Among them Charles de Beaumont, Julien Vallon de Villeneuve, Quillenbois (comte de Sarcus), Bertall (Vicomte Albert d'Arnoux), and Cham (Amédée de Noé).

54. From a group of cartoons by G. Doré, "La Promenade aux Tuileries," in *Le Journal pour rire*, vol. 2 (April 1849), n. pag., N. G. Sandblad (*Manet, Three Studies in Artistic Conception* [Lund, 1954]) published another parallel (plate 1), to which A. C. Hanson ("Popular Imagery and the Work of Edouard Manet," in *French 19th Century Painting and Literature*, ed. U. Finke [Manchester, 1972], p. 148) added "another possible source" from the 1876 edition of *Les Français peints par eux-mêmes*, an illustration not included in the original edition of 1841, and hence not a possible source for Manet's painting of 1862 (see note 52 above).

55. See particularly A. C. Hanson, "Manet's Subject Matter and a Source of Popular Imagery," in *Museum Studies*, vol. 3 (Chicago, 1968), pp. 64ff., and the same author's "Popular Imagery and the Work of Edouard Manet" (see note 54 above), in which (p. 134) she concludes "It is usually futile to search for the one 'correct' source for a given motif in Manet's work. Since numerous equally convincing sources present themselves, and we know he worked from models as well, we can conclude that he practiced a kind of image-collecting." An example of a probably "correct" source for a motif in one of Manet's paintings is the figure of a girl holding an

infant, from a painting by H. G. Schlesinger, *L'Enfant volé* — illustrated in *Magasin pittoresque*, vol. 28 (1861), p. 293 — that Manet appears to have borrowed for the corresponding figure in *The Old Musician* (cf. Hanson, "Popular Imagery and the Work of Edouard Manet," p. 146).

56. Cf. Hanson "Manet's Subject Matter," pp. 64ff., and "Popular Imagery," pp. 133ff.

57. The Hannoverian artist J. H. Ramberg (1763–1840), active in England in 1780–88 and significantly influenced by English traditions of caricature, published in 1828 a series of plates, entitled *Homers Ilias, seriös und comisch,* which treated Homeric subjects in the manner of John Flaxman in paired plates that juxtaposed serious and burlesque — i.e., ludicrously modernized — versions of the same scene. His style of graphic parody interestingly anticipates that of Grandville. (See F. Forster-Hahn, *Johann Heinrich Ramberg als Karikaturist und Satiriker* [Bonn, 1963], pp. 112ff.)

58. See L. Rosenthal, *Du Romantisme au Réalisme* (Paris, 1914), pp. 168ff.

59. Grandville [Jean-Ignace-Isidore Gérard], *Un Autre Monde* (text by "Taxile Delord" actually, Grandville himself) (Paris, 1844). The visit to Rheculanum (a pun on *reculer* — "to regress") is described on pp. 177ff. The actress "Mlle. Leucothoé" represents the famous tragedienne Rachel.

60. Ibid., p. 191.

61. "Quelques Caricaturistes Français," published in 1857. Cf. Baudelaire, *op.cit.,* p. 1,006.

62. The series *Histoire ancienne* was published in *Charivari* from December 1841 to January 1843; see L. Delteil, *Daumier,* vol. 3 (*Le Peintre-graveur illustré,* vol. 22) (Paris, 1906), numbers 925–75. For the preface, see number 925.

63. Delteil, *Daumier,* number 971.

64. Ibid., number 930.

65. A curious parallel to this combination of the iconographies of Penelope and Dibutade is to be found in the work of Joseph Wright of Derby, i.e., his two pendant paintings of 1783–84, *Penelope Weaving Her Web* and *The Corinthian Maid* (Dibutade). See B. Nicolson, *Joseph Wright of Derby* (London, 1968), pp. 243–44, numbers 224, 225.

66. Delteil, *Daumier,* vol. 6 (*Le Peintre-graveur illustré,* vol. 25), number 1,980; other parodies of that time: *Les Horaces d'Elysée* (D. 2,105), *Un Nouveau Bélisaire* (D. 2,107), *Le Nouvel Oedipe* (D. 2,115), *La Tentation* (D. 2,149), all dating from 1851.

67. The libretto of *Orphée* was by H. Crémieux and L. Halévy, that of *La Belle Hélène* by H. Meilhac and L. Halévy. Famous "courtesans" sometimes acted the parts of divinities; Cora Pearl premiered in the role of Cupid in *Orphée.* Cf. S. Kracauer, *Offenbach and the Paris of His Time* (London, 1937), and J. Richardson, *La Vie Parisienne* (New York, 1971), pp. 263ff.

68. R. R. Brettell and S. M. McCullagh, *Degas in the Art Institute of Chicago* (Chicago, 1984), pp. 32ff.; C. Galus, "Degas' *Young Spartans Exercising,*" *The Art Bulletin,* vol. 67 (September 1985), pp. 501ff.

69. T. J. Clark, in *The Painting of Modern Life: Paris in the Art of Manet and His Followers* (New York, 1985), pp. 83ff., offers a comprehensive selection of the press reviews of *Olympia.*

70. See Clark, ibid., p. 94.

71. Ibid., pp. 94–96.

72. T. Reff, *Manet: Olympia* (London, 1976), pp. 67ff.

73. *Le Peintre de la vie moderne,* "IV. La Modernité," Baudelaire, *op.cit.,* p. 1,165.

74. "How can one possibly take Manet at his word . . . when he assures us that it is merely the 'sincerity' of his works that gives them their 'character of protest,' or when he pretends to be

shocked at the hostility with which the public has greeted them. . . . [His] words ring hollow in the face of such outright affronts to public sensibility as *Déjeuner sur l'herbe* and *Olympia.* What has never been sufficiently taken into account by 'serious' criticism is the character of these works as monumental and ironic put-ons, *blagues,* favorite form of destructive wit of the period, inflated to gigantic dimensions — pictorial versions of those endemic pranks which threatened to destroy all serious values, to profane and vulgarize the most sacred verities of the time." L. Nochlin, "The Invention of the Avant-Garde: France 1830–80," in *Art News Annual,* vol. 34 (1968), p. 16.

■ PICASSO, COLLAGE,

AND THE MUSIC HALL ■

There is [in the music hall] a certain satirical or skeptical
attitude towards the commonplace, there is an attempt to
turn it inside-out, to distort it somewhat, to point up the
illogicality of the everyday. Abstruse, but — interesting.

V. I. LENIN TO MAXIM GORKY, 1907

Cubism hit the music hall stage for the first time on October 12, 1911. The occasion was a *revue* in two acts and three *tableaux* by Robert Dieudonné entitled *Et Voilà!*, performed at the otherwise "straight" Théâtre des Capucines. Included among the cast of characters was a *cubiste*, played by the director of the Capucines himself, M. Armand Berthez (fig. 77). His costume consisted of a conventional man's suit that had been painted with overlapping polygons, and to which cubes were attached at the shoulders and the trouser cuffs. The gag is that Cubists parse even the most unlikely things into small, carefully calculated units of geometrical shape; the Cubist painter is shown in production photos for *Et Voilà!* "demonstrating his theories of art and measuring with a compass the charms of the *commère*."[1] The critic for *Comoedia* thought *Et Voilà!* "smart, licentious, a bit naughty, ironical, lively, exuberant, spirited. It mocks everything including itself."[2] The Cubist costume is, of course, meant to be utterly ridiculous, a joke; it also predates by two years Sonia Delaunay's earliest application of Orphic Cubism to clothing design (fig. 78), and by six Picasso's costumes for the music-hall-styled ballet *Parade*—the debut of Cubism on the avant-garde stage.

At virtually the same moment in 1911, the music hall appeared for the first time in a Cubist picture: toward the bottom of a canvas representing a seated woman, Pablo Picasso inscribed the phrase "MA JOLIE" (fig. 79). These words, a pet name for the artist's new lover, Eva (Marcelle Humbert),[3] were extracted from the refrain of the popular song "Dernière chanson," which begins, "O Manon, ma jolie . . ." The three verses of the song were written by H. Christiné to music by Harry Fragson, but the words of the refrain were written by Fragson and set to a melodic "motif" from a ballet dance by Herman Finck originally called "In the Shadows."[4] On October 1, 1911, "Dernière chanson" was introduced at the Alhambra music hall by Fragson, an immensely popular music-hall artist of the prewar period who wrote and performed songs in both French and English (fig. 80). Hit songs often developed a life of their own outside the theater; the music hall, that is, typically saturated the daily life of prewar Paris. *Le Journal* reported throughout the month on Fragson's nightly performances at the Alhambra, where he was engaged from October 1 to 31. Every concert was sold out, and the performer was greeted with "delirious" applause.[5] A number of his new songs received instant public acclaim, but the "ma jolie" refrain of "Dernière chanson" was particularly visible, appearing as a miniature musical score in the theater pages of daily newspapers such as *Excelsior* and *Le Journal* (fig. 81).[6] It soon became a fashionable dance tune played as a tango by "gypsy" orchestras (the words refer to a tune that "the *tziganes* play"); such was the case at the Cabaret l'Ermitage on the Boulevard de Clichy, where the Picasso circle could often be found in 1911–12.[7] *Ma Jolie* is undated, but given the vast proliferation

JEFFREY S. WEISS
■

of popular songs at the time and the speed with which one hit followed another, it seems likely that Picasso reproduced the lyric in October, when the song was first in vogue.[8]

Between the Cubist painter in *Et Voilà!* and the song lyric in Picasso's *Ma Jolie* there is an open channel. Identifying music-hall style in modern painting is a function of mapping the territory they share. While the music hall might, from our vantage, seem like a mere frivolity, it actually enjoyed the favor of the avant-garde as a peculiarly modern entertainment charged with an exhilarating capacity for novelty and surprise. In 1913, F. T. Marinetti devoted an entire Futurist manifesto to the music hall, hailing it as nothing less than "the crucible in which the elements of an emergent new sensibility are seething."[9] Later, Jean Cocteau was equally direct: "That force of life which expresses itself on a music hall stage renders all of our audacities obsolete at first glance."[10] In fact, the history of prewar music-hall performance opens a window onto the comedics of early modernism, a structure and iconography of parody, irony, and play. In Picasso's collages, music-hall manner is pervasive, and it asks us to integrate and reconcile serious aesthetic purpose with a subversive practice of serious fun. The music hall permits us to address Picasso as a comic artist as well as a metaphysician of the picture plane, and to return collage Cubism to its place within a larger cultural expression — to reenvision Cubism as a contraption of the prewar years.

■ The music hall — what we are now more likely to refer to as "vaudeville" — is a progeny of the mid-nineteenth-century *café-chantant* and *café-concert*. Its shared origins in London and Paris are betrayed by French retention of the English genre name — *le music hall*. Music-hall performance is distinguished by its variety; the Edwardian term "variety theater," a synonym for the music hall, was devised to emphasize the difference: café-concert shows were comprised largely of song (though the songs came in an assortment of genres, from the sentimental to the nonsensical to the crude and obscene), while music hall incorporated song within a larger *spectacle*. Across the music-hall stage might pass, in rapid turn, circus acrobatics, juggling, sports (such as boxing), magic, animal acts, comic sketches, cinema (beginning in the 1890s) and *défilés* of lavish modern or historical costume and female flesh.[11] Such performances were available to a wide range of classes. There was also a good deal of mix and crossover between types of patron — workers and *petites employées* could occupy the cheap gallery seats at expensive halls such as the Folies-Bergère or Olympia, while the *haute bourgeoisie* might seek out the greater abandon of a more "popular" theater such as La Pépinière.[12]

By 1900, the music hall was no longer a new institution; but it had been

renewed. In Paris, it was still recognized as something startling, outlandish, and fundamentally modern. The French had intensified every aspect of their music-hall performance: the lavishness of the *spectacle,* the liberal sexuality of the chorus line, the energy and speed of acrobatic and slapstick *numéros* (under the influence of the English), the raucousness of the music, and the bite of the satire. The café-concert and music hall can never be entirely disentangled, yet we can and do speak of the gradual death of the café-concert. Writing in *Gil Blas* in 1901, one observer reported that the music hall—"sensational, paradoxical, ultramodern"—had definitively replaced the cabaret, the café-concert, and the theater, which was too attached to conventional formulas.[13] As late as 1912, a critic could still refer to the music hall as "a new genre which will engender the fusion of two pleasures which were once distinct: that of the *café-concert* and that of the circus."[14] Marinetti was reflecting common, even established, prewar sentiment when, in 1913, he extolled the music hall for having "no tradition, no masters and no dogma."[15]

Our knowledge of Picasso's theater-going habits is largely dependent upon the recollection of others in his circle. Picasso left no written memoirs, and beginning in around 1906, his art grows increasingly less illustrative of life outside the studio and the café. The artist's passion for acrobatic performances at the *fêtes forains*—outdoor, itinerant fairs which took place on the streets and the *terrain vague* of Montmartre—is clear from the oeuvre of 1903–05, where saltimbanques figure in such large quantity. We have also long known of Picasso's assiduous attendance at the Cirque Medrano. All of his closest friends have attested to his delight in the slapstick antics of circus clowns, though it remains singularly curious that there is little if any real visual evidence of the clown—as opposed to the saltimbanque—in his prewar work.[16]

The visual record of Picasso's early work from Paris does, however, reveal the larger scope of his taste in entertainment. There we find that the young Spaniard, new to Paris, was a *habitué* of the café-concert and music hall. In addition to a large number of drawings, pastels, and paintings in the manner of Degas and Toulouse-Lautrec, a half-dozen extant notebooks from 1900–02 contain some fifty sketches by Picasso of performers and spectators (fig. 82).[17] These are probably studies for illustrations that Picasso created for the magazine *Frou-Frou* between 1901 and 1903.[18] While Picasso's compatriot Carlos Casagemas tells us that he spent some evenings at the rougher music halls of Montmartre,[19] Max Jacob relates that Picasso also frequented the Moulin-Rouge, the Casino de Paris, and other fashionable halls, where he made the acquaintance of great stars such as Liane de Pougy, "la belle" Otero and Jeanne Bloch.[20] Bloch, who built her career upon a rotund physique and an equally broad comic manner (often comprised of vulgar jokes about her own size and weight), is easy to spot among Picasso's

sketches (fig. 83). Her specialty during the 1890s had been the burlesque of military life (an unusual genre for a woman), for which she appeared in an army *kepi* wielding a riding crop or a snare drum (fig. 84). Bloch was a headliner at the Cigale music hall in Montmartre throughout Picasso's early visits to Paris in 1900–02.[21] Since Picasso depicts her with a military drum, it is likely that he sketched her in a performance of *A nous la veine!*, the only Cigale *revue* of the period in which Bloch played roles typical of her celebrated café-concert persona, in this case a *deputé* from Dunkerque and a *majoresse*.[22]

Fernande Olivier, who lived with the artist in 1904–12, remembers that Picasso "loved risqué cabarets and music halls."[23] Members of Picasso's circle such as Olivier, D. H. Kahnweiler, and André Salmon also describe soirées at the Bateau-Lavoir studio and the bistros Chez Azon and Chez Vernin around 1908–12, during which they were all entertained by Max Jacob, whose specialty was sentimental and comic songs (including travesty) from past and present café-concert and music-hall repertory.[24] Nevertheless, the next introduction of the music hall into Picasso's work comes with the song lyric "ma jolie," which will recur throughout the pictures of 1911–14. Then, during the fall of 1912, Picasso pasted sheet music onto a sequence of five collages. These pages are clipped from two other songs of the sentimental café-concert/music-hall variety: "Trilles et Baisers" ("Trills and Kisses") and "Sonnet" (figs. 85 and 86).[25] The first series of collages in which the pasted papers are bound by a single iconographical theme, these pictures signal that Picasso has found a renewed significance in music hall and popular song culture.

The case of "Sonnet" is particularly intriguing. The song was published in 1892, twenty years before Picasso pasted it down.[26] In *Violin and Sheet Music* (see fig. 86), page one of the song tells us that words by Pierre Ronsard have been set to music by Marcel Legay, who introduced the song during a *soirée artistique* at the Eldorado. Legay had been one of the great cabaret and café-concert singers of the 1890s, a legendary "bard of Montmartre";[27] the Eldorado, on the Boulevard de Strasbourg, was the oldest and most venerable music hall in Paris, yet celebrated through 1914 for its dedication to conserving the tradition of café-concert song recitals.[28] The "Sonnet" collages resonate not only with the history of the French *chanson*, but with Picasso's own history as a patron of popular song in Paris. During his nine years in Montmartre, the artist's circle spent many evenings at the Cabaret du Lapin Agile on the Rue des Saules. Performances of popular song accompanied by guitar and violin (both of which are depicted in the sheet-music collages) were a nightly occurrence at the cabaret. By all accounts, the repertory of Frédé, the guitar-playing *bonhomme* proprietor, was especially strong in dark or romantic lyrics drawn from Ronsard, Villon, and other early French poets.[29] Moreover, the Lapin Agile was itself some-

thing of a legend by Picasso's time, having played host during the 1880s and 1890s to the great Montmartre singers, including Legay.[30]

Around the time of the sheet-music collages Picasso moved from Montmartre to a more urban neighborhood in Montparnasse. Echoes of the Lapin Agile cast an aura of nostalgia about the "Sonnet" pictures. The text of the song, moreover, is a plain and elegiac "vanitas" on love, beauty, and fleeting youth — an especially poignant counterpart to the public/private sentiment of "ma jolie." Appropriately, perhaps, two of the "Sonnet" collages are broad, flat, uncomplicated works. A third, *Guitar, Sheet Music and Glass* (fig. 87), is a good deal less coherent in form and content; its song fragment is much smaller — less nostalgic — than those of the other two, and the music is mixed with five other types of paper, including the critical first appearance of newsprint in the collage oeuvre. *Guitar, Sheet Music and Glass* introduces us to a series of complex pictures by Picasso — stunning, seat-of-the-pants pictorial performances that jumble the hermetic formal experiments of Cubism with the banal materials of popular culture — in which the music hall is an informing agent not just of iconography, but of style, structure, and bearing.

Picasso's collages contain a universe of pasted materials — and painted imitations, with which he frequently juxtaposed or replaced them. In addition to sheet music, newspaper articles and advertisements (as well as other forms of publicity such as brand labels) comprise the greatest share; wallpaper, imitation wood grain, playing cards, and *cartes de visite* — the collage universe is inhabited by ephemera, cheap and disposable stuff. A large number of these papers contain printed words, which correspond with examples of commercial typography that had already been introduced into precollage Cubist painting (such as *Ma Jolie*). It is some measure of just how utterly unprepared spectators were for the materials of collage that some fifty years passed before any critic or historian actually *read* these words for *meaning*. In 1960, Robert Rosenblum showed us that Cubists, and above all Picasso and Braque, often cropped and juxtaposed newspaper and advertising typeface for puns and wordplays, many of which alluded back to the visual puns of Cubism itself.[31] Indeed, it is not remarked often enough that the wordplay is simple, as Picasso's French was little more than functional at the time. Nonetheless, the pictures are populated by verbal games played predominantly in French, with only occasional excursions into his native Spanish. Picasso's primary pun, inscribed on numerous Cubist pictures from 1912–14, was derived from the name of the newspaper *Le Journal*, which, when clipped, becomes "jou," suggesting the French word *jouer*, "to play" (or *jouir*, "to enjoy"; in sexual slang, "to come") (fig. 88).[32] "Jou" is, in fact, something of a logo for these pictures, the *mot d'ordre*, and it signals us to "play" Picasso's epistemological game.

The "Sonnet" collage *Guitar, Sheet-Music and Glass* (see fig. 87) is a

classic example, where picture making itself is understood as a sort of advanced practice of the pun: sheet music — *partition* in French — suggests the division of objects throughout the collage; fragments of music and newspaper *are* what they "represent," yet the glass is a Cubist stylization; a white paper disk — material yet empty — stands for the void of a guitar sound hole, while the hollow body of the guitar is described by the arrangement of pasted papers around an empty space; wood grain is a "real" pasted paper, yet "fake" in that it is a simulation painted with a technique borrowed from the unexalted metier of *peinture en bâtiment;* wallpaper concretizes the vertical surface of a wall, and of the picture itself, yet simultaneously alludes to the horizontal surface of a table, upon which the objects rest; finally, all of the objects signal both the work to which they are attached and the world from which they have been detached. Beneath "le jou" we read "la bataille s'est engagé(e)" ("the battle has begun"), words that are at once the headline of a news story on the Balkan Wars[33] and the challenging slogan of a picture so unlike any other before it.

Newspapers, advertising, and popular music; ephemerality and the play of the pun: these are the salient contents and qualities of collage. In the history of art there simply is no precedent for this combination of iconography and attitude. We might look for Pre-Cubist *depictions* of newspaper and café advertising typography in Impressionist and Post-Impressionist painting, where they typically function as attributes of urban life. But this is clearly inadequate — we don't need a history of this subject matter in painting before Cubism in order to come to Cubist collage with the proper frame of reference; neither did Picasso. Like all artists, Picasso engages consciously and unconsciously with the nonart world; but Picasso stands out for having drawn striking attention to this fact by *affixing* peculiar bits of that world onto a painting or drawing. We should, then, follow his lead and venture back not into the history of art so much as into the contemporary realm of prewar popular culture. Newspapers, advertising, and song were, around the time of Cubism, all far more vital to the daily aesthetic life of Paris than to the aesthetics of French easel painting. As such, they were in turn the signal ingredients for a genre of music-hall performance that bears strikingly upon the history of collage: the *revue.* In a very real sense, collage existed at the music hall before Picasso, and it flourished there throughout the history of collage Cubism.

■ "The *revue,* what a setting! There exists none which permits more fantasy with more reality. . . . The *revue* is the triumph of the 'neither head nor tail,'" or so says Henry Buguet in his 1887 pamphlet *Revues et revuistes.*[34] The history of the *revue* as a performance genre in France is, in fact, older than the music hall. Reaching back to the eighteenth century, it was first fully

formed during the Restoration period. Peaking at the music halls of the Second Empire, the *revue* was revived with a new extravagance after 1900, and gained a second wind. By around 1910, this revival had erupted into a virtual mania, and the *revue* exploded throughout the music halls of Paris. So popular was the *revue* during the prewar period that it was discussed with the energy of debate in the daily and entertainment press.[35] It was also the subject of a monographic study in 1909 by one Robert Dreyfus: *Petite Histoire de la revue de fin d'année*. Dreyfus provided a pedigree for the *revue*, tracing its origins and its history throughout the nineteenth century and, most importantly, furnished a detailed definition of the genre.[36]

The *revue* is a sequence of satirical *tableaux* (sometimes as many as two dozen or more), which are commentated by a mistress and master of ceremonies, the *commère* and *compère*. The text is comprised of both dialogue and song "couplets." *Revue* scenes are based almost exclusively on current events extracted from the news of the past year. Buguet assures us that a *revue* might contain events from the very morning of the first rehearsal.[37] In 1912, for example, the critic Curnonsky congratulated the director of the Olympia music hall for adding new current events to a *revue* that was already a great success, making it "une sorte de spectacle d'actu-alité incessante" ("a kind of spectacle of incessant actuality").[38] The *revue* can be written and performed anytime throughout the year, though it proliferates with special fervor during the late fall and winter, at which time it is known as *la revue de l'année* or *de fin d'année*—literally, a "review" of the past year's events.

The primacy of current events makes the daily press something of a bible for the *revuiste*. Indeed, the newspaper is such a fundamental source that *revues* from the nineteenth century through 1914 often simply sport titles such as *Le Grand Journal* and *Le Petit Journal* (fig. 89).[39] Among the *actualités* favored by *revuistes*, recent political events are among the most common (though, Dreyfus tells us, the *revue* traditionally caters to the middle class, and it tends to emphasize political issues on which bourgeois opinion is fairly unanimous).[40] Other aspects of the latest news are wide open to the "promenade" of the *revuiste*, who can be especially clever on the manners and fads of modern Paris (including the theater itself), as well as "economic life, *machinisme*, the applications of science to industry and commerce, the continued perfection of means of transport and exchange, or, as we used to say, the 'progress' of human genius."[41] To Dreyfus's list we can append the earlier inventory of *revue* iconography by Arthur Pougin, from his *Dictionnaire historique et pittoresque du théâtre* of 1885: "revolu-tions, wars, new inventions, fashions, artistic and literary matters, crimes, public calamities, etc."[42] But Buguet further specifies a related branch of modern manners with which the *revuiste* has great fun: the slogans and claims of advertising, such as publicity for Mines de Cornerille or Pastilles

Géraudel, which were set to the music of the most popular café-concert songs. Buguet adds that the "practical *revuiste*" will not fail to "propagate a little *réclame* (almost invisible) on the address of his tailor or bootmaker, or in favor of his wife's dressmaker and milliner."[43]

Dreyfus insists that the accessibility of the *revue* depends upon not only the diligent author, but the well-informed spectator. Similarly, if the vivid immediacy of the *revue* is a function of its source in the news clipping and the recent fad, future readers of *revues* past are likely to find the text impenetrable, filled with mere "*signs* of knowledge and, above all, of sentiments that they suppose once to have been alive" [Dreyfus's emphasis].[44]

The tone of the *revue* — the posture that belongs to the *revue* alone among genres of theater — is glib and ironic. French vocabulary for this comic manner is specific: *blague* at its most confident and careless, *rosserie* at its most spiteful or cynical.[45] The primary formal device of the *revue* is the play on words, or the "allusion" (the word is identical in French and English). Dreyfus elaborates:

> What is the allusion?
>
> The allusion, says Littré, is a "figure of rhetoric consisting in saying one thing that makes us think of another." Littré adds: "We distinguish historical allusions when they recall a point of history; mythological, if they are based upon the fable; nominal, if they depend on a name; *verbal, if they consist of the word alone, that is, an ambiguity.*" [Dreyfus's emphasis]
>
> This last type of allusion is perhaps the most prevalent in *revues de fin d'année*. I even believe that they properly constitute that which one calls "the spirit of the *revue*."
>
> . . . The "verbal allusion," as it is named by Littré, that chemist of our language, is quite simply that which, without examining so deeply, we call the *à peu près* and the *pun*. [Dreyfus's emphasis]
>
> Assuredly, the pun is not always so humble a means of allusion. . . . But I have willingly sought the bottom of the scale, because the more rudimentary the pun, the better it permits us to isolate the stark naked allusion, the drained and, as perhaps Kant would have said, pure allusion.
>
> This allusion is not sustained, touched-up, heightened by anything. Equally, the pleasure that it affords — when it affords any — is unadulterated.[46]

Dreyfus illustrates his philosophy of the *revue* pun with the poster from an 1855 *revue de l'année* entitled *Le Royaume du calembour* (The Kingdom of the Pun) (fig. 90). He goes on to trace the pun or allusion as a secondary tool of political comedy and the comedy of manners, in Molière and Sardou for example.[47] But, he assures us, the *revue* is nothing so deep; in the *revue*, the allusion is not an accessory, but "the essential and the all."[48] The enjoyment

of a *revue* resides almost exlusively in getting the joke — recognizing onstage figures and incidents of the past year, and understanding the "gay, rapid, satirical and philosophical remarks" or allusions made at the expense of these *actualités*.[49]

By 1911, the year Picasso and Braque introduced printed words into Cubist painting and one year before *collage,* the *revue* had attained the status of a craze. When, as Fernand Olivier tells us, Picasso went to the music hall, he confronted the *revue* vogue at its highest pitch. One theater critic wrote, in December 1911, of that season's "avalanche of *revues,* the extraordinary vogue for this fashionable genre," predicting a reaction not unlike that which occurred during the Universal Exposition of 1889, when a spate of *revues* provoked one anonymous author to compose *Pas de Revue!,* (a *revue* that ran for 150 performances).[50] Reviewing a *revue* at the Théâtre de l'Ambigu, also in December 1911, Léon Blum observed that the *revue* fad had extended beyond the bounds of the music hall:

Who doesn't have his *revue!* From the music hall and related stages, the contagion has overtaken the large theaters. Yesterday, it was the Bouffes, today the Ambigu; tomorrow it will be the Théâtre Réjane. I well know that the *revue* is what one calls a supple genre, so supple that if need be it could finish by absorbing all the others.[51]

He might have added the Guignol to his list for, already back in May, even the puppet theater had mounted its own *revue des actualités,* entitled *Pourquoi pas?*[52]

The *revue* showed no signs of exhaustion. The article "La Revue Triomphante" appeared in the magazine *Le Théâtre* in April 1912:

The *Revue!* it is invading everywhere; the 1912 theatrical season will mark a date in the history of this original form of French spirit, and could furnish Robert Dreyfus with one of the most abundant chapters in the next volume that he will consecrate to it. Marigny, the Folies-Bergère, the Olympia, La Scala, the Moulin-Rouge, the Ambassadeurs, the Alcazar d'Eté, the Capucines, the Bataclan . . . all the cafés-concerts and all the music halls are performing *revues;* there is not a faubourg in Paris which does not sing, to a familiar tune, about the "Dancers' Strike," "The Adventures of M. Cochon" and other *événements d'actualité* that inspire mordant, subtle or vividly satiric couplets, because [the *revue*] exhibits on all the Parisian stages, large or small, over the course of one evening, a singular expenditure of spirit. One even occasionally begins to regret that this spirit is so liberally dispensed in works which, by their very essence, are ephemeral, since they do not represent an epoch but, of necessity, a season. . . .[53]

The *revue de fin d'année* had an intense cultural life outside of the music hall during the prewar years. So attractive and convenient was the *revue* as a

comic vessel for the events, trends, fashions, and gossip of the past year, that newspapers and magazines themselves borrowed the genre with regularity. The format was especially popular with theatrical and humorist periodicals during the period of the *revue* craze, though it was also common in the regular press. In some examples, allusion to the music hall is implicit. The daily paper *Paris-Midi,* for example, printed a synopsis of the year's main events from politics to sports on the front page of its December 31, 1912 issue, entitled "Revue de fin d'année pour 1912."[54] Elsewhere, the structure and tone of the music hall *revue* is adapted literally. The humorist weekly *L'Indiscret* ran a series of "almost weekly" *revues* from fall 1912 through summer 1913, complete with dialogue, punning songs, numbered scenes, and stage directions.[55] *Le Charivari* published two *revues* in 1912: "Revue Charivarique" in October, concerning the Balkan Wars (Kaiser Wilhelm and France's allegorical Marianne are the *compère* and *commère*); and "Encore une revue d'actualité!," a send-up of advertising claims for the popular cure-all medicines Urodonal and Globeol in which Esculape, the ancient Greek god of medical science, is administered the modern miracle drugs after being run over by a bicycle and a bus on the streets of Paris (revived, he dances the can-can and sings the café-concert classic "Tararaboum dié!").[56] "L'année 1910, revue par M. le Président de la Chambre" occupied the entire December 31, 1910 issue of the satirical magazine *L'Assiette au beurre*. Presented as "sung" at the "Folies Bourbon" (a splicing of Folies-Bergère and Palais Bourbon) with words and music by Henri Brisson, president of the Chambre des Députés, this mock-*revue* consists of song lyrics and caricatures satirizing various events from the year's news. The cover illustration by d'Ostoya demonstrates the natural affiliation of *revue* and newspaper clipping: as a backdrop for Brisson, who is dressed in imitation of the music-hall comic Dranem, two fragments of the *Journal officiel de la Chambre des Députés* are reproduced in a cut-and-paste fashion that presages the look of Picasso's newspaper collages from winter 1912–13 (figs. 91 and 92).

To practice the *revue* in any form was, then, to cultivate an aesthetic of the newspaper. At the music hall, the newspaper dominated in spirit and fact; embodying the raw material of reportage, it was the essential subtext and context of the *revue* genre. To make this point visibly clear — for the audience appeal of a *revue* depended on its being attuned to the pulse of the daily press — the *revuiste* could call upon a stock character type: the personification of various newspapers and genres of news. Dreyfus tells us that the first such character appeared in a *revue* of October 1831, in which "La Politique" was portrayed by Mlle. Déjazet at the Palais Royal, "clothed in a dress on which all the newspapers were pasted."[57] Costumes composed of imitation and authentic printed papers were commonly featured; such a costume was worn by "Emile Viltard, compère de revues," who appeared sometime in the

1850s in a coat and pants bearing the printed titles and authors of past *revues* for which he had been the master of ceremonies (fig. 93). By 1900, the newspaper costume was a *revue* fixture, most typically worn by a woman and emblazoned with the name — in the original typeface — of a single newspaper or periodical. The title was usually affixed as a banner to the performer's hat, though variations might find the newspaper in question displayed for greater *risqué* effect (figs. 94 and 95). Another version of this costume type would be to plant a larger-than-life newspaper title across the entire length of a long, wraparound skirt. Here the title would never be entirely visible, but cut instead by the folds of the skirt and the direction in which the performer faced at any given time during her appearance on stage. In this manner, *Le Journal* might be read as "Le Jou(r)" (fig. 96). Dozens of newspapers were routinely "depicted" in this way. The results were always a typical music hall mix of glitzy *féerie* extravagance, racy *déshabillé,* and a mock, hyperbolic seriousness that was basically, playfully ridiculous. Still, as deliberately preposterous as these costumes were, they were a fundamental music hall device, emblematic of the newspaper as the soul of the *revue.*

Picasso's own choice of *Le Journal,* the predominant newspaper in his collage oeuvre, is a corresponding device. He may have selected it in part for its coverage of specific events and for formal reasons, such as the quality of its typeface and the disposition of its columns; it may, in fact, have been his favorite paper. But it is equally clear that, unlike *Excelsior* or *Le Figaro,* which he used comparatively little, the title *Le Journal* stands simultaneously for a specific newspaper and for the generic category of "newspaper" itself: *journal* means "newspaper." Moreover, though *Le Journal* provided Picasso with the logo-pun *jou,* the word *jouer* — from which we derive the implication of play in the cropped word *jou* — also happens to be the French verb for theatrical performance; one "plays" a *revue.* Indeed, the proliferation of the suggestive *jou* throughout Picasso's 1912–14 oeuvre virtually labels the Cubist picture plane as a kind of stage space in which every object — including *Le Journal* itself — is accorded the protean adaptability of a player, changing costume and character in order to perform a new role. Picasso's visual and verbal game of *journal-jouer-jou* was not lost on the music hall *revuiste.* One *revue* in particular, which played at the Théâtre de l'Athenée in January 1912, was written exclusively and explicitly according to a newspaper format, with a different author for each category of *actualité:* society gossip, politics, foreign affairs, theater news, bulletins in brief, legal proceedings, literature, fashion, and sports. The title of this *revue* is *Le Journal joué* (the "played" or "performed" newspaper), a ready, alliterative play on words that seemed as obviously appropriate to the *revuiste* as to Picasso.[58]

■ Picasso executed his first and most conspicuous group of newspaper collages, a run of approximately three dozen works, between November and January 1912–13, the annual high season for the music hall *revue de fin d'année*.[59] While it is true that no one collage contains material referring back to the *actualités* of an entire year, the force of the here-and-now in the collage oeuvre is astonishing. Rather than perpetuate the continuity of values that art might once have been understood to preserve, Picasso introduced the *actualités* of news, advertising, fashions, and fads into painting and drawing, shuffling and sorting the iconographical and physical facts of fleeting contemporaneity. The "subjects" of these works are as fast fading as the newsprint that contains them, once grubby white and now crumbling brown. The anti-illusionistic shallow or flat pictorial space that results from the predominance of pasted paper signals a new role for the picture plane as a field of transience. Not since Impressionism had the modern moment been given such startling pictorial urgency. This is not to say that collage comprises an appreciation of modernity in the sense of any slippery notion of "progress" (for this we might look to Delaunay's airplanes and athletes, and his bright, celebratory palette); rather, it represents a more banal, immediate, everyday sensation of ephemeral events, the fabric of the artist's world as a shifting and unraveling thing. With the pun, Picasso distanced the *actualité*, treating it as material for aesthetic paradox, social satire, and licentious humor. It is this same fresh *actualité* upon which the *revuiste* sharpened the swift edge of his irony, for he, too, was less interested in perpetual truths than in the half-truths of the unfolding present.

The Balkan Wars, a hot news item of the day, received simultaneous attention — and identical treatment — from Picasso and the *revuiste* during those months late in 1912 and early in 1913.[60] In *Guitar, Sheet Music and Glass* (see fig. 87), Picasso matched the headline "La bataille s'est engagée" — a dispatch from Constantinople — to a snippet from the Legay song that reads "(pen)dant qu'êtes bel(le)" ("while you are beautiful"). The counterpoint is curious: massacre and music, sudden death and fading beauty, foreign affairs of war and domestic affairs of the heart. Under the sign of the boldface pun "le jou," we recognize Picasso's conniving wink and think, for example, of La Marocaine's black-comic refrain in "Au Parlement Turc" from the Folies-Bergère *revue* of October 1912:

The bullets are flying / tra la la la la / And the good French / tra la la la la / of the Republic / Tell us that it's / *La pénétration* / zim-boum *pacifique!* ("peaceful penetration").[61]

It should be noted that, like *Le Charivari*, *Le Journal* published a mock program for its own seasonal Balkan Wars *revue à grand spectacle* on November 10, the very issue from which Picasso extracted the *bataille*

headline, his first newspaper clipping. The "program" is an irrepressible sequence of wordplays, jokes, and comic song titles at the expense of enemy and ally alike. Its author, Curnonsky (whose byline is the pseudonymous pun "l'Obscur Nonsky"), introduced it as "a detailed program of the final *Revue* soon to be presented at the Theatre of War."[62] Among his list of *tableaux*, one stands out: "The Paths of War (Numbering the Retreats)" is described as a "tableau uskubiste, par Ridendum," playing on the Turkish city Uskub and the phrase "tableau cubiste" ("Cubist picture"), as well as Bibendum, the Michelin Tire man, whose Latin name has been converted from a drinking toast into a call for laughter.

Less than a month later, in *Table with Bottle, Wineglass and Newspaper* (fig. 97), Picasso cropped the December 4 Balkans headline "Un Coup de Théâtre," transforming it into his own multiple pun: "un coup de thé," which has since been translated variously as "a cup of tea" (a printed description standing in for the representation of an object) and "a toss of the die" ("coup de dé").[63] Moreover, a synonymous phrase, "le sort en est jeté" ("the die is cast"), often appeared in headlines of the period in reference to the gamble of irreversible military action.[64] But the original headline was a ready-made pun before it was cropped, since the metaphor "coup de théâtre" can, as we have just seen, allude to the "theater of war" and to a dramatic turn of events on the theatrical stage—or stage-*cum*-picture plane. Above the headline, "urnal" from *Le Journal* prankishly places our cup of tea (or tossed die) beneath a *urinal*.[65] Smaller print, which reads "La Bulgarie, la Serbie, la Monténégro sign—" discloses more detailed contents of the dispatch, but we cannot approach with a straight face.

Compare *Table with Bottle, Wineglass and Newspaper* to, for example, *Madame est Serbie,* a revue that opened at the Gaîté Rochechouart in December 1912. Its punning title—"Madame is Serbia"/"Madame is served"—alerts us to what one reviewer described as "a spirited and amusing satire of all diplomacy."[66] The third *tableau* of Act II is entitled "Les Alliés balkaniques," and features a banquet given by the Great (European) Powers to the Balkan allies at the Elysée palace, where Raymond Poincaré, France's foreign minister, serves as the *maître d'hôtel*. Among the dishes "passed under the noses of the poor, starving allies" (one representative each from Serbia, Montenegro, Greece, and Bulgaria) are territorial offerings such as a roast pork (*rôti de porc*) renamed "Rôti de Port sur l'Adriatique."[67] In collage, the typography of mastheads and headlines—where the gags generally occur—catches our eye before the columns of news, or replaces them. Picasso's treatment of the bold print subverts the subtext, or fine print; like the burlesque of news and newsmakers at the music hall, it dominates the way we "read" the collages.

"Revolutions, wars, new inventions, fashions, artistic and literary matters, crimes, public calamities"—politics is just one category of myriad *actualités*.

Flying machines made the papers virtually everyday during the prewar period, as aviators from around the world vied with one another for long-distance flight records. While most reports dealt with tragic failure, both Picasso and the *revuiste* emphasized the promise of flight. Three works by Picasso executed around the time of his first collage depict the cover of a brochure on the development of French military aviation that bears the title "Notre Avenir est dans l'air" (Our Future Is in the Air) (fig. 98).[68] A number of *revues* were titled in the same spirit: *L'Année en l'air* (The Airborn Year) at the Apollo in fall 1908; "Tout en l'air" (Everything in the Air), a *tableau* at the Cigale in September 1911; and, at the Ambassadeurs in summer 1912, "En avion . . . marche!" (*avion* means "airplane"; the phrase is a pun on "en avant, marche," or "forward march").[69] Sports were another popular music hall *actualité*, since they permit a variety-theater display of athletics (and slapstick) within the *revue* format. Among dozens of examples, a *tableau* from *A la Baguette!* at the Cigale entitled "La Culture Physique"[70] matches the date—spring 1913—of the collage *Bottle of Vieux Marc, Glass and Newspaper* (fig. 99), onto which Picasso has pasted the *Journal* headline for a "Congrès International sur l'Éducation Physique."

Cubism itself was a popular music hall *actualité*. Between 1911 and 1914, modern "isms" were a visible, semiannual scandal at the Salon d'Automne and Salon des Indépendants, where Cubism and related schools were subjected to ridicule and hostility in the daily press: For example, the article "Cubisme, Futurisme et Folie" ("Cubism, Futurism and Madness") appeared on the weekly Health and Science page of *Le Journal* just as Picasso rescued his first clippings.[71] In the *revue*, every season was open season, and beginning with M. Berthez in *Et Voilà!*, the prewar music hall was riddled with costumes, sets, and skits lampooning new art. Cubism, the dominant "ism," bore the biggest brunt, and was characteristically renamed *cucubisme*—from *cucu* (or *cucul*), with connotations of idiocy that are the same in French as in English, though *cul* ("ass") adds a cruder implication. There was a Cubist at the Ambigu in November 1911 who "recalled the early days when, succumbing to the first *frissons* of his vocation, he showed his cube to all passers-by;"[72] "Sem's Cube Game" at the Ambassadeurs in June 1912 (Sem was an illustrator who adapted a Cubistic style to caricature); "Paris Cucubique," the prologue for Rip and Bosquet's *La Revue de l'Année* at the Olympia in fall 1912, featuring a set design by Paquereau depicting Paris as a Cubist city; a Cubism song at the Eldorado in January 1913; a "Fauste cubiste" at the Little Palace in February 1914.[73] It is clear that the perceived extravagance and eccentricity of Cubism was being treated by the music hall here as a fad. The Olympia's "Paris Cucubique" stage set was the backdrop for a prologue in which "all the 'folies à la mode' are ridiculed."[74] How would Picasso have been struck by all of this Cubist stage business? Cubism is, obviously, the "backdrop" (as well as the very fabric) of collage. But it is

also intriguing to consider Cubism as its own current event; in *Guitar, Sheet Music and Glass* (see fig. 87), Picasso has pasted the Cubist drawing as an autonomous paper *actualité,* a counterpart to world news and popular song.

The range of advertising *actualités* in Picasso's collages is broad, reaching from the well known to the obscure. Labels and logos for Job cigarette papers, the apéritif Suze, Bass Ale, Vieux Marc, and other drinks occur throughout 1912–14 (see fig. 92). For the newspaper collages, Picasso clipped various kinds of publicity and advertisements just as often as he did news items: the department stores Bon Marché and Samaritaine (fig. 100); products such as Laclo-Phosphate de Chaux ("truly the most powerful fortifier") and Lampe Eléctrique O.R. (fig. 101); "readymade garments for men and children," furs, gramophones, small ads for loan agencies (fig. 102); and theater listings, including music halls and cinemas.[75] Newspaper titles, such as *Le Journal, Le Figaro* (fig. 103), and *Excelsior,* also qualify as a type of publicity.[76] Advertising functions at the personal and private levels, as well: Picasso appropriated the *cartes de visite* of his friends "Miss Stein/ Miss Toklas" and the dealer André Level, in addition to a modest prospectus circulated by a publisher on behalf of a forthcoming book by Max Jacob entitled *La Côte* (which was three years old when Picasso used it in 1914).[77]

Hardly a *revue* was played during the collage years that did not include some run-down or send-up of recent brand names and marketing schemes. Newspaper costumes were, of course, a music-hall staple—a device calcu-lated to prove the currency of a *revue. Madame est Serbie* contained a scene in which two companions ride a train through the French provinces, taking the trade names on large advertising billboards (an object of recent contro-versy)[78] for the names of cities and towns. The Cigale's *A la Baguette!* presented "La Professeur de publicité théâtrale," a sketch concerning a rash of advertising endorsements propagated by music-hall stars for products such as Cadum soap, Coryza *crème de riz,* A. Bord pianos, and Kub bouillon; the *tableau* closes with a parodic ode to the advertising kiosk ("O, little kiosk, kiosk that I adore."). In *Pourquois pas? . . .* at the Cigale, February 1914, "La Publicité ambulante" told the story of a painter who has been rejected from every annual *Salon* exhibition (nineteen of them, if we are to believe the authors) and sells his paintings to manufacturers as commercial advertising. One scene from *Ce que je peux rire!* at the Alcazar d'Été, June 1912, transforms the Place Vendôme into a giant novelty store, bringing together the Printemps, Louvre, Bon Marché, and Galeries Lafayette department stores. Another satirizes Dr. Macaura, inventor of a cure-all massage appa-ratus, which is applied to the "infante Euphémie" by the comic Dranem (Dranem's song is set to the music of the "*ma jolie*" refrain from *Dernière chanson*). The first act of the Cigale's *La Revue des T.,* summer 1911, even included a parade of living *cartes de visite;* the thirty-third *tableau* of the Folies-Bergère's spring 1912 *revue* was entitled "L'Origine du prospectus."[79]

"On réclame, on réclame," sang the music hall comic Montel in 1912 — "Everybody's advertising through the newspapers / In these claims, there are some laughable schemes. . . ."[80] In the *revue* and collage *tableau* both, advertising is addressed with equal doses of fascination, bemusement, and mockery. It is clear that advertising graphics and extravagant promotionalism could be perceived as especially striking in the alien context of a stage or an easel picture. In addition, marketing tactics such as uncomplicated presentation and bold, shameless claims — crucial ingredients for the fast read and the hard sell — rendered publicity susceptible to canny manipulation for an inside joke. As Rosenblum has pointed out, the text in Picasso's ad for the "Lampe Eléctrique O.R." (see fig. 101), which "sheds light in every direction" and can be "placed in any position," puns into a caption for the stylistic peculiarities of Cubism (in which a newspaper clipping can be placed upside down, as it has been here, and made to stand in for the contents of a bottle).[81] Acting as what Buguet called the "practical *revuiste*," Picasso has appropriated commercial advertising as a claim for Cubism, a boast and a spoof on the forward march of pictorial and technological progress. The "Publicité théâtrale" *tableau* at the Cigale activates the same device: celebrity endorsement could be an object of mockery and a pretext for parodic self-referentiality. In the prologue for *En Scène . . . Mon Président!* earlier in 1913, the Louvre department store was transformed into the Cigale — one giant, reciprocal metaphor of dizzy self-promotion called "Le Magasin Music Hall" (Act I was entitled "Assez de Boniments!" — "Enough Sales Talk!").[82] Similarly, the *revue* often contained scenes depicting its own backstage and its own audience (fig. 104). Transforming the popular stage into a Moebius-strip of aesthetic ambiguity, the music hall addressed itself *to* itself, and to its own artifice.

The still life *Au Bon Marché* (1913) (see fig. 100) contains Picasso's most notorious pun of this kind, an allusion that is at once licentious speculation and pictorial fact. The cut-and-pasted words "trou ici" ("hole here") designate the hidden lower anatomy of the otherwise poised representative from Samaritaine and the pictorial anatomy of a pasted paper, cut to expose a gap.[83]

The revue is also the art of incarnating individuals, events, manners, absurdities, fashions and ideas of the day as small women scantily clad who regale the public with some couplets. These couplets can be satirical, licentious or sentimental. . . . Their spirit is not always inoffensive. There are those which are vulgar and wicked.[84]

Picasso's heavy dose of wallpaper in *Au Bon Marché* raises the stakes. The very word "collage," from *coller* ("to paste"), has two meanings that are germane: technically, in the phrase "collage du papier," it describes the job of hanging wallpaper; as period slang, however, "collage" also refers

to the unmarried cohabitation of two people (a particular set of domestic circumstances to which Picasso was no stranger) and bore overtones of socio-sexual impropriety.[85] Sexual *collage* was, indeed, familiar to prewar music-hall slang; examples include the songs "Collages" (introduced at La Scala music hall), which was published in 1898 with a cover illustration by the future Cubist painter Jacques Villon (fig. 105), and "Les Plaisirs de collage" ("The Pleasures of Collage"), published in 1911.[86]

The music hall was, in fact, subjected to numerous debates on censorship and pornography between the 1880s and World War I. High on the list of "immoral" transgressions were onstage nudity and scatalogical or licentious songs. While nudity could be remedied with flesh-colored body stockings, supporters of the music hall defended vulgar and licentious text (*grivoiserie*) as a risk worth taking in order to preserve the music hall's native *saveur.*[87] Official censors (who themselves became the subject of many *revue* sketches)[88] had some effect in curbing content that was explicitly coarse and crude. The music hall, however, had a built-in line of defense: the sly and refined art of saying one thing while meaning something else. Puns or allusions, the *à peu près* and the *sous-entendu,* were mechanisms with which the lyricist or *revuiste* not only skirted the censor, but invested an evening at the music hall with an aura of conspiracy; censorship only served to sharpen the technique. In the *à peu près,* for example, a performer would begin pronunciation of a questionable word such as *merde* ("shit"), only to pause, then finish the thought on safer ground: "Viens te rouler dans la mer D . . . ominique!" ("Come roll in the waves/shit Dominique!").[89] This manner of pause before the moment of truth was typical of *revue* titles themselves, both of the bawdy and innocent variety, such as *En avion . . . marche!* The punning allusion was equally common, as in La Scala's *revue Ménage à Troyes* ("Trojan Household," a homonym for the *ménage à trois*),[90] or the song *Mon Thermomètre:* "I have a thermometer, a thermo mo / A little thermometer / I have a shocking thermometer / Which goes up and which comes back down. . . . "; here, the comic effect would depend in part on stage gesture.[91] Yet another method was mispronunciation: one could sing "je bisse partout" ("I sing *encores* everywhere") but suggest, with a slight slip, "je pisse partout" ("I piss all over").[92]

Picasso's word fragment "jou," we recall, is a typical case of the *à peu près,* for it suggests other meanings that are both innocent (*journal* and *jouer*) and sexual (*jouir*). "Trou ici" is a classic *sous-entendu;* and "coup de thé" forever waits to be completed (at the music hall, it would be written "Coup de thé . . . âtre!"). The cropped word also conforms to patterns of informal speech at the music hall. The dropped vowel or syllable would shorten a word, making it fit into the predetermined cadence of a song (music-hall lyrics were typically written to an existing popular tune) or speed up the performer's delivery. Such ellipses were often transcribed into *revue*

titles, where the missing letters are marked by apostrophes: *R'mettez-nous ça!* (*remettez*) and *Sauf vot' respect* (*votre*).[93] The title of the aviation brochure in Picasso's third still life *"Notre Avenir est dans l'air"* (see fig. 98) has been abbreviated in exactly this fashion; transcribed, it reads "Not' Av'nir." The missing "e" of *avenir* is not simply hidden by another object in the picture; it represents a verbal elision and signals a visual rift. Ultimately, Picasso's wordplay is the natural linguistic equivalent of his pictorial gambit. Abbreviation, ellipse, allusion, *à peu près* and *sous-entendu* — these are the tools of Cubist engineering, fabricating a world in which objects suggest but do not describe, change and exchange identities; where guitars are heads, walls are tables, newspapers are bottles; a rarefied plane where no contiguous illusion of our world pertains, yet that is inhabited by fragments of illusion and of real things.

The cardinal structural principle of the music-hall *revue* is the jumbling and splicing of current events in *tableaux* that occur in rapid succession and utter disregard for continuous narrative. True to the "variety" aspect of music-hall performance, plurality is the prime directive, both from category to category and within a given group. The *Grande Revue* of March 1912 at the Nouveau Cirque is typical: a "parodie clownesque" of the Chambre des Députés, followed by "Marocco in Paris," the "Théâtre ambulant Rémier," a lampoon of the Carpentier-Harry Lewis boxing match, a scene from the Chinese Revolution, Dr. Tacaura, "Mlle. Beulemans' Return to Brussels," the ballet dancers' strike, and a finale that takes place on the Pont de l'Alma. In February 1913, under the rubric "Les Déstractions Parisiennes," *La Revue de la Scala* introduced the characters le Polo, le Golf, la Boxe, le Cinéma, le Skating, Luna-Park, l'Aérodrome, and a Télégraphiste. Mutually exclusive *actualités* or character types might also greet each other in the same *tableau:* Mounet-Sully, a toga-clad tragedian from the Comédie Français, meets the comic Dranem in the December 1911 *Revue de l'ambigu,* where both stars are actually impersonated by music-hall performers (fig. 106); Madame Job (dressed in a poster for Job cigarette papers) convenes with Louis XIV in the final scene of *La R'vu . . . u . . . e!* at the Boîte à Fursy, February 1913 (fig. 107).[94]

There were, in fact, a number of attempts at the time to write and produce *revues* endowed with a more coherent flow of events (often by linking tableaux with explanatory interludes narrated by the *commère* and *compère*). These met with the disapproving protest of music-hall purists:

In effect, the dramatic action of a vaudeville or operetta . . . is a *whole,* and includes characters predesignated to act from the beginning to the end of the play, while the cortege of a *revue* is composed of multiple characters, disparate, ceaselessly renewed, always inevitably foreign to an initial postulate. . . . All of this sufficiently

proves how much the *revue* is a special genre, quite different from all the others. It is precisely the *revue*'s lack of cohesion which gives it its charm. . . .[95]

"Lack of cohesion" is equally the fundamental law of collage. The cropping, splicing, and shuffling of paper *actualités* heeds the disjointed structure of collage-period Cubism itself. Even for pictures that include a single clipping, Picasso often selects the area of a newspaper page in which news items or advertisements are shown back-to-back.[96] The confounded formal coherence characteristic of both Cubism and the *revue* takes its comic toll on the news of the day. The results are a jump cut from seriousness to frivolity. In *Bowl with Fruit, Violin and Wineglass* (fig. 108), sports, finance, a *roman feuilleton* episode and an advertisement for "Huile de Vitesse" motor oil are jammed together with fake wood grain and cheap color reproductions of fruit; in the still life *Au Bon Marché*, department stores and dirty jokes offer comic relief from a political assassination (see fig. 100); Balkan Wars news could be followed by a new prescription to facilitate blood circulation;[97] ads for ready-made clothes, fur coats, loans, and gramophones could be spliced to recent results in rugby, track and field, skating, and a new record for calculating the depth of the ocean floor with a plumbline (see fig. 102); dispersed among ads for "Vin Désiles — the best tonic," "Sakalom," and "Force virile" medicine are reports of a construction workers' strike and a theft of 27,000 francs worth of registered mail;[98] sandwiched in between "Lampe Eléctrique O.R." and "Lacto-Phosphate de Chaux" is an item concerning a vagabond in Fontainebleau who has turned himself in as the perpetrator of a grisly murder, while the International Congress on Physical Education sits next to news of an artist who has poisoned his lover (see fig. 99). (Picasso cultivated his penchant for stories of dark, violent crime by reading contemporary pulp-fiction tales of Fantômas, a villainous master of disguise who also appeared in *La Revue de la Scala* in March 1912.)[99]

Picasso's sharp elision of *actualités* is the modern newspaper's own; collage and *revue* aestheticize this quality, manipulating it as a source of comedy and urgency — of disrupted narrative and spirited incoherence (or new coherence). But Picasso and the *revuiste* also share the juxtaposition of current events and *old* current events. Thanks to Robert Rosenblum and Theodore Reff, we know that Picasso included amidst the pasted papers of at least four collages, from spring 1913, clippings from *Le Figaro* dated May 28, 1883 (concerning the coronation in Moscow of Czar Alexander III) (see fig. 103).[100] And in *Guitar, Sheet Music and Glass* (see fig. 87), the fragment of the song "Sonnet" from 1892 floats in close proximity to the *Le Journal* Balkan Wars bulletin; nostalgic scenes from the café-concerts and cabarets of times past were a staple subject of the prewar *revue* (fig. 109), and

reciprocate Picasso's choice, a song that was created by Marcel Legay at the old Eldorado.

In addition to the shuffling of paper *actualités,* "lack of cohesion" also characterizes Picasso's abrupt juxtaposition of visual component parts, dynamic shifts in handmade and ready-made pictorial style. In this regard, every pasted paper, whether it contains printed words or not, commands the autonomous weight of a *tableau de revue.* In *Guitar, Sheet Music and Glass* (see fig. 87), for example, the apposition of bold, unmodulated papers, decorated wallpaper, imitation wood grain, newspaper, sheet music, and a Cubist drawing violates every previous standard of pictorial coherence. Equally startling are works such as *Bottle of Vieux Marc, Glass and Newspaper* (see fig. 99), where fragments of newspaper, wallpaper, and imitation picture frame project bold, dense graphic patterns that are utterly irreconcilable.

One critical factor for this property of disjunction has to have been speed. Building a work from the juxtaposition of discrete parts is, in a sense, easier than establishing an overall unity of narrative and formal structure. Simultaneously, it represents a challenge, a breach of decorum, which substitutes quick wits for slow study. The facility and speed with which a collage can be constructed must have represented an exhilarating departure from old rules of picture making, for the impact of dynamic heterogeneity within given pictures is matched by the brisk momentum of innovation and change across the entire collage oeuvre. Music hall observers recognized this dual role—practical and aesthetic—of self-imposed haste. The distinct thrill of good music hall was a function of variety plus reckless pace, each of which amplifies the other. Remarking on the unprecedented favor that the *revue* genre seemed to be commanding during the prewar period, the critic Ergaste wondered if this weren't because "the *revue,* where all aesthetic liberties are permitted, is more readily mounted than the smallest play, and that, these days, it is above all a matter of rapid production?"[101]

Rapid production pertains as well to the decor of *revue* and collage. While *revues* were sometimes sumptuous affairs, including large, luxurious *tableaux* on exotic themes, most music-hall settings were expectedly provisional. One can observe, in period photographs, that music-hall stages were generally quite small. Some scenes took place against a curtain backdrop, others before broadly brushed background settings and ready-made interiors that suggest, rather than contain, real luxury. In collage, pasted (and painted) imitations of marble, wood grain, and chair caning and objects such as tassels—stick-on luxury—are stage effects of this kind, inexpensive substitutes for expensive materials. Further, at the music hall wallpaper was also a handy means of creating the ambiance of a formal room, a dress-up foil for the comic antics occurring downstage. In *La Revue de l'ambigu,* such a wall, contained within an elaborate moulding that recapitulates the shape of the

proscenium arch, sets off a scene involving the *commère, compère,* and Fallières, the president of the Republic (fig. 110). Applied against the entire background of a collage, as in *Guitar, Sheet Music and Glass* (see fig. 87), Picasso's wallpaper elicits a corresponding impression of bourgeois formality; suggesting simultaneously a wall and a table (tablecloth), the paper game of ambiguity constitutes both an aesthetic pretense and a mockery of social pretentiousness, as well as a music-hall conceit: in the foreground, newspaper fragment and popular song comprise our comic *tableau,* a current event set to music. In *Glass and Bottle of Bass* of 1914 (fig. 111), fake picture-frame moulding heightens the effect. Here now is the proscenium arch, within and before which the Bass and the glass—cut from a newspaper *roman-feuilleton* narrative—show and tell.

■ The *revue,* a comic system according to which French society commentated itself, comprises a set of larger cultural coordinates for collage. Paris was permeated by the music-hall *revue* during precisely those months when Picasso was introducing into Cubist pictures verbal and material facts from the ephemeral world of contemporary printed paper. The *revue* furnishes virtually a complete agenda of the motifs and devices in Cubist collage, especially in the oeuvre of Picasso. As a model, it accounts for the entire range of pasted subjects in any given picture, rather than requiring us to acknowledge some and ignore others. The vocabulary of the *revue* is the vocabulary of collage, a period lexicon of technical language specific to both: the *actualité;* the pun, the *allusion,* and the *à peu près;* the *sous-entendu* and *entente;* irony, satire, and *grivoiserie;* newspaper, advertising, and song.

One factor in the growing currency of the *revue* during the collage period was the new momentum it received from the authors "Rip" and Bosquet, whose *revues* of 1911–12 were treated by critics as a virtual revolution in the genre; such was their achievement, as it was perceived by critics of the day, that Aristophanes was invoked as a rightful ancestor. The terms "literary" or "intellectual" *revue* were coined for the sophistication of their work, and they were credited with having saved the *revue* from being corrupted at the larger halls into a pretext for lavish costume display by deftly blending a *grand spectacle* style with satiric sketches of brilliant wit.[102] While Rip and Bosquet were accused by some of straining the very nature of the music hall as nontaxing entertainment, their fall 1911 *revue* for the Olympia theater set a music hall box-office record.[103]

The most prominent example of a theater piece predicated upon the "intellectual" *revue* was *Mil-neuf-cent-douze* by Charles Muller and Régis Gignoux, performed at the Théâtre Antoine in April 1912. Subtitling the work "scènes contemporaines," the authors implemented the classic *revue*

devices of short *tableaux*, extravagant costumes, and comic personifications (characters include an Ubu-like "1912," the "Journal Officiel," and "Illusion") for a dense satire of public dupery, hitting hard on *actualités* such as the false claims of modern advertising and the appropriation of the workers' café as a pulpit for vote-seeking politicians.[104] Most reviews of *Mil-neuf-cent-douze* congratulated Muller and Gignoux on bringing a fresh sense of style and bite to *revue* buffoonery; Ernest La Jeunesse hoped that this "masked *revue*" would exercise a positive influence outside the music hall.[105]

In fact, the flexibility of the *revue* format and the today's-paper currency of its contents proved irresistible to nonspecialists, including members of the "bande à Picasso."[106] Most significantly, André Salmon, a close friend and critical supporter of Picasso during the prewar years, wrote a thoroughly idiomatic *revue* entitled *Garçon! . . . de quoi écrire!*, which was performed at the Salle Malakoff in June 1911. *Garçon!* was written as a "*revue* of literary life" but, Salmon confirmed, conceived along the lines of those music-hall *revues* "at the Européan, the Cigale and the Gaîté-Montparnasse with titles like *Pour qui votait-on?* and *Dénichons, dénichons!.*"[107] Salmon's own title quotes the poet to the café waiter, calling for a paper and pen. His *revue* is set in two legendary literary cafés, the Pré Catalan and the Napolitain, and it is populated by a typically heterogeneous music-hall cast that has been skewed toward the literary theme: parodies of *littérateurs* such as Maurice Rostand, Henri de Regnier, Saint-Pol-Roux, Jules Romain, and Marinetti; personifications of newspapers and literary periodicals, including *Excelsior, Mercure de France, Revue des Deux-Mondes* and *La Phalange;* various fantasy figures, such as "Glory" and the nymph Glycère; and well-known abstractions from the world of arts and letters — an Academician, a "*Réfusé*," an Agent. Each character sings punning or satiric couplets set to the music of well-known popular tunes.

The rhyming refrain sung by *Excelsior* derides the large two-*sous* newspapers of the day for mixing — and cheapening — serious but low-paying journalistic and literary material with the money-making trivia of commercial advertising:

Hop! *Excelsior,* hédi, ohé! / Hop! I give you, for two sous: / Some Lemaitre and some rubber, / Some Barrès and some bamboo chairs; / I propose with Tristan Bernard / Some liquors and some duck paté, / I propose with some Lavedan / A nice tooth brush. / Hop! Excelsior! ohé![108]

Excelsior's parodic refrain calls to mind the very structure and content of *revue* and collage as ironic *journaux joués.* One year later, in an article on the Paris daily press (which appeared in a small literary periodical), critic Jean Puy would accuse the large two-*sous* papers of betraying quality for pandering journalism, commercial interests, and an improper "ton de blague"; such

newspapers, he feared, simply confirm the low opinion of Paris intellectual life that visitors will have already formed at the music hall.[109] Yet, like collage, the "intellectual" *revue* and its progeny demonstrate that music hall could also be perceived as a vessel of fresh potential among younger authors, including members of the avant-garde. Even the irony and screwball quality of the *revue* (its *loufoquerie*) — which might be perceived as the equivalent of bad journalism written in a "ton de blague" — could be a source of energy, a purge. One of the compliments Salmon fondly remembers having received on the occasion of his *revue* was that before him lay "a career as attractive as that of Rip." In the chapter on *Garçon!* from his memoirs, Salmon confessed that he kept his "texte de revuiste" more carefully bound than most of his other works.[110] It represents for him an "esprit de blague et d'atelier" — a spirit of irony, pranks, and inside jokes. "There was," he writes, "an 'esprit de blague et d'atelier' around 1913 at the Bateau-Lavoir where, at the same time, modernism, orphism, cubism were all in serious preparation."[111]

Salmon's *revue* is composed in a popular mode, but its contents are confidential. Collage and the *revue* share this paradox of accessibility and hermeticism. Works of collage abound in the most mundane of materials, yet Cubism was virtually impenetrable to all but a tiny proportion of its prewar audience; the materials constitute a vernacular, but the syntax is abstruse. The devices of cropping and splicing in collage subvert the easy, common currency of the pasted papers, and the visual and verbal games that result suggest an inside joke. As at the music hall, the structure and comic irony of collage cause the *actualités* of the day to function at once as themselves and their own parodic critique. Both genres also presuppose what Dreyfus calls "the secret *entente*" between author and audience. Of course, at the *revue* "hidden" meaning was a charade of sorts, for the music hall needs a large audience in order to survive. But the *entente* was real to the extent that the pleasure of the *revue* was derived from decoding the allusions and *sous-entendus*. Picasso survived upon the appreciation and material support of his immediate circle, and it is to the inner circle that he pitched the jokes of collage. We have no written evidence that, say, Apollinaire, Kahnweiler, or Salmon read the collages for puns and other verbal-visual play, though it seems likely that they did. The collages of Braque and Juan Gris, however, tell us that Picasso had a co-conspiratorial audience of at least two.

The materials of collage are forever attached to life outside art, yet they have been physically extracted from still-life objects that can be confined to a relatively small, actual or fictional space — a table or an easel picture. In *revue* fashion, collage pictures reach out to culture at large, then turn back in. Dreyfus describes a *revue* subgenre, the "revue de société." Played in salons, *cercles,* and *cénacles,* such *revues* are more "mordant and provoca-

tive" than those of the theater, and would be unintelligible to a general audience.[112] We recognize the operative principle: it is Salmon's "esprit de blague et d'atelier." This is what permits a still life to be the perpetrator of a dazzling comic turn. Picasso's collage oeuvre from 1912–14 constitutes a transposition of music-hall *revue* strategies to the Cubist cénacle—a pictorial "revue de société" for companions of the café and the studio.

NOTES

■ This article is based on research for a Ph.D. dissertation from the Institute of Fine Arts, New York University, which I conducted on a Paul Mellon Fellowship (1987–90) offered by the Center for Advanced Study in the Visual Arts. I am very grateful to the Center for its support. I am indebted to the staff of the Bibliothèque de l'Arsenal and the Bibliothèque Nationale in Paris, in particular the miraculous services of *bibliothécaire*-sage F. Peyraube, recently retired and sorely missed; the Musée de Publicité, Paris; and Madame Paule Madelin, curator at the Musée de Montmartre. I would also like to thank Kirk Varnedoe for his encouragement and his example.

With deep gratitude and love, I carve the initials "SC" on this place.

1. Spectator, "*Et Voilà!!,*" *Comoedia illustré,* November 15, 1911, p. 114.

2. Louis Schneider, "*Au Théâtre des Capucines,*" *Comoedia,* October 13, 1911, p. 3.

3. Gertrude Stein, *The Autobiography of Alice B. Toklas* (New York, 1933), p. 136.

4. Maurice Jardot was the first to identify the origins of the phrase "ma jolie" in the refrain from Fragson's "Dernière chanson"; see Jardot, *Picasso,* catalogue of an exhibition at the Musée des Arts Décoratifs, Paris, 1955, number 26. More specific information about the song is obtained from the sheet music published in Paris by Edouard Salabert in 1911, in the collection of the Bibliothèque Nationale, Paris.

5. See Crispin, "Théâtres et Concerts," *Le Journal,* October 4, 1911, p. 5; October 7, p. 6; October 9, p. 9; October 11, p. 5; October 14, p. 5; October 16, p. 5. For more on Fragson, born Léon-Victor Philippe Pot (shot and killed by his father in December 1913), see Chantal Brunschwig, Louis-Jean Calvet, and Jean-Claude Klein, *Cent Ans de chanson française* (Paris, 1972), p. 156; and Dominique Jando, *Histoire mondiale du music-hall* (Paris, 1979), p. 140.

6. "Une des chansons de Fragson à l'Alhambra," *Excelsior,* October 5, 1911, p. 9; and *Le Journal,* October 12, 1911, p. 7. The text accompanying the reprint of "Ma Jolie" is identical in both newspapers. It is likely that the entire item was promotional copy placed there by the Alhambra music hall or the publisher of the song (whose name appears at the bottom). Newspaper ads of the period were often presented in a form that resembles a piece of news; space in the front page "Echoes" section of many major papers, for example, could be purchased. On the subject of this *publicité masquée,* see J. Arren, *Comment il faut faire de la publicité* (Paris, 1912), pp. 169, 173–74; for advertising tariffs for "the principal periodicals of Paris, pp. 234–96."

7. Jaime Sabartes makes an explicit reference to Picasso and friends at the Cabaret l'Ermitage, and to performances of "Dernière chanson" there. See Sabartes, *Picasso: Documents iconographiques* (Geneva, 1954), number 101. For a period recollection of "Dernière chanson" as a popular tango in "restaurants élégants," see Alice Halicka, *Hier (Souvenirs)* (Paris, 1946), p. 35.

For the Picasso circle at the Cabaret (or "Café") l'Ermitage, see Halicka, *Hier,* p. 54; and Fernande Olivier, *Picasso and His Friends,* trans. Jane Miller (London, 1964), pp. 171–72.

8. On stylistic grounds, "*Ma Jolie*" is placed by Pierre Daix and Joan Rosselet in the fall of 1911; see Daix and Rosselet, *Picasso: The Cubist Years, 1907–1916: A Catalogue Raisonné of the Paintings and Related Works* (New York, 1979), number 430. Most recently, William Rubin has put the painting in the winter of 1911–12; see Rubin, *Picasso and Braque: Pioneering Cubism,* catalogue of an exhibition at the Museum of Modern Art, New York, 1989, p. 210. Of course, Picasso may have retained the "Ma jolie" lyric for months or more. Since even the exact date of the beginning of Picasso and Eva's relationship is unknown, I am merely suggesting that iconographical evidence adds a fresh—an earlier—piece to the puzzle. The words of the refrain, which are always quoted in the context of Picasso's painting, are: "O Manon ma jolie / Mon coeur te dit bonjour / Pour nous les Tziganes jouent m'amie / La chanson d'amour." ("Oh Manon, my pretty one / My heart greets you / For us the gypsies play, my friend / The song of love.") It is intriguing, however, to consider the refrain in the context of the song's three verses. They are sung by a man to a woman of his past whose love he hopes to rekindle. The first two times we hear the "Ma jolie" refrain, the "song of love" which the gypsies play is described as "our first song"; after the third verse, when it is clear that his lover is forever lost to the singer, the song has become a "song of farewell" ("chanson d'adieu") and "our last song" (hence the title "Dernière chanson"). Given the bittersweet character of the lyric, could the subject of "*Ma Jolie*" be *both* Fernande Olivier and Eva? Such a sentimental ambiguity would not be out of place in a picture of a woman whose identity is otherwise indecipherable. In addition, Picasso's interest in "Dernière chanson" as an expression of transient love would be consistent with his choice of sheet music one year later, for collage (see pp. 70–71). We may be able to indicate the appearance of a second Fragson song lyric in Picasso's work. Sheet music with the title "Si tu veux" is held by a harlequin-violinist in *Harlequin with Violin ("Si Tu Veux")* (1918). "Si tu veux, Marguerite" was another Fragson hit, and Picasso may be remembering the song from his prewar days. This seems a more likely source for the song title in the picture than Erik Satie's "Je te veux," which was proposed by Helen O. Borowitz, "Three Guitars: Reflections of Italian Comedy in Watteau, Daumier, and Picasso," *Bulletin of the Cleveland Museum of Art,* February 1984, p. 127 and n. 54; "Je te veux" was first published in 1903, while "Si tu veux, Marguerite" was composed in 1913 and enjoyed popular success on a far grander scale.

9. F. T. Marinetti, "The Variety Theatre" (1913), in *Futurist Manifestos,* ed. Umbro Apollonio, trans. R. W. Flint (London, 1973), p. 127.

10. "Cette force de vie qui s'exprime sur une scène de music-hall démode au premier coup d'oeil toutes nos audaces." Jean Cocteau, *Le Coq et l'arlequin* (Paris, 1918), p. 34.

11. There are dozens of histories of the *café-concert* and the music hall in England and France where this information can be found. For the music hall in London, see Archibald Haddon, *The Story of the Music Hall* (London, 1935); M. Willson Disher, *Music Hall Parade* (London, 1938); Raymond Mander and Joe Mitchenson, *British Music Hall* (London, 1974); *The Last Empires: A Music Hall Companion,* ed. Benny Green (London, 1986); and *Music Hall: The Business of Pleasure* (Philadelphia, 1986). For the music hall in Paris, see Georges d'Esparbes et al., *Les Demi-Cabots: Le Café-concert—le cirque—les forains* (Paris, 1896); André Chadourne, *Les Cafés-concerts* (Paris, 1889); E. Rouzier-Dourcières, "L'Evolution du café-concert," *La Semaine politique et littéraire de Paris,* September 1, 1912, pp. 13–16; Gustave Fréjaville, *Au music-hall* (Paris, 1922); J.-L., "Music-halls: Du 'café-chantant' au 'music-hall,'" *Le Temps,* October 5, 1912, pp. 4–5, October 7, pp. 5–6, October 13, p. 5; Paul Derval, *The Folies-Bergère* (London, 1955); Jacques Charles, *Cent Ans de music-hall* (Paris, 1956); Dominique Jando, *Histoire mondiale du music-hall* (see note 5 above); François Caradec and Alain Weill, *Le Café-concert* (Paris, 1980); André Sallée and Philippe Chauveau, *Music-hall et café-concert* (Paris, 1985).

12. Maurice Talmeyr, "Cafés-concerts et music-halls," *Revue des deux-mondes,* 1902, p. 178. For a recent discussion of music hall and class, see Charles Rearick, *Pleasures of the Belle Epoque* (New Haven, 1985), pp. 83–115.

13. Santillane, "Les Music-halls," *Gil Blas,* September 12, 1901, p. 1.

14. "Nouveau genre qu'engendra la fusion de deux plaisirs autrefois distincts: celui du café-concert et celui du cirque." Akademos, "En sortant d'un music-hall," *Gil Blas*, September 13, 1912, 1.

15. Marinetti, "The Variety Theatre," p. 126.

16. There is a great deal of literature on the saltimbanque and related themes in Picasso's Rose Period work. The most thorough overall iconographical treatment remains Theodore Reff, "Harlequins, Saltimbanques, Clowns and Fools," *Artforum,* October 1971, pp. 30–43. To Reff's discussion of *mémoirs* by members of the early Picasso circle that attest to the artist's love for the circus, we might add André Salmon's claim that this circus mania was attached to a taste for Seurat, reproductions of whose *Le Cirque* and *Le Chahut*—images of the circus and the music hall, respectively—first ornamented the walls of Picasso's studio on the "eve of cubism." For Salmon, *Le Chahut* was "une des grandes icones de la dévotion nouvelle" ("one of the great icons of the new devotion"). See Salmon, *Propos d'atelier* (Paris, 1922), p. 42, and *L'Air de la butte* (Paris, 1945), p. 33.

17. *Carnet* numbers 95, 96, 98, 101, and 102, at the Musée Picasso, Paris.

18. Jean-Pierre Jouffroy and Edouard Ruiz discovered these illustrations, which Picasso signed "Ruiz" (his mother's maiden name), and reproduced them for the first time. See Jouffroy and Ruiz, *Picasso: de l'image à la lettre* (Paris, 1981). Among the performers Picasso depicted are Grille d'Egout and Jane (Jeanne) Avril, favorite subjects of Toulouse-Lautrec's.

19. This information is contained in a letter from Casagemas and Picasso to Ramon Raventos dated October 25, 1900, reprinted in Josep Palau i Fabre, *Picasso: The Early Years 1881–1907* (New York, 1981), appendix 8, p. 513.

20. Max Jacob, "Souvenirs sur Picasso contés par Max Jacob," *Cahiers d'art,* no. 6, 1927, p. 199.

21. Bloch's whereabouts are readily determined by following newspaper listings for the Cigale throughout the period. The Cigale opened a new *revue* every three to four months, and Bloch was featured in each one.

22. *A nous la veine!* ran from November 7, 1901 through late January 1902, dates which correspond to Picasso's second trip to Paris (May 1901–January 1902). For a review, see Arlequin, "Soirée Parisienne: A la Cigale—A nous la veine!," *Le Journal,* November 9, 1901, pp. 4–5.

23. Olivier, *Picasso,* p. 126.

24. Ibid., pp. 58–60, 101; Daniel Henri Kahnweiler, *My Galleries and My Painters,* trans. Helen Weaver (New York, 1971), p. 89; André Salmon, *Souvenirs sans fin, deuxième époque* (*1908–1920*) (Paris, 1956), pp. 92, 95–96. The writer Francis Carco, an acquaintance of the Picasso circle in Montmartre, also earned modest fame within the community singing *café-concert* songs at the cabaret Lapin Agile. See Guillaume Apollinaire, "La boîte aux lettres," *L'Intransigeant,* March 24, 1911, reprinted in Apollinaire, *Petites merveilles du quotidien,* ed. Pierre Caizergues (Montpellier, 1979), p. 46; and Halicka, *Hier,* p. 40. Carco also sang in André Salmon's music-hall-style revue *Garçon! . . . de quoi écrire!* in 1911 (see pp. 88–89).

25. Daix and Rosselet, *Picasso,* numbers 513, 518–521. These works are preceded by two pictures on which Picasso has stenciled the word "Valse" (numbers 504, 506).

26. A copy of Picasso's sheet music for "Sonnet" can be found at the Bibliothèque Nationale, Paris, where it is stamped "Dépôt légal 1892." "Sonnet" was not otherwise dated by the publisher, but the yellowing paper alone would have told Picasso that the song was already old when he selected it.

27. D'Esparbes et al., *Les Demi-Cabots,* pp. 64–65; F. Berkeley Smith, *The Real Latin Quarter* (New York, 1901), pp. 113–21. During the prewar years, Legay was fondly associated with the pre-1900 Eldorado; see Rouzier-Dorcières, "L'Evolution du café-concert," p. 15.

28. For the history of the Eldorado, see Sallée and Chauveau, *Music-hall et café-concert*, pp. 143–46. For a prewar reference to the reputation of the Eldorado, see Curnonsky, "Music-halls," *Le Théâtre*, December [II] 1913, p. 30.

29. All of the memoirs concerning Picasso during the prewar years discuss evenings at the Lapin Agile. See, for example, Olivier, *Picasso*, pp. 155–58; Kahnweiler, *My Galleries*, p. 45; Salmon, *Souvenirs sans fin, première époque (1903–1908)* (Paris, 1955), pp. 181–186. In an article on the Lapin Agile, critic André Arnyvelde even refers to "a song by Ronsard or by Marcel Legay" as standard fare in Frédé's performances. See Arnyvelde, "Frédé (Le Cabaret du Lapin Agile)," *Le Monde illustré*, September 30, 1911, p. 228. For performances of Villon and Ronsard (both songs and recitations) at the cabaret, see Olivier, ibid., p. 156; Roland Dorgelès, *Bouquet de Bohème* (Paris, 1947), p. 18; Pauline Teillon-Dullin and Charles Charras, *Charles Dullin ou les ensorcelés du Chatelard* (Paris, 1955), pp. 208–13. There is, in fact, a deep strain of medieval-ism (and Villonism) in the Picasso circle in Montmartre that deserves wider study.

30. Edmond Barbier, "Marcel Legay," *L'Album musical*, April 1906, pp. 1–2. For a discussion by a member of the Picasso circle of the Lapin Agile as a legendary cabaret, see Salmon, *Souvenirs, première époque*, p. 18.

31. Robert Rosenblum, *Cubism and Twentieth-Century Art* (New York, 1960). Rosenblum's pioneering work on the significance of words in Cubism is most fully developed in his essay "Picasso and the Typography of Cubism," in Roland Penrose and John Golding, eds. *Picasso in Retrospect* (New York, 1973), pp. 49–75. While historians were slow to get the joke, the work of Kasimir Malevich, Kurt Schwitters, and many others demonstrates that artists were quick to recognize the implications of wordplay in Cubism.

32. Rosenblum, "Typography of Cubism," p. 51.

33. Patricia Leighten was the first to indicate the original context of this headline. See Leighten, "Picasso's Collages and the Threat of War, 1912–13," *The Art Bulletin*, LXVII no. 4, December 1985, p. 664.

34. "Une revue, quel cadre! Il n'en existe pas qui permette plus de fantaisie avec plus de réalité. . . . La Revue est le triomphe légitime du sans queue ni tête." (Henry Buguet, *Revues et revuistes* (Paris, 1887), pp. 3, 5) Buguet collaborated with Georges Grison on *Places aux jeunes!* (1886), the first *revue* ever to be performed at the Folies-Bergère; see Eugène Héros, "La Première revue des Folies-Bergère, 30 Novembre 1886," *Le Music-hall*, December 1911, p. 14.

35. For the prewar popularity of the revue in Paris, see p. 75.

36. Robert Dreyfus, *Petite Histoire de la revue de fin d'année* (Paris, 1909), from which I have derived my whirlwind synopsis of *revue* history.

37. Buguet, *Revues et revuistes*, p. 15. In fact, the *revue* was originally invented for troupes of actors at the *foires* St.-Laurent and St.-Germain who, forbidden by larger theaters to perform plays from the conventional repertoire, were driven to stake out their own territory in material drawn from *actualités*. See Dreyfus, *Petite Histoire*, p. 10.

38. Curnonsky, "La Nouvelle Revue de l'Olympia," *Le Music-hall*, April 15, 1912, p. 24.

39. For more on the role of the newspaper as a source for the *revue*, see pp. 76–77.

40. Dreyfus, *Petite Histoire*, p. xxviii.

41. "De la vie économique, du machinisme, des applications de la science à l'industrie et au commerce, du perfectionnement continu des moyens de transport et d'échange, ou, comme on disait naguère, des 'progrès' du génie humain." Ibid., pp. xxviii–xxx.

42. "Révolutions, guerres, inventions nouvelles, modes, faits artistiques ou littéraires, crimes, malheurs publics, etc." Arthur Pougin, *Dictionnaire historique et pittoresque du théâtre et des arts qui s'y rattachent* (Paris, 1885), p. 653.

43. "De lancer une petite réclame (presque invisible) à l'adresse de son tailleur ou de son

bottier, ou en faveur de la couturière et de la modiste de sa femme." Buguet, *Revues et revuistes,* pp. 16–17.

44. "*Signes* des connaissances, et surtout des sentiments, qu'elles supposaient jadis en vie." Dreyfus, *Petite Histoire,* p. xxiv.

45. *Blague* and *rosserie* are two recurring terms used by music-hall critics to describe *revue* jokes, but they also made their way into the language of the *revues* themselves during the prewar period. For example, the *revue* title *Ça Sent la Rosse* (performed at the Scala music hall in December 1913) puns from "that smells like a rose" into "that smells like a *rosse*"—a person who practices *rosserie.*

46. "Qu'est-ce que l'allusion? L'allusion, dit Littré, est une 'figure de rhétorique consistant à dire une chose qui fait penser à une autre.' Littré ajoute: 'On distingue les allusions en historiques, quand elles rappellent un point d'histoire; mythologiques, si elles sont fondées sur un point de fable; nominales, si elles reposent sur un nom; *verbales, si elles consistent dans le mot seulement, c'est à dire dans une équivoque.'* Cette dernière sorte d'allusions est peut-être la plus répandue dans les revues de fin d'année. Et je crois même qu'elles forment proprement ce qu'on appelle 'l'esprit de revue.' . . . 'L'allusion verbale,' comme la nomme Littré, ce chimiste de notre langue, c'est tout simplement ce que nous appelons, nous, sans regarder si à fond, l'*à peu près* et le *calembour.* Assurément, le calembour n'est pas toujours un moyen d'allusion si humble. . . . Mais j'ai cherché, volontairement, au bas de l'échelle: car le calembour, plus il est rudimentaire, mieux il nous permet d'isoler l'allusion toute nue, l'allusion vide et, comme eût peut-être dit Kant, l'allusion pure. Cette allusion-là n'est soutenue, avivée, relevée par rien. Aussi le plaisir qu'elle donne, — si elle en donne, — n'est-il adultéré par rien." Ibid., pp. xiii–xvi.

47. Ibid., p. xviii.

48. "L'essentiel et le tout." Ibid., p. xx.

49. "Remarques gaies, rapides, satiriques, philosophiques." Ibid., p. xx.

50. "L'avalanche des revues en cette saison, la vogue extraordinaire de ce genre à la mode." "Informations—Pas de Revue!" *Comoedia,* December 4, 1911, p. 4.

51. "Qui n'a pas sa revue! Des scènes à côté et des music-halls, la contagion a gagné les grands théâtres. Hier, c'étaient les Bouffes, aujourd'hui c'est l'Ambigu; ce sera demain le théâtre Réjane. Je sais bien que la revue est ce qu'on appelle un genre souple, si souple qu'à la rigueur il pourrait finir par absorber tous les autres." Léon Blum, "La Revue de l'Ambigu," *Comoedia,* December 1, 1911, p. 1.

52. "Une Revue Chez Guignol," *Excelsior,* May 19, 1911, p. 6.

53. "La Revue! elle s'évit partout, et la saison théâtrale de 1912 fera date dans l'histoire de cette forme si originale de l'esprit français et pourra fournir à Robert Dreyfus un des chapitres le plus abondants du prochain volume qu'il lui consacrera. Marigny, les Folies-Bergère, l'Olympia, la Scala, le Moulin-Rouge, les Ambassadeurs, l'Alcazar d'Eté, les Capucines, Bataclan, et j'en passe, d'une façon générale, tous les cafés-concerts et tous les music-halls, représentent des revues; il n'est pas un faubourg de Paris, ou ne se chantent sur un air connu la 'Grève des danseuses,' 'les Aventures de M. Cochon' et autres événements d'actualité qui savent inspirer à nos chansonniers des couplets mordants, fins, ou vivement satiriques, car il se fait sur toutes les scènes parisiennes, grandes ou petites, dans le courant d'une même soirée, une singulière dépense d'esprit. On se prend même parfois à regretter que cet esprit soit ainsi répandu sans compter dans des oeuvres, par leur essence même, éphémères, puisqu'elles ne marquent pas une époque, mais à peine une saison." "Bulletin—La Revue Triomphante," *Le Théâtre,* April [II], 1912, p. 26.

54. André Joubort, "Revue de fin d'année pour 1912," *Paris-Midi,* December 31, 1912, p. 1.

55. The *revue* series, by Victor Hoerter and various collaborators, began on October 9, 1912, and was resumed in the fall of 1913.

56. Victor Hoerter and Max Eddy, "Revue Charivarique," *Le Charivari,* October 26, 1912, p. 1; and Victor Hoerter, "Encore une revue d'actualité!," *Le Charivari,* December 29, 1912, p. 6. Intriguingly, the second *revue* is followed by a statement informing readers where Urodonal and Globeol can be purchased. We must consider, then, whether the *revue* constitutes a mockery of the two drugs, or an endorsement in accord with Buguet's observation about *revuistes* who benefit by incorporating advertising in their work (see note 43 above).

57. "Vêtue d'une robe sur laquelle tous les journaux sont collés." Dreyfus, *Petite Histoire,* p. 146.

58. See the anonymous review "Le Journal Joué," *Le Music-hall,* January 15, 1912, p. 23.

59. Dates and statistics for Picasso's collages are derived from two sources: Daix and Rosselet, *Picasso;* and Edward F. Fry, "Picasso, Cubism and Reflexivity," *Art Journal,* Winter 1988, appendix 2, p. 310.

60. Patricia Leighten (see note 33 above) was the first to demonstrate the sizable quantity of newspaper clippings concerning the Balkan Wars in Picasso's collages. For a discussion of this subject matter within the larger context of Picasso's early career and sociopolitical proclivities, see Patricia Leighten, *Re-Ordering the Universe: Picasso and Anarchism, 1897–1914* (Princeton, 1989).

61. The entire refrain runs: "De'barqu'nt leurs troupiers / Tra la la la la / A cheval et à pied / Tra la la la la / De suit' leurs canons / Flanqu'nt des coups de tampon / Tra la la la la / On reçoit des boulets / Tra la la la la / Et les bons Français / Tra la la la la / De la République / Nous disent que c'est / La pénétration / Zim-boum pacifique!" These lyrics are printed in an original program for *La Revue des Folies-Bergère* (P. L. Flers, 1912), n.pag. All references to original programs relate to *revue* materials in the Collection Rondel, Bibliothèque de l'Arsenal, Paris. Programs are filed according to the name of the music hall and the year in which the *revue* was performed; most of them are not paginated.

62. "Le programme détaillé de la Revue finale qui sera prochainement donnée sur le Théâtre de la Guerre." Curnonsky, "Programme," *Le Journal,* November 10, 1912, p. 6.

63. Robert Rosenblum was the first to identify the subject of this headline and to read it as a punning reference to tea and a die; he also suggests that Picasso's "coup de thé" pun might be an allusion to Mallarmé's typographical experiments in the poem "Un coup de dès n'abolira jamais le hasard." See Rosenblum, "Typography of Cubism," p. 52. For the words "coup de thé" as a stand-in for an actual (or depicted) object, see David Cottington, "What the Papers Say: Politics and Ideology in Picasso's Collages of 1912," *Art Journal,* Winter 1988, p. 356.

64. As in "Le Sort en est jeté," *La Petite République,* October 18, 1912, p. 1, a front-page editorial also concerning the Balkan Wars.

65. Rosenblum, "Typography of Cubism," p. 51.

66. Le Monsieur de Promenoir, "A la Gaîté Rochechouart: Madame est Serbie," *Le Music-hall,* January 1, 1913, p. 12.

67. Original program for *Madame est Serbie* by Lucien Boyer and Henri-Bataille.

68. Daix and Rosselet, *Picasso,* number 463; the three works are numbers 463, 464, and 465.

69. Original program for *L'Année en l'air* by Mouézy-Eon and Henri-Bataille; for "Tout en l'air," see the original program for *Elle l'a l'sourire!* by Wilfred; for *En avion . . . marche!* by Rip and Bosquet, see R. B., "Aux Ambassadeurs," *Le Music-hall,* June 15, 1912, p. 18.

70. Original program for *A la Baguette!* by Dominique Bonnaud, Numa Blès, and Georges Arnould.

71. Dr. V . . . , "Cubisme, Futurisme et Folie," *Le Journal,* November 7, 1912, p. 6.

72. "Le temps lointains où, tenaillé par les premiers frissons de la vocation, il montrait son cube à tous les passants." Léon Blum, "La Revue de l'Ambigu," *Comoedia,* December 1, 1911, p. 1.

73. For "Le Jeu de Cubes de Sem," see the original program for *En avion . . . marche!* (see note 69 above); for "Paris Cucubique," see the original program for *La Revue de l'Année* by Rip and Bosquet; for the Cubism song, see reference in Louis Laloy, "Le Mois—Music-halls et chansonniers: Eldorado," *S.I.M.*, December 1, 1913, p. 49; for the "Fauste cubiste," see d'Arbeaument, "Petits Echos—Au Little Palace," *Le Triboulet*, February 8, 1914, p. 12.

74. "Music-halls," *Le Temps,* November 26, 1912, p. 5.

75. Daix and Rosselet, *Picasso,* number 652.

76. Ibid., number 610.

77. For "Miss Stein / Miss Toklas," see Daix and Rosselet, *Picasso,* number 661; for André Level, see ibid., number 660; for *La Côte,* see ibid., number 696.

78. Considered by many to be a blight on the French countryside, billboards were a topic of public debate in 1912, when they were targeted for a nearly prohibitive advertising tax. See Freddy, "Les Barre-la-vue," *Le Monde illustré,* July 27, 1912, pp. 64–65.

79. For the billboard *tableau,* see Monsieur de Promenoir, "A la Gaîté Rochechouart," number 10; for "Le Professeur de Publicité Théâtrale," see original program for *A la Baguette!* (see note 70 above); for "Publicité ambulante," see Curnonsky, "Music-halls et cafés-concerts—La Cigale," *Le Théâtre,* March [I], 1914, p. 21; for department store and "Dr. Macaura," see "Alcazar d'Eté," *Le Music-hall,* June 1, 1912, p. 18; for the *cartes de visite,* see original program for *La Revue des T.* by H. de Gorsse and G. Nanteuil; for "L'Origine du Prospectus," see original program for *La Revue de Printemps des Folies-Bergère* by Georges Arnould.

80. "On réclame, on réclam' par la voie des journaux; / Dans les réclamations, y a des trucs rigolos." Plébus, Danerty, and Serpieri, "On réclame," *Paris qui chante,* February 17, 1912, pp. 12–13.

81. Rosenblum, "Typography of Cubism," p. 60.

82. Original program for *En Scène . . . mon Président!* by Hugues Delorme.

83. Rosenblum, "Typography of Cubism," p. 53.

84. "La revue c'est aussi l'art d'incarner les individus, les événements, les moeurs, les ridicules, les modes et les idées du jour en des petites femmes court vêtues qui régalent le public de quelques couplets. Ces couplets peuvent être satiriques, grivois, ou sentimentaux. . . . Leur esprit n'est pas toujours inoffensif. Il en existe des grossiers et de méchants." (Ergaste, "Aux Capucines," *Le Théâtre,* December [I] 1911, p. 23).

85. For *collage* as paper-hanging, see E. Littré, *Dictionnaire de la langue française. Tome premier* (Paris, 1878), p. 664; for the sexual definition of *collage* (which does not appear in Littré, 1878), see John Grand-Carteret, *Les Trois formes de l'union sexuelle: mariage, collage, chiennerie* (Paris, 1911).

86. The song appeared in *Paris qui chante,* November 18, 1911, p. 8. Strikingly, the same issue contains words for a song called "Le Cubisme," written to be sung to the *tune* of "Les Plaisirs de collage"!

87. The contemporary literature on issues of censorship at the music hall is vast; during periods of crackdown, items and editorials appeared with frequency throughout the daily press. For articles that address this matter at some length, see: Francis Carco, "La Rénovation du café-concert," *Le Feu,* September 1908, p. 274; Emile Henriot, "D'un moraliste et d'une psychologie du music-hall," *Vers et Prose,* April–May–June 1910, pp. 181–84; Charles Holveck, "La Moralisation du café-concert," *La Renaissance contemporaine,* August 24, 1911, pp. 1,011–16; André Joubert, "Chez les antipornographes," *Paris-Midi,* March 25, 1912, p. 3; Curnonsky, "La Morale au music-hall," *Le Music-hall,* August 15, 1912, pp. 2–3; J. Paul-Boncour, "La censure et le public," *Excelsior,* November 12, 1912, p. 2; Maurice Hamel, "La Pornographie au café-concert," *Paris-Journal,* July 4, 1913, p. 1. For a satirical treatment of censorship, see

Robert Dieudonné, "Le Nouveau Café-concert," *Fantasio,* July 15, 1911, pp. 849–50; and the song "La Rénovation du café-concert" by J. Combe, A. Danerty, and Albert Valsien, published in *Paris qui chante,* May 18, 1912, pp. 6–7.

88. See, for example, the *tableau* "Le Café-Concert Moraliste" in the original program for *La Revue de Rip et Bosquet,* which played at the Olympia in the fall of 1911; and "Le Senateur et la Danseuse Nue" in the original program for *N . . . U . . . NU, c'est Connu!* by Valentin Tarault and Léon Granier, which played at the Cigale in the summer of 1913 (the "senator" is René Bérenger, arch-moralist of the day).

89. Eugène Héros, *Les Lyriques* (Paris, 1898), p. 202. The identical technique was employed by Alfred Jarry for the notorious opening word of his play *Ubu-Roi* (1896), where the scandalous *merde* is transformed into *merdre.* Inserting the "r" creates the music-hall effect of veering away from the vulgar truth at the last second ("mer . . . dre"). Of course, since *merdre* is a nonsense word, it doesn't actually offer any alternative meaning; the original audience reacted as if Ubu had said "merde." For a description of opening night, see Roger Shattuck, *The Banquet Years* (New York, 1968), pp. 207–08.

90. "A la Scala," *Le Music-hall,* January 15, 1913, p. 15.

91. "J'ai un thermomètre, un thermo mo / Un p'tit thermomètre / J'ai un thermomètre épatant / qui monte et qui r'descend." Plébus, Danerty, and Serpieri, "Mon Thermomètre," *Paris qui chante,* June 8, 1912, pp. 3–4.

92. Héros, *Les Lyriques,* pp. 202–03.

93. Original program for *R'mettez-nous ça!* by Georges Arnould and Léon Abric, which played at the Eldorado in fall-winter of 1910; for *Sauf vot' respect,* see Léon Royan, "Au Théâtre des Capucines," *Comoedia illustré,* November 1, 1910, pp. 71–72. Abbreviation and ellipse at the music hall are, in turn, derived from street slang or argot, for which they are standard devices. Thus, the newspaper *L'Intransigeant* becomes "L'Intran"; the Eldorado music hall is "L'Eldo"; *café-concert* itself is *caf'-conc'.* For an example of slang abbreviation in a pre-collage Cubist picture, see Picasso's *Still Life with Fan* ("*L'Indépendant*") of 1911 (Daix and Rosselet, *Picasso,* number 412), where the newspaper title *L'Indépendant* is boldly cropped to read "L'Indép." As in most examples by Picasso, the abbreviation can also be understood as the result of folding a newspaper, which conceals the rest of the word.

94. For the *Grande Revue,* see Curnonsky, "La Grande Revue du Nouveau Cirque en 16 tableaux," *Le Music-hall,* March 15, 1912, pp. 12–14; for "Les Déstractions Parisiennes," see original program for *La Revue de la Scala* by André Barde and Michel Carré; for Mounet-Sully and Dranem, see "La Revue de l'Ambigu," *Comoedia illustré,* December 15, 1911, p. 190; for Madame Job and Louis XIV, see "A la Boîte à Fursy," *Le Music-hall,* February 15, 1913, pp. 7–8.

95. "En effet, une action dramatique d'opérette ou de vaudeville . . . est *une* et comporte des personnages désignés, devant agir d'un bout à l'autre de la pièce, tandis que le cortège d'une revue est composé de personnages multiples, disparates, sans cesse renouvelés, toujours forcément étrangers à un postulat initial. . . . Tout ceci prouve assez combien la revue est un genre spécial et bien différent de tous les autres. C'est justement le manque de cohésion de la revue qui en fait tout le charme." Trébla, "La Revue à l'Intrigue," *Le Music-hall,* May 1, 1912, p. 17. About one year later, in his "Variety Theatre" manifesto, Marinetti addressed the same question, specifically blaming the *commère* and *compère* for inflicting an undesirable logic on the sequence of characters and events in the *revue.* "One must," he declared, "completely destroy all logic in Variety Theatre performances." Marinetti's remarks cannot, however, be taken as a blanket dismissal of the *revue* genre; one of the first qualities of variety theater that he praises in the manifesto is that it is "fed by swift actuality." In addition, the only model example of music-hall performance that occurs in the manifesto is actually drawn from the *Revue de l'Année* at the Folies-Bergère in 1911 (two English dancers, "Moon and Morris," performing a comic dance based on diplomatic negotiations between France and Germany over colonial possessions in North Africa). See Marinetti, "The Variety Theatre," pp. 126, 128, 130.

96. The best discussion of this property of disjunction is still to be found in the penultimate (and unjustly neglected) chapter of Shattuck's *The Banquet Years,* pp. 331–45. Shattuck has identified the key term "juxtaposition," and opposed it to formal and narrative "transition" as a fundamental aesthetic principle—in all the arts—of the late nineteenth century and early twentieth century. Shattuck recommends the writings of Sergei Eisenstein for further reading on this subject. If we turn to Eisenstein's book *Film Form,* we find that the filmmaker traces the origins of montage (the filmic version of collage, or the splicing and "juxtaposition" of autonomous parts) back to the music hall: "I think that first and foremost we must give credit to the basic principles of the circus and the music-hall—for which I had had a passionate love since childhood. . . . The music-hall element was obviously needed at the time for the emergence of a 'montage' form of thought. Harlequin's parti-colored costume grew and spread, first over the structure of the program, and finally into the method of the whole production." Eisenstein, *Film Form,* ed. and trans. Jay Leda (New York, 1957), p. 12.

97. Daix and Rosselet, *Picasso,* number 524.

98. Ibid., number 547.

99. Curnonsky, "A propos de 'La Revue de la Scala'," *Le Music-hall,* March 1, 1912, p. 12. On Picasso and *Fantômas,* see Salmon, *Souvenirs, deuxième époque,* pp. 232–34; and J. Charlat Murray, "Picasso's Use of Newspaper Clippings in His Early Collages," New York (Master's thesis, Columbia University) 1967, p. 54.

100. Robert Rosenblum, "Picasso and the Coronation of Alexander III: A Note on the Dating of Some *Papiers Collés,*" *Burlington Magazine,* October 1971, p. 605 (and n. 12, in reference to Theodore Reff). In the two pictures with the largest *Le Figaro* clippings, the old newspaper fragments are placed near bottles of "Vieux Marc" ("*old* marc").

101. Ergaste, "Aux Capucines," p. 23.

102. Louis Delluc, "A l'Olympia, la Revue de Rip et Jacques Bosquet," *Comoedia illustré,* October 15, 1911, pp. 58–60; Picrochole, "L'Actualité théâtrale," *Le Charivari,* April 20, 1912, p. 6; Paul Abram, "Le Théâtre: Olympia—La Revue de l'Année," *La Petite République,* November 22, 1912, p. 4; Georges Talmont, "La Revue de l'Année," *Comoedia,* November 25, 1912, p. 1; Curnonsky, "La Revue de l'Année à l'Olympia," *Le Music-hall,* December 1, 1912, pp. 5–13.

103. "Attractions," *Excelsior,* October 14, 1911, p. 8.

104. Charles Muller and Régis Gignoux, *Mil-neuf-cent-douze* (Paris, 1912).

105. Robert de Flers, "Aux Théâtres—Aux Théâtres des Arts: Mil-neuf-cent-douze," *Le Figaro,* April 19, 1912, p. 5; Louis Delluc, "Mil-neuf-cent-douze," *Comoedia illustré,* May 1, 1912, pp. 587–590; Ernest La Jeunesse, "La Bataille théâtrale," *Comoedia illustré,* May 1, 1912, p. 585; Curnonsky, "Théâtre des Arts: Mil neuf cent douze," *Le Music-hall,* May 1, 1912, pp. 15–16.

106. Guillaume Apollinaire clearly had the *revue* in mind when he wrote *Les Mamelles de Tirésias,* a wild burlesque set in Zanzibar and Paris, which was performed at the small Théâtre Renée Maubel in Montmartre on June 24, 1917. Its disjointed narrative (written in a tone that was alternately understood at the time as sincere and mocking) concerns the theme of "repopulation," an *actualité* that was widely discussed in the prewar and wartime press, in the context both of France itself and French colonial Africa. Its characters include a newspaper kiosk and Thérèse-Tirésias, the protagonist who transforms herself into a man. In his review of *Les Mamelles,* André Warnod observed, "It is an art which makes one think of Jarry, a Jarry to the twentieth power, with such a regard for the *actualité* that one believes, at times, one is attending a *revue de fin d'année.*" ("C'est une art qui fait penser à Jarry, un Jarry à la vingtième puissance, avec un tel souci de l'actualité qu'on croit, par instants, assister à une revue de fin d'année.") See Warnod, "Petit Courrier des arts et des lettres," *L'Heure,* June 25, 1917, p. 2.

107. André Salmon, "Garçon! . . . de quoi écrire!" *Le Printemps des Lettres,* July–August 1911, pp. 93–127. For commentary, see Salmon *Souvenirs, deuxième époque,* pp. 191–99; André Billy, *L'Epoque contemporaine (1905–1930)* (Paris, 1956), pp. 56, 141–42.

108. "Hop! *Excelsior,* hédi, ohé! / Hop! j'offre pour deux sous: / Du Lemaître et du caoutchouc, / Du Barrès et des chais's en bambou; / J'offre avec du Tristan Bernard / Des liqueurs, du pâté d'canard, / J'offre avec du Lavedan / Une jolie brosse à dents. / Hop! Excelsior! ohé!" Salmon, "Garçon! . . . , de quoi ecrire!" p. 105.

109. Michel Puy, "Le journal à deux sous," *L'Ile sonnante,* December 1912, pp. 234–42.

110. Salmon, *Souvenirs, deuxième epoque,* pp. 197–98.

111. "Il y eut un esprit de blague et d'atelier dès 1913, au Bateau-Lavoir, où, en même temps, se préparaient sérieusement le modernisme, l'orphisme, le cubisme" (Ibid., p. 199). We can discern something of a modernist tradition of addressing the daily news in a "ton de blague," from Félix Fénéon's hilarious-deadpan "nouvelles en trois lignes," the "three-line news" reports that he composed for *Le Matin* in 1906, to the fake news dispatches from London and New York that Apollinaire "translated" for the newspaper *Paris-Midi* and the *fausses nouvelles* column in the avant-garde journal *391,* both from 1916. For the "nouvelles en trois lignes," see Fénéon, *Oeuvres plus que complètes. Tome II,* ed. Joan U. Halperin (Paris, 1970), pp. 973–1,020, and Halperin, *Félix Fénéon: Aesthete and Anarchist in Fin-de-Siècle Paris* (New Haven, 1988), pp. 348–58; for Apollinaire's dispatches, see André Billy, *Apollinaire vivant* (Paris, 1923), p. 92; for the *fausses nouvelles* column, see "On demande: 'Pourquoi *391?* Qu'est-ce que *391?,*'" in Gabriel Buffet-Picabia, *Rencontres* (Paris, 1977), p. 204.

112. Dreyfus, *Petit Histoire,* p. xxii.

■ CUBISM AS POP ART ■

By 1911, the visual and cerebral intricacies of Cubism had reached such a lofty and mysterious peak that in order to approach the exalted heights of a painting we now all recognize as a museum masterpiece, Picasso's "*Ma Jolie*" of winter 1911–12 (see fig. 79), even so rigorously analytic a scholar as William Rubin felt compelled, in the Museum of Modern Art's 1972 collections catalogue,[1] to describe it by using words like "metaphysical" and by invoking the name of Rembrandt. At the same time, as we also now all know, the bottom of Picasso's painting, with its painted inscription, "MA JOLIE," descends to another level of experience. For here Picasso not only offers the joke of a mock title that serves as a surrogate nameplate and a personal allusion to the nickname of his then girlfriend, Marcelle Humbert, but a far more public reference to the refrain of a popular music hall song that would have been known to most Parisians who had never stepped inside the Louvre.[2] Transposed to the 1960s, the effect would be like finding the name of one of the Beatles' most famous songs inscribed on the bottom of a Rothko.

Here, in a nutshell, is the collision of two seemingly separate worlds, that of the artist's hermetic seclusion in an ivory tower, with its private explorations of unknown aesthetic territories, and that of the coarse but tonic assault lying outside the studio door, a world of cafés, newspaper kiosks, music hall entertainment, billboards, packaged goods, newspapers, commercial illustrations, department stores, and a battery of new inventions that could soar as high as the airplanes manned by the Wright Brothers and Louis Blériot or be as useful in adding pleasure or convenience to daily life as the movies, the electric light, the safety razor, the alarm clock, or packaged breakfast cereal from America. Such major or minor technological triumphs, in fact, all have cameo roles in the repertory of Cubist art.

Demonstrating once again that the experience of important new art can radically alter our view of older art, the revelation of this Cubist seesawing between the most audacious reaches of aesthetic invention and the commonplace facts of modern city life was slow in coming, having to wait, it would seem, until the advent of Pop Art. In the 1950s, in tandem with the sacrosanct aura of spiritual search and primal mysteries radiated by Abstract Expressionism and echoing the visual purities distilled by formalist critics like Clement Greenberg, Cubism remained elite, one of the highest moments, as it still is today, in the history of art for art's sake. But then, a countercurrent within Cubism also began to be discerned more clearly in a decade when artists like Warhol and Lichtenstein, following the leads of Rauschenberg and Johns, were delighted to sully the unpolluted domain of abstract art with a barrage of visual offenses culled from the real world — comic strips, front pages, cheap ads, modern gadgets, factory food and drink, movie stars — the stuff that most proper aesthetes, whether artists or spectators,

recognized as lamentable, if inevitable eyesores of the modern environment, which should be kept outside the sacred precincts of the world of art.

This, at least, is how I experienced these changes, both as a New Yorker and as a professional art historian who began to write and to lecture about Cubism in the late 1950s. In my first published study of this venerable movement, *Cubism and Twentieth Century Art* (1960), I gave the lion's share of attention to the still miraculous formal evolution of the language of Cubism, following the patterns set in such classic introductions to the subject as those by Daniel-Henry Kahnweiler and Alfred H. Barr and clearly reflecting Greenberg's concentration on the emergence of what then seemed to be a quantum leap in the history of painting, a picture plane of such insistent flatness that the techniques of collage almost had to be invented in order to affirm, in the most literal way, this disclosure. Nevertheless, in this first study I offered peripheral nods in the direction of such fascinating intruders within this new pictorial syntax as an occasional verbal pun lurking in the words selected from signs and newspapers or even a visual pun in, say, the shuffling of the anatomies of a woman and a guitar.[3] Soon, the secondary matter of the word, whether handmade by the artist's brush or pencil or printed by a machine, loomed large for me; and in 1965, a few years after the first explosion of Pop Art, I pulled these verbal snippets together in a lecture, "The Typography of Cubism,"[4] that was finally published eight years later, in 1973,[5] in sadly unexpected time to commemorate Picasso during the year of his death. With this new focus, I hoped, among other things, to contaminate a bit the pristine air that Cubism had earlier been breathing by indicating the abundance of witty, topical, and at times, even smutty double and triple entendres camouflaged by the fluctuating planes and spaces. These overt and covert puns and allusions corresponded to the multiple visual identities conjured up by the ambiguities of this new pictorial language, which usually opted for "not either/or but both," as well as to the growing revelation that Picasso and his fellow Cubists were eager to absorb the nonstop proliferation of the written word as part of the experienced environment of daily life in the modern city. They echoed, as I then suggested,[6] the inventory of printed matter itemized by Apollinaire in his epic, Whitmanesque poem *Zone* (1913)—prospectuses, catalogues, posters, newspapers, cheap detective stories, inscriptions on walls, street signs, nameplates, notices—a list that, in fact, is virtually duplicated in the choices made by Cubist artists. And once again, a parallel with what was then contemporary art could be made; for already in the late 1950s, in what seemed at the time the impudent, even heretical work of Johns and Rauschenberg, stenciled, drawn, and painted letters and numbers, not to mention newspaper fragments and even comic strips began to invade the remote and poetic spaces of abstract art, an invasion that by 1962, in the

work of Warhol and Lichtenstein, expanded to a full-scale takeover of the rectangular field of painting.

This direction, once sighted, could embrace even broader areas of popular culture, a viewpoint I then began to explore, now more consciously under the new historical shadow of Pop Art. In 1975, I gave a lecture titled "High Art versus Low Art: Cubism as Pop,"[7] and since then, I continue to realize, along with older and younger generations of art historians, that this was a theme which, far from being only a footnote to the study of Cubism, kept prodding it left, right, and center, constantly providing a juggling act between, on the one hand, an arcane visual language that was legible only to an elite group of artists and their audience and, on the other, a profusion of popular references that, while often obscure to us, could be understood by any resident of Paris on the eve of World War I.

Only to survey the kind of objects that turn up on Cubist tabletops is to realize the extent to which the modern world of streamlined packaging, advertising logos, and new inventions (especially from America) was rapidly substituted for the more traditional still-life components — the venerable earthenware jugs and fruitbowls, the generic wineglasses and carafes, the timeless apples, oranges, pears, and lemons — that allied the earliest Cubist still lifes of Picasso and Braque to the past of Cézanne and Chardin. When, in 1965, I scrutinized with a magnifying glass a newspaper ad for an electric light bulb that Picasso had pasted upside down in a drawn still life (see fig. 101), I was mainly interested in the verbal joke revealed in the very small print, which boasted that the bulb was the only one that gave light from all sides and could be placed, as the artist demonstrated, in any position at all.[8] Now, however, the proto-Pop character of this choice of newspaper ad — which singles out a floating symbol of modern urban life and depicts it via the impersonal hand of a commercial draftsman — has become conspicuous, a voice in the Cubist wilderness announcing not only a Dada fascination for mechanical imagery in style and subject, but Lichtenstein's and Warhol's early compilation of a virtual emblem book of cheap illustrations advertising modern products. A similar point can be made with a Braque still life of 1914 (fig. 112), which, amidst a drawn wineglass and bottle, offers a flurry of pasted papers that might once have been looked at uniquely as elements of textural contrast or indications of finely layered planes in the shallowest of spaces. But in center stage, one rectangle of newspaper print excerpts an advertisement for a Gillette safety razor, a new American product first patented in 1901 and then aggressively marketed abroad. Apart from the Cubist wit that transforms this newspaper clipping into a symbol of the package itself, which might contain a razor blade whose paper-thin weightlessness is akin to the neighboring Cubist planes, the mere presence of such a new product is a jolt of technological modernity, the counterpart to

Picasso's light bulb. It is telling that, a decade later, when that most American of 1920s Cubists, Gerald Murphy, composed a still life (fig. 113), it was again a safety razor that figured large in his repertory, which also included, in the same painting, safety matches and a fountain pen, two more new-fangled inventions from America.[9] Yet once more, the roots of this machine-age selection go back to Parisian Cubism. For example, Picasso had already included a real box of safety matches in a still life of 1914,[10] and Diego Rivera, while defining his own brand of Cubism in Paris on the eve of World War I, also clearly felt the need to select still-life objects in tune with the modern era. In his only known *papier collé,* that of 1914 (fig. 114), Rivera depicted not only a fountain pen (for which the first patent was made in New York in 1884, and then widely proliferated), a choice that precedes Murphy's by a decade, but another blaring symbol of modernity, an actual telegram he had received (a triumph of the new wireless, which was younger than the artist himself and had only just begun to connect nations and continents at the turn of the century).[11] And in the same year, 1914, Rivera arranged a Cubist still life (fig. 115) around another modern invention, an alarm clock,[12] clearly updating the more old-fashioned watch selected by Juan Gris as the centerpiece for a still life of 1912[13] and heralding as well Picabia's Dada alarm clock of 1919.[14]

Such a commitment to the artifacts and inventions of the modern world was directly articulated by Gris, who, according to Cocteau,[15] was proud to claim that it was he who had introduced the siphon bottle into art, a boast that could be traced in his work back to 1909, for his commercial cartoons, and to 1910 (fig. 116), for his loftier work in oil on canvas.[16] Although, in fact, Gris was wrong in his claim — the siphon had made an appearance as early as 1857 in a painting by Thomas Couture[17] — the more important point was his self-consciousness in modernizing a repertory of still-life objects, a direction confirmed in Léger's 1924 painting (fig. 117) of a syphon inspired by a newspaper ad for Campari (fig. 118).[18] And again, the comparison conjures up Lichtenstein and Warhol's adaptation of commercial illustrations within the domain of high art.[19] As for Gris, even in the 1920s, when his art took a more retrospective, old-master turn, he could feature in two still lifes of 1925 (fig. 119) not the premodern grid of a chessboard that he had so often used before, but its modern update, the grid of a crossword puzzle,[20] an American invention that first appeared in newspaper form in 1913.

Such emblems of the commonplace, machine-made facts that defined the urban world of the early twentieth century were, in fact, ubiquitous in Cubist still lifes. Match holders ("pyrogènes") with ads for Dubonnet or Quinquina printed upon them; packages of cigarette papers with the brand name JOB; ads for KUB, a bouillon-cube product particularly susceptible to Cubist punning would all turn up,[21] as would such other manufactured food products as the French version of the very American Quaker Oats box, which

makes its debut in a 1915 still life by Gris (fig. 120), who exaggerates further the comic-strip crudity of the logo of William Penn surrounded by the consumer imperative, "Exigez la Marque du Quaker," and who underscores the harshly unartistic manufactured colors of the box's yellow, red, and blue—shades of Warhol's soup cans![22]—in a way that was soon to be tempered by Gino Severini in his far more chaste and seemingly vacuum-packed *Still Life: Quaker Oats* of 1917 (fig. 121).[23] The disparity between the look of such manufactured food products and the old-fashioned conventions of academic painting and drawing was pointed out with still greater irony in one of Picasso's earliest about-faces from the language of Cubism, a modest little drawing from the 1914 summer sojourn in Avignon (fig. 122) that renders, in a mock-Ingresque style of linear precision and exquisitely nuanced shading, an uncompromisingly modern still life of a plate displaying freshly unwrapped cookies. One brand name, LA SULTANE, is prominently machine stamped amidst an inventory of other manufactured baked goods that offer a variety of waffled and serrated decorative patterns reminiscent of the machine-made, trompe l'oeil weaving of the oil-cloth chair caning in the master's first collage.[24]

It was this kind of aesthetic clash between the hallowed domain of museum-worthy art and the plebeian facts of modern life that must also have prompted Picasso to do the most arcane Cubist drawings not on a sheet of proper Ingres drawing paper, but rather on an entire sheet of the daily newspaper. In a particularly startling example from 1913 (fig. 123),[25] he selected a whole page bristling with the coarsest commercial illustrations and with ads for such up-to-date hygienic products as a septic tank and Scrubb's ammonia, and then, after turning it upside down, used it as the trash-can background for a mustachioed Cubist head that would have looked totally crazy to the vast majority of readers of the same newspaper. And contrariwise, the illegibility of this Cubist scarecrow could be balanced, at the same time, by the appearance of the human figure in a Cubist context not as reinvented by the artist with the obscure hieroglyphs of Cubism but simply as depicted by the most anonymous of commercial illustrators. In a still life of winter 1912–13 (see fig. 100), which seems to be hawking the wares of two major Parisian department stores, Au Bon Marché and La Samaritaine, Picasso includes a snippet of a fashionably dressed lady who, surrounded by a still life and a barrage of commercial come-ons, may even be a sly reference to Manet's *Bar at the Folies-Bergère,* which had been seen in Paris from June 1–17, 1910 at the Galerie Bernheim-Jeune, just before Picasso left for Cadaqués.[26] But the figure, rather than being drawn by Picasso himself in a Cubist mode, is, instead, a "ready-made" *avant la lettre,* a commercial drawing that, unlike the objects in the ambient still life, would obviously be legible to all viewers. It was a visual and cultural paradox that Braque also picked up, a year later, in a still life of winter 1913–14 (fig. 124)

that includes, among the barely decipherable still-life objects on a tabletop, another pasted snippet from a newspaper ad, this time for furs, featuring the fragment of yet another fashionable lady, now decked out in a fur boa and florid hat. In both these papiers collés, Picasso and Braque reintroduced legible, populist, and anonymous versions of the human figure into their nearly illegible, elite, and individualist vocabulary of Cubism, a strident reminder of the visual disparity as well as the historical simultaneity of these two separate social levels. Invading the territory of high art from the enemy position and swiftly rising to the top, these commercial humanoids again ring bells in the story of Lichtenstein's early adaptations of the crassest figures from the cheapest ads and comic strips.[27]

It is, of course, not only the source of this imagery but the look of it that the best Cubists attempted to assimilate into their work. Picasso, in his usual role as artist-chameleon, clearly enjoyed mimicking the stylized simplifications of the commercial artist. In the summer of 1914 in Avignon, just months after Braque's lady in a fur boa, he imitated—this time in a completely painted Cubist fashion plate of a seated lady—the flattened decorative flourishes of a feather boa and a fancy hat that were part of the language of the journeyman illustrator of the day (fig. 125).[28] Elsewhere, he preferred the still cruder simplifications of the lowliest cartoonist or sign painter, a point borne out by the almost comic-strip economy of his frequently childlike Cubist heads with their circle eyes, cartoonish mustaches, and crescent-moon or X-shaped mouths, as well as in his high-spirited efforts to mock the look of the pictures of the daily fare that might be found in a low-class restaurant. Most conspicuously, in a still life of 1914,[29] (fig. 126) Picasso imitated not only the kind of lettering one would find on the walls and windows of a Parisian bistro, but more to this point, the rendering of a roast chicken in a style of such clumsy vigor that we might almost think he had incorporated the work of a professional sign painter, as Duchamp was later to do,[30] in order to confuse the boundaries between elite and populist styles. It is telling that this Cubist vignette of a restaurant was, in fact, illustrated in an article by Roger Vitrac about a show of signboards held in Paris in 1935,[31] a context that would also have suited Picasso's earlier rendering of a chicken cut out of paper as well as his coarse and lusty recreations of roast hams, breads, cheese and sausages in both two and three dimensions.[32] Once more, these witty translations of populist imagery in the depiction of restaurant still lifes anticipate the repertory of American Pop Art. In both style and subject, Lichtenstein's hot dogs and Oldenburg's hamburgers may find their ancestry in a food chain linked to Picasso, a chain, in fact, that even reaches back to his Barcelona years when, still a teenager, he designed a menu card in Catalan for the famous café Els Quatre Gats (fig. 127),[33] on which the identity of the Plat del dia (the Plat du jour) would have been scribbled in a mock frame below a swiftly drawn waiter whose broad

silhouette and minimal detail echo the bold economies of turn-of-the-century commercial artists.

Such connections with the world of popular illustrations were, in the case of Gris, more than casual, since from 1907 until 1912, he published humorous cartoons in a variety of magazines in both Paris and Barcelona.[34] Far from suggesting an unhappy descent to the level of commercial art in order to support his higher calling, these illustrations maintain a constant and nourishing dialogue in both theme and style with the most ivory-tower cerebrations of his Cubist paintings and drawings.[35] In his 1908 series of cartoons, *Les Aéroplanes* (fig. 128), a send-up of the lunatic new world of aeronautics,[36] he not only prefigures Braque and Picasso's own sly allusions to the Wright Brothers and the future of aviation,[37] but employs a whole battery of Cubist things to come. Spaces are made paper thin by schematic perspective lines that irrationally fuse the vast sky with the earthbound figures below; clothing is ironed out into the flattest silhouettes of uniform blackness or belt-line patterns that signify texture; faces are defined by comically simple geometries of arcs and angles; an abundance of words and signs floats through the air with the greatest of ease. But the distance between this popular language and the high achievements of Gris's mature Cubism is hardly immeasurable. In fact, the overlap is found everywhere.

So it is that his 1912 painting of a respectable, well-heeled gentleman seated at a Parisian café (fig. 129) bears the marks not only of the caricaturist's breezy topicality, but of the jaunty, angular stylizations Gris himself had employed in his earlier cartoons for *L'Assiette au Beurre* (fig. 130).[38] There, too, one could find such graphic rhymes as the top hat clicking into place against the stripes of the café awning or such rapid evocations of a city milieu as the dollhouse grid of windows in the background. Moreover, the cartoon-like treatment of the face, hands, and limbs (in which arcs stand for eyebrows and mustaches and rectangles become the joints of fingers or trousered legs) also depends upon this language of popular imagery. The point becomes still clearer in Gris's close-up drawings and paintings of men's heads from 1913, *The Smoker* and *The Bullfighter* (figs. 131 and 132), whose comical physiognomies look as though they were scrambled into a Cubist jigsaw puzzle from a cartoonist's manual of crude geometries that could stand in for nostril, ear, eye, or mouth. Gris, in fact, seemed to enjoy even more than Picasso the brusque, yet humorous clash between the rudimentary modules of an emphatically modern, mechanized vocabulary and the old-fashioned styles of nineteenth-century illustration. For instance, like both Picasso and Rivera,[39] he selected, with comparable ethnic relevance, a Spanish liqueur, Anis del Mono, for inclusion in a still life (fig. 133); but unlike Picasso and like Rivera, he willfully included the bottle's label, whose florid, Victorian rendering of a simian drinker and of the prizes awarded the liqueur in the 1870s brusquely and wittily collides with the

streamlined, intersecting geometries around them, a diamond-patterned grid also inspired by the manufactured bottle.[40] And elsewhere, he would produce the same cultural and visual frictions by using as collage elements fragments of nineteenth-century engravings,[41] much as Picasso, in the winter of 1912–13, had composed a mock Cézannesque still life by filling a Cubist compotier with whole and fragmentary apples and pears cut out of highly realist, colored illustrations of fruit.[42]

Gris's willingness to explore the look of modern and popular styles that would release his art from the conservative shackles of tradition even extended to his choice of color. Although in his earliest painting, he often conjured up the old-master effects of a somber and dramatic tenebrism particularly associated with Spanish seventeenth-century still-life traditions, he could also embark upon a conspicuously different counter-current of chromatic vulgarity, especially in 1913, during a sojourn at Céret near the Spanish border. There, he lustily embraced a synthetic rainbow of fiesta colors — of a kind associated with the costumes and posters for bullfights which he had recorded in *The Torero* — a riotous palette that he could also use for landscapes and still lifes and one that would unsettle any conventions of chromatic decorum he had learned at the Louvre or at the Prado.[43] It was an assault comparable to the use of Day-Glo and printer's-ink colors in the heyday of Pop Art, a head-on challenge to the nuanced, organic palette of the Abstract Expressionists.

Such invigorating descents into the visual facts of popular life pertained as well to the decorative materials and trompe l'oeil devices commercially disseminated throughout a burgeoning low-budget market that would ape, with manufactured products, the luxury stuffs and exquisite craftsmanship of old money and aristocracy. Braque himself was the son and the grandson of professional house painters and was apprenticed as a teenager to several *peintres-décorateurs* who trained him in the tricks of a modern trade that could imitate, with factory-made papers, anything from marble to wood grain, and that could make letters with stencils and wavy paint patterns with steel combs. His delight in these popular surrogates for old-fashioned skills and finances, techniques he quickly shared with Picasso, was typical of the Cubists' witty enjoyment of an inventory of cheap new materials that mocked the real thing, from the carved leaves of a wooden frame to the polished marble of a fireplace. Elegant as Braque's papiers collés may look to us today, their inclusion of materials as lowly as corrugated cardboard[44] undid their genteel ancestry in the still-life arrangements of a master like Chardin, to whom Braque would so often allude both before and after the high years of Cubism; and expectedly, the more raucous taste of Picasso and Gris would embrace a repertory of, among other things, large swatches of common wallpaper patterns and decorative borders, whose cheap floral repeats again assailed preconceptions of aristocratic good taste, permitting

dime-store products to invade the precincts of high art. Even the paint itself was dethroned. By the spring of 1912, in fact, Picasso, in a nod toward his dual national allegiances, French and Spanish, included the flags of both countries in several still lifes and in at least two cases used a most unartistic commercial paint, Ripolin enamel, to do so.[45] In the *Souvenir du Havre* (fig. 137), the French tricolor is painted with this product so alien to the old-master chiaroscuro nuances of the preceding two years of Analytic Cubism, and in the *Spanish Still Life* (fig. 134), the Spanish flag that signifies a ticket to the bull ring (with the fragments of the words "sol y sombra" floating above it) is even more emphatically rendered with the opaque enamel paint, providing, among other things, a brilliant chromatic contrast to a somber Cubist background, a color chord of red and yellow whose patriotic echoes can be found, alternating with the French color chord, throughout the master's work.[46] Apart from such matters of public flag-waving with private allusions to his own divided loyalties, Picasso's use of Ripolin enamel is again a precocious step in a Pop direction, opening the door to, among other things, Duchamp's far more subversive use in 1916–17 of an actual ad on painted tin for Sapolin enamel paints[47] and the full-scale assault of the 1960s upon the venerable medium of oil paint. And in terms of assimilating the most up-to-date synthetic materials, Gris, whose patchwork-quilt Cubist patterns often resemble fragments of decorative papers bought at the local equivalent of Woolworth's, would even imitate the machine-age look of such new plastics as Bakelite, invented in 1909. In his *Still Life with Plaque* of 1917 (fig. 135), the trompe l'oeil frame, with the artist's name and the painting's date mechanically stamped upon it, resembles a plaque made of the toughest synthetic stuff, a joke on old-fashioned hand-made wooden frames.

Picasso constantly explored this territory of popular materials and artifacts as a way of both undoing and invigorating moribund traditions. His pivotal *Still Life with Chair Caning* (see fig. 88) of May 1912 not only uses a new machine-made material, oil cloth, whose printed trompe l'oeil weave replaces handicraft traditions, but reflects, in the rope frame, a world of kitsch objects. My own hunch is that this use of a nautical rope as a mock oval frame, which Picasso had also used in a still life bearing the popular slogan "Notre avenir est dans l'air" (see fig. 98) floating over the French tricolor,[48] is related to the world of kitsch products, such as an oval mirror framed by a sailor's rope (see fig. 136) of a kind found in souvenir shops in port towns.[49] Perhaps during the trip to Le Havre with Braque in April 1912, Picasso had seen just such an object. But in any case, that the two great Cubists shared a taste for such kitsch is clear from, among other things, the postcard that Braque sent to Kahnweiler on November 27, 1912 from Le Havre (fig. 138).[50] The picture on the card is a popular send-up of high art, depicting a photograph of the city's commercial core, La Bourse, honored by

■

a fancy frame and nameplate and set upon an artist's easel garlanded with roses. Above, the phrase "Souvenir du Havre" floats across this trompe l'oeil joke, reminiscent, in fact, of the way Picasso inscribed the same phrase on a ribbon at the bottom of his Le Havre still life of May 1912, whose compilation of seaport motifs — scallop shells, anchor, rope, and life preserver — may well mimic the "artistic" arrangement found on a kitsch postcard or artifact he observed at a local souvenir shop. And speaking of picture postcards, the one that Picasso sent to Kahnweiler on August 13, 1911 (fig. 139) again ricochets between the souvenir shop and the Louvre.[51] In this case, the image, inspired by a popular song, is of Mignon playing a mandolin in a Romantic costume and setting, a kitsch descendant of the theme that Corot had often treated and that presumably inspired Picasso's as well as Braque's variations on this motif in 1910 (fig. 140)[52] as it would inspire Gris more literally in 1916.[53] But as is usual in Cubism and in Picasso source hunting, this is probably not a question of either/or but of both being relevant. Given the fact that Picasso selected this picture-postcard mandolinist to send to his dealer, it is clear that he enjoyed these vulgar echoes of his own work or that, reversing directions, he might have been inspired by such popular imagery to take a fresh look at Corot.

Even the master's famous constructed sheet-metal guitar of 1912 (fig. 141) may have comparably humble origins, as I suggested in 1982,[54] when I indicated its affinity with a cake mold from Mexico (see fig. 142) of a kind which must have its kitchen counterparts throughout the Hispanic world. Here, in the form of a decorative utensil, was not only a symbol of the most popular musical instrument in the culture that nurtured Picasso, but a new kind of sculptural construction and medium, a lightweight tin skin enclosing a void.

Such a descent to ethnic roots may, of course, be only coincidence in the case of this parallel, but in another example, recurrent in the work of Braque and Picasso, there is no doubt. Thus, as Lewis Kachur has discovered,[55] the mysterious woodwind that turns up again and again on Cubist tabletops and that has been consistently misidentified as a clarinet (despite the obvious dissimilarity of its mouthpiece)[56] is, in fact, a folkloric instrument from Catalonia, a *tenora*, which Picasso had heard in performance in the Pyrenees and which both he and Braque often included in their still lifes (see fig. 143) as what must have been an ethnic memento of Spanish culture, comparable to their many allusions to the bullfight and other Spanish motifs. And here, too, the choice not of a clarinet, for which Mozart himself had written concert and chamber music, but of a crude woodwind from a lower cultural stratum was characteristic of the constant fluctuation in Cubist art between high-brow cultural traditions and grass-roots reality, whether in the heart of Paris or in the remoteness of the Pyrenees. Any survey of the musical references in Picasso and Braque's work indicates the double-track

allusions to both the music of the concert hall (whether composers like Bach and Mozart or performers like Kubelick and Cortot) and that of popular café-concerts, whose songs and dances find their titles, refrains, and even scores fragmented throughout the writings and pastings in Cubist art.[57] The parallel is close to Stravinsky, who, in 1911, within the most avant-garde thickets of *Petrouchka*'s polyrhythms and polyharmonies, could introduce the lilting popular tune, *"Elle avait un' jambe de bois."*[58]

Such an attraction to the tonic excitement of the vast range of popular reality outside the traditional confines of art expanded for the Cubists in every direction. When Apollinaire mentioned in *Zone* the lure of cheap detective stories, he might well have been thinking of the enormously popular fictional detective Fantômas, who, beginning in 1911, appeared in serial format not only as pamphlets to be picked up like the daily newspaper but as a movie by Louis Feuillade and as a character who turned up both overtly and covertly in works by Gris of 1914 and 1915 (fig. 144).[59] And the most popular of modern forms of entertainment, the movies, could appear in even more direct ways in two papiers collés of Braque that display the pasted announcements of the very first program of the Tivoli Cinema in Sorgues (fig. 145), which opened to its eager provincial audience on October 31, 1913, as well as a fragment from another movie program at the same theater (fig. 146).[60] As for that grand opening, one of the movies shown, we read, was "Cow-Boy, Millionaire," clearly a reflection of those popular myths about America that appealed to Europeans and that were prominent in the Picasso-Braque milieu in the form of Buffalo Bill, whose Wild West company toured the United States and Europe and who turns up in a painting by Picasso of 1911,[61] in Picasso's library of detective and adventure stories,[62] and in his circle's friendly slang references to "notre pard," as in Buffalo Bill's calling a friend "my pard,"[63] an Americanism comparable to Picasso's addressing Braque, in allusion to the Wright Brothers, as "mon cher Wilbur."[64] And by 1917, in *Parade,* whose offensiveness to theatrical con-ventions had everything to do with its full-scale absorption of the compo-nents of popular entertainment,[65] Picasso had materialized just such American myths in his costume for the Manager from New York, who wears a skyline of Cubist skyscrapers above a pair of cowboy boots worthy of Buffalo Bill.

If the Cubists felt, as Duchamp and Picabia soon would, that the raw, forward-looking vigor of popular culture and modern technology was a wind that blew strongest from America, in general, and from New York, in particular, a younger generation of American artists, with appropriate rec-iprocity, felt compelled to translate the language of Cubism, especially its populist elements, into an American vernacular. This theme comprises a huge chapter in the history of modern American art, and one that would take us through artists of the 1920s and 30s like Gerald Murphy, Charles

CUBISM AS POP ART

127

Shaw, and Charles Demuth right into Pop territory of the 1960s. But there would be no better place to begin the story than in Gar Sparks's Nut Shop in Newark, New Jersey, where in 1921 Stuart Davis completed a wrap-around mural (fig. 147) in which the inventory of free-floating words from Cubist café scenes — the names of beers, liqueurs, and wines — has been re-created as an all-American bill of sweet-toothed fare — banana royal, nut sundaes, ice cream, taffies.[66]

But no less than Davis in New York, the Parisian Cubists, beginning in 1911, were determined to absorb into their art as into their daily lives the fullest impact of a teeming world of popular culture that by convention would have been censored out of the purer domain of high art. Or would it have been? For just as clearly, what would appear to be the Cubist revelation that everything from the movies to American breakfast cereal was grist for the mill of art had a long nineteenth-century history. We now know, for example, that many of the apparent innovations of the Impressionists in terms of abrupt cropping and rapid, abbreviated draftsmanship were inspired by the coarsest newspaper illustrations of the 1860s and 70s;[67] or that in the 1880s, Seurat, in a remarkable prophecy of Lichtenstein, would be fascinated by the grotesque figural distortions of contemporary caricature as well as by the new printer's-dot techniques of primary colors used in chromolithography.[68] And getting closer to the Cubist generation, it has long been apparent that artists as exquisitely refined as Bonnard and Vuillard, not to mention as streetwise as Toulouse-Lautrec, would immerse themselves, like lesser artists of the 1890s, in commercial designs that merged words and images in a way that would stop urban dwellers in their tracks.

But there is really nothing surprising about this. Artists, like the rest of us who live in the modern world, may choose, of course, to shut their eyes and ears to the overwhelming assault of urban life and popular culture; but they may also try to adapt to these urgent realities, to integrate the private and the public, the elite and the commonplace. In their art as in their life, the Cubists, on the eve of World War I, smilingly and triumphantly bridged that gulf.

NOTES

1. William Rubin, *Picasso in the Collection of the Museum of Modern Art* (New York, 1972), p. 68.

2. The identity of this phrase as an excerpt from the song "Dernière chanson" by Harry Fragson was, I believe, first spotted by Maurice Jardot in the exhibition catalogue *Picasso* (Paris, Musée des Arts Décoratifs, 1955, number 26). I elaborated on its multiple meanings in "Picasso and the Typography of Cubism," in Roland Penrose and John Golding, eds., *Picasso 1881/1973* (London, 1973), pp. 57—58 (hereafter referred to as Rosenblum, "Typography").

3. I have indicated some of these early references in Rosenblum, "Typography," p. 266, preface to the notes.

4. The lecture was first given on January 28, 1965, at a meeting of the College Art Association of America held in Los Angeles and was often repeated in the following years.

5. This was reprinted, without illustrations, by Harper and Row, New York, in 1980, and more recently, with illustrations, in Katherine Hoffman, ed., *Collage: Critical Views* (Ann Arbor, Mich., 1989), pp. 91–120.

6. Rosenblum, "Typography," p. 75.

7. This lecture was first given on May 11, 1975, at the Hirshhorn Museum and Sculpture Garden, Washington, D.C., and subsequently repeated with many variations on both sides of the Atlantic. Some of these observations on Picasso's popular sources are now also found in the publication as a brochure in 1989 of a lecture, "Picasso: Now and Then," that I gave at the Art Gallery Society of Western Australia, Perth (Third Christensen Lecture), in December 1988.

8. Rosenblum, "Typography," p. 60.

9. For a full discussion of Murphy's painting, see William Rubin (with the collaboration of Carolyn Lanchner), *The Paintings of Gerald Murphy*, catalogue of an exhibition at the Museum of Modern Art, New York, 1974, pp. 29–30; and Rick Stewart, *An American Painter in Paris: Gerald Murphy*, catalogue of an exhibition at the Dallas Museum of Art, 1986, p. 7.

10. See Pierre Daix and Joan Rosselet, *Picasso: The Cubist Years, 1907–1916: A Catalogue Raisonné of the Paintings and Related Works* (New York, 1979), number 669 (hereafter referred to as Daix, *Picasso*).

11. I discussed this Rivera collage, from the point of view of the witty variations on true and false signatures and handwriting, in Rosenblum, "Typography," p. 68. On this papier collé, see also Ramón Favela, *Diego Rivera: The Cubist Years*, catalogue of an exhibition at the Phoenix Art Museum, 1984, p. 73.

12. On this Cubist still life, see ibid.; and Florence Arquin, *Diego Rivera: The Shaping of an Artist, 1889–1921* (Norman, Okla., 1971), p. 77.

13. Douglas Cooper, *Juan Gris: Catalogue raisonné . . .* (Paris, 1977), number 27.

14. For this and other Cubist timepieces, see Rubin, *Paintings of Gerald Murphy*, p. 32.

15. See Mark Rosenthal, *Juan Gris* (New York, 1983), p. 40.

16. See, for example, the commercial illustration in *Papitu*, no. 8, January 13, 1909, p. 128, reproduced in Gary Tinterow, ed., *Juan Gris* Madrid, catalogue of an exhibition at Salas Pablo Ruiz Picasso, 1985, p. 446; and the oil painting *Siphon and Bottles* of 1910, reproduced in Cooper, *Juan Gris*, number 1.

17. In *Two Politicians*, discussed and illustrated in Albert Boime, *Thomas Couture and the Eclectic Vision* (New Haven and London, 1980), p. 311, including the painted sketch. Couture's painting, incidentally, offers surprising prophecies of Cubist iconography, not only in the siphon, but in the poster announcing a "bal" and the behind-the-scenes view of figures dressed as Pierrot and Harlequin.

18. See Christopher Green, *Léger and the Avant-Garde* (New Haven and London, 1976), pp. 272–73.

19. A particularly apt analogy is Roy Lichtenstein's *Spray* of 1962, which similarly shows a disembodied hand operating a spray can.

20. Cooper, *Juan Gris*, numbers 520, 521. These crossword puzzles, however, now appear in books, rather than in newspapers.

21. I have discussed the use of most of these brand-names from a more verbal point of view in Rosenblum, "Typography," passim.

22. I originally suggested the Warhol comparison in "Typography," p. 268 n. 75; and repeated it in "Warhol as Art History," in Kynaston McShine, ed., *Andy Warhol: A Retrospective,* catalogue of an exhibition at the Museum of Modern Art, New York, 1989, p. 35.

23. See also *Léger and Purist Paris,* catalogue of an exhibition at the Tate Gallery, London, 1970–71, p. 32.

24. I first discussed this drawing, from a quite different point of view, in *Cubism and Twentieth Century Art* (New York, 1960), p. 98.

25. This drawing, unlike the better-known one also executed on a full sheet of upside-down newspaper (Daix, *Picasso,* number 551), is not included in Daix.

26. This complex collage has been most provocatively and fully discussed by Christine Poggi in "Mallarmé, Picasso, and the Newspaper as Commodity," in Hoffman, *Collage,* pp. 180–83 (originally published in the *Yale Journal of Criticism,* vol. 1, no. 1 [Fall 1987]). Poggi relates the collage, among other things, to contemporary attitudes to saleswomen in department stores, a point that would support the allusion to Manet.

27. The most obvious comparison is with Lichtenstein's *Girl with Ball* of 1961, an adaptation of an ad for a vacation resort (Mount Airy Lodge) that still appears in New York newspapers.

28. Daix (*Picasso,* number 784) identifies the object at the lower left as a light bulb, a more plausible reading than the traditional one of a flame, and one that would reintroduce, in a different visual language, the commercial light bulb from the papier collé of 1912 (number 543).

29. Zervos's original date of 1912 (Vol. II, fig. 347) is obviously incorrect. I would follow Daix's suggested dating of spring 1914 for this still life (*Picasso,* number 703), which corresponds to the other restaurant still lifes of 1914, comparably crammed with food and words (numbers 704, 705).

30. In *Apolinère Enameled* (1916–17) and *Tu m'* (1918).

31. See Daix, *Picasso,* number 703.

32. For example, see Daix, *Picasso,* numbers 609, 703–705, 746.

33. I first discussed this menu card in connection with its mix of words and images in the poster tradition of the 1890s (Rosenblum, "Typography," p. 74). Marilyn McCully dates it about 1900 and mentions that we do not know whether Picasso's design was, in fact, ever printed. See McCully, *Els Quatre Gats: Art in Barcelona around 1900* (catalogue of an exhibition at Princeton, N.J., 1978), p. 33.

34. For a full list of these cartoons, see the appendices by Rosario Maseda and Anne M. P. Norton in Tinterow, *Juan Gris,* pp. 445–62.

35. They are discussed, with references to their connections with Gris's Cubist style, by Marilyn McCully in "Los Comienzos de Juan Gris como Dibujante," in Tinterow, *Juan Gris,* pp. 17–24.

36. See McCully, "Los Comienzos," pp. 455–56.

37. For more comments on the imagery of the Wright Brothers and aviation in the Picasso-Braque milieu, see Rosenblum, "Typography," p. 55; Daix, *Picasso,* numbers 463–465; Linda Nochlin, "Picasso's Color: Schemes and Gambits," *Art in America,* December 1980, p. 109; and William Rubin, *Picasso and Braque: Pioneering Cubism,* catalogue of an exhibition at the Museum of Modern Art, New York, 1989, pp. 33–34.

38. McCully ("Los Comienzos," p. 22) also singles out this painting in connection with Gris's popular illustrations.

39. Picasso so camouflaged a bottle of Anis del Mono in a still life of 1909 that it was traditionally considered to be a tube of paint until William Rubin was able to identify it correctly (Rubin, *Picasso in the Collection,* p. 63). Rivera, on the other hand, depicted the bottle as legibly as did Gris in two still lifes of 1913 and 1915 (Ramón Favela, *Diego Rivera,* pp. 72, 103).

40. In Picasso's still life, this diamond pattern, which is actually on the bottle, may have provided a surreptitious reference to his alter ego, Harlequin.

41. In two papiers collés of 1913. See Cooper, *Juan Gris,* numbers 38, 42.

42. Daix, *Picasso,* number 530.

43. For some conspicuous examples, see Cooper, *Juan Gris,* numbers 55–57.

44. For a useful inventory of the materials used in these works, see Isabelle Monod-Fontaine, with E. A. Carmean, Jr., *Braque: The Papiers Collés,* catalogue of an exhibition at the National Gallery of Art, Washington, D.C., 1982, p. 147.

45. See Rubin, *Picasso and Braque,* entry in early May 1912, p. 390; and Daix, *Picasso,* numbers 458, 476. Clearly, Picasso was aware that his use of commercial paint and lettering would be considered outré, for in a letter of July 15, 1912, to Kahnweiler (ibid., p. 400), he wondered what Shchukin might have thought of these new techniques.

46. Nochlin ("Picasso's Color") has fully discussed Picasso's tricolorism, if not his Spanish bicolorism, which is also shared by Miró's preference for red and yellow, the national colors of Spain.

47. In *Apolinère Enameled.*

48. Daix, *Picasso,* number 465.

49. I first proposed this connection in my discussion of *Still Life with Chair Caning* in *Picasso from the Musée Picasso, Paris,* catalogue of an exhibition at the Walker Art Center, Minneapolis, 1980, pp. 41–47.

50. See Rubin, *Picasso and Braque,* p. 410.

51. Ibid., p. 376.

52. See Rubin, *Picasso in the Collection,* p. 205 n. 3. Closely related are Picasso's *Woman with Mandolin,* 1910 (see Daix, *Picasso,* number 341) and Braque's *Woman with Mandolin,* 1910 (see Nicole Worms de Romilly and Jean Laude, *Braque: Cubism, 1907–1914* [Paris, 1982], number 71).

53. Cooper, *Juan Gris,* number 197.

54. In *The Sculpture of Picasso,* catalogue of an exhibition at the Pace Gallery, New York, 1982, p. 6.

55. In a forthcoming article on Picasso and popular music that he was kind enough to let me read.

56. Without knowing the real identity of this enigmatic instrument, I suggested as far back as 1960 (*Cubism and Twentieth Century Art,* p. 94) that the clarinet in a Braque papier collé of 1913 more closely resembled an oboe with a projecting reed.

57. I rapidly surveyed the question of musical references in Cubism, both popular and classical, in my "Typography," p. 57; but the field is now being investigated far more fully by Lewis Kachur and Jeffrey Weiss.

58. See "Typography," pp. 57–58.

59. See ibid., pp. 64–65. For a more expanded discussion of this theme, see E. A. Carmean, Jr., "Juan Gris's 'Fantômas,'" *Arts Magazine,* January 1977, pp. 116–19.

60. See Monod-Fontaine, *Braque,* numbers 31, 34. For an expanded view of the impact of the movies on Cubism, see Natasha Staller, "Méliès' Fantastic Cinema and the Origins of Cubism," *Art History,* vol. 12 (June 1989), pp. 202–32.

61. Daix, *Picasso,* number 396.

62. Rubin, *Picasso and Braque,* p. 55 n. 3.

63. Ibid., p. 374.

64. Cited in Ronald Penrose, *Picasso: His Life and Work,* 2nd. ed. (New York, 1962), p. 161.

65. The importance of the popular elements of street and circus entertainment in the program of *Parade* has now been fully explored in a Ph.D. dissertation by Deborah Menaker (Institute of Fine Arts, New York University, 1990).

66. See John R. Lane, *Stuart Davis: Art and Art Theory* (catalogue of an exhibition at the Brooklyn Museum, 1978), p. 11; and Diane Kelder, ed., *Stuart Davis* (New York, 1971), fig. 17 and page 21 (where the mural is dated c. 1916), for some of Davis's own comments on the owner of the store. The photograph of Davis's now destroyed murals, incidentally, inspired a very different kind of American word scramble of homophobic slang, vintage 1940s. See McGough and McDermott, *A Friend of Dorothy, 1943* (1986), illustrated in the catalogue of the Whitney Museum of American Art, *Biennial Exhibition,* 1987, p. 91.

67. See especially Joel Isaacson, "Impressionism and Journalistic Illustration," *Arts Magazine,* June 1982, pp. 95–115.

68. For two important articles on these themes see: Robert Herbert, "Seurat and Jules Chéret," *The Art Bulletin,* June 1958, pp. 156–58; and Norma Broude, "New Light on Seurat's 'Dot': Its Relation to Photomechanical Color Printing in France in the 1880s," *The Art Bulletin,* December 1974, pp. 581–89. Seurat's connections to the world of popular entertainment and imagery are fully integrated into Richard Thomson's discussion of the artist in his monograph *Seurat* (Oxford, 1985).

A BRAZEN CAN-CAN IN THE TEMPLE OF ART: THE RUSSIAN AVANT-GARDE AND POPULAR CULTURE

The subject of the Russian avant-garde and popular culture is a vast and complex one that, until recently, has not been the focus of consistent and comprehensive study either in the Soviet Union or in the West.[1] One reason for this is that the potential researcher must be familiar not only with the history of Russian modernism, but also with a conglomeration of disparate artistic disciplines, levels, and conditions that, at first glance, may seem distant, if not irrelevant to Cubo-Futurism, Suprematism, and Constructivism—from rural handicrafts to Siberian effigies, from shaman rituals to peasant festivities, from children's drawings to consumer advertising, from Black art to North Coast Indian art.[2] In turn, each of these categories can be broken down into subsections and explored in contextual comparisons with particular achievements of the Russian avant-garde. We think, for example, of Natalia Goncharova's interpretations of peasant costumes and fabrics in her major Neo-Primitivist canvases or in her stage designs for the *Coq d'Or* of 1914. Her colleagues such as Mikhail Larionov and Alexander Shevchenko collected children's paintings and drawings, included them in their exhibitions, reproduced them in their publications, and even tried to imitate the child's perception of form and space in their own art—something very apparent in Varvara Stepanova's stick figures of 1919–21. Vasilii Kandinsky, of course, was deeply aware of his "primitive" roots, and his first exposure to peasant art in 1889, when he was legal consultant to an imperial ethnographical expedition, resolved him to become a professional artist:

For the first time I encountered the miracle that would later become one of the elements of my work. There and then I learned how not to look at a picture from the side, but to revolve in the picture, to live in it. I remember so vividly stopping on the threshold of this unexpected spectacle. The table, the benches, the imperious, enormous stove, the closets, and the sideboards—everything had been painted with bright and sweeping ornaments.[3]

It is becoming increasingly clear that the rituals of the Siberian shaman, too, might explain some of Kandinsky's stylistic investigations and formal configurations.[4] The list of such interconnections is extensive, and Goncharova, Kandinsky, Larionov, Shevchenko, and Stepanova are just a few of Russia's avant-garde artists who sought a new artistic vigor in what we now call loosely "popular culture."

In order to discuss the entire scope of such connections between "low" and "high" in the context of the Russian avant-garde, the researcher would also have to determine the extent and availability of relevant materials at the beginning of the twentieth century, i.e., to study the locations and strengths of public and private collections of Russian peasant crafts and analogous ethnographical artifacts in Moscow, St. Petersburg, and other centers.[5] For

JOHN E. BOWLT
■

example, this would entail examination of the holdings of the Dashkov collection at the former Rumiantsev Museum, and of the vast assemblages of materials brought back from the Pacific Rim by Nikolai Miklukho-Maklai and the Jewish folk art acquired by An-ski during the Baron Horace Guenzburg expeditions in 1911–14.[6] To a considerable degree, this flurry of anthropological activity and general rediscovery of indigenous traditions was encouraged by the efforts of several enlightened patrons, scholars, and philanthropists in the late nineteenth century who did much to preserve and record peasant artifacts, ceremonies, and oral literature. Chief among these individuals were Elizaveta and Savva Mamontov, owners of the Abramtsevo art colony near Moscow, and Princess Maria Tenisheva, owner of Talashkino near Smolensk. Much has been written about these two retreats; their contribution to the so-called Neo-Nationalist movement and to the Russian *style moderne* has long been recognized, and there is no need to repeat known data here.[7] Suffice it to say that Abramtsevo and Talashkino signaled the real beginning of the intense cultural cross-fertilization between "high" and "low" that resulted in the exotic hybrids of the Russian avant-garde. True, the professional artists at Abramtsevo and Talashkino such as Viktor Vasnetsov and Nikolai Rerikh (Roerich) tended to "aestheticize" popular culture, remove "vulgarity," and streamline it for consumption by an elegant, educated, and sophisticated clientele. The direct consequence of this elevation of low to high can be seen in the deliberations on Russian peasant art published in Sergei Diaghilev's *Mir iskusstva* ("World of Art") magazine and, most vividly, in his presentation of Russian ballets to Parisian audiences during the first Saisons Russes. On the other hand, the artists of the Russian avant-garde, especially Larionov, Kazimir Malevich, and Vladimir Tatlin, often provincial, ill educated, and naive, were more concerned with debasing "high" art, with preserving the integrity of popular culture, and with shocking and bewildering their audience.

Obviously, only a small segment of this intricate interrelationship between the Russian avant-garde and popular culture can be explored in the present essay. However, since certain aspects of the subject have already received some discussion in other sources, such as the role of the icon and the *lubok* (cheap, handcolored print) in the work of Goncharova, Larionov, and Malevich,[8] it seems judicious to draw attention to those parallels, paraphrases, and connections that have so far eluded scholarly appraisal. One such avenue of inquiry is the position of the Russian avant-garde vis-à-vis urban folklore, specifically, the lowly artistic expressions of the new capitalist economy that Russia was developing just before the Revolution of October 1917, i.e. store signboards, consumer advertising, café culture, the circus, and the menial occupations of barber, washerwoman, prostitute, etc. These and other manifestations of modern urban life acted as vital sources of inspiration for the new artists, and they merit extended discussion, if we are

to understand the full impact of "low" culture on the evolution of modern Russian art.

In 1913 Aristarkh Lentulov, a stellar member of the Russian avant-garde, painted a large panel entitled *Moscow* (fig. 148).[9] In this intricate interpretation of Moscow, city of a thousand churches, we can distinguish parts of the Kremlin, St. Basil's Cathedral, the Novodevichii Monastery, and other monuments fragmented and reconstituted to transmit the sensation of the dynamic, teeming metropolis. In many ways, Lentulov's *Moscow,* which was shown at the Jack of Diamonds exhibition in Moscow in 1914, summarizes a primary aspiration of the Russian avant-garde—to transcend conventional artistic and social boundaries and to undermine the then accepted categories of "high" and "low" art. If we look carefully at *Moscow,* we see that the dominant image looming large at the very axis of this fantastic mosaic of colors and collage is the Bell Tower of Ivan the Great in the Kremlin. On the one hand, this strategic accentuation of one of Moscow's highest and most famous buildings in 1913 indicates Lentulov's recognition of his domestic artistic legacy; on the other hand, the repeated patterns in red, green, and blue bring to mind the Simultanist pictures of Sonia Delaunay. Moreover, when we recall that Lentulov spent the fall of 1911 and spring of 1912 at La Palette in Paris and frequented the Delaunays' studio, we should not be surprised to see Robert Delaunay's Eiffel Tower now transformed into the Kremlin Bell Tower and Sonia's "rhythm based upon color relations"[10] enhancing the architectural motifs of medieval Moscow.

Of course, the artists of the Russian avant-garde produced innumerable paraphrases of French works—from Mikhail Larionov's imitations of Gauguin and Vladimir Tatlin's combinations of Cézanne and Matisse to Kazimir Malevich's and Liubov Popova's interpretations of Braque and Picasso. But Lentulov's Parisian *Moscow* both supplements the long list of Russian borrowings and also emphasizes the originality of the Russian avant-garde, for it is this audacious transposition of contexts (the Eiffel Tower transmuted into the Kremlin Bell Tower) that tells us of the creative strength and elasticity of Russian modernism. In other words, artists such as Larionov, Lentulov, and Malevich were able to borrow Western forms and reprocess them within their indigenous environment, a procedure that often involved a sudden shift of aesthetic registers from "high" to "low." These artists found that the simplest method of desanctifying or, as they liked to say, "defrenchifying," art[11] was to adjust Western artistic innovations to Russian traditions and to temper or even replace those momentous achievements with the most vulgar manifestations of their local mass cultures. That is how Shevchenko, the chief apologist of Neo-Primitivism, explained the state of affairs in 1913 when he argued that Picasso's Cubism had already been done in "Russian icons . . . our painted woodcarving, in Chinese wood and bone carving."[12] The year before Goncharova anticipated this nationalist

affirmation in her impromptu speech at the Jack of Diamonds exhibition in Moscow, arguing that:

Cubism is a positive phenomenon, but it is not altogether new. The Scythian stone images, the painted wooden dolls sold at fairs are those same Cubist works.[13]

Goncharova repeated the sentiments in the preface to the catalogues of her one-woman exhibition in Moscow in 1913.[14]

This pattern of references back to the "low" cultures of Russia and the East distinguishes the Russian avant-garde from other "peripheral" interpretations of metropolitan styles such as Czech Cubism and Hungarian Activism. These movements produced remarkable extensions of Cubism and Futurism, which, however, often proved to be lifeless and anonymous, precisely because they lacked connections with indigenous traditions. With the Russians, as Lentulov demonstrates in *Moscow,* we are reminded again and again that the finest attainments of Western art have been studied with diligence and enthusiasm and then have been undermined and threatened by the imposition of a vernacular artifact or inferior social status.

The heroes of the Russian avant-garde pictures of around 1910–15 are not the paramours and art dealers of Cubist Paris, but the floor polishers, streetwalkers, barbers, washerwomen, barmen, and knife grinders of Russia's new masses. Store signboards, window displays, painted trays, *lubki,* consumer advertising, postcards, household gadgets, *balagany* (Punch and Judy shows at fairgrounds), ballroom dancing, the family photograph, and many other "low" objects and rituals became part and parcel of the avant-garde endeavor.[15] Malevich scattered Russian newspaper print among the convolutions of his Synthetic Cubist paintings, Olga Rozanova depicted a *kamennaia baba* (stone effigy) from Moscow's Historical Museum in her Gauguin-like *Still Life* of 1911 (State Museum of Art, Slobodsk), Rodchenko imbued his collages of 1919–20 with a rich subtext of references to Russian cigarettes, matchboxes, and candies, thereby distancing himself from the parallel work of Kurt Schwitters. The result is often an ironic questioning and parodying of high art either through the deliberate confrontation of the two aesthetic systems within the same work of art or through the direct substitution of "high" by "low." Ilia Maskov's *Self-portrait with Petr Konchalovsky* (1910) (fig. 149), shown at the first Jack of Diamonds exhibition in Moscow in 1910–11 is a case in point.[16] In this enormous canvas, looking more like a primitive signboard than a studio painting, not only are the symbols of scholarship on the left (the Bible, books on Egypt, Greece, Italy, the arts, and Cézanne) overshadowed by the cheap and cheerful tin trays on the back wall, but the very profession of artist has been supplanted by that of weight lifter or wrestler, for both Maskov and Konchalovsky have associated themselves with dumbbells and weights, not with palettes and

brushes—one of many references to the culture of the circus and fairground that was of vital importance to the development of the avant-garde. For an example of the total cancellation of high art by low, we need look no further than Malevich's *Composition with Mona Lisa* of 1914 (fig. 150), in which a photograph of the Mona Lisa has been crossed out twice and juxtaposed with part of a newspaper advertisement announcing an apartment swap.

It is significant that Malevich is threatening the Mona Lisa with a newspaper cutting rather than with a motif from a peasant embroidery, a *lubok* or an icon: Malevich is replacing this universal symbol of high art with a universal symbol of vulgarity and superficiality (the newspaper)—an example of urban, not rural or native culture. Of course, patriarchal, rural traditions were important and much has been written about the relationship of the Russian avant-garde to the domestic heritage of folk art (costumes, toys, trays, embroideries, woodcarving, *lubki*). Suffice it to take one image from that lexicon—the eighteenth-century *lubok* of an Old Believer having his beard cut off—to understand the extent to which popular peasant culture penetrated the consciousness of twentieth-century Russian artists. David Burliuk, Marc Chagall, Nikolai Kupreianov, Larionov, Shevchenko, I. A. Skuie were among the many who interpreted this particular *lubok* at different times and in different media.[17] In fact, such artists paid particular attention to the medium of the *lubok,* adapted it to their own pictorial systems, and even revived it as a sociopolitical vehicle during the First World War and just after the October Revolution.[18]

But perhaps even more important for these artists was Russia's contemporary urban folklore, especially of Moscow, which so impressed them when they reached the great metropolis from their provincial towns and villages (the Burliuks, Malevich, Rodchenko, and Shevchenko came from the Ukraine, Larionov from Tiraspol, Lentulov from Penza District, etc.). While retaining a strong allegiance to their local cultures, these artists were excited by the hustle and bustle, the visual confusion, and technological novelties of the big city, as Larionov exclaimed in 1913:

the whole brilliant style of modern times—our trousers, jackets, shoes, trolleys, cars, airplanes, railroads, grandiose steamships—is fascinating, is a great epoch, one that has known no equal in the entire history of the world.[19]

This grafting of a common species onto a cultured rarity coincided with, and reflected, an unprecedented integration of cultural, social, and political conditions in Russia in the late nineteenth and twentieth centuries. Horticultural grafting and agricultural crossbreeding and the first investigations into genetic engineering were new avenues of inquiry that the scientific worlds of St. Petersburg, Moscow, and Kharkov were discussing and de-

veloping with enthusiasm. Just as the first experimental greenhouses were being built on the outskirts of Moscow and St. Petersburg and the first glass atriums were being introduced into the Art Nouveau edifices (such as the Europa Hotel in St. Petersburg and the Metropol Hotel in Moscow), encouraging the intense cultivation of orchids and other exotic plants that previously were unthinkable in Russia's bleak and hostile climate, so new forms of expression blossomed in the visual arts, producing rich amalgams of the *style moderne.* This, too, was distinguished by botanical excess, just like the fashionable Bengal roses of that time, "almost constantly blooming."[20] If we take account of this horticultural context, it becomes logical that the first major public manifestation of the Russian avant-garde was the Moscow exhibition called The Blue Rose in 1907, then a botanical fiction, but soon to be a reality thanks to artificial treatment. The Blue Rose was itself a heady mixture of French and Belgian Symbolism overlaid with references to the *balagan* (Nikolai Sapunov), the icon (Pavel Kuznetsov), and other native sources, causing one critic to describe the event as "heralding that primitivism to which modern art has come in its search for a renaissance at its very sources."[21] The horticultural metaphor attains even greater relevance when we recall that the Blue Rose artists wore flowers in their buttonholes at their vernissage.[22]

The image of the Moscow nurseryman, pruning, grafting, and evolving new and delicate species is a genteel evocation of the general impulse of Russian society at the beginning of the twentieth century toward cultural and social pluralism. It is important to remember that the artists of the Russian avant-garde not only created works of art that relied substantially on extensions of profane culture, but also behaved often in accordance with low or lowly rituals and ceremonies that were often quite opposed to the conventional comportment of Orthodox and petit-bourgeois Russia. For example, Tatlin and Malevich were especially interested in the *balagan* and the mummers and buffoons of folk theater, whose elements of irreverent farce and satire they applied to their scenographies for *The Emperor Maximilian and His Disobedient Son Adolf* (1911) (fig. 151) and *Victory over the Sun* (1913).[23] Artists such as Chagall, Goncharova, Larionov, and Malevich borrowed freely from the activities of the circus and the fairground with their clowns, gypsies, magicians, and fakirs (see fig. 152). They were fascinated by the acts of juggling, decapitation, levitation, and prestidigitation, and the subjects of some of their masterpieces—Burliuk's *Headless Barber* (1912, Private collection), Chagall's floating couples, Larionov's *Circus Dancer* (1911, Regional Museum of Visual Arts, Omsk), Malevich's portrait of the beheaded Kliun (1913, State Russian Museum, Leningrad)—may well derive as much from the observance of conjuring tricks as from higher philosophical concerns.

The most graphic way in which the avant-garde artists extended their love of the "low" into everyday behavior was through face and body painting. Konstantin Bolshakov, David Burliuk, Goncharova, Vasilii Kamensky, Larionov, Mikhail Le-Dantiu, Shevchenko, and Ilia Zdanevich all tried their hand at this ancient rite, painting their faces with cryptic signs and fragmented words (fig. 153). As Larionov and I. Zdanevich declared in their manifesto "Why We Paint Ourselves" of 1913:

We paint ourselves for an hour, and a change of experience calls for a change of painting, just as picture devours picture, when on the other side of a car windscreen store windows flash by running into each other: that's our faces. Tattooing is beautiful, but it says little—only about ones tribe and exploits. Our painting is the newsman. . . .

Our faces are like the screech of the trolley warning the hurrying passers-by, like the drunken sounds of the great tango.[24]

Of course, Goncharova, Larionov, and their colleagues drew on many sources of inspiration for their face painting. They referred to tattooing, Egyptian body painting, and cosmetic make-up as precedents, and in applying their mysterious signs and images, they were repeating the incantational and "liturgical" condition of the witch doctor and the shaman. But in the urban environment, graffiti on fences and walls must have also been a strong stimulus, especially since they often included rude words or used a recondite language that was intelligible only to a particular group (e.g., thieves or prostitutes). Larionov and Shevchenko, in particular, were drawn to graffiti and repeated them literally in their soldier and Venus paintings, for example, Larionov's *Soldier Relaxing* (1911, Tretiakov Gallery, Moscow), Larionov's *Venus* of 1912 (fig. 154) and Shevchenko's *Venus* of 1915 (fig. 155), and it is not unreasonable to assume that some of the Cubo-Futurist paintings that incorporate "low" words (e.g., "blockhead" in Larionov's *Portrait of Tatlin* of 1913, Private collection), rebuses (e.g., Goncharova's *Rayist Garden* of 1912–13, Private collection), and neologisms (e.g., "KIAGAS" in Malevich's *Soldier of the First Division* of 1914, Museum of Modern Art, New York) owe their literary dimensions to this interest in graffiti.

Applying graffiti to their faces, therefore, Larionov and his friends appeared at art exhibitions and other public events, inciting both abuse and jocularity in the same way that circus clowns did. In their little theaters, such as the Pink Lantern and the Tavern of the 13, they offered to paint the faces of their audiences, recited *zaum* (i.e., "transrational") poetry and, in general, did all they could to erode the limits of social and artistic decorum. One correspondent observed the result:

A disgraceful, brazen, and talentless can-can reigns dissolutely in the temples of art, and grimacing and wriggling on its altars are these shaggy young guys in their orange shirts and painted physiognomies.[25]

Such resentment only prompted Goncharova, Larionov, and their friends to fall still lower by making a film about their theatrical activities entitled *Drama in the Futurists' Cabaret No. 13,* released in January 1914. Although no copy of this movie survives, witnesses recall that it told the story of a Futurist party at which the guests had painted faces, Goncharova was very décolletée, Krüger danced a Futurist tango, there was a Futurist *crime de passion,* and the fun ended with a Futurist funeral.[26]

Krüger dancing the Futurist tango reminds us that the Larionovu/Zdanevich manifesto "Why We Paint Ourselves" is illustrated by photographs of the artists with their faces painted and of a couple dancing the tango.[27] Malevich's 1914 *Woman at a Poster Column* (also called *Woman at an Advertisement Column* (fig. 156) also contains part of a newspaper photograph of a couple tangoing, while Kamensky and the Burliuks danced a "tango with cows" in their miscellany of the same name published in Moscow in 1914. Rodchenko's fifth photomontage for Vladimir Maiakovsky's *Pro eto* ("About It") of 1923 also shows a couple dancing the tango beneath the caption "Jass [sic] Two Step, Fox-trot, Shimmy." The tango, which in Russia at the beginning of the twentieth century was often referred to as the "Argentine Tango" (cf. Malevich's *Argentine Polka,* 1911, Private collection),[28] was regarded as a gesture of radical chic and sexual emancipation. Practiced by the demi-mondes and artistic bohemias of St. Petersburg and Moscow, it was condemned, of course, by the pillars of social decency. For this reason, artists such as Goncharova and Larionov identified their unconventional aesthetics with the tango, and the leading *tangisty* of the time such as Mak (pseudonym of the artist Pavel Ivanov), Elsa Krüger, and Antonina Privalova moved closely with the avant-garde (see fig. 157).[29] Goncharova painted Mak's portrait in 1913 (present whereabouts unknown) and designed Krüger's dresses, Privalova joined in the fashion for face and body painting, and Alexandra Exter, incidentally, designed Krüger's Berlin apartment in 1927. Some of the Russian Cubo-Futurists welcomed the tango not only for its scandalous potential, but also as the first phase in a "dance as such" by analogy with their poetry and painting "as such," a correlation that they discussed at their public lecture "On the Tango" in St. Petersburg in 1914.[30] The great actress Vera Kholodnaia, a friend of Goncharova and Larionov, even played the lead role in the movie *The Last Tango,* released in Moscow in 1915.[31]

This close interrelationship between professional artists and the practitioners of the "low" arts such as tattooing, ballroom dancing, and the cinema is symptomatic of the complex process of cross-fertilization and

assimilation of images, attitudes, and forms that occurred during the time of Russian modernism. The primary members of the Russian avant-garde took an active part in this desanctification of high art through the superimposition of shocking images, the recognition of "unartistic" objects (e.g., telephones, postcards) as "artistic," the frequent placement of the work of art in an unartistic environment, and the application of "absurd" or misleading titles to their art exhibitions. But in this context the grafting of artistic styles was often a more brutal and abrasive procedure than in the horticultural nursery, especially when "microbes" of profane art were injected deliberately into the body of high art. The result, for many observers, was elegant and deceptive, bearing the "suspicious smell of a cadaver."[32]

Two of the "lowest" species that the avant-garde grafted onto the sophisticated systems of Cubism, Futurism, and Constructivism were the pig and the herring. The pig trotting in and out of Larionov's Neo-Primitivist paintings of 1906–12 is a symptom of the artist's rejection of the middle-class concepts of art and beauty and relates immediately to his humble iconographic arsenal of soldiers, provincial dandies, gypsies, barbers, and streetwalkers. *Gypsy in Tiraspol* of around 1906 (fig. 158) and *Walk in a Provincial Town* (1907, Tretiakov) are major examples of Larionov's *svinstvo* (uncouth behavior, literally, "piggery") and must have perplexed his public at the Jack of Diamonds and Donkey's Tail exhibitions in 1910 and 1912, for whom the pig was, at worst, a diabolical appurtenance of the Anti-Christ or, at best, a butt of coarse merriment. After all, Anatolii and Vladimir Durov, members of the great clown family of Larionov's day, used to enter the arena on pigs (see fig. 159), and once Vladimir's pig even impersonated Kaiser Wilhelm — which resulted in arrest and prosecution in Germany.[33] Niko Pirosmanashvili, the Georgian primitive, whom Le-Dantiu and the Zdanevich brothers discovered in 1912, also endeared himself to Larionov by his fondness for pigs, as is manifest from his magnificent rendering *Sow and Piglets* of around 1910 (fig. 160)[34] Surely, Alexei Kruchenykh and Malevich were paying homage to this tradition when they called one of their Cubo-Futurist publications *Porosiata* ("Piglets") (St. Petersburg: EUY, 1913). In turn, Larionov and Malevich were restoring an organic connection with the popular image of the pig treated numerous times in *lubki* of the eighteenth and nineteenth centuries. The witch in the *lubok* called *Baba-Yaga Rides to Fight the Crocodile* (a satire on Peter the Great) and the jester in the *Red Nosed Jester Farnos* (the first Russian "fool") (see fig. 152) ride pigs as if emphasizing their status as outsiders, a social association that would have appealed to the avant-garde artists.[35]

A motif perhaps even more mundane than the pig was the herring (and the mackerel and the *voblia*), which, in various refractions, appears in the still lifes, interiors, and even portraits by Pavel Filonov, Konchalovsky, Larionov, Vladimir Malagis, Malevich, Kuzma Petrov-Vodkin, Rozanova, David

Shterenberg, Tatlin, and Yurii Vasnetsov. Deliberately or not, this simple image of the staple Russian diet, often wrapped in newspaper and consumed with beer, tends to undermine and satirize the values of any elevated artistic system that the artist may be using as a point of departure. In Malevich's masterpieces of transrationalism, *Englishman in Moscow* (1913, Stedelijk Museum, Amsterdam) and the *Aviator: A Portrait* (1914, Russian Museum) the herring/mackerel dominates the surface, destroying both the Cubist syntax of these pre-Suprematist works and establishing a series of random, alogical associations that *zaum* was supposed to evoke. As Malevich wrote in 1914:

For the artist reason is the prisoner's chain and consequently, I would that every artist lose his reason.[36]

In both Petrov-Vodkin's *Still Life with Herring* of 1918 (fig. 161) and Shterenberg's *Still Life with Lamp and Herring* (1920, Russian Museum) the modest fish reconnects with the ordinary reality of everyday after these sophisticated exercises in spherical geometry. For Filonov, too — as is evident from his untitled painting of fish (1912–15, Ludwig Collection, Cologne) — the herring is a mere component of the organic universe in which everything has a uniform beauty beyond any hierarchy of spiritual and moral values. Larionov's famous *Sausage and Mackerel* of 1912 (fig. 162) acts as a vehicle for the exposition of Rayism, according to which

the objects that we see in life play no role here, but that which is the essence of painting itself can be shown here best of all — the combination of color, its saturation, the relation of colored masses, depth, texture.[37]

The grafting of pigs, fish, and other vulgar species onto serious artistic discourse was encouraged not only by the general wish to shock "you old bags crammed with wrinkles and grey hair,"[38] but also by the rediscovery of particular kinds of urban folklore. In the case of pigs and fish, an immediate derivation was the store signboard which D. Burliuk, Chagall, Shevchenko, and others collected and included in their exhibitions such as Target in 1913. Pirosmanashvili, the artist of *Sow and Piglets* (see fig. 160) was a signboard painter by profession; Konstantin Dydyshko (a member of the Union of Youth) made a serious study of St. Petersburg signboards, noting their measurements, color combinations, and locations; Filonov maintained that a special department of signboards and other examples of contemporary popular culture should be included in the Museum of Painterly Culture in Petrograd;[39] Maiakovsky published his poem "To Signboards" ("Vyveskam") illustrated by Tatlin in 1913 (fig. 163);[40] Pavel Mansurov based some of his *Painterly Formulae* on a signboard for beer,[41] Shevchenko painted at least

two pictures based on fruiterers' signboards, in 1913 *Signboard Still Life: Wine and Fruit* (fig. 164) and in 1914 *Black Still Life* (Rubinshtein Collection, Moscow); and Malevich actually regarded the signboard as the ultimate point of influence in his early career:

At first I imitated icon-painting. . . . The second period was a purely "labor oriented one": I painted peasants at work . . . The third was when I came to the "suburban genre" (carpenters, gardeners, dacha places, and bathers). The fourth period was that of the "city signboard" (floor-polishers, maids, butlers, servants).[42]

Painted in bright colors and lapidary forms, these signboards depicting clothes, drinks, sausages, loaves, etc. were intended to communicate—to the often illiterate passerby—the function of the respective store. As Vera Ermolaeva, one of Malevich's students, wrote in 1919:

A good signboard is elegant, didactic, and durable. Both the shopkeeper and the customer appreciate it for being well made. And it's well made when good quality paint has been put on a piece of new and heavy iron with skill and dexterity, when each depiction has been executed in its conventional form germane to it alone and with a method peculiar only to that form, and when all the depictions combine into a rigorously constructed whole.[43]

Sometimes, the signboard would be an image only, for example of a joint of meat (see fig. 165), which seems to have inspired Goncharova's *Still Life with Ham* of 1912 (fig. 166); a loaf or loaves (see figs. 167 and 168), an image that returns in Konchalovsky's *Still Life with Loaves* of 1913 and Larionov's *Loaves* of 1910 (both in the Tretiakov), and Mashkov's *Loaves* of 1912 (in the Russian Museum); or a boot, something paraphrased by Valentin Kurdov in his *Felt Boot* of 1926–27 (in the Russian Museum). Alternatively, the signboard would advertise the services of some profession, such as barber or washerwoman (see fig. 169). A vivid example of the avant-garde's appreciation and extrapolation of a particular signboard stereotype is the recurrent motif in the 1910s and 1920s of a woman ironing clothes—from Shevchenko's *Woman Ironing* of 1920 (fig. 170) to Vladimir Lebedev's series of paintings and drawings on the same theme, culminating in his total "cubization" of the figure in his paintings of the mid-1920s (*Cubism,* Russian Museum) where the woman, no longer recognizable, has been reduced to a purely formal sequence.[44]

Occasionally, the signboard would be a simple, three-dimensional item such as a hanging glove made of wood to indicate a glove store or a top hat to indicate a hat store—volumetrical objects that recur in a number of paintings, reliefs, and sculptures of the avant-garde period. The ubiquitous top hat worn by the Cubo-Futurists such as D. Burliuk and Maiakovsky

together with their wooden spoons and fancy waistcoats reached its most absurd reembodiment in Maiakovsky's contribution to the Exhibition of Painting in Moscow in 1915, which consisted of a "top hat cut into halves with gloves on either side."[45] Ivan Puni (Pougny) distilled such appurtenances in his 1915 paintings called *Hairdresser* (Musée National d'Art Moderne, Paris), *Baths* (Herman Berninger Collection, Zürich), and *Washing Windows* (fig. 171), the last of which was inspired by an advertisement for yogurt in a pharmacy near the artist's studio in Petrograd. In around 1914 Malevich complicated matters further with his incorporation of the signboard for a fishmonger (see fig. 172) into a transrational context, i.e., his juxtaposition of an ace of clubs, abstract forms, and a fish above the word "Tailor" (fig. 173). This particular combination was abstracted still further by Rozanova (or Kruchenykh) in an untitled collage of around 1916 (fig. 174) in which she canceled the fish with a diagonal collage.[46]

This enthusiasm for *vyvesochnoe iskusstvo* (signboard art) on the part of the avant-garde artists extended to the allied, "low" arts of backdrops for photographers' studios, fairground and circus scenery, surrounds for rifle ranges, and wallpaper. Such elements inspired a number of important paintings such as Fedor Bogorodsky's and Nikolai Rogovin's portraits of people having their photographs taken. But it was wallpaper that seemed to attract the most artists, both because of its decorative patterns and also because of its association with mass production, chintzy living rooms, and bad taste. Both issues of the miscellany *Sadok sudei* ("A Trap for Judges") in 1910 and 1913 had covers of wallpaper, Popova actually wrote the word "wallpaper" on one of her still lifes of 1914 (Ludwig Collection, Cologne), Rozanova included wallpaper in her *Room* (c. 1914, State Museum of Art, Krasnodar), Rodchenko produced a collage in 1915 called *Wallpaper* (Private collection), and Goncharova and Larionov actually designed wallpaper for a Moscow factory in 1914, repeating the happy peacocks, parrots, and flowers of the cheap, do-it-yourself wallpaper available in the new Moscow department stores. Naturally, these artists often looked beyond the external signboards and advertisements into the stores themselves, finding a simple and refreshing artistry in window dressing, store interiors, and the paraphernalia peculiar to the various trades, such as the dummies wearing wigs in barbershop windows, the wooden mannequins in tailors' stores, the medical bottles of pharmacies, and the cotton reels, scissors, brushes, and vanity cases of haberdashers that so appealed to Rozanova in works like *Barbershop* (c. 1914, Tretiakov); and *Workbox* of 1915 (fig. 175).

Such images were a component part of the new urban folklore that accompanied Russia's rapid industrialization toward the end of the nineteenth century. Her capitalist boom led not only to an unprecedented economic expansion, but also to the visual transformation of Moscow, St. Petersburg, and other cities as new railroad stations, banks, department

stores, functional complexes such as water towers, and sumptuous villas for the nouveaux riches were constructed.[47] The architectural silhouette of Moscow changed radically during those years as the first high-rise, ferro-concrete buildings began to vie with the old churches and palaces for social recognition and prestige. Artists paid attention to this visual transformation, and there is no question that members of the avant-garde such as Rodchenko and Tatlin were inspired as much by the steel-frame buildings of water towers, pavilions, and silos as by icons and Cézanne. It is important to remember that this intense urbanization was accompanied by an extraordinary flood of new consumer commodities, furnishings, and fixtures that were advertised to, and acquired by, the new bourgeoisie. The "yellow pages" (actually, they are pink, green, and white) in the Moscow telephone directory for 1898, for example, contain announcements for flush toilets, electric massage parlors, and American typewriters,[48] and the leisure magazines of the 1900s, such as *Ogonek* and *Stolitsa i usadba,* contain detailed statements on all manner of gadgets—from phonographs and airplanes to electric elevators and air fresheners (see fig. 176). Leafing through these journals, one realizes that, within a generation, the respectable Russian household had moved from gas to electric lighting, from music boxes to gramophones, from handmade chocolates to industrial candies, and from horse-drawn to horseless carriages. Even though most of the avant-garde artists lived too modestly to afford these middle-class novelties, they were, inevitably, affected visually and emotionally by the influx of mechanical wizardries. They touched these things in the homes of their rich patrons, such as Nadezhda Dobychina, the Girshmans, and the Riabushinskys, or read the advertisements in the many posters, billboards, and brochures.

In some cases, Russian artists accepted these gadgets as symbols of the new epoch of speed and industrial production, and they quoted them in their paraphrases of Italian Futurism. Their fascination with airplanes and electric trams, for example, is evident in many of the avant-garde expressions such as Goncharova's *Airplane over a Train* (1913, State Museum of Art, Kazan), Malevich's *Simultaneous Death of a Man in an Airplane and on the Railroad* (1913) and *Woman at a Tram Stop* (1914, Stedelijk Museum, Amsterdam), Mikhail Menkov's *Tram No. 6* (1914, State Museum of Art, Kuibyshev), and in the very title of the "last Futurist exhibition," Tram V, which was held in Petrograd, 1915. Consistent with this theme is the fact that, literally, a primary vehicle for the extension of Suprematism "into life" after the October Revolution was the side panels of trams in Vitebsk to which Malevich and his pupils applied their elaborations of Suprematist colors and forms (see fig. 177). We should also remember that Nikolai Suetin, one of Malevich's closest disciples, designed Suprematist store signboards in Vitebsk in 1919–21.[49]

The references to the consumer commodities of the ideal Russian home in

avant-garde paintings were evoked as much by the typographical and lithographic representations of these things as by their three-dimensional presence. It is clear from both pre- and post-Revolutionary works that the patterns and schemes of commercial advertising that accompanied the new products were of particular interest to professional artists, and they played a prominent part in the radical creativity of the avant-garde. Of course, this particular interrelationship was not entirely new, since a number of professional artists in the nineteenth century—not least, Georgii Leonov (see fig. 178)—had already produced collages incorporating newspaper print, cigarette packs, playing cards, and pieces of postcards.[50] Certainly, by the end of the nineteenth century the popular press offered artists a wide choice of typefaces, calligraphies, and typographical layouts, symmetrical and asymmetrical, constituting a rich graphic source that was especially relevant to the development of Cubo-Futurist visual poetry, such as the typographical montages by the Burkiuk brothers or the "ferro-concrete" poems by Kamensky. A clear example of this aesthetic borrowing is Ilia Zdanevich's famous dramatic poem *Lidantiu—faram* ("Le Dantiu—the Beacon") (fig. 179), which draws on the same notion of varied visual accompaniments to varied phonic values as in standard ABC books of the late nineteenth century (see fig. 180). For the professional artist, consumer advertising also pointed to the potential applications of collage and photomontage, and to the possibility of combining the incompatible, such as the simultaneous appearance of advertisements for tea and corsets on the same printed page. (Larionov actually subtitled his painting *Woman in a Blue Corset* "Newspaper Ad" at the Donkey's Tail in 1912).

Encouraged, of course, by French Cubism, Malevich also relied on these typographical games in his transrational paintings of 1913–14, in which the photographic reproduction, the newspaper script, and the printed number are often taken from Moscow and St. Petersburg dailies. As tiny reliefs, these collages establish a movement away from the surface into space, when semantically logical, they may add an ironic commentary on the composition, and as parts of a "low" art (a newspaper) they challenge our presuppositions about aesthetic nobility and artistic quality. Perhaps the most convincing example in title and in content of this grafting of commercial advertising ("low" art) onto a traditional genre such as the female portrait ("high") is Malevich's *Woman at a Poster Column* of 1914 (see fig. 156) in which fragments of announcements from a poster column have been imposed on the Suprematist color planes, which, in turn, are eclipsing the world of recognizable figures and objects. Five years later Stepanova reversed this procedure in her cycle of transrational graphic poetry *Gaust-Chaba* (fig. 181) in which she applied abstract shapes and letters in watercolor ("high") to a "canvas" of newspaper script and photographs

("low"), i.e., the newspaper has now become the "sensible" foundation of the work, while the "senseless" component has become the painted appliqué.[51]

This collaging of commercial design onto the professional work of art achieved spectacular results at the hands of Gustav Klucis, Rodchenko, Sergei Senkin, Stepanova, and Solomon Telingater just after the October Revolution. Rodchenko and Stepanova produced their most exciting collages in 1918–21 when they worked very closely together, often sharing the same paper fragments (see fig. 182).[52] For example, they both cut up the same picture books, producing, as it were, twin collages based on the same images, e.g., from postcards of the Museum of Fine Arts in Moscow (now the Pushkin Museum of Fine Arts). It is tempting to try and explain why in his collages Rodchenko might place four studies of women and one torso on a scrap of newspaper carrying the latest news or integrate pharmaceutical descriptions with theatrical announcements. But as in Schwitters's collages of the same period, there are numerous private allusions to contemporary social and political events; some of the collages carry sharp, ironic juxtapositions of references to the old and new regimes, and others are brilliant exercises in non sequiturs. Rodchenko and Stepanova were quite capable of creating visual harmonies out of advertisements for pianolas, milk, flour, and Isadora Duncan or cigarette packs, Narkompros stationery, and postcards. In some cases, the collages are independent works of art, in other cases they are book illustrations, e.g. by Rodchenko for Kruchenykh's transrational poem *Tsotso* (1921) and by Stepanova for his poem *Gly-Gly* (1918) or for her own abstract poetry.

Rodchenko's familiarity with the world of commercial advertising served him in good stead when he embarked upon posters and wrappers for the new state enterprises in the early 1920s. Candies, galoshes, cigarettes, baby pacifiers were among the many products that Rodchenko packaged in 1923–25 according to Constructivist formulas, and some of them such as the 1923 baby-pacifier poster are now acknowledged to be primary examples of Constructivist design. Still, these severe interplays of schematic images with their exclamatory captions constitute an economy of visual means and message that was not new in the history of Russian commercial design. Professional artists were involved in such advertising well before the Revolution, often for the same factories that were nationalized in 1918. The anonymous posters for the Veiner Beer Factories in Astrakhan of around 1910 bring to mind Rodchenko's 1925 poster for the Three Hills Beer Factory; the various posters for the Einem Candy and Biscuit Factory in Moscow of around 1910 are no less audacious than the Rodchenko/ Maiakovsky wrappers for the same enterprise in 1923–24 (then called the Red October Candy Factory); and the posters for galoshes produced by the

Conductor Corporation in Riga in about 1910 surely inspired those of Rodchenko and Maiakovsky for the State Rubber Trust in Moscow in 1923–24 (see figs. 183 and 184).[53]

Obviously, Rodchenko and his colleagues paraphrased or elaborated particular typographical layouts that they found in pre-Revolutionary magazines and posters (including movie posters): the diagonal scripts, repeated exclamation marks, and contrasting typefaces were devices that Rodchenko transferred to his advertisements for state commodities and enterprises.[54] This is evident from direct comparisons between the advertisements for Teikhman's insulation materials of 1906 (fig. 185) or the movie posters for the Khanzhonkov and Filipp Corporations of around 1915 — e.g., those for *The State Councillor's Love* (fig. 186) and *The Eagle* (fig. 187) and Rodchenko's book and magazine covers of the mid-1920s. El Lissitzky's cover design for the cover of *ASNOVA* in 1926 and Popova's music cover designs of 1922 also extend basic polygraphical stereotypes from the previous two decades.[55] But, of course, in spirit and sensibility, Rodchenko's designs for the nationalized companies of the 1920s do depart from the pre-Revolutionary models. Posters such as *There Have Not Been and There Are No Better Pacifiers* of 1923 no longer represent the grafting of a low art form on a high one, but rather, the reverse, since the product (in this case, baby pacifiers) and the selling thereof are presented according to the rigorous principles of the Constructivist credo:

In rationalizing artistic labor, the Constructivists are putting into practice — not in verbal, but in concrete terms — the real qualifications of the *object*. They are raising its quality, establishing its social role, and organizing its forms in an organic relationship with its utilitarian meaning and purpose.[56]

At this point, the very categories of "high" and "low" cease to be meaningful, since "Art is finished! It has no place in the human labor apparatus. Labor, technology, organization!"[57] Exter, Popova, Rodchenko, Stepanova, and Alexander Vesnin made this clear in their statements at the 5 × 5 = 25 exhibition in Moscow in 1921 at which they dismissed the notion of the "fine arts," of the artist painting and sculpting in the privacy of the studio, and of art as an activity of privilege and prestige. The Constructivists argued for the cancellation of this traditional primacy or, rather, for the substitution of "low" for "high," so that Popova and Stepanova moved from studio paintings to dress design, Vsevolod Meierkhold from dramatic theater to the circus, and Georgii and Vladimir Stenberg from their free-standing constructions to movie posters.

Symptomatic of this orientation toward mass culture among the Constructivists and of their conviction that the "vulgar" media such as photography, cinema, consumer design should now be the primary focus of attention

was Klucis's move from abstract paintings and constructions to posters and postcards in the mid- and late 1920s.[58] As a member of the October group in the late 1920s, Klucis himself made this clear in his article on photomontage published in 1931:

In replacing the drawing made by hand with the photograph, the artist depicts this or that detail more truthfully, more vitally, and—to the masses—more comprehensibly.[59]

From 1919 onward Klucis concentrated more and more on photomontage in poster, postcard, and magazine design, from the first experiment called *Dynamic City* (1919) to the layouts for *Pravda* in the 1930s. While favoring a documentary but still imaginative approach, Klucis organized his compositions in a severe and schematic manner that made their sense immediately accessible to the new consumer, just as in a commercial advertisement. An associate of the magazine *Lef,* Klucis was in direct contact with Rodchenko, Senkin, Stepanova, and Telingater, and he supported the group's strong preference for industrial and propaganda design as vehicles for the dissemination of political ideas.[60] From his projects for radio loudspeakers in 1922 through his postcards for the All-Union Spartakiada in Moscow in 1928 (fig. 188) and the reconstruction posters of the 1930s, Klucis claimed that art could and should serve ideological commitments. To this end, he also tried to adjust "low" to "high" or perhaps we should say "low to low" by drawing on the traditions of the picture postcard and the cheap newspaper, and his photomontages and collages are among the most vivid examples of this artistic transmutation.

■ Popular culture provided a vital source of energy to the artists of the Russian avant-garde, offering a new vocabulary of image and perception that distinguished them immediately from their Realist precursors and Western competitors. But, of course, even in the case of the Constructivists with their claim to be proletarian and democratic, this artistic efflorescence could survive only in an artificial environment of rich nutrition and rare ether. By its very nature, the avant-garde was an exotic species, distant from the society that it satirized or served and intolerant of deviant taste. It was a species that could be appreciated only by the connoisseur and by members of the same club that romanticized—and misunderstood—the common man, whose common culture they praised and advocated. One of the many enigmas of the time that followed, the Stalin era, is that Socialist Realism restored the arts to their former hierarchies, and with the resurgence of the academies, the professional painter, sculptor, and architect turned back to classical Greece and Rome and the High Renaissance for inspiration. Popular culture

flourished, but once again, it was divorced from the higher echelons of aesthetic experience. The fine arts also flourished, even though just a few years before artists had sung the praises of graffiti and called for the liquidation of Michelangelo, Raphael, and Rastrelli; now, they dismissed "low" taste and welcomed the return of Titian in painting, Pericles in sculpture, and Palladio in architecture—even the arts of gardening and grafting were now brought into line with the principles of Socialist Realism.[61] The result was the abrupt reestablishment of that very same hierarchy of artistic values which the avant-garde had sought to undermine and destroy. Obviously, in that cold and suppressive environment such an exotic hybrid could no longer survive.

NOTES

1. Even though a detailed examination of the subject has yet to be made, a number of recent publications that deal with particular aspects of modern Russian art and popular culture should be mentioned, i.e., Neia Zorkaia, *Na rubezhe stoletii* (Moscow: Nauka, 1976); Alexander Kamensky et al., *Primitiv i ego mesto v khudozhestvennoi kulture novogo i noveishego vremeni* (Moscow: Nauka, 1983); Viktor Plotnikov, *Folklor i russkoe izobrazitelnoe iskusstvo vtoroi poloviny XIX veka* (Leningrad: Khudozhnik RSFSR, 1987). Gennadii Pospelov has discussed the issue of urban folklore and the Russian avant-garde in his monograph on the Jack of Diamonds group, i.e., *Karo-Bube* (Dresden: VEB, 1985); and in his article "O 'valetakh'bubnovykh i valetakh chervonnykh" in *Panorama iskusstv 77* (Moscow: Sovetskii khudozhnik, 1978), pp. 127–42; see also G. Ostrovsky, "Iz istorii russkogo gorodskogo primitiva vtoroi poloviny XVIII–XIX veka" in Kamensky, *Primitiv,* pp. 77–104. An especially valuable contribution to our understanding of this particular area is the book by Alla Povelikhina and Evgenii Kovtun entitled *Russian Painted Shop Signs and Avant-Garde Artists* (forthcoming from Aurora, Leningrad, in English, French, German, and Russian editions). A primary goal of the exhibition currently being organized by the State Russian Museum, Leningrad, and Intercultura, Fort Worth, Tex., via the Ministry of Culture of the USSR, is also to examine the question of how popular art affected the development of the Russian avant-garde, i.e., The Donkey's Tail: The Russian Avant-Garde and Primitive Art (touring Leningrad, Fort Worth, Los Angeles, and Chicago in 1992–93).

2. For information on Siberian art, including *kamennye baby* (stone effigies), and shaman rituals, see Sergei Ivanov, *Materialy po izobrazitelnomu iskusstvu naradov Sibiri XIX-nachalo XX veka* (Moscow and Leningrad: Akademiia nauk, 1954); Sergei Ivanov, *Skulptura narodov severa Sibiri XIX—pervoi poloviny XX v.* (Leningrad: Nauka, 1970); Vladimir Basilov, *Izbranniki dukhov* (Moscow: Politizdat, 1984); *Nomads of Eurasia,* catalogue of an exhibition at the Natural History Museum, Los Angeles, and other institutions, 1989; see also Boris Rybakov, *Yazychestvo Drevnei Rusi* (Moscow: Nauka, 1987). Artists and writers of the Russian avant-garde cultivated a particular interest in children's drawings, including them in their exhibitions and publications, e.g., at the Salon, International Exhibition organized by Vladimir Izdebsky in Odessa and other cities in 1909–10; at the Moscow Salon in 1911; and at the Target in Moscow, 1913 (children's drawings from Nikolai Vinogradov's and Shevchenko's collections). Alexei Kruchenykh paid homage to children's creativity by including their drawings and poems in two of his Cubo-Futurist booklets, i.e., *Porosiata* ("Piglets") (St. Petersburg: EUY, 1913) and *Sobstvennye razskazy i risunki detei* (St. Petersburg: EUY, 1914). The avant-garde was also aware of the achievements of African, American Indian, and other "native" cultures, albeit in a limited fashion, through Russian collections. Sergei Shchukin, for example, owned several pieces of African art (now in the Pushkin Museum of Fine Arts, Moscow), and a number of

museums in Moscow, St. Petersburg, and Riga included examples in their collections. The artist and critic Vladimir Markov (pseudonym of Waldemar Matvejs), a leading member of the Union of Youth group in St. Petersburg, made a thorough examination of African art in Western European collections in 1913 and wrote an important book on the subject, i.e., *Iskusstvo negrov* (published posthumously in 1919 by IZO Narkompros in Petrograd; for commentary, see Irina Kozhevnikova, *Varvara Bubnova. Russkii khudozhnik v Yaponii* [Moscow: Nauka, 1984], pp. 42–45); Markov also published an essay on the art of Easter Island, i.e., *Iskusstvo Ostrova Pashki* (St. Petersburg: Soiuz molodezhi, 1914). For information on Markov, see John E. Bowlt, ed., *Russian Art of the Avant-Garde: Theory and Criticism 1902–1934* (London: Thames & Hudson, 1988), pp. 23–38; Troels Andersen et al., *Art et poésie russes, 1900–1930. Textes choisis* (Paris: Centre Georges Pompidou, 1979), pp. 53–57; Kovtun, "Vladimir Markov i otkrytie afrikanskogo iskusstva," in *Pamiatniki kultury. Novye otkrytiia. Ezhegodnik 1980* (Leningrad: Nauka, 1981), pp. 411–16; and Varvara Bubnova, ed., "V. I. Matvei. 'O "printsipe tiazhesti" v afrikanskoi skulpture,'" *Narody Azii i Afriki* (Moscow), no. 2, 1966, pp. 148–57. By the 1890s Russia had (and still has) one of the finest collections of Pacific and American Indian art, thanks, above all, to the explorations and acquisitions of Nikolai Miklukho-Maklai. See Elsie Webster, *The Moon Man* (Berkeley: University of California Press, 1984); see also, *Sobranie grafa Nikolaia Petrovicha Rumiansteva* (Moscow: Levenson, 1913), especially pp. 24–29.

3. Vasilii Kandinsky, *Tekst khudozhnika* (Moscow: IZO Narkompros, 1918), p. 28.

4. For information on Kandinsky and shamanism, see Peg Weiss, "Kandinsky and 'Old Russia': An Ethnographic Exploration," in Gabriel Weisberg and Larina Dixon, eds., *The Documented Image: Visions in Art History* (Syracuse, N.Y.: Syracuse University Press, 1987), pp. 187–222. Peg Weiss is now completing a monograph on the subject under the provisional title "Kandinsky and Old Russia: The Artist as Ethnographer and Shaman," for Yale University Press, New Haven.

5. The main depositories of Russian peasant and ecclesiastical art at the beginning of the twentieth century were the Kustarnyi [Handicraft] Museum in Moscow, Petr Shchukin's private collection in Moscow, and Princess Mariia Tenisheva's private museum in Smolensk. For information on these collections, see L. K. Rozova et al., *Muzei narodnogo iskusstva i khudozhestvennye promysli* (Moscow: Izobrazitelnoe iskusstvo, 1972); *Objets d'art russes anciens*, catalogue of an exhibition of part of the Tenisheva collection at the Musée des Arts Décoratifs, Paris, 1907; Petr Shchukin, *Kratkoe opisanie Shchukinskogo muzeia v Moskve* (Moscow: Mamontov, 1895). Major ethnographical collections were held in the Dashkov collection in the Rumiantsev Museum, Moscow. See N. Ianchuk, *Musée Etnographique Dachkov au Musée Public et Musée Roumianzov* (Moscow, Sobko, 1910), and N. Yanchuk, "Dashkovskii etnograficheskii muzei i otdelenie inostrannoi etnografii," in *Piatidesiatiletie Rumiantsevskogo muzeia v Moskve. 1862–1912. Istoricheskii ocherk* (Moscow: Levenson, 1913), pp. 161–82.

6. On Miklukho-Maklai, see Webster, *Moon Man*. On the Guenzburg expeditions and the revival of interest in Jewish folk art in Russia, see Ruth Gabriel-Apter et al., *Tradition and Revolution: The Jewish Renaissance in Russian Avant-Garde Art 1912–1928* (exhibition catalogue, Jerusalem: Israel Museum), 1987.

7. For information on Abramtsevo and Talashkino, see Nina Beloglazova, *Abramtsevo* (Moscow: Sovetskaia Rossiia, 1981); Grigorii Sternin et al., *Abramtsevo* (Leningrad: Khudozhnik RSFSR, 1988); Boris Rybchenkov and Alexander Chaplin, *Talashkino* (Moscow: Izobrazitelnoe iskusstvo, 1973); Larisa Zhuravleva, "Tenishevskie emali" *Tvorchestvo* (Moscow) no. 11 (1989), pp. 16–19; see also John E. Bowlt, "Two Russian Maecenases, Savva Mamontov and Princess Tenisheva," *Apollo* (London), December 1973, pp. 444–53.

8. The standard histories of the Russian avant-garde all discuss the influence of icons and *lubki* on modern Russian art, although many aspects of the connection have yet to be analyzed in detail. See, for example, Camilla Gray, *The Russian Experiment in Art, 1863–1922* (London: Thames & Hudson, 1986; rev. ed. by Marian Burleigh-Motley), especially chapter 4; Valentine Marcadé, *Le Renouveau de l'art pictural russe* (Lausanne: L'Age d'Homme, 1971), especially chapter 2; Tatiana Loguine, *Gontcharova et Larionov* (Paris: Klincksieck, 1971), especially

pp. 32–37, which carry details on Larionov's exhibitions of icons and *lubki* in Moscow in 1913. See also Valentine Marcadé, "The Peasant Theme in the Work of Kazimir Severinovich Malevich," in *Malewitsch,* catalogue of an exhibition at the Galerie Gmurzynska, Cologne, 1978, pp. 94–119; and her "O vliianii narodnogo tvorchestva na iskusstvo russkikh avangardnykh khudozhnikov desiatykh godov 20-go stoletiia," in *VIIe Congrès international des slavistes. Communications de la délégation française* (Paris: Institut d'études slaves, 1973), pp. 279–99. Important information on the general rediscovery and reassessment of icons at the beginning of the twentieth century in Russia is provided by Gerold Vzdornov in his book *Istoriia otkrytiia i izucheniia russkoi srednevekovoi zhivopisi XIX veka* (Moscow: Iskusstvo, 1986), especially chapter 7; and by Yurii Bobrov in his *Istoriia restavratsii drevnerusskoi zhivopisi* (Leningrad: Khudozhnik RSFSR, 1987), especially chapter 3.

9. On Aristarkh Lentulov, see *Aristarkh Lentulov,* catalogue of an exhibition at the Central House of the Artist, Moscow, 1987. *Moscow* is reproduced in color on page 37. The following abbreviations are used in these notes to indicate the whereabouts of works: PC = private collection; RM = State Russian Museum, Leningrad; TG = State Tretiakov Gallery, Moscow.

10. Sonia Delaunay, "Letter" (1926), translation in Arthur Cohen, ed., *The New Art of Color: The Writings of Robert and Sonia Delaunay* (New York: Viking, 1978), p. 202.

11. Alexander Shevchenko, *Neo-primitivizm* (1913), translation in Bowlt, *Russian Art,* p. 49. For further information on Shevchenko see Zh. Kaganskaia et al., *A. V. Shevchenko. Sbornik materialov* (Moscow: Sovetskii khudozhnik), 1980.

12. Alexander Shevchenko, *Printsipy kubizma* (Moscow: Shevchenko, 1913), pp. 17, 18.

13. Natalia Goncharova's speech is published in Benedikt Livshits, *Polutoraglazyi strelets* (1933), English translation under the title *The One and a Half-Eyed Archer* (Newtonville, Mass. ORP, 1977), pp. 80–81.

14. Natalia Goncharova, untitled preface to the catalogue of her one-woman exhibition at the Art Salon, Moscow, 1913, pp. 1–4.

15. For information on Russian signboards, see Yurii Gerchuk, *Zhivye veshchi* (Moscow: Sovetskii khudozhnik, 1977), chapter 4; G. Ostrovsky, "Russkaia vyveska," in *Panorama iskusstv 78* (Moscow: Sovetskii khudozhnik, 1979), pp. 238–62; and Povelikhina and Kovtun, *Russian Painted Shop Signs;* on painted trays, see Irina Krapivina, *Russian Hand-Painted Trays* (Leningrad: Aurora, 1981); on *lubki,* see Alla Sytova, *The Lubok: Russian Folk Pictures* (Leningrad: Aurora, 1984); on consumer advertising, see Nina Baburina, *Russkii plakat, vtoraia polovina XIX–nachalo XX veka* (Leningrad: Khudozhnik RSFSR, 1988); Volia Liakhov, *Sovetskii reklamnyi plakat* (Moscow: Sovetskii khudozhnik, 1972); Mikhail Anikst, ed., *Soviet Commercial Design of the Twenties* (London: Thames & Hudson, 1987); on postcards, see Emmanuil Fainshtein, *V mire otkrytki* (Moscow: Planeta, 1976), and Nikolai Tagrin, *Mir v otkrytke* (Moscow: Izobrazitelnoe iskusstvo, 1978); on *balagany,* see Anna Nekrylova, *Russkie narodnye gorodskie prazdniki, uveseleniia i zrelishcha* (Leningrad: Iskusstvo, 1988); on ballroom dancing, see Natalia Sheremetievskaia, *Tanets na estrade* (Moscow: Iskusstvo, 1985); on photography, see Sergei Morozov, *Russkaia khudozhestvennaia fotografiia* (Moscow: Iskusstvo, 1955).

16. The most comprehensive sources of information on Petr Konchalovsky and Ilia Maskov are: Mark Neiman, *P. P. Konchalovsky* (Moscow: Sovetskii khudozhnik, 1967); and I. S. Bolotina, *Ilia Mashkov* (Moscow: Sovetskii khudozhnik, 1977) (his self-portrait with Konchalovsky is reproduced there as colorplate 12).

17. Reproductions of some of the barbershop scenes can be found in the following sources: D. Burliuk, *Headless Barber* (1912, PC), in *Russian Avant-Garde 1908–1922,* catalogue of an exhibition at the Leonard Hutton Galleries, New York, 1971, p. 33; Chagall, *Barbershop (Uncle Zusman)* (1914, TG), in Marina Bessonova, comp., *Shagal. Vozvrashchenie mastera* (Moscow: Sovetskii khudozhnik, 1988), p. 58; Kupreianov, *Men's Hairdresser;* and *Women's Hairdresser* (1920–22, PC), in N. S. Iznar and M. Z. Kholodovskaia, comps., *N. N. Kupreianov. Literaturno-khudozhestvennoe nasledie* (Moscow: Iskusstvo, 1973), plates 48, 49; Larionov, *Officer at the*

Hairdresser (1910, TG), in Waldemar George, *Larionov* (Paris: Bibliothèque des Arts, 1966), p. 63; Shevchenko, *At Her Toilette* (1920, PC), in *Alexander Shevchenko,* catalogue of an exhibition at the Pushkin Museum of Fine Arts, Moscow, 1975, n. pag.; Skuie contributed a *Family Portrait of a Hairdresser* (whereabouts unknown) to The Donkey's Tail exhibition in 1912.

18. Just after the outbreak of World War I, in August 1914, a corporation called the Modern Lubok was established in Moscow for the publication of patriotic *lubki* in poster and postcard form. Some of the avant-garde artists, including D. Burliuk, Vasilii Chekrygin, Larionov, Lentulov, Maiakovsky, Malevich, and Mashkov participated in this enterprise and produced rousing anti-German scenes accompanied by patriotic jingles. To a considerable extent, the propaganda sheets by Vladimir Lebedev, Maiakovsky, and other artists for the Okna ROSTA (Windows of the Russian Telegraph Agency) in Moscow, Petrograd, and other cities in 1919–22 also maintained the traditions of the *lubok.* For reproductions of some of these *lubki,* see *Russian Avant-Garde Art: The George Costakis Collection,* ed. Angelica Zander Rudenstine (New York: Harry N. Abrams, 1981), pp. 422–29; Vsevolod Petrov, *V. Lebedev* (Leningrad: Khudozhnik RSFSR, 1972), passim; Wiktor Duwakin, *Majakowski Rostafenster* (Dresden: VEB, 1975).

19. Mikhail Larionov and Natalia Goncharova, "Luchisty i budushniki: Manifest" (1913), translation in Bowlt, *Russian Art,* p. 89.

20. *Verkmeister, Odessa* (Odessa: Fesenko, 1912), p. 10 (catalogue of roses issued by the E. G. Verkmeister Nursery). For information on the horticulture and nursery industries in Russia at the beginning of the twentieth century, see Vladimir Kurbatov, *Sady i parki* (Petrograd, 1916); L. B. Lunts et al., eds., *Problemy sadovo-parkovoi arkhitektury* (Moscow, 1936); L. B. Lunts, *Zelenoe stroitelstvo* (Moscow: Goslesbumazhizdat, 1952); P. A. Kosarevsky, *Iskusstvo parkovogo peizazha* (Moscow, 1977).

21. Sergei Makovsky, "Golubaia roza" *Zolotoe runo* (Moscow), no. 5, 1907, p. 25.

22. Artists of the Blue Rose and Jack of Diamonds groups also made and painted paper flowers and used them in their still-life arrangements. See Anna Ostroumova-Lebedeva, *Avtobiogaficheskie zapiski* (Leningrad: Iskusstvo 1945), vol. 1, p. 130.

23. On the *balagan,* see Nekrylova, *Russkie narodnye;* on the minstrels and buffoons, see Russell Zguta, *Russian Minstrels: A History of the "Skomorokhi"* (Philadelphia: University of Pennsylvania Press, 1978). For commentary on the ways in which Malevich and Tatlin drew on folk sources in their design work for the indicated productions, see Flora Syrkina, "Tatlin's Theatre," in Larissa Zhadova et al., *Tatlin* (New York: Rizzoli, 1988), pp. 155–79, and John E. Bowlt, *Russian Stage Design. Scenic Innovation, 1900–1930. From the Collection of Mr. and Mrs. Nikita D. Lobanov-Rostovsky,* catalogue of an exhibition at the Mississippi Museum of Art, Jackson, 1982, pp. 214–17, 292–95.

24. Ilia Zdanevich and Mikhail Larionov, "Pochemu my raskrashivaemsia" (1913), translation in Bowlt, *Russian Art,* p. 82 (see note 27 below). Zdanevich wrote a second explanation of face painting under the title "O raskraske litsa" (Manuscript Section, State Russian Museum, Leningrad, f. 177, ed. khr. 29, undated).

25. "Opiat futuristy (vmesto peredovoi)," *Akter* (Moscow), no. 4, 1913, pp. 1–2.

26. I would like to thank Jerry Heil for providing me with valuable information on the movie *Drama in Futurists' Cabaret No. 13.* See his article "Russian Futurism and the Cinema: Majakovskij's Film Work of 1913," in *Russian Literature* (Amsterdam), no. 19, 1986, pp. 175–92.

27. The text of "Pochemu my raskrashivaemsia" ("Why We Paint Ourselves") appeared in the journal *Argus* (St. Petersburg), December 1913, pp. 114–18. The two illustrations of the couple dancing the tango are on page 115.

28. Malevich borrowed the theme and image of his *Argentine Polka* from a photograph in the contemporary magazine *Ogonek.* For commentary and explanation, see Anatolii Strigalev, " 'Krestianskoe,' 'gorodskoe' i 'vselennoe' u Malevicha" *Tvorchestvo* (Moscow), no. 4, 1989, pp. 26–30.

29. For some information on Mak, Krüger, and the tango, see Sheremetievskaia, *Tanets na estrade*, pp. 22–26. For Krüger's comments on the tango, see Z., "E. A. Krüger o 'tango,'" *Teatr v karrikaturakh* (Moscow), no. 16, 1913, p. 24. Another close context in which Goncharova, Krüger, and Larionov appeared was the miscellany *Almanakh verbnogo bazara* (Moscow: Levenson, 1914), which carried a photograph of Krüger and Valli dancing the tango next to a photograph of one of Goncharova's portraits of Larionov together with a photograph of Larionov. It cannot be ruled out that, in their enthusiasm for the tango, Goncharova and Larionov were taking a conscious stand against Filippo Marinetti and his rejection of the tango, i.e., the letter — "Abbasso il tango et Parsifal!" — that he circulated among his friends and then published in 1914 in French in Milan as "A bas le tango et Parsifal."

30. The public lecture "On the Tango" was held at the Kalashnikov Bread Exchange, St. Petersburg, on April 13, 1914. Nikolai Kulbin was among the protagonists, Natan Altman and Ilia Zdanevich were among the antagonists, and a section of the discussion was devoted to the Marinetti declaration on the tango and Parsifal. See I. Zdanevich, "O tango" (1914) in State Russian Museum, Manuscript Section, fond 177, ed. khr. 29.

31. The poster for the movie *The Last Tango* is reproduced in Zorkaia, *Na rubezhe stoletii*, p. 197. For information on Vera Kholodnaia and her connections with Russian modernism, see A. Kapler, *Zagadka korolevy ekrana* (Moscow, 1979).

32. Apollinarii Vasnetsov, *Khudozhestva* (Moscow: Knebel, 1906), p. 122.

33. Anatolii Durov's autobiography is of particular relevance to the relationship of the Russian avant-garde to popular culture. See Anatolii Durov, *V zhizni i na stsene* (Voronezh, 1914; Moscow: Iskusstvo, 1984). The story of Vladimir Durov's pig and Kaiser Wilhelm is narrated by Joel Schechter in his book *Durov's Pig* (New York: Theatre Communications Group, 1985), pp. 1–17.

34. For information on Pirosmanashvili, see Erast Kuznetsov, *Niko Pirosmani* (Leningrad: Aurora, 1983); *Pirosmani* (Leningrad: Iskusstvo, 1984). For reproductions and commentary on other naive artists, see Natalia Shkarovskaia, *Narodnoe samodeiatelnoe iskusstvo* (Leningrad: Aurora, 1975).

35. Both *lubki* are reproduced in Sytova, *Lubok*, plates 27, 38.

36. Kazimir Malevich et al., "Paskhalnye pozhelaniia," *Sinii zhurnal*, April 1915. The page is reproduced in Herman Berninger and Jean-Albert Cartier, *Pougny* (Tübingen: Wasmuth, 1972), vol. 1, p. 49.

37. Mikhail Larionov, "Luchistskaia zhivopis" (1913), translation in Bowlt, *Russian Art*, p. 90.

38. Vladimir Maiakovsky, "Kaplia degtia" (1913), translation in Anna Lawton, ed., *Russian Futurism through Its Manifestoes, 1912–1928* (Ithaca, N.Y.: Cornell University Press, 1988), p. 101.

39. Pavel Filonov, "Doklad na muzeinoi konferentsii" (1923), translation in Nicoletta Misler and John E. Bowlt, *Pavel Filonov: A Hero and His Fate* (Austin, Tex.: Silvergirl, 1983), p. 181. Filonov incorporated a number of signboard motifs into his paintings and drawings. See, for example, his watercolor *Market* (1923–24, RM) and sepia *Still Life (Vegetables: Study of a Signboard)* (1920s, RM). Both are reproduced in *Pavel Nikolaevich Filonov*, catalogue of an exhibition at the State Russian Museum, Leningrad, 1988, pp. 69, 70.

40. For a detailed commentary on Maiakovsky's "Vyveskam" and Tatlin's illustrations, see Juliette Stapanian, "V. Majakovskij's 'To Signs' (Vyveskam) — a Cubist 'Signboard' in Verse," *Slavic and East European Journal* (Tucson, Ariz.), vol. 26, no. 2 (1982), pp. 174–86; and *Mayakovsky's Cubo-Futurist Vision* (Houston, Tex.: Rice University Press, 1986), chapter 5.

41. Mansurov described his appreciation of signboards in an undated letter to Carlo Belloli. See *Mansurov*, catalogue of an exhibition at Lorenzelli Arte, Milan, 1987, p. 25.

42. Kazimir Malevich, "Avtobiografiia," in Nikolai Khardzhiev, ed., *K istorii russkogo avangarda* (Stockholm: Almquist and Wiksell, 1976), p. 118.

43. Vera Ermolaeva, "Peterburgskaia vyveska," *Iskusstvo kommuny* (Petrograd), no. 8, January 26, 1919, p. 2.

44. Shevchenko's *Woman Ironing* is reproduced in color in Kaganskaia, *A. V. Shevchenko*, p. 67, and in black and white in *Alexander Shevchenko*, catalogue of an exhibition at the State Russian Museum, Leningrad, 1978, n. pag. Several of Lebedev's pictures of women ironing are reproduced in Petrov, *V. Lebedev*, pp. 35–40.

45. Aristarkh Lentulov, "Avtobiografiia," in *Sovetskie khudozhniki* (Moscow: Ogiz, 1937), vol. 1, p. 160. Maiakovsky participated, though his work was not mentioned in the catalogue.

46. The Malevich fish is reproduced in *Malewitsch*, p. 210; the Rozanova (Kruchenyhk) fish is reproduced in Rudenstine, *Russian Avant-Garde*, p. 457. For other examples of Malevich's "alogical" use of fish imagery, see Jean-Claude Marcadé, ed., *Malévitch* (Lausanne: L'Age d'Homme, 1978, illustration numbers 74, 76.

47. For information on Russia's new industrial architecture in the late nineteenth century and early twentieth century, see Yurii Volchok et al., *Konstruktsii i arkhitekturnaia forma v russkom zodchestve XIX–nachala XX vv* (Moscow: Stroiizdat, 1977), especially the section by Nina Smurova, "Inzhenernye sooruzheniia i ikh vliianie na razvitie russkoi khudozhestvennoi kultury," pp. 60–93; Marietta Gize, *Ocherki istorii khudozhestvennogo konstruirovaniia v Rossii XVIII–nachala XX veka* (Leningrad: Leningradskii universitet, 1978).

48. A. Suvorin, ed., *Vsia Moskva. Adresnaia i spravochnaia kniga na 1898 god* (Moscow: Chicherin, 1898).

49. For reproductions of Suetin's Suprematist signboards, see Larissa Zhadova, *Malevich* (London: Thames & Hudson, 1982), plates 158–61; for reproductions of Nina Kogan's and Suetin's Suprematist designs for trams, see ibid., plates 174, 175.

50. For information on Georgii Leonov and his collages, see Gerchuk, *Zhivye veschi*, pp. 66–68.

51. For reproductions of Stepanova's collages, including those for *Gaust-Chaba*, see *Die Kunstismen in Russland / The Isms of Art in Russia*, catalogue of an exhibition at the Galerie Gmurzynska, Cologne, 1977, pp. 134, 135; Rudenstine, *Russian Avant-Garde*, p. 469; Alexander Lavrentiev, *Varvara Stepanova*, Cambridge, Mass.: MIT Press, 1988, pp. 18–31.

52. For reproductions of Rodchenko's collages, see German Karginov, *Rodchenko* (London: Thames & Hudson, 1979), plates 102–4; *Rodcenko / Stepanova. Alle origini del Costruttivismo*, catalogue of an exhibition at the Palazzo dei Priori e Palazzo Cesaroni, Perugia, 1984, p. 65; Selim Khan-Magomedov, *Rodchenko: The Complete Work* (Cambridge, Mass.: MIT Press, 1987), passim.

53. For reproductions of pre-Revolutionary commercial posters, including those for the Veiner Beer Factories, the Einem Candy and Biscuit Factory, and the Conductor Corporation, see Baburina, *Ruskii plakat*. Reproductions of Rodchenko's designs for posters for beer, candies, and galoshes can be found in the standard books on the artist and in Anikst, *Soviet Commercial Design*.

54. See, for example, Rodchenko's designs for GUM posters, reproduced in Khan-Magomedov, *Rodchenko*, pp. 150, 151.

55. Lissitzky's cover for *ASNOVA* is reproduced in Anikst, *Soviet Commercial Design*, p. 121; some of Popova's music cover designs are reproduced in Rudenstine, *Russian Avant-Garde*, p. 413.

56. Grigorii Miller, et al., "Pervaia rabochaia gruppa konstruktivistov" (1924), translation in Bowlt, *Russian Art*, p. 241.

57. Alexei Gan, *Konstruktivizm* (1922), translation in Bowlt, *Russian Art*, p. 223.

58. The main source of information on Klucis (Klutsis) is Larisa Oginskaia, *Gustav Klutsis*

(Moscow, Sovetskii khudozhnik, 1981). The postcards are reproduced on pp. 89–97. See also *Gustav Klucis,* catalogue of an exhibition at the Galerie Gmuryznska, Cologne, 1988.

59. Gustav Klutsis (Klucis), "Fotomontazh kak novyi vid agitatsionnogo iskusstva," in Pavel Novitsky, ed., *Izofront. Klassovaia borba na fronte prostranstvennyh iskusstv* (Moscow and Leningrad: Ogiz and Izogiz, 1931), p. 120.

60. Klucis published an anonymous article on photomontage in *Lef.* See "Foto-montazh," *Lef* (Moscow), no. 4, 1924, pp. 41–44.

61. See, for example, E. V. Shervinsky, "Sotsialisticheskii realizm v sadovo-parkovom iskusstve," in *150 let arkhitekturnogo obrazovaniia v Moskve* (Moscow: Akademiia arkhitektura SSSR), 1940.

■ NO JOY IN MUDVILLE:

GREENBERG'S MODERNISM

THEN AND NOW ■

Coming and going we cross his way. For fifty years Clement Greenberg has planted himself squarely in the midst of debate about the past and future of modernism. Sequentially or simultaneously a cultural essayist, gallery reviewer, studio coach, and panel pundit, he has been and remains the single most controversial critic of his time—and by virtue of that controversy, the single most influential one as well. The Wizard of Oz of Formalism, commanding the allegiance of a host of curators, historians, dealers, and critics, he has issued edicts, sanctioned movements, and punished recalcitrants from behind the screen of his connoisseurship. For many the figure of ultimate and unimpeachable authority, for others—in particular former acolytes—Greenberg is the focus of Oedipal curiosity and envy. Previously enthralled by his aura of certainty and the heavily edited historicism of his thought, these disillusioned dependents currently revisit the scene of his self-invention, hoping to find relics of the personal and social past he has tried so assiduously to erase from memory.

There is much there to rediscover and sort out. For everyone concerned, including those immune to his mystique and well practiced at calling his doctrinal bluff the stakes are high. By usurping the American tradition of radical social criticism only to write it off as the preamble for a capricious and deterministic aestheticism willfully blind to its unsettled and impinging circumstance, Greenberg deprived subsequent generations of their true intellectual heritage. Although usually silent on contemporary affairs, even now the subject of this retrospective investigation can be heard commenting on and to a large extent setting the tone of its proceedings. Indeed, the tenor of his idiom and the grammar of his thinking can readily be detected in the work of many of his erstwhile disciples and present inquisitors, as well as in that of his constant admirers. Like the Great Oz, he thus continues to impose his will through a theatrical absence intermittently and unpredictably punctuated with new pronouncements and unexpected twists on old arguments. As always, even when they depart from or trivialize his former positions, they are spoken with an unflagging confidence that posterity will bear them out.

"After all, the best taste agrees in the long run," Greenberg announced to a symposium in 1953.[1] Such statements are his hallmark. Cueing the art-historical applause track, they firmed the resolve of the fainthearted and bullied the doubtful that Greenberg sought to rally around his version of the modernist cause. Over the long haul, however, opinions conditioned on a promised consensus beg for back-checking. Consider some of his more recent pronouncements: Speaking to *ARTnews* in 1987, he said, "I think the best painter alive now is Jules Olitski . . . Noland is still a great painter . . . I think Wyeth is way better than most of the avant-garde stars of this time. Better than Rauschenberg. Better now than Jasper Johns."[2] While it is always possible to assemble a quorum of the "happy few" to ratify one's

ROBERT
STORR
■

prejudices, surely Greenberg does not believe that among members of the informed art audience "the best taste agrees" on this score.

It is tempting then to write these remarks off as the products of a temperamental kink or signs of professional intransigence in the face of changing times. To a degree they are both. A kind of pontifical wisecracking, nevertheless, they also provide a useful analytic tool. For not only do Greenberg's views fly in the face of the conventional wisdom of the day — lending them, it must be admitted, a certain desperate piquancy — by example they call into question the very basis of his own critical practice. Unwilling to argue or modify his publicly declared preferences, yet seemingly restless within the structure they blandly ornament, Greenberg has lately been toying with the criteria that originally determined those choices.

First articulated in two seminal articles, "Avant-Garde and Kitsch" and "Towards a Newer Laocoon," Greenberg's initial premises are so familiar as to seem axiomatic. The destiny of modernism, he contended, lay in the purification and the self-referentiality of artistic means and ends. The modernist project hence consisted of the progressive elimination of the influence of one medium upon another and the gradual reduction of each to its "essential" properties and possibilities. Supported by a self-assured, liberal bourgeoisie "to which it has always remained attached by an umbilical cord of gold," the agent of this process was the avant-garde.[3] Its opposite and adversary was represented by "kitsch." Introducing into general parlance a German epithet for the gaudy and sentimental excess of bourgeois decoration, Greenberg named its American analogs: "popular, commercial art and literature with their chromotypes, magazine covers, illustrations, ads, slick and pulp fiction, comics, Tin Pan Alley music, tap dancing, Hollywood movies, etc., etc."[4] Originally slang for "gutter scrappings," Greenberg's usage repolarizes the word's referents by suggesting more a fall from grace than a welling-up of cultural drek. Inherent trashiness is not enough; devolution is involved. For Greenberg kitsch is specifically *debased* high art. Mass-produced simulacra of creations whose informing conventions it exploits as manufacturing templates, kitsch gratifies the demand for pleasure without making any demands of its own. Whether painting or sculpture, object or idea, it reproduces artistic effects but ignores their causes. Citing the facile realism of I. Y. Repin, Greenberg argued that even talent cannot redeem a work whose ambition does not include a close examination of its guiding formal principles.[5] To the contrary, in the hands of a skilled craftsman, art may fail precisely by succeeding too well at disguising its artifice. Doing all the work on behalf of the public, kitsch thus betrays art's obligation to make that public think. The avant-garde, by distinction, takes nothing for granted. Rather, it uses art to question and elucidate art's "givens." By virtue of its ceaseless self-criticality, the avant-garde serves the society to which it is otherwise marginal by resisting the tendency toward cultural inertia in-

scribed in the canons of the academy and reiterated in the witless appropriations and crude reproductions of merchandisers.

Paradoxically, Greenberg's enduring fixation with Olitski, his abiding antipathy for Rauschenberg and Johns, and his recent enthusiasm for Wyeth affirm by inversion the antithesis first proposed in these two articles. Employing the term "avant-garde" as a pejorative, and singling out the Repin of Brandywine for praise, Greenberg in effect stands his own hierarchy on its head, offering his assessments as a negative proof of the lasting validity of his fundamental schema. Loyal to the Color Field academy, whose oracle he was, Greenberg displays an Alexandrian condescension toward — and ignorance of — the abstract art of the present. Sworn enemy of Surrealism and Dada, he has taken side against Rauschenberg and Johns and chosen that of our greatest living "kitsch-meister," Wyeth, whose arid illustrations make formulaic use of the picture-plane-puncturing techniques of chiaroscuro once anathema to Greenberg while "lending" themselves to endless reproduction. Most of all, Wyeth's dreary vignettes celebrate the cultural and social immobility against which the avant-garde has traditionally been locked in struggle. Pugnacious as ever — and as ever proud — Greenberg has in effect reasserted his categorical opposition of high and low culture while reversing his optic. To that extent his recent exercises in taste making instructively redirect our attention to the arbitrariness of that vision and telescope it into the past.

Despite Greenberg's conviction that true quality of judgment transcends the stresses and vagaries of time, it is impossible to make sense of or do justice to his ideas in any but historical terms. Those ideas had their moment, and that moment its mood. Delmore Schwartz's "New Year's Eve," a barely fictional account of a social gathering of Greenberg's crowd, describes it.

Yes it was 1938. How strange that it should be 1938, how strange seemed the word and the fact. No one knew that this was to be the year of the Munich Pact, but everyone knew there would be a new world war . . . As Shenandoah, Nicholas and Wilhelmina parted in emptiness and depression, Shenandoah was already locked in what was soon to be a post-Munich sensibility: complete hopelessness of perception and feeling.[6]

Testimony to the despair brought on by the spread of fascism and the failures and crimes of Soviet Communism is remarkably consistent. Left-wing aesthetes of most tendencies professed much the same bleak view of their collective future. "All a writer can do," Stephen Spender wrote Christopher Isherwood in 1938, "the only completely revolutionary attitude for him today, is to try and create standards which are really civilized."[7] The phrasing is strikingly similar to the final sentences of "Avant-Garde and Kitsch."

Here as in every other question today, it becomes necessary to quote Marx word for word. Today we no longer look toward socialism for a new culture — as inevitably one will appear, once we do have socialism. Today we look to socialism *simply* for the preservation of whatever living culture we have right now.[8]

By the fall of 1939, when "Avant Garde and Kitsch" appeared in the *Partisan Review* (see fig. 189) events had gone from bad to catastrophic. August saw the signing of the Hitler-Stalin pact followed by the outbreak of hostilities in Europe. A year later, the same month that "Towards a Newer Laocoon" was published, Leon Trotsky, the journal's unpredictable and often harsh guiding light, was assassinated.[9] The apocalyptic tone of Greenberg's essay thus clearly echoed the anguished uncertainty that had suddenly beset the once confident radical intelligentsia. Declaring toward the middle of the essay that modernism's historical mission was to "keep culture *moving*," by the end. Greenberg's message was different in spirit; against the prevailing menace of global reaction, the best that could be accomplished, he felt, was a holding action.[10] Of paramount significance, this shift in emphasis was more than circumstantial, as Walter Benjamin (see fig. 190), a true martyr of that moment and a profoundly subtle Marxist, had foreseen. Anticipating this turn of mind, ten years before, Benjamin had said of the Surrealists, whom he considered the last flowering of the old avant-garde:

It is typical of these left-wing French intellectuals — exactly as it is of their Russian counterparts, too — that their positive function derives entirely from a feeling of obligation, not to Revolution, but to traditional culture. Their collective achievement, as far as it is positive, approximates conservation.[11]

Even without Benjamin's caution, however, Greenberg's ostensible politics, in particular his appeal to Marx's authority, demand close scrutiny.

Greenberg was a latecomer to the Left of his generation. A 1955 autobiographical statement quoted in the introduction to his *Collected Essays and Criticism* makes no mention of any political affiliation whatsoever. It does recount his graduation from Syracuse University in 1930, time spent in his father's dry-goods business, his work as a translator, and finally his tenure as customs officer prior to his joining the editorial staff at *Partisan Review* in 1940. Only social and family ties and his freelance literary work seem to have brought him into contact with radical circles. In the mid-1930s he translated *The Brown Network, the Activities of the Nazis in Foreign Countries,* a report on the victims of fascism, as well as some works of Bertolt Brecht. Although a brother, Sol, belonged to Max Shachtman's Worker's Party, a Trotskyite splinter group, never, it seems, was Greenberg himself a member of a party. Neither did he take an active role in the affairs of the Artists' Congress (1935–42) or any other such cultural caucus. Indeed, since

he had sat out most of the factional fights and organizational efforts that had animated the discourse and tempered the will of his New York colleagues, Greenberg's experience of Depression era politics was bookish and remote even by the standards of the intellectual Left in general.

Strong parallels nevertheless existed between his political and aesthetic positions. Naming militarism as reaction's social manifestation, and kitsch its artistic one, Greenberg's response to both was to signal for retreat and retrenchment on high ground. In a July–August 1941 tract entitled "10 Propositions on the War," written in conjunction with Dwight MacDonald, who had commissioned "Avant-Garde and Kitsch" from the previously unknown critic, Greenberg opposed participation in the war on the grounds that any collaboration with the ruling oligarchies of England and its allies would only reinforce their power over the working class and hasten the rise of domestic fascism.[12] Equating the fundamental interests of Hitler and Mussolini with those of the ruling castes in the liberal democracies under Churchill and Roosevelt, Greenberg and MacDonald urged radicals to abstain from the conflict and await an imminent revolution, one which, the authors speculated, "will be neither a protracted nor an especially violent struggle."[13] Nor would the success of the rebellion depend upon expert or elite leadership. Such cadres were obviated by the "technical competence and relatively high cultural level of the individual worker, [which allowed] for a much wider distribution of initiative and authority, thus making possible, indeed necessary, a quite different kind of revolutionary party from the Bolshevik model."[14] Implicitly—and ironically—trusting the masses to make spontaneously subtle political choices based on their "relatively high cultural level," while mistrusting their capacity to read books or look at pictures, Greenberg urged socialists to preserve their purity of purpose by refusing actively to support the war against the Axis just as, on the cultural front, he called upon writers and painters to protect the purity of their endeavors by effecting a staged withdrawal into "art for art's sake."

The problem, made obvious by the collapse of the Spanish Republic in 1939 and the betrayals of Stalin, was that no such upheaval was forthcoming. Around the world socialism had failed to sustain the momentum of change, and popular movements inspired by it had fragmented or turned to the Right. Although it struck a nerve in veteran radicals who recalled the Left's co-optation at the beginning of World War I, Greenberg and Mac-Donald's case against involvement was patently schematic and their political categories hazy if not altogether devoid of reality.[15] A sophomoric gloss of Marxism, and a grossly simplified and distorted understanding of the forces at work in mass society thereby contributed to the formulation of a stance that pitted an unfounded revolutionary optimism against more justified but no less absolute pessimism. That combination would henceforth be typical of Greenberg's thinking and writing.[16]

For the record, moreover, Greenberg's policy on the war, like the mission he assigned the demoralized avant-garde, directly contradicted positions taken by Trotsky. On the one hand, believing that the defeat of fascism was of the first importance, Trotsky had repeatedly affirmed his "critical support" of the Soviet Union in the event of Nazi aggression. Defense of the existing worker's state, he maintained, was an unequivocal revolutionary duty as well as a precondition for the overthrow of the reactionary bureaucracy superimposed upon it by his arch enemy Stalin.[17] On the other hand, Trotsky's socially committed but nonsectarian views on art were articulated with equal vehemence and clarity. Greenberg, indeed, could scarcely have missed them or their import. In an essay published in the August 1938 *Partisan Review*, for example, Trotsky wrote, "Art which is the most complex part of culture, the most sensitive and at the same time least protected, suffers most from the decline and decay of the bourgeois society . . . To find a solution to this impasse through art itself is impossible . . . Art can neither escape the crisis nor partition itself off. Art cannot save itself."[18] Moreover, in a manifesto printed in the pages of the *Partisan Review* that same year over the signatures of Diego Rivera and André Breton, and publicly endorsed, *and* secretly coauthored, by Trotsky (see fig. 191), could be found further and still more explicit condemnation of the concept of art for art's sake. "It is far from our wish," the document flatly stated, "to revive a so-called pure art which generally serves the extremely impure ends of reaction."[19]

Against this background, Greenberg's revolutionary rhetoric rings hollow. At the time, however, it rang clear. As the grandiloquent looseness of his arguments proves rather than disproves, Greenberg's intuitions regarding the dramatic shift in cultural power then in progress were extremely shrewd, as was his pioneering translation of the ideas of the Right into the terminology of the Left. Blurring ideological distinctions and foreshortening historical processes, a plea for international solidarity and the militant defense of enlightened culture was thus enlisted to confer legitimacy on what in truth was a policy of Left-wing isolationism and the call for a return to Parnassus. "Someday," Greenberg wrote in a much cited comment added to his 1957 memoir, "The Late Thirties in New York," "it will have to be told how 'Anti-Stalinism,' which started out more or less as 'Trotskyism,' turned into art for art's sake and thereby cleared the way, heroically, for what was to come."[20] Accustomed to the historical voice, Greenberg betrays by the abbreviations of this chronology just how limited was his actual participation in the process that it apparently describes. For Meyer Schapiro, Harold Rosenberg, and other Marxist-oriented critics of the period covered by Greenberg's summary, the drift away from activism followed a long and wrenching commitment of which "Anti-Stalinism" was not the beginning but the middle and "Trotskyism" scarcely the code word for a nascent Formalism (see fig. 192).[21] But timing is all, and Greenberg's was perfect. Seizing upon

the disarray in which the intellectual community found itself, he understood how the consolidation of a "saving remnant" would make it possible to salvage the idea of the avant-garde. Entering the ranks of the independent socialists just as they were breaking up, therefore, Greenberg sought to conjure "a third force" out of the mists of radical rhetoric, showing a beleaguered Left the path toward "honorable" disengagement through deft paraphrases of the language of engagement.[22]

Contentious in tone and ostensibly rigorous in its analysis, from the outset Greenberg's position subsumed a staggeringly eclectic range of attitudes and ideas. From the neo-Platonist aesthete Walter Pater he took the notion that, "all art aspires constantly to the condition of music," and from Bernard Berenson the paradigm and posture of the connoisseur. From the anti-Romantic critic Irving Babbitt's 1910 book, *A New Laocoon: An Essay on the Confusion of the Arts,* he adapted the title for his own essay.[23] Littering his reviews with references to empiricism and positivism, by 1942 Greenberg began making frequent allusion to Kant's theories regarding the universality and disinterestedness of taste. A contagious "chutzpah" initially informed these piratical appropriations, in particular the last. *Partisan Review* Editor William Barrett recalled:

There was a special sense of triumph when Greenberg trotted out the reference to Kant: for one thing the reference was a little arcane, and there was special cachet in citing a philosopher who did not fall anywhere within the Marxist canon. But sometimes the reference did sound rather sententious coming from Greenberg's lips, and Delmore [Schwartz] would growl, Clem is always putting on the dog— intellectually speaking. . . . you know Clem doesn't know what he's talking about when he mentions Kant.[24]

What "Clem" knew about Kant — or eventually learned — is less significant than the manner in which he introduced him and the role he assigned him. Reading one step ahead of his class, Greenberg avoided any serious attempt to reconcile the discrepancies between his latest critical *trouvaille* and his original premises. An increasingly brittle carapace overarching the theoretical hodgepodge of his aesthetic program, Greenberg's "Marxist" materialism covered for his undisciplined albeit dogmatic idealism.

Nor did "Marxism" simply drop from his discourse once more suitable models came to the fore. It was fundamental to his polemical strategy, and Greenberg persistently revived it throughout his career, most notably in his 1953 text, "The Plight of Culture," in which he returns to the theme of the mutual hostility between advanced art and the popular audience.[25] Responding to T. S. Eliot's "Notes Toward the Definition of Culture," Greenberg takes the poet to task for miscalculating the extent of technology's influence on the "organic" cycles of cultural growth and decay. Whereas the tech-

nological revolution is responsible for the death of "folk culture," and "abysses of vulgarity and falsehood unknown in the recoverable past," Greenberg once again holds out for a long-term utopian solution to the problems of civilization's decline, this time proposing the replacement of Western industrial society by one modeled on a primitive, preindustrial socialism.[26] Under such hypothetical circumstances, art, rather than being consigned to the realm of leisure — that is, passive enjoyment — would, on a mass basis, be given the status of work — that is, unalienated labor. "Beyond such speculation, which is admittedly schematic and abstract, I cannot go," Greenberg said, concluding that, "nothing in these ideas suggests anything that could be sensibly hoped for in the present or near future."[27]

Typically hedged with last-minute disclaimers, the glimmer of distant yet profound social transformation is once again summoned to lend a radical aura to Greenberg's increasingly conservative preoccupation with cultural leveling.[28] Addressing many of the same issues and fears as "Avant-Garde and Kitsch," "The Plight of Culture" makes grudging allowance for previously unanticipated conditions. Contrary to Greenberg's initial scenario, the outcome of the late war was neither a final descent into barbarism nor a swift and relatively peaceful revolution. Far from sinking into a rigid Statism, in fact, America had emerged from the conflagration richer, more powerful, and socially more fluid than before. Hence, while the essential structure of Greenberg's dichotomy remained intact, his definition of its variables altered. Whereas in 1939 the enemy at the gates was fascist vulgarity — regimented low-browism — by 1953 it is liberal vulgarity — market-driven low- and middle-browism.[29]

In particular, Greenberg recoiled from the supposed convergence of the latter constituencies and decried the deleterious effects on artists and intellectuals of the expanding audience these middle and lower sectors together created. Already in 1947, he could write,

Yet high culture, which in the civilized past has always functioned on the basis of sharp class distinctions, is endangered — at least for the time being — by this sweeping process which, by wiping out social distinctions between the more or less cultivated, renders standards of art and thought provisional . . . It becomes increasingly difficult to tell who is serious and who is not. At the same time as the average college graduate becomes more literate the average intellectual becomes more banal, both in personal and professional activity.[30]

Ignoring for the moment its digressive insinuations — who, one may well ask, is the "average" intellectual and what bearing does the unseemliness of their unspecified "personal activity" have on the matter at hand — this text nicely explicates the hidden sociology of "The Plight of Culture" and, by extension, the class bias of all Greenberg's writing. In "Avant-Garde and Kitsch" Green-

berg prematurely predicted and mourned the passing of the old patronage aristocracy. In "The Plight of Culture," he bemoaned its dilution, meanwhile subtly fudging the distinction between the concept of the avant-garde and that of a cultural elite with the euphemistic deployment of categories such as "uppermost," "middle," and "lower." Far from advocating fundamental change in the relations between the avant-garde and its "haut bourgeois" sponsors or its "petit bourgeois" milieu, Greenberg proceeded to adjust his description of the status quo ante, in an effort at semantically forestalling drastic slippage caused by the arrival of a newly prosperous and avid middle class. Ostensibly in favor of a far-off abolition of class distinctions and the division of labor, in the immediate context Greenberg used "Marxist" terminology to insist upon them. Thus cloaking his horror at the rise of a leisured public in "progressive" garb, Greenberg adroitly assumed Eliot's position without incurring the stigma attached to the latter's frankly reactionary statement of their common views.

Historian T. J. Clark's labeling Greenberg an "Eliotic-Trotskyist," although it spawned a clever contraction, gives the critic the benefit of too much doubt, inferring a genuine ideological contest where, in fact, one finds a flurry of feints and parries followed by an artful striking of triumphant poses.[31] Eliot, not Trotsky, was Greenberg's hero in combat, and a Marx impersonator, the poet's unlikely sparring partner. Indeed, the prolonged public face-off between these two contenders for his allegiance resembled an exhibition boxing match, refereed by a promoter who had a vested albeit unequal interest in both fighters and no desire to see either knocked out of the ring. Accordingly, each successive bout ended in a TKO and the guarantee of a rematch. Always, however, it was the Eliotic Greenberg that reigned in the interim.

Consistently dismissing artistic revolt or experimentation while still professing a desire for social revolution, Greenberg thus shared Eliot's conviction that continuity of tradition was an ultimate value and art itself was a product of purely aesthetic dynamics. "For my meaning is, that the poet has not a 'personality' to express, but a particular medium, which is only a medium . . . in which impressions and experiences combine in peculiar and unexpected ways," Eliot declared in 1919 in "Tradition and the Individual Talent."[32] Greenberg was in complete agreement: "Purity in art consists in the acceptance, willing acceptance, of the limitations of the medium of the specific art," he wrote in "Towards a Newer Laocoon," adding, "the arts have been haunted back to their mediums, and there they have been isolated, concentrated and defined."[33] A quarter century later in "Modernist Painting," he elaborated on that principle: "The essence of modernism lies, as I see it, in the use of the characteristic methods of a discipline to criticize itself, not in order to subvert it but in order to entrench it more firmly in its area of competence."[34] Primarily if not exclusively concerned with the identification

of its "irreducible" characteristics, Greenberg defined art by its revealed essence rather than by the dynamic interaction of separate or contrary elements. Inasmuch as all the arts imitated music, all art of quality, therefore, tended toward harmony rather than dissonance, toward integration rather than fragmentation. The outstanding question remained the degree to which art might be exempted from the decadence toward which Greenberg believed industrial capitalism as a whole was destined. "We might sum up Greenberg's position, translating it into Spenglerian language, by saying that the coinciding of avant-garde and kitsch shows that we are dealing with a Civilization now unable to produce a Kultur," Renato Poggioli concluded.[35]

Despite his condemnation in "The Plight of Culture" of Eliot's Spenglerian excesses, in fact, Greenberg has shown a long-standing affinity for Spengler's epochal fatalism and has recently owned up to it. "Cultures and civilizations do run their 'biological courses,'" he told a 1981 conference on modernism, "the evidence says that and the evidence forces me to accept Spengler's scheme in the largest part."[36] That scheme, however, precludes anything like a dialectical relation between society and culture—and more particularly between avant-garde and kitsch—insofar as an eventual and definitive failure of creative will presents itself as a forgone conclusion. Mindful of this problem from the start, and anxious to draw attention to and explain modernism's persistent vital signs, Greenberg countered with his own "natural" determinism, substituting an aquatic metaphor for Spengler's organic one. From these intellectual headwaters emanated the "main-stream," Greenberg's signature trope and greatest fallacy. Variants of this coinage appear in earlier texts, but a 1943 review of an exhibition by Marc Chagall uses it for the first time in its definitive form. "Chagall's art," Greenberg wrote, "turns from the mainstream of ambitious contemporary art to follow its own path. It is pungent, at times powerful, but opens up no vistas beyond itself."[37] "Abstract art today," he went on to assert in covering the 1944 Whitney Annual, "is the only stream that flows toward an ocean."[38] In "Towards a New Laocoon" Greenberg had stated that he "could find no other explanation for the present superiority of abstract art than its historical justification." The introduction of the concept of the mainstream subsumed that rationale within a larger teleology, putting in place the last of the rhetorical devices that make up Greenberg's "theory."[39] Channeled by history, abstraction was a current gathering momentum and coherence as it advanced toward an unbounded prospect. With the al-lowances habitually made for figurative artists dear to him, for example Arnold Friedman (see fig. 193) and Louis Eilshemius, and qualified by admiration for the old masters and tactical concessions to charges of dogmatism— "Art is under no categorical imperative to correspond point by point to the underlying tendencies of its age"[40]—Greenberg proceeded

without qualm to superimpose his grand design upon the contradictory facts of art as he found it in the 1940s.

Those facts were contradictory indeed, and insofar as the American public was concerned, still sketchy. To speak with comprehensive authority about the complex genesis of modernist painting and sculpture — or their hybrids — required a familiarity with a rapidly changing and far-flung international scene that very few critics, curators, scholars, or artists in the United States were privileged to claim. Given this and his repeated insistence on the primacy of direct experience in forming taste, it is remarkable how scant Greenberg's knowledge of the plastic arts actually was when "Avant-Garde and Kitsch" and "Towards a Newer Laocoon" were written.[41] Prior to their publication, Greenberg had had little exposure to contemporary painting or sculpture beyond his enrollment in a drawing class at the Art Students League and attendance at three out of a series of six lectures on modernist aesthetics delivered by Hans Hofmann.[42] Unpublished during his lifetime, Hofmann's talks provided Greenberg with a basic understanding of painterly values and mechanics from which the critic later extrapolated his fundamental theses, although often at the cost of reducing Hofmann's fertile insights into catch phrases. In these lectures — which in fairness it must be said Greenberg has consistently acknowledged as being of crucial value to his own thinking — Hofmann emphasized attention to the purity of color relationships, the importance of making the medium visible, and an appreciation of the dynamics of the picture plane. Hofmann's influence notwithstanding, however, almost all the notions presented in Greenberg's first essays were founded on literary not visual precedents, a fact made especially ironic when considering how quick he was to criticize the confusion of the literary and the plastic arts.

Moreover, as was true of those used to argue his political positions, the propositions and examples initially forwarded in his aesthetic writing were largely if not entirely hypothetical. The career of Greenberg the exhibition reviewer, who in 1941 sprung without warning or preparation from the forehead of Greenberg the literary essayist, is the story of the fast start obliged to be a fast study. To be sure, all good critics learn on the job. If they do not, they are unworthy of being read. In certain ways, Greenberg excelled at this challenge. As a stylist and scold he remains fresh. Inveighing against institutional compromise, he is still capable of inspiring contempt for the targets of his abuse; too little has changed in the art world for us not to find examples of comparable bureaucratic muddle-headedness in our day. Moreover, as a general advocate of American painting and sculpture at the hour of its majority, he deserves respect. Nevertheless, in his most important capacity as a witness to art seen in galleries and museums and a reporter on the ideas that informed it, he is woefully and consistently unreliable. By turns cavalier and hectoring in manner, and always ready to pigeonhole work

he did not comprehend and movements into which he had not inquired in detail, Greenberg's lapses are even harder to excuse when measured against his ultimate cause. For example, although an advocate of purity in art and politics, Greenberg showed a general ignorance of the Russian Constructivists that is astonishing. Reviewing Malevich (see fig. 194) in 1942, he dismissed his work as "of documentary value but meager aesthetic results."[43] His praise of Mondrian is just as strange. In a 1943 column having just declared Mondrian a "great painter," Greenberg went on to disparage the artist's *Broadway Boogie Woogie* (fig. 195) with a stunning arrogance. "There is a resolution, but of an easy struggle" Greenberg said of the painting's tension between pattern and ground, and then complained of its "floating, wavering, somehow awkward quality," concluding that "the color wanders off in directions I am sure belie the artist's intent."[44] Except that here, as in many other instances, Greenberg's grasp of the artist's intent and the pictorial facts was pure projection. Mistaking primaries for secondaries in spite of the Dutch artist's well-documented and rigorously applied color theory, Greenberg's description of the work's chromatic scheme was, in reality, grossly inaccurate.[45] Such errors are scarcely minor, especially for an "eye" or "mind" of such pretension.

Predicating his theoretical and historical case for abstraction on the development of Cubism, Greenberg thus managed to misconstrue the work and motivation of two of its principal followers—this despite the Museum of Modern Art's 1936 survey exhibition Cubism and Abstract Art in which the work of both were prominent. As late as 1951, Alfred Barr, the exhibition's curator, still thought it necessary to point out the "serious historical confusion" in Greenberg's habit of "includ[ing] all the abstract movements of the previous forty years," under the rubric of Cubism.[46] In a famous diagram (fig. 196) published on the dust jacket of the show's catalogue, Barr had, in fact, enumerated the tributaries of nonobjective art—Fauvism, Expressionism, Surrealism, Constructivism, Suprematism, etc.—and rendered their course as they fed into each other and then redivided into two omnibus channels: nongeometrical and geometrical abstraction. However, even Barr's own provisional attempt to track and focus art history's forward motion produced a puzzling picture as the central portion of his drawing—a welter of lines indicating overlapping and reciprocal influence—makes plain.[47] Three years later, when Greenberg began to write, the currents and whirlpools of modernism were if anything more difficult to chart.

Meanwhile, Meyer Schapiro's critique of Barr's formalist account of abstraction also appears to have escaped Greenberg's notice. Writing for the *Marxist Quarterly* in 1937, Schapiro credited "Barr's recent book, [as] the best, I think, we have in English on the movements now grouped as abstract art." He observed, however, that

although Barr sets out to describe rather than defend or criticize abstract art, he seems to accept its theories at face value in his historical exposition and in certain random judgments. In places he speaks of this art as independent of historical conditions, as realizing the underlying order of nature as an art of pure form without content . . . Hence if the book is largely an account of historical movements, Barr's conception of abstract art remains essentially unhistorical . . ."[48]

Correcting Barr's methodological bias toward a cyclical explanation of stylistic action and reaction, Schapiro sketched an alternative interpretation of the origins of nonobjective art that emphasized both social and personal factors, quoting at some length from the writings of Malevich and Kandinsky in support of his case. Nothing in this exchange made an impression on Greenberg, who persistently finessed questions of social engagement on the part of abstract artists and regularly dismissed their often extensive theoretical texts as essentially irrelevant to their work.

Careless with regard to some who had carried forward the mission of the "purist" avant-garde, and unwilling to contend with the complex interplay among its various contributing tendencies, Greenberg was glib or accusing when it came to artists and schools that substantially deviated from his precepts. In his writing, Dada as a whole was reduced to a minor episode. In the entire first decade of Greenberg's criticism Marcel Duchamp receives one mention. Schwitters (see fig. 197) is dealt with only in terms of the formal syntax of his collages, which, like those of the Cubists, mattered to Greenberg only insofar as they undid the conventions of painterly illusionism. Berlin Dada is passed over without comment. Indifferent to if not simply oblivious of the political ideas and graphic innovations of John Heartfield and George Grosz, Greenberg refused or failed to contend with the implicit parallels between their work and that of Brecht, whose use of popular motifs he countenanced.[49] Surrealism, meanwhile, is caricatured as a retrograde pictorial movement. Where absolutely necessary, as Barr noted, Greenberg made exceptions by reassigning labels. Hence Miró (see fig. 198), about whom Greenberg wrote his only monograph, was described as a "late Cubist," as was Pollock, whom Greenberg hoped thereby to rescue from the entanglements of Surrealist symbolism and the unconscious.[50] Stripsearching art for literary contraband, be it Schwitters's cheeky and ephemeral poetry or Miró's simultaneously droll and disturbing erotic vignettes, Greenberg, the aesthetic customs agent, stood vigilant guard at the frontier of American modernism.

Anywhere that strings of appropriation, invention, biography, or belief attached art to the world, Greenberg was ready to cut them clean, particularly when those strings lead to directly vernacular culture. Unlike Schapiro, who as a Marxist activist and art historian had long inquired into the social content and context of art in general and Impressionism in particular,

Greenberg retreated to a tautological formalism that obviated such dis-quieting questions. Still, addressing the work of certain artists forced his hand, and frequently the results are more telling than his theoretical treatment of the issues involved. When writing of Georges Seurat (fig. 199), for example, Greenberg shrank from the very urban spectacles that beckoned this nonetheless supremely optical painter.

Like Manet, Toulouse-Lautrec, Renoir and other contemporaries, he [Seurat] was fascinated by the mass produced recreations of the city which the nineteenth century had conventionalized into circuses, night clubs, dance halls, cafes and variety theaters. Seurat seems to have been sensitive to the outside-looking-in attitude that modern entertainment forces upon the spectator. More than the entertainment itself, the inhuman glamour of the entertainers keeps us at a distance. Both the entertainers and the spectators in "Le Chahut" and "Le Cirque" are cartooned . . . It is a world most of us will never enter. Twenty years after Seurat, painting entered a world not unlike it and left a good many of us standing at the door.[51]

This is as close to an open admission of critical incapacity as one encounters in Greenberg's writing. Accepting to stand outside the door opened by Manet, Lautrec, and their followers, Greenberg condemned himself to watch much of the avant-garde file past and out of sight. The question is, why? To what degree, one wonders, was his demurrer a product of philosophical design or a matter of default, a consequence of ascertainable principles or the result of a simple lack of affinity for rude pleasures? Did he, for example, recoil from the music hall on the grounds that it was debased Bach or Beethoven, or did he simply have a tin ear for Tin Pan Alley?[52] Neither answer satisfies; yet how does one explain so crippling a critical weakness in so quick an intelligence? Projecting his own discomfort onto others, Greenberg often hints at the underlying ambivalence that appears to have prompted his sweeping disdain for popular culture. His complaint against the cartoonist William Steig (see figs. 200 and 201) is particularly revealing: "If, however, Steig were somewhat more susceptible to those dangers of middle-class existence he too triumphantly points out, he would score much more frequently."[53] Turned back on himself, the charge sticks more firmly still.

In his comments on literature, Greenberg was more forthcoming about his own predicament. Contributing to a 1944 conference, "American Literature and the Younger Generation of American Jews," he was indeed quite outspoken about the underlying anxieties and self-imposed strictures it entailed.

There is a Jewish bias toward the abstract, the tendency to conceptualize as much as possible, and then a certain "Schwarmerei," a state of perpetual and exalted

surface — and sometimes disgust — at the sensuous and sentimental data of existence that others take for granted.[54]

Continuing in this vein, Greenberg's theoretical commentary borders on autobiographical testimony and is therefore worth quoting at length:

Again and again, they [Jewish writers] describe escapes or better flights, from the restrictions or squalor of the Brooklyns and Bronxes to the wide open world which rewards the successful fugitive with space, importance and wealth . . . Sometimes it is a flight from loneliness to identification with a cause . . . Flight — as well as its converse, pursuit — is of course a great American theme, but the Jewish writer sets himself apart by the more concerned and immediately material way he treats it. It is for this reason that the Jewish writer is so reluctant to surrender himself to a truly personal relation with an objective theme. His personal relation is to the success of the writing, writing becomes almost altogether a way of coping with the world.[55]

Ironically, it is precisely at this point that Eliot's Anglo-Catholicism and Greenberg's Jewishness coincide. "The progress of the artist is a continual self-sacrifice, a continual extinction of personality," Eliot wrote. "Poetry is not the turning loose of emotions but an escape from emotion, not the expression of personality but the escape from personality."[56] Greenberg's similar insistence on the aesthetic "extinction of personality," and his determination to purge from art all traces of mundane existence, for which kitsch became the shorthand term, reflect not so much a political or even an art-historical perspective, as they do a fundamentally religious one. Located against the backdrop of Jewish emigration from the shtetl and the ghetto, the opposition of purity and impurity stands as a metaphor for the perilous choices imposed by cultural assimilation in the New World. If indeed a preoccupation with form is typical of the first- or second-generation Jewish-American writer, in Greenberg's reckoning that preoccupation is a sublimated expression of his deep alienation from the surrounding environment. "His need of course is a greater feeling of integration with society," Greenberg said, but he added, repeating his standard coda, "I do not believe this will be possible for him except under socialism."[57]

Simultaneously a refugee from his community of origin and an outsider to his adopted one, Greenberg the cosmopolitan intellectual occupied a no-man's-land. And though his constant appeals for revolution are hardly credible as politics, in this context they acquire a new and poignant meaning, haunted as they now seem by sacred eschatology consistent with his inertial pairing of apocalyptic pessimism and millennial optimism. As before, one must look to his literary criticism for clues, this time to his essay on Kafka:

For the Jew who lives in tradition—the Orthodox Jew—history stopped with the extinction of an independent Jewish state in Palestine two millennia ago and will not start up again until that state is restored by the Messiah. In the meantime Jewish historical existence remains in abeyance. While in exile, Jews live removed from history, behind the 'fence' or 'Chinese Wall' of Halacha. Such history as goes on outside that 'fence' is profane history, Gentile history, which belongs more to natural than to human history . . . During the last century and more Gentile history has begun to intervene in Diaspora Jewish life in a new way by 'emancipating' Jews, which means 'enlightening them' as well as by recruiting them as citizens. But this turns out not to have rendered Gentile history any less hostile, whether to Orthodox or to assimilated Jews. Gentile history may, it is true, have become more interesting to the later sort of Jew for and in itself, but this has not really made it gentler or less a part of nature. Therefore the emancipated Jew must still resort to some sort of Halachic safety or stability, or rather immobility.[58]

Intellectually committed to an avant-garde whose task it was to precipitate radical social change and to keep culture "moving," spiritually it seems Greenberg imagined a frozen Halachic world remote from the contagion of the "natural" and safely insulated from a Gentile world that so often masked a brutal anti-Semitism in the "folkish" or "popular" forms.[59]

As compelling as Greenberg's description of the crisis of the Jewish writer is, it cannot be indiscriminately applied. Nor was his retreat from coarse contingency into a realm of self-protective high-mindedness typical of all those artists who shared his heritage or his uneasiness. Also a careful reader of Kafka, Philip Guston suffered the divided consciousness of the Jewish artist and intellectual in a secular society as well. Although long torn between abstraction and image making, Guston never fled from his existential discomfort into pure aestheticism. During the 1970s, the last decade of his career, the mess of daily life and the stress of daily contradiction flooded the serene spaces of his Abstract Expressionist pictures. What Greenberg once belittled as Guston's "homeless figuration" had finally come home. A better student of Eliot's poetic than Greenberg (see fig. 202), Guston understood the capacity of art to transfigure quotidian pettiness and the reciprocal power of the vernacular to rescue art from enfeebling rarification. As obsessed as Greenberg with art-historical continuity, moreover, Guston's faith in it was based on the perpetual tension between a striving for transcendent order and the imperfection of the artist's nature and means. While still an abstract painter, he thus stated:

There is something ridiculous and miserly in the myth we inherit from abstract art: That painting is autonomous, pure and for itself, therefore we habitually analyze its ingredients and define its limits. But painting is impure. It is the adjustment of impurities which forces its continuity.[60]

Directed toward Ad Reinhardt during a panel discussion, Guston's retort might just as easily have been aimed at Greenberg. A member of the American Abstract Artists group around whose periphery Greenberg moved during the 1940s, Reinhardt (see figs. 203 and 204) in turn would seem to have been the critic's natural ally, being the only one among the New York School painters to defend artistic purity as an absolute value. In theory as well as practice, however, Reinhardt was a far more thorough and consistent defender of vanguard probity than Greenberg. An undaunted Leftist whose cartoons debunking kitsch concepts of modern art featured purposefully "dumb" images and bad puns, Reinhardt decried not only the confusion of aesthetic aims, but also the confusion of professional roles — critic, collector, adviser, dealer — a confusion in which Greenberg was deeply implicated.[61] Snubbing Reinhardt, the "pure" purist whose work explicitly fulfilled his criteria but whose doggerel manifestos implicitly accused him of betraying his social vision, Greenberg jumped headfirst into the maelstrom of Abstract Expressionism.

Although Greenberg was the first among art writers of the late 1940s and early 1950s to seize upon and articulate the "look" and formal logic of "American-type painting" — in particular its scale and overall composition — it is easy to forget how out of sympathy he was with the basic motives and furiously improvisatory aesthetics that fueled postwar art in this country.[62] Deaf to or disdainful of the eroticized bucolics of Gorky or the mystical "literature" of Rothko, Still, and Newman, he was even less prepared to deal with the lyricism of Pollock, de Kooning, and Kline, or its rough metropolitan accents. Kline said it best:

Hell, half the world wants to be like Thoreau at Walden worrying about the noise of the traffic on the way to Boston: the other half use up their lives being part of that noise. I like the second half.[63]

Nominally, of course, Greenberg partook of their experience and outlook. Cubism, he believed, was an urban art, and "all profoundly original art," he claimed, "looks ugly at first."[64] Yet, if "ugliness" marked a stage of artistic creation or its recognition a moment in the development of individual taste, it was "beauty" that Greenberg sought and the codification of its new laws that he set about to effect. Modernism's periodic aggressions and its attraction to the discordant realities of the city were necessary but not-to-be-exaggerated dimensions of a process, justifiable in the end insofar as it yielded the rewards and comforts of private delectation. Although a revolutionary at his desk, as a connoisseur of pictures Greenberg seems to have taken all too literally Matisse's suggestion that a good painting was like an armchair awaiting the tired businessman at the end of the day.

Replacing the patron/critic's chair for that of the artist — and doubtless

mindful of Greenberg's proscriptions—de Kooning spoke for much of his generation when he countered that "some painters, including myself, do not care what chair we are sitting on. It does not have to be a comfortable one. They are too nervous to find out where they ought to sit. They do not want to sit in style."[65] Pressing his advantage, de Kooning then asserted as a primary the very quality that Greenberg most abhorred: "Art never makes me peaceful or pure," he said in 1951. "I always seem to be wrapped in the melodrama of vulgarity."[66] De Kooning was seconded by David Smith, who was preeminent among sculptors in Greenberg's pantheon, but whose errors of aesthetic judgment the critic would eventually "correct" when, as the executor of his artistic estate, he had some of Smith's work repainted. Smith stated:

To the creative artist, in the making of art it is doubtful whether aesthetics have any value to him. The truly creative artist deals with vulgarity . . . this term I use because to the professional aesthetician, it is vulgarity in his code of beauty, because he has not recognized it as yet or made up rules for its acceptance . . . It will not conform to the past, it is beyond the pale.[67]

In Greenberg's case, the difficulty resulted instead from the fact that the libidinous "Schwarmerei" in which Smith, Pollock, de Kooning were immersed *did* conform to the present. Everywhere that vulgarity seeped out: in Smith's notebook drawings and angrily sexual assemblages, in Pollock's psychoanalytic sketches and his turbulent late figuration, and most of all in de Kooning's "Women." Asked by Selden Rodman whether one of these paintings was inspired by Marilyn Monroe, de Kooning answered, "I don't know, I was painting a picture, and one day—there she was." "Subconscious desire?" Rodman inquired. "Subconscious hell!" the painter replied.[68] Prefiguring Andy Warhol's Marilyns and their Pop Art sorority, de Kooning's "Women" showed how deliberate irony could serve both as a universal cultural solvent, and a tonic capable of rejuvenating high-art conventions that had fallen victim to enervating piety (see figs. 205 and 206). And, while Pollock's lifelong reliance on subconscious imagery drew upon the tradition of Surrealist automatism—contradicting Greenberg's emphasis on the purely formal aspects of his work—de Kooning's flirtation with the tabloid Muse who emerged from the sea of his exquisite gestures demonstrated that in the modern era automatism is as likely to conjure up a fleshy screen idol as a spare Jungian archetype.

Greenberg hated the example of de Kooning's unbiased readiness to be "wherever my spirit allows me to be," yet never understood the lesson it taught.[69] Tolerant of "naive" art and of "Art Brut," though critical of its stylistic inertia—he granted Dubuffet a special dispensation for the "superior literature" of his work that he withheld from Abstract Expressionism's

infidels — Greenberg continued to treat mass culture as irredeemably crude, institutional, and retrograde. Far from static, however, and despite the conservatism of its industrial captains and media bosses, the mass culture of the postwar years was enormously dynamic. The product of a chaotically prosperous entrepreneurial economy rather than of a closed one ruled by scarcity, the eddies of popular imagination found prompt access to "mainstream" venues just as the creations of Madison Avenue and Hollywood entered the minds of vanguard artists with increasing frequency and speed. Denying this constant two-way traffic and insisting upon absolute separation of high culture from low, Greenberg played his set piece game of avantgarde versus kitsch to repeated stalemates.

Treating kitsch as a raw material for art rather than its antithesis, however, Greenberg's more basic description of modernist process still applied and, if anything, applied more fully than ever before. "Modernism," he maintained, "criticizes from the inside, through the procedures themselves of that which is being criticized."[70] The generative and determining principle of modernism consists of the methods by which it transforms its substance; it is not a preordained standard of excellence against which the results of that transformation are judged. Hence, modernism's spirit resides in a developing process rather than in a canon of artifacts. Detailing instead of overturning the precedents set by de Kooning and his more worldly colleagues, artists of the late 1950s and early 1960s put Greenberg's idealist theory into radical practice. Junk assemblagists, Neo-Dadaists, and Pop artists, enthralled by popular images and the publicity machine that produced them, thus used the castoffs of mass culture to criticize that culture from within. Like their Cubist and Dadaist predecessors, they understood that the essence of the medium included rather than excluded the social and human provenance of the emblems and stuffs they incorporated into their work by collage or painted facsimile. "I am for an art that embroils itself with the everyday crap and still comes out on top," avowed Claes Oldenburg, in whose work the elusive subjectivity of Abstract Expressionism first met the deadpan objectivity of Pop.[71] To embroil art "in everyday crap" is to admit that the artistcitizen is already in deep. Soon, in fact, the vanguard found itself a prime target of the very media whose "false and cynical treatment of real emotion," Oldenburg once said, "fascinates me and yields more truth."[72] Taking over and taking apart the techniques and iconography of the press that courted them, many artists of the 1960s rightly saw their future — to recast Robert Rauschenberg's remark — in the gap between *Life* and art. The "negative" dimension of that project never precluded a sympathetic regard — Warhol simply and subversively called it "liking" — for the found objects of their affection equaling the disaffection they felt toward the society that had simultaneously produced and discarded them. As it turned out, then, the door through which Seurat had passed issued not only onto

the spectral rivulets, spray mists, and polymer mud of Olitski and other Color Field painters, but offered a more compelling view beyond to the patchwork, photo-mechanical, screened, and socially encoded matrixes of Rauschenberg, Johns, and their peers and artistic progeny.

With few exceptions, art in our time has thus demanded a critic as "wrapped in the melodrama of vulgarity" as the artists upon whose work he presumed to sit in judgment. "A man watches a movie," said Robert Warshow, an editor at *Commentary* and Greenberg's office mate, "and the critic must acknowledge that he is that man."[73] Greenberg, however, could never concede being such a man among the semidarkened multitude. Although street-smart in intellectual skirmishes, his preferred critical stance has been studied and aloof and his critical voice mandarin. Presently that same voice echoes in the countless articles, catalogues, and lectures that emanate from our contemporary journals, museums, and symposia. Categorical, disembodied, and censorious, it is the voice of the academy, a voice we too readily confuse with that of modernism itself. Its habit is to speak in gross historical generalizations, ignoring obvious and major exceptions as well as intriguing if sometimes obscure anomalies. Among these academicians, theoretical name-dropping is the norm, coupled with an astonishing disinterest in and disregard for the stated intentions of the artists who fall victim to their attentions. They are humorless in their solicitude for art and artists, moreover, since humor acknowledges weakness and exposes the complex and irreconcilable facts of character. Meanwhile, the "terminal argument" is their favorite tactic.[74] In ostensible defense of the best, they predict the worst, routinely trumping their critical hand with doomsday utterances that curiously lack the urgency one would expect of those convinced that their case was definitive or the end nigh.

Though only a segment of this group are full members of the scholarly guilds, to varying degrees all trade in the same commodity: intellectual kitsch, a debased form of thinking, which differs from its artistic equivalent only in that fetishized opacity rather than fetishized transparency is its principal selling point. To be sure, divergent tendencies exist within this academy, yet in keeping with Greenberg's original emphasis in "Avant-Garde and Kitsch," all see themselves as dedicated to the "preservation of culture" against Philistine encroachments and barbarian onslaughts. Mistaking tunas with good taste for tunas that taste good, the dwindling band of Greenberg's "neo-Kantian" disciples has accepted his example as so complete an affirmation of the cult of "quality" and the mystique of the "eye" as to forever absolve them of responsibility for examining the social issues in which his criticism was originally, albeit shallowly, rooted. To those of a still more reactionary bent, Greenberg's story permits another retelling of the fable of "the God that failed." Followed by long laments over the precipitous drop in "cultural literacy," the exercise satisfies a deeply self-congratulatory

nostalgia for an art pure of spirit but most especially pure of radical politics. Of course, as Greenberg himself reminds us, "it is in the very nature of academism to be pessimistic, for it believes history to be repetitious and a monotonous decline from a former golden age."[75] That warning applies equally to the scholastic Left that exhausts its revolutionary zeal by rewriting the revolutions of the past while second-guessing the anarchic energies of the moment.

Just how confused criticism has become about which moment we are now living in is obvious from the shell game of prefixes currently in vogue. Resulting in a string of compounds — *post*industrial, *post*modernist, *late* capitalist and *neo-* almost any artistic style one can name — the practice does nothing to clarify the ill-defined root terms to which they are annexed. However, if postmodernism means anything that can be generally agreed upon, it means post-Formalism and — in America at any rate — post-Greenberg. Still, Greenberg's casuistic style of thought survives the repudiation of his dogmas and in all probability will remain his great legacy. Indeed, such hyphenates are a part of that legacy — a verbal strategy for eliding the present with a heavily expurgated past and a vaguely articulated future so as to hold all in permanent suspension. While going Greenberg the critic and gallery adviser at least two better, the team of Collins and Milazzo have arrived at the most absurd of these periodic labels; "*post*recent." Besides the amusement such jargon affords, we should be grateful for their having narrowed to near zero the span between then and now. For if the "post" in postmodernism signals any critical weakness, it is our current inability to tell time.

"What time is it?" is the question with which modernism began. Restless, ironic, always out of place, and everywhere alert, Charles Baudelaire's "Painter of Modern Life" exposed the anachronism of the academy by exposing his senses and nerves to the flux of the actual (see fig. 207). To speak with accuracy and conviction about the moment, the critic of modern life must likewise be — and remain — a creature of immediate sensation and unorthodox mind. Far from complacent, of course, such a critic, Baudelaire said, would be "partial, passionate and political."[76] All of these qualities Greenberg has possessed in abundance. More was demanded, however. An absolute prerequisite was an honest estimate of one's own place in the social system and thus the full measure of a political candor for which no political cant will substitute.

Financially dependent upon a middle-class audience he despised for its ignorance and utilitarianism, Baudelaire still preferred that public to the taste-makers of the old regime: "the aristocrats of thought, the distributors of praise and blame, the monopolists of spiritual things [who] have denied you [the Bourgeois] the right to feel and enjoy."[77] (Fearful of the masses and scornful of his own class, Greenberg decried the lack in democratic society of just such aristocracy, and sought to invent one in his image and install it in

power.) The scathing sarcasm of Baudelaire's appeal to the bourgeoisie to complement their wealth and power with poetry does not belie his grasp of aesthetic Realpolitik; it reflects it. Envy is beneath a self-made man of taste just as taste and intelligence are the currency of those who have no other. A man of the crowd, meanwhile, Baudelaire's model critic—like his archetypal modern painter—relished the parade of contemporary fashion and was participant observer of the often grotesque pageant of urban pleasure.[78] Although hating its presumption, he therefore took an intense interest in the manners of a bourgeoisie whose reign had just begun.

Despite the horrendous cruelties and dislocations of the century, their reign has not ended, nor has the profound ambivalence it stirs been lifted from the consciousness of the modern artists or intellectuals. Despite the sometimes despairing but usually wishful references to cultural "lateness" that have long been a feature of Greenberg's criticism and currently punctuate the writing of his epigones, we are in fact in a period of *high* capitalism. And, for all its structural debility and all the misery and fraud it propagates, capitalism has no rivals, only economic cycles and internal competition. In fact, rather than collapsing of its own weight—although partial collapses always threaten—capitalism is about to reabsorb the still weaker socialist systems that have so long been its political adversaries. For worse and for better, as Baudelaire was the first to acknowledge frankly, modernism *is* bourgeois art, a fever graph of the enthusiasms, discontents, bad conscience, and bad faith of its patrons' and practitioners' class. So long as that class survives and rules, modernism continues. Its contradictions are ours, from which no revolution has saved us in the past and none seems likely to do so in the future. Resistance of any meaningful kind to the constraints and crimes of bourgeois society must therefore begin with the admission and constantly updated appraisal of our compromised position within it. For if, in its crisis-ridden and frequently brutal unfolding, that reality seems intolerable, nevertheless we cannot stand apart from it and tell the truth.

The prospect before us is to reenter modernity in the fullness of its enduring ambiguity, magnificence, and corruption. To that end we must acknowledge and surrender to the complete if sometimes tragic fascination with contemporary life that Baudelaire first demonstrated. More than "taste," in this regard, the basic credential of the critic is disciplined but childlike avidity. In the final analysis, such desire often dictates that either theories crumble or the sensibility and critical faculty atrophy. This Baudelaire knew by experience as well as instinct, and his words serve permanent notice to those who, like Greenberg, seek to buttress the testimony of their own experience, "a priori" truths, or borrowed authority.

Like all my friends I have tried more than once to lock myself inside a system, so to pontificate as I liked. But a system is a kind of damnation that condemns us to

perpetual backsliding : we are always having to invent another and this is a cruel form of punishment. And every time my system was beautiful, big and spacious, convenient, tidy and polished above all; at least so it seemed to me. And every time some spontaneous unexpected vitality would come and give lie to my puerile and old-fashioned wisdom, much to be deplored daughter of Utopia . . . To escape from the horror of these philosophic apostasies I arrogantly resigned myself to modesty; I became content to feel; I came back and sought sanctuary in an impeccable naïveté.[79]

Stripped of utopian illusions, we struggle to contemplate the confusing spectacle before us with "an impeccable naïveté" similarly distilled from skepticism and appetite. Lately that vista encompasses a new Alexandrianism, for which Formalism provides the crucial buzz words. Exploiting the notions of "quality" and aesthetic "purity," government now censors work that troubles the public mind and challenges the public order. Flag art—from Dread Scott Tyler to Johns—goes on trial while Wyeth pin-ups are enshrined as patriotic icons and cynically applauded by embittered *cognoscenti*. At the same time, the means and market for the production and dissemination of images of high or low rank have reached a technical sophistication and scope that vastly exceeds anything conceived of heretofore. Although flawed in its formulation, Greenberg's dialectic of avant-garde and kitsch thus remains at issue, its antitheses ever changing rather than fixed in their opposition and its specific manifestations ever more phantasmagorical as the years pass. At long last disabused of our own purity of intent and suspicious of any project predicated on the near or far term perfection of society, we are left, as modernity began, with only the intoxicating improbabilities of our imagination and the vivid, often disquieting, actuality of our perceptions.

NOTES

1. Clement Greenberg (hereafter referred to as Greenberg), in "Contribution to a Symposium," in *Art and Culture: Critical Essays* (Boston, 1961), p. 124 (hereafter referred to as *Art and Culture*).

2. Greenberg, quoted in *ARTnews*, September 1987, p. 16.

3. Greenberg, "Avant-Garde and Kitsch," in *Clement Greenberg: The Collected Essays and Criticism*, ed. John O'Brien, vol. 1: *Perceptions and Judgments 1939–1944* (Chicago and London, 1986), p. 11 (hereafter referred to as *Perceptions and Judgments*).

4. Greenberg, ibid. About the original use of the term, Greenberg has said: "Albert Gerard Jr. used 'kitsch' in English for the first time, as far as I know, in the mid-'30s, but the word seems to have caught on in English after my piece." "Avant-Garde and Kitsch, Fifty Years Later, a Conversation with Saul Ostrow," *Arts Magazine*, December 1989, p. 57.

5. Writing in answer to an essay by Dwight MacDonald on Soviet cinema, in which MacDonald speculated on the aesthetic instincts of the average Russian peasant, Greenberg, in "Avant-Garde and Kitsch," summoned his own Russian peasant to view a "battle scene" by Ilya Repin and a painting by Picasso and then imagined his stereotype's response to each. When the essay was republished in *Art and Culture*, Greenberg added the following note: "P.S. To my dismay I learned years after I saw this in print that Repin never painted a battle scene; he wasn't that kind of a painter. I attributed someone else's picture to him. That showed my provincialism with regard to Russian art in the nineteenth century." Taking this apology into account, one wonders who painted the battle scene Greenberg was thinking of, if indeed any particular painting was ever at issue. Maybe the entire situation — peasant, Picasso, and unspecified battle scene — was equally hypothetical. Perhaps it was literary license, or the result of a regretted "provincialism with regard to Russian art in the nineteenth century"; nevertheless, one suspects that the lapse simply resulted from Greenberg's reckless compulsion to schematize aesthetic problems and his (at that time) little more than a layman's knowledge of art in general. In the end, Repin's "battle scene," like much else in Greenberg's subsequent writing, seems the invention of a Union Square polemicist and Sunday painter. Further, Greenberg's most recent explanation of the genesis of "Avant-Garde and Kitsch" ("Avant-Garde and Kitsch, Fifty Years Later," p. 57) makes still plainer the essentially instrumental, if not wholly arbitrary, basis upon which he selected his examples. "I had to choose my examples from the visual arts because a Russian peasant obviously couldn't be expected to read any other language than Russian. . . . The names that figured in 'Bohemia' were those of painters and sculptors, only secondarily those of writers. I'm exaggerating a bit, but I elected after that to take my examples from poetry. I talk about Eliot then Eddie Guest . . . I also take Ella Wheeler Wilcox and Robert Service for examples of kitsch verse. I didn't choose examples from fiction because I didn't know what to choose. I guess any pulp novel would have done but I couldn't think of any on par with Eddie Guest."

6. Delmore Schwartz, "New Year's Eve," in *In Dreams Begin Responsibilities and Other Stories*, ed. and intro. James Atlas (1937; New York, 1978), p. 113.

7. Stephen Spender, quoted in Christopher Isherwood, *Christopher and His Kind* (New York, 1976), p. 199. Others in this period withdrew from politics even more completely. For instance, in 1939 Herbert Read announced, "In our decadent society . . . art must enter into a monastic phase. . . . Art must now become individualistic, even hermetic. We must renounce, as the most puerile delusion, the hope that art can ever again perform a social function." Quoted in Helena Lewis, *The Politics of Surrealism* (New York, 1988), p. 158.

8. Greenberg, "Avant-Garde and Kitsch," p. 22.

9. Responding to overtures from the *Partisan Review*, Trotsky damned its contributors with faint praise. In a letter of 1938 to Dwight MacDonald, he wrote: "It is my general impression that the editors of *Partisan Review* are capable, educated and intelligent people but *they have nothing to say*. . . . A world war is approaching. . . . Currents of the highest tension are active in all fields of culture and ideology. You evidently wish to create a small cultural monastery, guarding itself from the outside world by skepticism, agnosticism and respectability." *Leon Trotsky on Literature and Art*, ed. and intro. Paul N. Siegel (New York, 1981), pp. 101, 103.

10. Greenberg, "Avant-Garde and Kitsch," p. 8.

11. "Surrealism: Last Snapshot of the European Intelligentsia," in Walter Benjamin, *Reflections: Essays, Aphorisms, Autobiographical Writings,* ed. and intro. Peter Demetz (New York and London, 1978), p. 187.

12. Struggling to establish their distance from the noninterventionist policy of socialist re-former Norman Thomas, as well as from the Right-wing isolationism of the America First movement, Greenberg and MacDonald performed a series of ideological contortions, finally claiming to be in line with the "revolutionary defeatism" preached by Rosa Luxemburg during World War I. While these distinctions may seem arcane to the contemporary reader, they highlight the degree to which the authors had to strain to protect their basic premise that "the issue [is] not war but revolution," and hence that any support for Roosevelt or Churchill was tantamount to collaboration with incipient fascism in America and Britain. As to support for the Soviet Union against Hitler, here Greenberg and MacDonald disagreed, prompting Greenberg to add the following footnote: "My position here, I admit, is a difficult one and open to serious misunderstanding but no matter: as Trotsky said, "If we admit war [involving the Soviet Union] without revolution, then the defeat of the Soviet Union is inevitable. If we admit this present war without revolution, the defeat of humanity is inevitable." Greenberg's exculpatory "admission" and jesuitical misappropriation of Trotsky's words is no less in character than his parting-shot prediction of the future should his views go unheeded. "10 Propositions on the War," *Partisan Review,* July–August 1941, pp. 271–78. MacDonald's and Greenberg's text is excluded from the first volume of Greenberg's *Collected Essays and Criticism,* although "An American View," a 1940 essay for *Horizon* that takes the same basic stand is printed there (pp. 38–41). This essay suggests that a revolution in Britain and United States might trigger one in Nazi Germany. Otherwise Greenberg saw no important distinction between the interests of British capitalism and those of Hitler — even going so far as to suggest that only the leadership of Churchill forced the German people into Hitler's ranks in fear of a new Versailles Treaty. "This fear had converted many a German from anti-Nazi to pro-Nazi. Without this fear the Nazis would have hardly any more moral reserves at their command than the erstwhile Allies. The bright future of plunder which Hitler promises his people only convinces the adolescents." To call this analysis Marxist is bizarre in the extreme. To ascribe Greenberg's eventual change of heart regarding the Nazi threat to de-Marxification is, correspondingly, no less bizarre. At any rate, by 1943 Greenberg had enlisted in the Army Air Force. For a revealing, albeit refracted, image of Greenberg in uniform see, "War and the Intellectual: Review of War Diary by Jean Malaquais," (*Perceptions and Judgments,* pp. 190–93), in which Greenberg writes of Malaquais, "His experience posed under what were almost laboratory conditions the problem of the right attitude towards his fellow men, in the flesh, of the Marxist who is supposed to love them in the abstract."

13. Greenberg and MacDonald, "10 Propositions on the War," p. 275.

14. Greenberg and MacDonald, ibid., pp. 276–77.

15. Reflecting a deep split among the *Partisan Review*'s editors and contributors, Philip Rahv's rejoinder to Greenberg and MacDonald, "10 Propositions and 8 Errors," was published in the journal's November–December 1941 issue. This critique of the authors' stance with regard to the impending war and analysis of their intellectual and rhetorical habits bears quoting at length: "Their dicta outline a position which I cannot adopt as my own because I regard it as morally absolutist and as politically representative of a kind of academic revolutionism which we should have learned to discard long ago. . . . Again we read that the social revolution is around the corner and that imperialism is tottering on the edge of the abyss and again we fail to recognize the world as we know it.
 Speaking for no movement, no party, certainly not for the working class, nor even any influential grouping of intellectuals, the authors of the *10 Propositions* nevertheless write as if they are backed up by masses of people and as if what has been happening is daily confirming their prognosis. They refuse to see anything which does not fit into their apocalyptic vision of a single cleansing and overpowering event which will once and for all clear away the existing

social system in Britain and America, administer the *coup de grâce* to the Hitler regime, and forthwith usher in socialism." (p. 449)

In passing, Rahv added another useful observation: "Here we have a series of bald assertions that wholly ignore the element of time, which is the one element one can least afford to overlook in political calculations." (p. 501)

"For in this article I am not arguing against a revolutionary policy in principle; I am arguing that in the absence of a revolutionary movement and also because certain other essential conditions are wanting, such a policy [as that of waiting for a revolutionary party to form itself in reaction to the war] is illusory. . . . At bottom all that Greenberg and MacDonald are really saying is that if a revolutionary party existed it would not fail to act in a revolutionary manner. But that is a tautology, not an insight." (p. 505) For a detailed account of the debate over the war on the Left, see Terry A. Cooney, *The Rise of the New York Intellectuals: Partisan Review and Its Circle* (Madison, Wis., 1986).

16. Speaking to Saul Ostrow in a 1989 interview ("Avant-Garde and Kitsch, Fifty Years Later," p. 57), Greenberg used the same language as mine to describe his Marxism. "When I read it ["Avant-Garde and Kitsch"] now there are things about it that churn my stomach. Its Marxism was too simplistic and maybe too Bolshevistic. I was going along with the times, being trendy. Most of my friends were Trotskyites, or nearly. The piece was smug and badly written; sophomoric." Indeed, but Greenberg's attempts to escape the onus of that smugness comes too late. Reprinted in 1961 in *Art and Culture,* and as recently as 1985 in *Pollock and After: The Critical Debate,* Francis Frascina, ed. (New York, 1985), "Avant-Garde and Kitsch" was permitted to stand for fifty years without comment from or substantive revision by its author. Only after careful examination of Greenberg's work began to unravel the expediencies of his arguments and the abuses of power they occasioned has he seen fit to engage in any measure of self-criticism. Greenberg's recent, offhand recantation amounts to little more than damage control; tellingly, his remarks were accompanied by a patently competitive attack on Walter Benjamin, whose authority has eclipsed his, and whose earlier "The Work of Art in the Age of Mechanical Reproduction" treats many of the themes in "Avant-Garde and Kitsch" with far more subtlety and with much more relevance to contemporary art.

17. See Leon Trotsky, "The USSR in War," in *The Basic Writings of Trotsky,* ed. and intro. by Irving Howe (New York, 1963), pp. 305–14.

18. Leon Trotsky, "Art and Politics in Our Epoch," in *Leon Trotsky on Literature and Art,* ed. and intro. Paul N. Siegel (New York, 1981), pp. 105–6.

19. "Manifesto: Towards a Revolutionary Free Art" (1938), in *Theories of Modern Art: A Source Book by Artists and Critics,* ed. Herschel B. Chipp (Berkeley, Los Angeles, and London, 1968), p. 485. At the end of this manifesto, the signatories appealed for a new coalition of artists in opposition to fascism and Stalinism, to be called the Fédération Internationale de l'Art Révolutionnaire Indépendant (FIARI). Although a journal was briefly published, nothing much came of efforts to organize this group before Trotsky's death and the outbreak of war. See Lewis, *Politics of Surrealism,* p. 147.

20. Greenberg, "The Late Thirties in New York," in *Art and Culture,* p. 230.

21. Meyer Schapiro addressed the problem of popular culture in an article entitled "Public Use of Art" that appeared in the November 1936 issue of *Art Front,* the journal of the Artists Union, which represented those working on the Federal Art Projects. In that essay he posed what Greenberg would later call "kitsch," not only as a threat but also, given the attraction it held for the average person, as an almost positive challenge to artists who sought to express their solidarity with the working class but remained stuck with a traditional bohemian idea of their role and subject matter. "The truth," Schapiro wrote, "is that public art already exists. The public enjoys the comics, the magazine pictures and the movies with a directness and wholeheartedness which can hardly be called forth by the artistic painting and sculpture of our time. It may be low-grade and infantile public art, one which fixes illusions, degrades taste, and reduces art to a commercial device for exploiting feelings and anxieties of the masses; but it is the art which

people love, which formed their taste and will undoubtedly affect their first response to whatever else is offered them. If the artist does not consider this adequate public art he must face the question: would his present work, his pictures of still-life, his landscapes, portraits and abstractions constitute public art? Would it really reach the people as a whole?" (p. 4)

22. Greenberg was not alone in his desire to create a "third force" between Stalinism and fascism. Ignacio Silone, whom he interviewed in 1939, was in fact a principal exponent of this idea. Given the deployment of political power at that moment, however, the reserves for such a force simply did not exist. Nor could they be marshaled by urgent desire or idle talk. That was the Left's tragedy, in face of which the imaginary legions of revolutionary workers called for by Greenberg's debate-society Marxism represented no hope of relief. Philip Rahv thus concluded his "10 Propositions and 8 Errors": "No, what has been lost in the past two decades through an uninterrupted series of blunders, betrayals, and defeats cannot so easily be regained. Oracular appeals to history and a mere show of will on the part of a few literary intransigents will avail us nothing."

23. Susan Noyes Platt points out Greenberg's debt to Babbitt in her essay "Clement Greenberg in the 1930s: A New Perspective on His Criticism" in *Art Criticism,* vol. 5, no. 3 (1989), p. 50. This text is a valuable source for biographical information about Greenberg.

24. William Barrett, *The Truants: Adventures among the Intellectuals* (Garden City, N.Y., 1982), p. 138.

25. Greenberg, "The Plight of Culture," in *Art and Culture,* pp. 22–33.

26. Ibid., p. 28.

27. Ibid., p. 33.

28. It is worth noting that during this period Greenberg's "Anti-Stalinism" led him to join the increasingly conservative group of former "socialists" in the *Partisan Review* circle who gathered around the Congress for Cultural Freedom, an organization later discovered to have been subsidized by the CIA. On another but related front, in 1951 Greenberg was sued for libel by the *Nation* — a publication for which he had previously written — because he had asserted that a column by their foreign editor, J. Alvarez del Vayo, "invariably parallels that of Soviet propaganda." Greenberg's accusations were reprinted in the *Congressional Record* by none other than Michigan Congressman George Dondero, who was then campaigning against modern art, which he thought to be Communist-inspired. In the context of McCarthyism and Donderism, Greenberg's active campaign against supposed Soviet "fellow travellers" made for strange aesthetic bedfellows and made his revisionist use of Marxism in "The Plight of Culture" (1953) even stranger still. See *Art-as-Politics: The Abstract-Expressionist Avant-Garde and Society* by Annette Cox (Ann Arbor and London, 1977, 1982, p. 142) and Congressman Dondero, speaking on how the *Nation* magazine is serving Communism, in the *Congressional Record,* 82nd Cong., 1st sess., May 4, 1951, pp. 4920–25.

29. Van Wyck Brooks had coined the terms "highbrow" and "lowbrow" in 1914, bequeathing to later generations of intellectuals an insidiously anthropological metaphor for explaining the relation of elite culture to that of the common man.

30. Greenberg, "The Present Prospects of American Painting and Sculpture," in *Clement Greenberg: The Collected Essays and Criticism,* ed. John O'Brian, vol. 2: *Arrogant Purpose 1945–49* (Chicago and London, 1986), p. 163 (hereafter referred to as *Arrogant Purpose).*

31. T. J. Clark, "Clement Greenberg's Theory of Art," in *Pollock and After: The Critical Debate,* ed. Francis Frascina (New York, 1985), p. 50.

32. T. S. Eliot, "Tradition and the Individual Talent," in *Selected Essays* (1932; London and Boston, 1980), p. 19.

33. Greenberg, "Towards a Newer Laocoon," in *Perceptions and Judgments,* p. 32.

34. Greenberg, "Modernist Painting," in *Art and Literature. An International Review,* no. 4, Spring 1965, p. 194.

35. Renato Poggioli, *The Theory of the Avant-Garde* (Cambridge, Mass., and London), p. 80.

36. Greenberg, "To Cope with Decadence," in *Modernism and Modernity. The Vancouver Conference Papers,* ed. Benjamin H. D. Buchloh, Serge Guilbaut, and David Solkin (Halifax, 1983), p. 163. In his conversation with Saul Ostrow (see note 4), Greenberg remarked, "But now normally I'm pessimistic and take Spengler much more seriously. I took him seriously from the beginning, although I detested his flavor."

37. Greenberg, "Review of Exhibitions of Marc Chagall, Lyonel Feininger, and Jackson Pollock," in *Perceptions and Judgments,* p. 164.

38. Greenberg, "Review of the Whitney Annual and the Exhibition *Romantic America,*" in *Perceptions and Judgments,* p. 171.

39. Greenberg, "Towards a Newer Laocoon," p. 37.

40. Greenberg, "Abstract Art," in *Perceptions and Judgments,* p. 204.

41. Philip Rahv did not like Greenberg, and both William Barrett in *Truants* and William Phillips in *A Partisan View* report Rahv as saying that Greenberg took over the art beat because there were no openings for a literary critic at the *Partisan Review.*

42. Platt, "Clement Greenberg in the 1930s," p. 50.

43. Greenberg, "Review of Four Exhibitions of Abstract Art," in *Perceptions and Judgments,* p. 104.

44. Greenberg, "Review of Mondrian's New York Boogie Woogie and Other New Acquisitions at the Museum of Modern Art," in *Perceptions and Judgments,* p. 153. (Mondrian's painting is presently titled *Broadway Boogie Woogie.*)

45. In a piece in *Art Journal* (Winter 1987), I was more forgiving of these errors, but in retrospect I find it harder to understand how Greenberg could have made such a mistake, given the long-established practices of the artist he presumed to judge in such severe terms.

46. Alfred H. Barr, Jr., *Matisse: His Art and His Public* (New York, 1951), p. 265.

47. Barr's diagram is hardly unique in pointing up the "simultaneity" of events in the early decades of the century. In this regard, it is interesting to consider a book entitled *The Isms 1914–1924.* Published in a trilingual edition in Germany in 1925, and coedited by El Lissitzky and Hans Arp, it lists sixteen isms in related development, implicating a clear recognition on the part of the authors — who were otherwise strongly committed to their own theories — of the general plurality, rather than mutual exclusivity, of modernist styles.

48. Meyer Schapiro, "Nature of Abstract Art," reprinted in *Modern Art: 19th and 20th Centuries* (New York, 1978), pp. 187–88.

49. Greenberg, "Bertolt Brecht's Poetry," in *Perceptions and Judgments,* pp. 49–62.

50. Greenberg, "Surrealist Painting," in *Perceptions and Judgments,* p. 225.

51. Greenberg, "Seurat, Science and Art: Review of *Georges Seurat* by John Rewald," in *Perceptions and Judgments,* p. 169.

52. Greenberg did, it seems, have an ear, or at least feet, responsive to pop music. William Barrett reports that he jitterbugged at The Club in the 1950s (*Truants,* p. 132). Speaking to Saul Ostrow ("Avant-Garde and Kitsch, Fifty Years Later," p. 57), Greenberg confirmed this, adding, "Even though I loved and still do love popular music, and loved to dance, it [kitsch] bothered me. . . . Today I'm not as bothered by kitsch as I used to be. I was bothered by it when I was growing up. I remember a record player at college that went on forever. It was the repetition that bothered me."

53. Greenberg, "Steig's Cartoons: Review of 'All Embarrassed' by William Steig," in *Arrogant Purpose,* p. 11.

54. Greenberg, "Under Forty: A Symposium on American Literature and the Younger Generation of American Jews," in *Perceptions and Judgments,* p. 177.

55. Ibid., pp. 177–78.

56. Eliot, "Tradition and the Individual Talent," pp. 17, 21.

57. Greenberg, "Under Forty," p. 178.

58. Greenberg, "Kafka's Jewishness," in *Art and Culture,* pp. 268–69.

59. Ibid. Both Allan Bloom in his book on the New York intellectuals and Susan Noyes Platt in her essay on Greenberg (*Art Criticism,* vol. 5, no. 3 [1989] pp. 47, 49–50, 61) draw attention to the significance of the critic's interest in the Halachic order and its relation to the circumstances of the assimilated Jew in the 1930s. See Bloom, *Prodigal Sons: The New York Intellectuals & Their World* (New York and Oxford, 1986), p. 154. I would also like to thank Rita Kaplan for providing me with reference materials on the Halacha.

60. Philip Guston, in "The Philadelphia Panel," eds. Philip Pavia and Irving Sandler, *It Is,* vol. 5 (Spring 1960), p. 37.

61. As noted by Lucy Lippard (*Ad Reinhardt* [New York, 1981]), p. 120.

62. The importance of Greenberg's advocacy of "American-type" painting should not be underestimated. Neither should it be overstated, however. While in many respects the most articulate and—during the early-to-mid-1940s—the most aggressive partisan of Jackson Pollock and the other New York School painters he favored, Greenberg was not alone in recognizing their importance. Certainly his was not the only "eye" capable of discerning the pictorial originality of their work. Downtown attention was already focused on these artists, and critical support in the general art press was building. By the late 1940s, Thomas B. Hess, Abstract Expressionism's great editorial champion, was presiding at *Art News,* from which position he could guarantee frequent and extensive coverage by a range of writers who, for all their differences in perspective, consistently supported Abstract Expressionist work. Greenberg's hold on the position of premier scout and shock-troop critic for the new American art, therefore, has its basis in a modicum of fact—his early reviews of Pollock, Robert Motherwell and David Smith, in particular—yet it is more generally the stuff of legend and proprietary professional claims. Frequently overlooked but also significant was Greenberg's early withdrawal of support from some of these artists. Most notable was his cooling towards Pollock and his shift of loyalty to "field" painters such as Clyfford Still, Mark Rothko and Barnett Newman, a shift that from the outset provoked him to make invidious comparisons between their work and Pollock's. Having reviewed neither Pollock's 1952 nor his 1954 exhibition, Greenberg articulated his dissatisfaction with the artist's course in the 1955 article that gave "American-Type painting," its name "American-Type Painting," in *Art and Culture: Critical Essays* (Boston, 1961) pp. 208–229. After praising Pollock's huge "'sprinkled' canvases of 1950," in which "value contrasts" were "literally pulverized . . . in a vaporized dust of interfused lights and darks," resulting in an absence of depth, "complicatedness" of contour, and degree of abstractness only glimpsed by Kandinsky, Greenberg went on to chide Pollock for reversing directions: "But in 1951 Pollock had turned to the other extreme, as in a violent repentance, and had done a series of painting, in linear blacks alone, that took back almost everything he had said in the three previous years." Thus, at the very moment when Greenberg codified his ideas about the new art, he both granted Pollock credit for past achievement and foreclosed on his future. Reiterating Bernard Berenson's hardly axiomatic notion that "in art, as in all matters of the spirit, ten years are the utmost, rarely reached limits of a generation," Greenberg told Jeffrey Potter, "Jackson . . . well he had his ten-year run." Considering Greenberg's unshakable opinion that Jules Olitski was the great painter of the past twenty-five years, the capriciousness of his remark resonates with brutality if not outright vindictiveness toward an artist who did not heed his counsel. His "correction" of Smith's polychrome sculptures follows the same pattern of possessive resentment. Berenson's observation is from "The Decline of Art," in Bernard Berenson, *The Italian Painters of the Renaissance* (London, 1932); for Greenberg's remark to

Potter, see Jeffrey Potter, *To a Violent Grave: An Oral History of Jackson Pollock* (New York, 1985).

63. Quoted in "Franz Kline Talking," in Frank O'Hara, *Standing Still and Walking in New York* (San Francisco, 1983), p. 94.

64. Greenberg, "Review of Exhibitions of Mondrian, Kandinsky and Pollock; of the Annual Exhibition of American Abstract Artists; and of the Exhibition *European Artists in America*" in *Arrogant Purpose,* p. 17.

65. Willem de Kooning, in "What Abstract Art Means to Me," in Thomas B. Hess, *Willem de Kooning,* catalogue of an exhibition at the Museum of Modern Art, New York, p. 145.

66. Ibid.

67. David Smith, "Aesthetics, the Artist, and the Audience," in *David Smith,* ed. Garnett McCoy (New York and London, 1973), pp. 88, 105.

68. Willem de Kooning, quoted in Selden Rodman, *Conversations with Artists* (New York, 1961), p. 104.

69. De Kooning, "What Abstract Art Means to Me," p. 145.

70. Greenberg, "Modernist Painting," p. 193.

71. Claes Oldenburg, in *Claes Oldenburg's Store Days,* selected by Claes Oldenburg and Emmet Williams (New York, 1967), p. 39.

72. Claes Oldenburg, quoted in Barbara Rose, *Claes Oldenburg,* catalogue of an exhibition at the Museum of Modern Art, New York, 1970, p. 192.

73. Robert Warshow quoted in Norman Podhoretz, *Making It* (New York, 1967), p. 150.

74. My thanks to Leon Golub for this useful phrase.

75. Greenberg, "Review of Exhibitions of Mondrian, Kandinsky, and Pollock; of the Annual Exhibition of American Abstract Artists; and of the Exhibition *European Artists in America*," p. 15.

76. Charles Baudelaire, "What Is the Good of Criticism?" in *Baudelaire: Selected Writings on Art and Arts,* trans. and intro. P. E. Charvet (Cambridge, 1972), p. 50.

77. Charles Baudelaire, "To the Bourgeois," in *Baudelaire: Selected Writings on Art and Artists,* trans. and intro. P. E. Charvet (Cambridge, 1972), p. 47.

78. In his interest in contemporary fashion, incidentally, he was not alone. Stéphane Mallarmé, whom Greenberg cites in "Avant-Garde and Kitsch" as a poet of radical purity, singlehandedly wrote and edited his own fashion magazine, "La dernière mode," and for all his fastidiousness seems to have vastly enjoyed and artistically profited from the task.

79. Charles Baudelaire, "The Universal Salon of 1855: Fine Arts, I. Critical Method," in *Baudelaire: Selected Writings on Art and Arts,* trans. and intro. P. E. Charvet (Cambridge, 1972), pp. 117–18.

■ THE INDEPENDENT GROUP: BRITISH AND AMERICAN POP ART, A ''PALIMPCESTUOUS'' LEGACY ■

To understand the advertisements which appear in the *New Yorker* or *Gentry* one must have taken a course in Dublin literature, read a *Time* popularizing article on cybernetics, and have majored in Higher Chinese Philosophy and Cosmetics. Such ads are packed with information—data of a way of life and a standard of living which they are simultaneously inventing and documenting. Ads which do not try to sell you the product except as an accessory of a way of life. They are good "images" and their technical virtuosity is almost magical. Many have involved as much effort for one page as goes into the building of a coffee bar. And this transient thing is making a bigger contribution to our visual climate than any of the traditional fine arts. . . . Mass-production advertising is establishing our whole pattern of life—principles, morals, aims, aspirations, and standard of living. We must somehow get the measure of this intervention if we are to match its powerful and exciting impulses with our own."[1]

ALISON AND PETER SMITHSON, 1956

The surprising thing is that it took until the mid-fifties for artists to realise that the visual world had been altered by the mass media and changed dramatically enough to make it worth looking at again in terms of painting. Magazines, movies, TV, newspapers, and comics for that matter, assume great importance when we consider the percentage of positively directed visual time they occupy in our society.[2]

RICHARD HAMILTON, 1968

In 1956 This is Tomorrow took place—a show generally considered the culmination of those activities, exhibitions, and discussions that had preoccupied the Independent Group during the previous four years.[3] It was also the year of another landmark exhibition in British art history. Entitled Modern Art in the United States, and containing examples of the much discussed but hitherto unseen (in England) Abstract Expressionist painting, this show was held at the Tate Gallery, the national museum for the collection of both historical British and modern international art.[4] The two exhibitions could hardly have been more different. The first, staged at the Whitechapel Gallery, a noted venue for contemporary art in London's then impoverished East End, contained a dozen installations, which had the effect of turning the whole gallery into a vast environment. These had been devised by twelve separate groups, each of which notionally contained at least one artist and one architect among its three or four members. That each acted quite independently of the others enhanced the very different areas of concern they represented, so that, alongside much Constructivist-related work, references to popular culture of diverse kinds, as well as to primitivism, archeology, and anthropology could be discerned, especially in the two most memorable and prophetic installations. Both of these were by members of the Independent Group: one by the Richard Hamilton-John McHale-John Voelcker trio, and the other by the quartet comprising Eduardo Paolozzi, Nigel Henderson, and Alison and Peter Smithson.[5]

Near the entrance to the exhibition the visitor encountered the Hamilton-McHale-Voelcker construction (fig. 208) with its perspectively distorted architectural spaces crammed with contemporary visual material of the most diverse kinds and scales, culled from movies, astronomy, comics, food and consumer-goods advertisements. All of this intermingled with sounds from a juke box competing with the highly amplified recordings of the voices of previous visitors, as well as with different smells. The effect sought was something close to multisensory disorientation. The other historically significant installation, by contrast, comprised a kind of minimal living space, a rude lean-to patio-cum-pavilion (fig. 209) containing a variety of battered homely objects—a bicycle wheel, a trumpet, a TV set—symbols of a devastated past and/or future life lain out as an archeologist might display the material culture that had been unearthed during an excavation of some lost society.[6]

The Tate show was a far more conventional affair, in part because it was a straightforward survey of twentieth-century American painting and sculpture and in part because it contained few echoes of that avowedly populist and participatory spirit that animated most of the This is Tomorrow participants for whom, according to the press release, "The doors of the Ivory Tower are wide open."[7] The key to the excitement it generated lay in the fact that it provided local artists with their first direct exposure to Abstract Expressionist painting.

LYNNE COOKE ∎

If both exhibitions attracted considerable public attention and media coverage, it may be supposed that in large part the audiences for the two were, notwithstanding some overlap from the younger art community, distinctively different. Certainly, the legacies attributed to each are quite separate — separate rather than conflicting.

The American show was followed three years later by another exhibition, held again at the Tate Gallery, this time devoted exclusively to Abstract Expressionism, loosely defined.[8] Stimulated by this example, a number of British artists began to make large-format color-field paintings, which they perceived to be radically abstract in configuration. Banding together, they presented their work in 1960 at the RBA Galleries in a polemical exhibition entitled Situation. A follow-up show was held the next year. The debt of these painters, who included John Hoyland, Robyn Denny, and Bernard Cohen among their number, to their American forebears was openly acknowledged. No ambiguity attends the transition of influence and inspiration from the most recent American works in the 1956 show to those that herald the debut of these British abstract artists coming to maturity in the early sixties, nor to their belief that the central strands of high modernism, as defined in the writings of critics like Clement Greenberg, were being actively carried forward in their art.[9]

The legacy of This is Tomorrow is altogether more complex and problematic. First, it is important to note that, although the most discussed sections of the show were provided by erstwhile members of the Independent Group, the group itself had by then formally disbanded. Nevertheless, in hindsight this show, rather than any of their other multifarious activities, has been deemed the inception of Pop Art and hence has been considered their most significant contribution to the history of art. And Richard Hamilton's small collage (fig. 210), which was designed for reproduction in the catalogue and as a poster, but not for inclusion in the display, has subsequently been lauded as the talisman of that moment, the first Pop icon.

In 1961 a number of young painters, most of whom had trained at the Royal College of Art in London, were included together in an anthology exhibition at the I.C.A., called Young Contemporaries: notable among the participants were David Hockney, Derek Boshier, Patrick Caulfield, and Peter Phillips. They, too, were soon to become celebrated as Pop artists. The connections between the members of the Independent Group and the younger sixties Pop painters, are, however, difficult to determine precisely, being more circuitous than direct, more circumstantial than causal. At most, the former seem to have contributed to a cultural climate conducive to the development of a figurative art that drew for its imagery and spirit — in a free-wheeling, hedonistic, subjective way — on contemporary youth and media culture.

It is important to remember, too, that it was only in 1957 that Richard

Hamilton executed the first of his paintings to incorporate motifs, techniques, and styles derived from the mass media. This was *Hommage à Chrysler Corps* (fig. 211), a painting he later described as

a compilation of themes derived from the glossies. The main motif, the vehicle, breaks down into an anthology of presentation techniques. One passage, for example, runs from a prim emulation of in-focus photographed gloss to out-of-focus gloss to an artist's representation of chrome to an ad-man's sign meaning "chrome." Pieces are taken from Chrysler's Plymouth and Imperial ads, there is some General Motors material and a bit of a Pontiac. . . . The sex-symbol is, as so often happens in the ads, engaged in a display of affection for the vehicle.[10]

(Nonetheless, as Lawrence Alloway soon pointed out, there are significant traces in Hamilton's mode of composing, as well as in his manner of layering meaning, of Duchamp's art, and of *The Bride Stripped Bare by Her Bachelors, Even* in particular.)[11]

Equally telling is the fact the other leading artist to have been connected with the Independent Group, Eduardo Paolozzi (see figs. 212 and 213), was at that moment better termed a New Brutalist than a Pop artist, if any labeling is required.[12] Although since the 1940s he had made numerous small collages in which he incorporated barely modified material drawn from comics and down-market pin-ups, Paolozzi's main activity as an artist at this point was the creation of bronze sculptures of anthropomorphic hybrids. Closer to primeval monsters than to futuristic robots — given their fractured carapaces constructed by embedding into wax sheets myriad small objects of various kinds, and imbued with a quasiexistentialist angst — these battered figures were more redolent of Surrealist grotesquerie than of any contemporary fascination with the new ethos of the mass media and consumer consumption. In addition, most of the other key artists associated with the Independent Group, notably Nigel Henderson, John McHale (see figs. 214 and 215), and William Turnbull, were closer in their interests and concerns to Paolozzi than to Hamilton, whose painting up to then had principally involved questions relating to perception and in ways that, ultimately, could be traced back through Duchamp to Cézanne.[13]

While the proliferation of elements often associated with particularly low-grade forms of mass culture caused many to see in Hamilton and Co.'s installation for This is Tomorrow a Dadaist effect if not intent, the focus of their thought was very different. As demonstrated both by the catalogue (in the layout of Hamilton's collage opposite a black-and-white image that ambiguously hovered between positive and negative figure-ground readings), and by their juxtaposition in the show of admass imagery with effects generated by devices frequently used in the realm of fine art, such as perspectival distortions, they sought to render sensory, and especially visual,

perception ambiguous. However, the lessons enshrined in this multimedia "high/low" cultural interplay were not presented didactically; what was understood by most participants was apprehended intuitively and experientially.[14]

Since Paolozzi's debts, by contrast, were more to Surrealism, which he had studied in Paris in the forties and to which thereafter he remained aligned, at least in his own eyes, his approach to mass culture was significantly different.[15] While in his sculpture this involved the metamorphosis of popular-culture items into high art, in his contributions to Independent Group activities he betrayed a more ethnographic slant.[16] However, over the course of the fifties his fascination with low-grade mass culture gradually was overlain with a pessimistic, existentially inflected view of the contemporary world, a view that later drew him to the science-fiction writer J. G. Ballard, with whom he shares a mistrust of technology, or at least of modern man's responses to technology.[17]

Yet this New Brutalist ethos — as it manifested itself within the framework of the Independent Group — was perhaps best expressed not in This is Tomorrow but in the exhibition that that same quartet of Paolozzi, Henderson, and the Smithsons, together with Ronald Jenkins, had organized for the I.C.A. in London in 1953. Entitled Parallel of Life and Art (fig. 216), it comprised over one hundred images garnered from a wide variety of visual sources, rephotographed and then printed, often enlarged, on grainy paper. Divested of labels and captions, and thus often defying easy identification, these photographs were arranged in a labyrinthine installation that created a seamless, encompassing, heterarchical mélange. Among the few fine-art images included alongside reproductions of children's drawings, hieroglyphs, and "primitive" art were photographs of works by Dubuffet, Pollock, and Klee; the majority, however, were images taken from other fields, especially from the sciences, technology, and photo-journalism — images that often resulted from the latest developments in the particular fields, such as microscopic photography, aerial photography, photo-finish cameras, and high-speed flash. Photography was seen to play a key role in this egalitarian view of the recently expanded visual world, in which, according to the catalogue statement, scientific and artistic information ought to be regarded as aspects of a single whole.[18] Yet for many critics the overall impression given by the show, which they deemed more attentive to the ugliness or horrors of everyday life than to its ostensible beauties, was disquieting — testimony to the effectiveness of what Reyner Banham, another member of the Independent Group and a leading writer on architecture and design, described as its subversive innovation, the flouting of "humanistic conventions of beauty in order to emphasize violence, distortion, obscurity, and a certain amount of 'humeur noir.'"[19]

The principal goals of this exhibition were therefore very similar to those

that later underpinned This is Tomorrow, at least as outlined by Lawrence Alloway (the leading art critic within the Independent Group) in his catalogue introduction to that show: "A result of this exhibition is to oppose the specialization of the arts. . . . An exhibition like this . . . is a lesson in spectatorship, which cuts across the learned responses of conventional reception."[20] Yet such goals were but the baseline of the Independent Group's endeavors: the implications they foresaw from a radical shift in cultural values were as important to them. In anticipation of the extensive social reconstruction they hoped would result from that shift, it was necessary, they believed, to begin to devise ways of studying the new phenomena that were rapidly overtaking and redefining the field of popular culture, both the novel technologies and the proliferating mass media.

Fundamental to any assessment of the legacy of the Independent Group as a whole (as well as to the problem of connecting the artists belonging to it with the Royal College Pop painters) is the fact that the Independent Group was not primarily engaged in making artworks. Discussion was its first concern, manifested most importantly in the series of seminars convened exclusively for its closely selected membership but also in certain public lectures devised for the I.C.A., its parent organization. Supplementary to that was the curating, designing, and installing of exhibitions.[21] Whether in debates or in exhibition making, the activities of the Independent Group were always collaborative. Both its vitality and the source of its historical significance lay in the flexibility and openness with which it accommodated the amiably competing, interdisciplinary interests of its leading protagonists. At no point, however, did it issue either joint statements or manifestoes, though many of its leading figures did publish articles on topics that had proved the focus of much discussion among the group. The artworks that a number of them made while members were, consequently, ancillary to its existence, no more influential on nor determined by the group activity than, say, the academic research on the pioneers of the early modern movement in architecture that concurrently preoccupied Reyner Banham as a postgraduate student at the Courtauld Institute, or the lectures Lawrence Alloway prepared on aspects of the historical collection as a temporary employee of the Tate Gallery.

The young artists emerging from the Royal College in the early sixties, by contrast, were painters *tout court*. They incorporated into their art imagery culled from the latest, most up-to-date aspects of their visual environment, its sites of leisure, pleasure, and desire. Theirs was an enthusiastic, personal, and uncritical response to an England in the first full flush of a newly won economic prosperity, a prosperity that, by the end of the fifties, had transformed the incipient consumerism of the mid-decade into an unprecedented boom in spending. But not only did these young sixties artists not share their predecessors' critical distance from the immediate environment, they

did not engage in theoretical or cultural studies of the kind that were the hallmark of the Independent Group.

However, it was not only the fact of their belonging to different generations with vastly separate interests that distinguishes these two groups; equally telling were the effects on them of the rapidly changing sociocultural milieus in which they began their careers. This so-called open society of the later fifties was a very different place from the prewar Orwellian England in which Hamilton and many of his peers had been raised, and from the dour working-class Scottish environment in which Paolozzi and Turnbull had passed their youth. Growing up in the interwar years, their lives then radically altered by the outbreak of hostilities, the members of the Independent Group eagerly welcomed the postwar reconstruction program whereby the newly elected Labour government sought to effect a more egalitarian society through a (partial) redistribution of wealth, reforms in education and health care, and the creation of a welfare state aimed specifically at improving the living standards of the lower echelons of society.[22] While their involvement in cultural studies was inevitably fueled by their Leftist sympathies, and their aesthetics informed by their political ideals, the methods they employed were never didactic nor overtly polemical. By contrast, the work of the younger artists was saturated in dreams, fantasy, and play; maturing in the wake of the somewhat belatedly achieved prosperity, they constructed for themselves a world in which comics, games, pin-ups, and other leisure pursuits had become all-pervasive.

Thus those for whom the impact of This is Tomorrow may, initially at least, have been greatest are unlikely to have been the generation who came to artistic maturity in the sixties. Rather, it was certain individuals who shared with the Independent Group a critically self-conscious attitude to the present, and who welcomed the cultural implications consequent on those social changes that burgeoned, not without a certain opposition, during the first half of the fifties. Instead of merely taking them for granted as did later generations, such viewers embraced the rapidly spreading novel forms of popular culture — such as glossy picture magazines, widescreen movies, TV, and LP records — with an impatient, if knowing, excitement. Among these, J. G. Ballard can be considered exemplary, given his enthusiasm for a show he found "fresh and revolutionary":

To go to the Whitechapel in 1956 and see my experience of the real world being commented upon, played back to me with all kinds of ironic gestures, that was tremendously exciting. I could really recreate the future, that was the future, not the past. And Abstract Expressionism struck me as being about yesterday, was profoundly retrospective, profoundly passive, and it wasn't serious. . . . Abstract Expressionism didn't share the overlapping, jostling vocabularies of science, technology, advertising, the new realms of communication. "This Is Tomorrow" came on a year

before the flight of the first Sputnik, but the technologies that launched the space age were already underpinning the consumer-goods society in those days. How much of this did Abstract Expressionism represent?[23]

What distinguishes Ballard's response — just as it informed the debates of the Independent Group — was a preoccupation with questioning the roles and relationships traditionally accorded high and low culture, with undermining the entrenched and elitist determinants of cultural leadership and value, and with thereby contributing to the redrawing of social boundaries.

The intensely contested struggles in the cultural field during the fifties did not erupt solely between the likes of the Independent Group and conservative defenders of the status quo, such as Evelyn Waugh, who vehemently opposed what they regarded as the denigration and subversion of the highest ideals and achievements of the British heritage by the onslaughts of popular culture, but between them and certain critics on the Left, most notably Richard Hoggart and George Orwell, who tried to defend what they regarded as an authentic working-class culture against the incursions of mass culture.[24] The product of a rootless, urban, consumer society — a society typified by the United States, which was then the most industrialized of all countries — this new American mass culture was anathema to them, the insidious destroyer of an indigenous popular culture.

Banham, Alloway, Hamilton, Paolozzi, and others in the Independent Group interpreted the situation very differently. Agreeing that the fundamental issues involved more than the ascription of value to other forms of culture than the entrenched high-art ones, they, however, defined these issues as pertaining ultimately to democracy. By substituting for the normative hierarchies embodied in notions of good and bad taste a continuum in which all forms of culture were held to be equally valid and significant, and hence of equal status, culture would become, as Alloway phrased it, "related to modern arrangements of knowledge in non-hierarchic forms . . . [as] shown by the influence of anthropology and sociology on the humanities."[25] This expanded notion of culture could then serve as an active agent of social change, they believed, since in its popular manifestations it responded not only to economic needs but to the social and psychological desires of individuals and subgroups. Because its audiences were able to appropriate and reshape its meanings in response to their collective needs, it contributed, they argued, to greater social mobility and self-determination. They advocated the furtherance of a consumerist society, one inevitably dominated by the mass media because, as Brian Wallis notes, consumption to them was "a socially legitimate activity which yields potential for individual and collective transformation by embodying certain cultural needs, pleasures and beliefs."[26]

Their optimistic vision is epitomized in the role Banham accorded the

product critic in the design of manufactured goods: he stressed not only the critic's responsibility to the audience but his function as a conduit of the audience's desires and needs.[27] In a similar vein, Hamilton's acts of discrimination between various types of admass presentation were directed to an audience whose abilities to differentiate keenly between the smallest nuances and inflections when making choices and readings based on related material he thoroughly appreciated. The affectionate wit that informs his work, and much of Banham's writing, is in part an expression of the positive freedom that each felt was gained by those consumers able to move knowledgeably and confidently within this expanding socio-cultural milieu. As Banham phrased it, "Pop puts the ultimate command in the hands, if not of the consumer, then at least of the consumer's appointed agent.": Dick Hebdige aptly characterizes this as a politics of pleasure.[28]

From their inception the Independent Group had brought a socio-anthropological approach to their inquiries, impelled as they were by a deep-seated interest in examining all the manifestations of contemporary culture, ranging across the spectrum from the proliferation of down-market mass culture to the innovative products spawned by science and the new technologies. Their lecture series for 1952–53, for example, included Banham discussing "Machine Aesthetics"; Jasia S. Shapiro, helicopter design; the philosopher A. J. Ayer, the "Principle of Verification"; Peter Floud, "Victorian and Edwardian Decorative Arts"; as well as two crystallographers talking on their specializations. Their early curatorial endeavors were likewise characterized by a fascination with the whole of the visual environment and with its rapid expansion through technological innovation and, in particular, photography, since it was this, the most modern of media, that largely made such expansion possible, via its constantly proliferating new guises.

Yet their understanding of contemporary visual languages, especially those emerging in the world of design to which most of them brought an informed, even specialized knowledge, was predicated on an historical as well as a sociological reading.[29] When it came, for example, to the exhibition Man, Machine and Motion (fig. 217), whose subject was the ways in which people today have extended their compass on the world around them through inventions that aid autonomous motion, Hamilton, the show's principal organizer, took a characteristically long and encompassing view, considering everything from Francesco de Giorgio's fifteenth-century drawings of a proto-bathosphere to the latest in aeronautics and in sci-fi predictions. Typically, the medium through which the material was presented, was photography. But equally telling was the decision to concentrate exclusively on images that depicted the human figure in active engagement with the machine. Technological development was not the primary concern, rather it was the plethora of means whereby mankind makes active sense of the contemporary world. In the catalogue introduction Hamilton, writing jointly

with Lawrence Gowing, stressed the affectivity of photographs that contain the human body, as a prelude to emphasizing the necessity of devising myths and rituals by which such technological developments can be made psychologically meaningful.[30] The concern for active participation on the part of the viewer that these statements imply was carried through into the design of the exhibition. An environmental installation of photographic panels in a rectlinear mazelike display, it was arranged to ensure that new conjunctions of images constantly came into play as the spectator moved through the space. While not overtly didactic, it nonetheless forced the viewer to be active, requiring an engaged response to the constantly shifting flow of material.[31]

The particular interest that Lawrence Alloway and John McHale, who was then just back from a year studying in the Department of Design at Yale University, shared in popular culture came to the fore in the series of meetings they organized for the Independent Group in the winter of 1954–55. This significantly changed the tenor of the group's activities, according to Richard Hamilton: "What had been cliquey, British and laudably academic became through their joint influence, cliquey, mid-Atlantic, adventurous, irreverent and relevant."[32] Having more contentious social implications, this theme also generated greater controversy outside the group's confines than had their previous subjects. Yet however passionate their interest in mass culture, it did not imply an assault on high culture per se, nor, as noted above, was it pursued at its expense. Equally significant, but more unprecedented, was the fact that the Independent Group brought to their study of popular culture that combination of seriousness and pleasure that they brought to all their activities: there was never a hint of slumming, of treating it as a chic form of escape. Thus when Banham, for example, lectured on developments in car styling, he treated his subject with the kind of informed and disciplined methodology that he used to address issues in architecture;[33] and when Hamilton analyzed the different effects produced by various types of photography, he deployed an expertise comparable to that he used in differentiating between methods and techniques found in traditional printmaking. Collectively, they pursued an approach that argued for the appropriateness of design to its context, contending that architecture, with its long life expectancy, required different design decisions from those attending an expendable, more rapidly outdated item like a toaster.[34] They were thus attentive to the high level of discrimination and sophistication, akin to connoisseurship, that informed audiences, fans, and aficionados alike bring to bear on their cultural choices, irrespective of the status of the genre in question.[35]

In exploring these issues in their work, most of the artists in the Independent Group stayed within the realm of what was unquestionably high cultural activity: painting and sculpture. And whereas their theoretical

positions, as expressed in Independent Group activity, in seminars, exhibitions, writing, and lectures, may have at times been controversial, their work as fine artists was readily accepted in mainstream venues and contexts, often by the very people who were otherwise opposed to them as well as being themselves the implicit objects of their critiques.[36] Paolozzi's bronze sculptures, for example, were unproblematically endorsed alongside those of a rising generation of younger sculptors. There was no conflict with the guardians of high culture since in his works, as in Hamilton's paintings of the late fifties, mass-cultural elements were being incorporated into the realm of high-art activity in ways that were perceived not to threaten it; indeed, theirs was an approach with a venerable tradition. Similarly, it could be argued that Banham's thesis, later published as *Theory and Design in the First Machine Age*, though ground-breaking in terms of the wealth of new information it uncovered and the originality of certain governing ideas, was far from subversive in its approach to the study of early modernism, depending as it did on the mainstays of architectural scholarship: key architects, major buildings, and so forth.[37]

While by questioning the absolutist hierarchies and elitist franchise that subtended high art, the members of the Independent Group could be said to have attacked certain of its foundations, they cannot be said to have attempted to undermine modernism as such. Their approach was firmly rooted in the legacy of early European modernism, that of the interwar years, of the Bauhaus, of Duchamp and Joyce, among others. They did not accept the notion that the modernist heritage had passed to New York and was currently centered in Abstract Expressionism, as did those of their British peers for whom the shows of American art held at the Tate Gallery at the end of the fifties proved so influential.[38] Like Ballard in 1956, they, too, felt that it failed to offer a persuasive model for a contemporary practice. As the quotations cited at the beginning of this essay attest, their interest in mass culture was doubly determined. In dominating and conditioning the visual data of contemporary lifestyles, and therefore requiring an informed understanding for modern living, popular culture warranted close study; in altering the visual landscape, it become a crucial, even preeminent source for the modern artist to consider.

■ While the Pop Art that emerged in Britain in the sixties was widely, enthusiastically, and rapidly embraced, in the United States it was bitterly contested.[39] However, its various advocates and denunciators cannot be divided along the lines of radical and conservative, academic and avant-garde, for what Pop Art initially seemed to propose was a far greater challenge than that which was normally implied in the shift from one art movement to another, that is, by a change in subject and/or style. The

situation in England was not comparable: neither the art objects made by members of the Independent Group nor the paintings of the sixties Pop artists offer equivalent challenges to those notions of originality, authorship, and innovation that lie at the heart of modernism, even to the very category of art qua art, that American Pop Art at its most rigorous and trenchant was believed to posit. In aesthetic terms, the British strains could be condemned, or celebrated, for being vulgar, tasteless, and jejeune; but in no sense did they present more fundamental assaults on normative categories.[40] And similarly in social terms: the Independent Group was expansionist and accumulative in its targets and only incidentally confrontational and contestatory, while British Pop of the sixties offered far less threat to the status quo than did either pop music or fashion. In fact, its ready acceptance at a general level could be ascribed in part to the ease with which it was assimilated into the new manifestations then sweeping the field of music, fashion, and design, manifestations that cumulatively became promoted as Pop culture, and hence as key elements in the scene soon known as "Swinging London."

The emergence of American Pop Art in 1962 aroused enormous controversy among the defenders of high culture, following as it did at least a decade of anxious defensiveness by those mandarins.[41] In their determination to safeguard high culture, certain strategies had been adopted to present Abstract Expressionism as a pinnacle of high-art achievement, one which had to be segregated from the incursions of all forms of kitsch. To this end, the degree to which de Kooning, for example, drew on both mass-cultural imagery and its themes was ignored or heavily underplayed.[42] Robert Rauschenberg's combines, which preserved unaltered the factuality, the "given" quality, of their preformed mass-cultural elements were, at least at first, able to be marginalized by being considered a form of Neo-Dada. Thus it was Jasper Johns's paintings that, in the late fifties, came to represent a major threat to the hegemony of Abstract Expressionism: for notwithstanding his virtuosity in handling paint, his overtly banal subject matter appeared highly provocative in the face of those transcendental ideals purportedly manifest in Abstract Expressionism.

The question of the relationship between high and low culture grew increasingly explosive with the steadily expanding proliferation of mass culture into all areas of daily life, a fact demonstrated first by the furor that surrounded the earliest show to bring together many of the American Pop protagonists, Sidney Janis's 1962 New Realists exhibition, and second, by the way that the greatest controversy centered around Andy Warhol (see figs. 218 and 219) and Roy Lichtenstein (see figs. 220 and 221), painters whose work not only drew on advertising and media imagery for its subject matter but which, more importantly, utilized the conventions and techniques of mass reproduction in representing it.[43] Moreover, in addition to





■ LYNNE COOKE



their seeming not to transform admass material, both artists presented it on a scale and in a format that directly challenged serious painting on its own ground. Unlike such patently avant-garde activity as "happenings," which adopted means, materials, and techniques, and even operated in venues, that were regarded as in some way alternative—nonart or antiart—American Pop Art sought to locate itself at the very heart of the mainstream. This was undoubtedly done highly consciously, for all its chief protagonists had, in their youth, flirted with or grown through phases of Abstract Expressionist painting. Moreover, since all had backgrounds in commercial art, they were thoroughly conversant with the normative distinctions that separated the two realms, their different codes, conventions, and values.[44] They therefore offered a challenge to prevailing concerns and larger cultural values of an order that the more conventional British artists emerging from the Royal College could not match. It was a kind of challenge that the Independent Group, operating in a quite different cultural matrix, did not seek to posit.

It is not surprising that no sustained parallels or significant connections can be drawn between the emergence of Pop Art in Britain and the United States. This involves more than the likelihood of local differences obscuring or modifying related impulses; rather it depends on the substantially different socio-cultural contexts in which each burgeoned. Such connections have nonetheless frequently been drawn largely because of the ways in which the history of Pop Art was first written. Were it not for the personal circumstances of Lawrence Alloway's life, the Independent Group might never have become a component integral to any discussion of Pop Art, nor might such weight have been given, at least in the early accounts, to its manifestations in Britain in the sixties.[45]

Alloway coined the term "Pop" initially to refer to the widespread interest in popular culture as it was expressed by the members of the Independent Group in their discussions, lectures, and other group activities. A particular interest of his, he fostered it wherever he was most active and influential, such as in the seminar series held at the I.C.A. during the winter of 1953–54. He was then, almost predictably, attracted by the arrival of certain younger British artists, mostly from the Royal College, who used it as the source of imagery in their paintings; and he subsequently modified the meaning of the term to accommodate them, dubbing their work, collectively, Pop Art. In 1962 he moved to the United States, where he quickly became an influential curator of pioneering exhibitions devoted to the work of key participants in what had emerged there under several rubrics before it finally became definitively known as Pop Art.

In later writing a history of the postwar art in Britain that drew on popular culture for its imagery and, sometimes, style, Alloway cojoined Pop and Pop Art in a quasilinear unfolding, which conformed to the progressivist evolu-







tionary models then prevailing in art history—and the Independent Group became the progenitors of Pop Art.[46] It is worth noting, however, that although Alloway had written extensively on various art and popular culture topics during the years of the Independent Group, and although at that time he also reviewed the work of its key artists Paolozzi and Hamilton in highly favorable terms, he never mentioned, let alone discussed, the group during its existence.[47] If it was in large part due to Alloway that the Independent Group came to have a recognized place in those histories of Pop Art written in the sixties, thereafter its stature waned as the preeminence of certain of its American principals grew and the careers of others elsewhere declined. By the beginning of the eighties, in general histories of twentieth-century art it was often reduced to little more than a cursory citation, a singular prefiguration, an obligatory footnote.[48]

British Pop Art of the sixties has with time suffered a similar eclipse, being increasingly seen as but one, local, manifestation among many, and arguably not a crucial one at that. The prodigious spread of the mass media and consumer culture throughout the Western world from the mid-fifties onward was rarely separable in most places from the infiltration of American influence—in the guise of both high and low cultural forms. This generated a range of reactions throughout Europe in which response to the former was inextricably linked to a response to the latter, and the results were deemed, collectively, manifestations of Pop Art. Overlooked then, and so never commandeered under that rubric, the works made during the 1960s by the German Capitalist Realists Gerhard Richter and Sigmar Polke now appear both more substantial and more significant, in the ways that they address the challenges offered by this proliferating mass culture than do those of any other non-New York "Pop" artists—the British included—with the singular exception of Richard Hamilton.[49] Only recently, however, has due attention begun to be accorded them in the English-speaking world: this will doubtless in turn contribute significantly to the rewriting of the standard histories of Pop Art, which to date are still largely determined by the perspectives taken by certain British and American authors of the sixties.

If by the later part of that decade (American) Pop Art seemed to have swept all before it, having been assimilated into mainstream accounts of the development of modern art as a parallel and counterpoint to contemporary abstraction,[50] developments in the seventies led to its being reconsidered in very different terms. In the wake of the Conceptualists' institutional critique and deconstruction of the art object, its languages and forms, Pop Art came under increasing attack, especially from the Left.[51] Far from offering a critique or even exposure of the dominant values of late capitalist consumer society as had formerly been argued, most notably in continental Europe, it was now seen to be thoroughly implicated in them, collusive and complicit.[52] Most historical accounts attempting, with the benefits of hindsight,

to assess its contribution to modernism have henceforth concentrated on little else.

By contrast, those artists and writers who came to maturity in the late seventies had grown up in a media-saturated world and were therefore attuned, it is argued, to the dominating effects of the electronics media and information technologies not only on the current visual landscape and its languages but on all conscious thoughts and unconscious desires. To them there seems no possibility of offering any critique from outside this context, that is, of providing a critique that is not itself marked by some degree of complicity with the prevailing ideology. Framed by the new theoretical writing emerging from poststructuralist authors, most recent investigations of Pop Art have therefore taken a different course, and a somewhat more positive reading has ensued—or at least one that may be construed as positive within an increasingly negative overview of Western culture at large. Media-literate in new ways, interpretations of this kind have been particularly forthcoming from those influenced by the writing of Jean Baudrillard, who has played a seminal role in the United States throughout the eighties in the thinking and development of many younger artists and writers.[53]

Most of the advocates of American Pop in the later sixties sought to argue for its high quality in orthodox terms, that is, for its formal affinities with concurrent modes of vanguard abstraction, and thus for its place in the mainstream of modernist expression. In so doing, they masked or suppressed, at least for a time, consideration of what has recently, once again, been considered essential to the radicality of its challenge, namely, its fundamental assault on certain central tenets of modernism: originality, authenticity, and innovation. Congruent with this has been the realization, admittedly more dependent on the example of Warhol than of Pop Art as a whole, that it is inextricably caught within the operations of the culture industry at large and yet at best not fully subservient to them. As Benjamin Buchloh argues:

the contradictions evidenced in the work's consistently ambivalent relationship to both mass culture and high art . . . [were crucial to] the way in which Warhol underlined at all times that the governing formal determination of his work was the distribution form of the commodity object and that the work obeyed the same principles that determine the objects of the cultural industry at large.[54]

This and related interpretations have given Warhol's art immense potency in the eighties, since even more than the issues pertaining to simulation and appropriation, the question of the commodification of the artwork has come to the fore. But the centrality of these questions to the postmodernist debate is such that Pop Art as a whole has gained renewed significance—so

much so, in fact, that Paul Taylor was recently able to claim quite persuasively, in the introduction to an anthology of theoretical writings devoted to this subject: "Two and a half decades after the event, Pop Art has re-emerged as the most influential movement in the contemporary art world."[55]

Whereas shifting theoretical perspectives largely account for the different readings that contribute to the renewed interest in Pop Art in general, the case of the Independent Group stands somewhat apart. For what was initially required was the retrieval of information long lost or otherwise obscured: only following that did it become possible to begin to reassess its contribution to the field of cultural studies, as well as to the history of art.[56] In the event, it is that contribution to cultural studies that has tended to dominate recent accounts, both because of its endeavors to create a high/low continuum, and its ideal of making the simultaneous appreciation of all types of culture not only possible but desirable. In this it anticipated the leveling of hierarchies and the blurring of boundaries that have become the hallmark of the contemporary situation in which, according to Fredric Jameson, the cultural, the social, and the economic are no longer easily distinguished from one another.[57]

While the Independent Group undoubtedly warrants homages from the sphere of cultural studies as well as from that of design history, where the sophisticated acuity of its analyses of product design are still pioneering, this should not preclude acknowledgment of certain crucial differences that separate the fifties from the present and so render it ultimately less memorable as a model than as an exemplar.[58] Such differences stem from changes both in theory and in society. Thus, for example, the belief that the mass media possess intrinsically liberating or democratic appeal—which is currently blocked or suppressed by the ruling groups or the power interests in whose hands they lie—is currently in question; and far from a greater heterogeneity resulting from a proliferation of the mass media, increasing control and homogenization occur as power becomes vested in the hands of a few giant corporations.[59] Moreover, recent studies of the producer-marketing-consumer relationship no longer accord such weight and influence to the consumer as did Banham, his colleagues, and others in the fifties; instead, control is believed to belong to the machinations of the mediating/marketing forces, manifest in the ever-increasing power of advertising and the electronics media. And still other studies draw attention to the high costs in ecological terms of a society geared to expendability and obsolescence. Congruent with all this is the unprecedented significance now attributed to language and representation in the determining of identity, desires, and needs.

However, when placed against those current theories that offer a relentlessly pessimistic vision, one that only too often manifests itself in the

aesthetic arena in cynical, parodic self-mockery, the more modestly circum-scribed and qualified, optimistic and amusedly affectionate stance adopted by the Independent Group posits something very different. Less manichean and less deterministic, more pragmatic and more nuanced in its approaches than are those encompassing social theories offered recently by most French writers and their American cohorts, it would presumably agree with those who argue that there is a degree of emancipation to be found in consump-tion in general, that consumption satisfies needs, and that, even though those needs can be distorted to an amazing degree, every need contains a smaller or larger kernel of authenticity.[60]

Equally important was their advocacy of popular culture for its capacity to articulate alternative cultural identities on the margins of dominant groups. By crediting mass culture with a subversive and/or a progressive potential, with the possibility of decentering and redistributing cultural power, they herald the ways in which contemporary postmodern theory has turned increasingly to popular-culture exemplars for its models for cultural plurality and resistance. Irrespective of how clichéd and stereotyped they may have become, it is out of those myths and rituals generated by mass culture that subversive if temporary subcultures, like punk, may flourish, and such progressive hybrid subgenres as the techno-sci-fi of William Gibson bur-geon.[61] While possibly no more than a form of licensed negation, subcul-tures nevertheless attain a quotient of autonomy, which gives them space for certain emancipatory stances and gestures.

But notwithstanding their precedent in drawing attention to such mar-ginalized phenomena, it is not there that the modern-day counterparts to the Independent Group are to be sought. For it was ultimately mainstream cultural forms, seen as the crucial bearers of meaning, value, and power, that preoccupied them. Their descendants are far more likely to be dissect-ing the "social symbology" of advertising, fashion, or rock music for *Artforum* than to be writing copy for *The Face*.[62] Equally, they are more likely to be confronting issues related to mass production, display, and consump-tion through the creation of art objects, as does, say Allan McCollum, than resigning themselves to a reproductive practice embodying a cynical nihilism.

1. Alison and Peter Smithson, "But Today We Collect Ads," *Ark*, (1956), reprinted in *Modern Dreams — the Rise and Fall and Rise of Pop*, ed. Brian Wallis (Cambridge, Mass., 1988), pp. 53–55 (hereafter referred to as *Modern Dreams*).

2. Richard Hamilton, "Roy Lichtenstein," *Studio International*, vol. 175, no. 896. January 1968, p. 23.

3. The exhibition was not organized by the Independent Group (hereafter referred to as IG) but by Theo Crosby, editor of *Architectural Design*. For a detailed study of the origin and form of the show, see Graham Whitham, "This Is Tomorrow: Genesis of an Exhibition," in *Modern Dreams*, pp. 35–39.

4. Modern Art in the United States contained the work of Arshile Gorky, Willem de Kooning, Jackson Pollock, Mark Rothko, and Clyfford Still; about 110 artists were represented in all. Pollock's work had in fact already been shown in London, in a group exhibition entitled Opposing Forces held at the I.C.A. in 1953. Thomas Hess gave a lecture entitled "New Abstract Painters in America" at the I.C.A. in November 1951; at a series of lectures at the I.C.A. in the winter of 1953–54, Toni del Renzio, a member of the IG, discussed Action Painting under the title "Non-Formal Painting." Reyner Banham argues that to the Smithsons, who first encountered Pollock's work at the Venice Biennale of 1950, "he became a sort of patron saint even before his sensational and much publicized death"; Reyner Banham, *The New Brutalism: Ethic or Aesthetic?* (New York, 1966), p. 61. One of Hans Namuth's pictures of Pollock in his studio was included in Parallel of Life and Art (an exhibition at the I.C.A. in 1953); for the organizers he represented something that was very much in concert with the prevailing impulse of the show, a flouting of humanistic conventions of beauty in lieu of violence, distortion and obscurity.

5. For a detailed study of the formation and activities of the IG, see Anne Massey, "The Independent Group: Towards a Redefinition," *Burlington Magazine*, no. 1,009, April 1987, pp. 232–42 (hereafter referred to as "Towards a Redefinition").

6. Kenneth Frampton described it acutely as a "symbolic temenos — a metaphorical backyard, an ironic interpretation of Laugier's primitive hut of 1753 in terms of the backyard reality of Bethnal Green"; Kenneth Frampton, "New Brutalism and the Welfare State: 1949–59," in *Modern Dreams*, p. 48. Paolozzi had stayed with the Nigel Hendersons, who lived in Bethnal Green; an anthropologist, Nigel's wife, Judy, was working on a project that involved a study of backyards in that community.

7. Lawrence Alloway, introduction to *This Is Tomorrow*, catalogue of an exhibition at the Whitechapel Gallery, London, 1956, n.pag.

8. Entitled The New American Painting, this exhibition contained the work of James Brooks, Sam Francis, Philip Guston, and Grace Hartigan, in addition to that of Pollock, de Kooning, and other "First Generation" Abstract Expressionists.

9. The continuity of this initial impetus was maintained especially through the figure of Anthony Caro, the sole sculptor invited to participate. Greenberg's advocacy of his sculpture and the continuing influence of Greenberg's theories in Britain are well documented.

10. Hamilton, quoted in Richard Morphet, introduction to *Richard Hamilton*, catalogue of an exhibition at the Tate Gallery, London, 1971, pp. 32–33.

11. Of the related painting *$he*, which grew out of an investigation Hamilton undertook into consumer goods for an IG lecture, Lawrence Alloway wrote: "*$he* extends the most elliptical sign language of the art world (minted by Marcel Duchamp) to consumer goods. The painting is characterised by the cool, clean hygienic surface of kitchen equipment and the detailing has the crisp, fine points of ads or explanatory booklets on the products that Hamilton is painting"; "Artists as Consumers," *Image*, no. 3, c. February 1961, pp. 14–19. Later he added, equally validly, "The twentieth century experience of overlapping and clustered sign systems is Hamilton's organising principle"; Lawrence Alloway, "Pop Culture and Pop Art," *Art International*, July 1969, p. 19.

12. "New Brutalism" is a term that was applied more often to the architecture of the Smithsons. For further discussion, see Frampton, "New Brutalism," pp. 47–51. Some years later, Paolozzi and the Smithsons attempted to disassociate themselves from the IG.

13. For a detailed examination of Hamilton's early work, see Morphet, Introduction to *Richard Hamilton*. Certain of these differences should also be attributed to the markedly contrasting temperaments and sensibilities of Paolozzi and Hamilton. Whereas the former is prolix, the latter is terse; whereas the former is anti-academic, the latter demonstrates a spare intellectualism; whereas the former mined tawdry pulp publications — often cheap and nasty, violent and sexist — the latter admired industrial design, the glossies, and other sophisticated products essential to the manufacturing of consumer dreams; and whereas the former found an element of fantasy and horror inherent in actuality, the latter regarded its latest forms of expression with what has been aptly termed "an irony of affirmation." Their differences in attitude could perhaps be compared to the difference between perceiving something receptively and thinking critically about it.

14. Lawrence Alloway later summarized their collective approach: "Any lessons in consumption or in style must occur inside the patterns of entertainment . . . and not weigh it down like a pigeon with *The Naked and the Dead* tied to its leg"; Lawrence Alloway, "The Long Front of Culture" (1959), reprinted in John Russell and Suzi Gablik, *Pop Art Redefined* (London, 1969), p. 42 (hereafter referred to as *Pop Art Redefined*).

15. See "Speculative Illustrations: Eduardo Paolozzi in Conversation with J. G. Ballard and Frank Whitford," *Studio International*, vol.183, no. 937 (October 1971), p. 136.

16. Paolozzi has had a greater interest than most of the IG members in the products of indigenous cultures and preindustrial societies. Whereas in his art of the fifties his aim was to metamorphose his found material into bronzes (rather than leave it in a preformed state, as occurs in assemblage work), in the activities he undertook as a member of the IG — such as his famous lecture of 1952), Paolozzi's attitude to his sources was what might be called ethnographic surrealism. In that pioneering lecture, Paolozzi presented under an epidiascope a large number of tear sheets without recognizable order, logical connection, or commentary; the material included painted covers from *Amazing Science Fiction*, advertisements for Cadillac and Chevrolet cars, a page of drawings from the Disney film *Mother Goose Goes to Hollywood*, and sheets of United States Army aircraft insignia as well as robots performing various tasks, usually with the help of humans. It was not until a decade later that he incorporated some of this material into his art, in the graphic suite *Bunk*.

17. For a more detailed discussion of the relation between Ballard and Paolozzi, see Eugenie Tsai, "The Sci-Fi Connection: The IG, J. G. Ballard, and Robert Smithson," in *Modern Dreams*, pp. 71–75.

18. Note should be taken of the influential role played by certain celebrated photo books, including László Moholy-Nagy's *Vision in Motion* (1947), D'Arcy Wentworth Thompson's *Growth and Form* (1916; 1st American edn. 1942), Amédée Ozenfant's *Foundations of Modern Art* (1931), and Sigfried Giedion's *Mechanization Takes Command* (1948), on the thinking of the IG. According to Diane Kirkpatrick (*Eduardo Paolozzi* [London, 1970], p. 19), these books, together with "Gutkind's *Our World From The Air*, and Kepes's *The New Landscape* each presented different aspects of the new visual frontiers which Kepes described as 'magnification of optical data, expansion and compression of events in time, expansion of the eye's sensitivity range, and modulations of signals.'"

19. Banham, *New Brutalism*, p. 62.

20. Alloway, Introduction to *This Is Tomorrow*, n.pag.

21. For a detailed discussion of the exhibitions organized by members of the IG, see Judith Barry, "Designed Aesthetic: Exhibition Design and the Independent Group," in *Modern Dreams*, pp. 41–45.

22. For a fuller account of the social changes taking place in Britain at this time and their

implications for responses to popular culture, see Arthur Marwick, *The Explosion of British Society 1914–1970* (1963; reprinted London, 1971); Christopher Booker, *The Neophiliacs* (London, 1969); Dick Hebdige, "Towards a Cartography of Taste 1935–1962," *Block*, no. 4, 1981, pp. 39–56. Note that the Labour party came into power at the end of the war with a campaign designed to "face the future." In 1951 the Conservatives were returned to office; by the end of the decade they were promoting their cause with the slogan "You've never had it so good"; Marwick, *Explosion*, p. 139.

23. Ballard, quoted in "Speculative Illustrations," p. 139.

24. See Hebdige, "Towards a Cartography of Taste." Note that Banham and, following him, Hebdige, have suggested that the IG was fundamentally a class-based challenge to bourgeois values and attitudes. This has been convincingly called into question by Anne Massey and Penny Sparke in their seminal study of the IG, "Towards a Redefinition." By contrast, the doyens of the various sixties Pop phenomena — fashion, art, music, etc. — stressed their "classlessness," an absence of overt class associations that was quite new in Britain.

25. Alloway, "Long Front of Culture," p. 41.

26. Brian Wallis, "Tomorrow and Tomorrow and Tomorrow: The Independent Group and Popular Culture," in *Modern Dreams*, p. 16.

27. Reyner Banham describes the role of the product critic in "A Throw-Away Aesthetic" (1955), published as "Industrial Design and Popular Art" in *Industrial Design*, March 1960, reprinted in Penny Sparke, ed., *Reyner Banham: Design By Choice* (New York, 1981), p. 93.

28. See Reyner Banham, "The Atavism of the Short-Distance Mini-Cyclist" (1964), reprinted in Sparke, *Reyner Banham*, p. 89; and Dick Hebdige, "In Poor Taste: Notes on Pop" (1983), reprinted by Dick Hebdige, *Hiding in the Light: On Images and Things* (London, 1988), p. 141.

29. As Judith Barry points out ("Designed Aesthetic," p. 41), "Reyner Banham was a design historian and critic, Alison and Peter Smithson, James Stirling, Colin St. John Wilson, and Alan Colquhoun were architects, Theo Crosby and Edward Wright were graphic designers, and Richard Hamilton taught design at the Central School of Arts and Crafts." Arguing incisively that "design, rather than fine art, was the language through which they observed and apprehended the structure of their environment and the technology which was reshaping it," Barry likens the group to a design team in an architect's office as distinct from the artist in a studio. However, her analogy attributes too much coherence and too great a directedness to the IG. It was more like an informal study group. Comparison should be made with The Club, which De Kooning and a number of his peers formed in New York in the early 1950s. This was also a carefully selected group, one that also met informally for scheduled lectures and debates. The key difference is that although scientists, poets, and philosophers were invited to talk at The Club, there was no brief for popular culture, and indeed such arts as photography tended to be dismissed by many (though not by de Kooning), according to the photographer Aaron Siskind, a founding member and longtime friend of certain of the Abstract Expressionists.

30. Because this exhibition seems to encapsulate much which was in the early 1950s fundamental to the anthropological and theoretical approach of Hamilton and Banham, together with many others in the IG, it is worth quoting at some length from the catalogue *Man, Machine and Motion* (May 1955, n.pag.). In the introduction, Hamilton and Gowing wrote: "A photograph of an early aeroplane standing unattended has a distinct and separate beauty: the elaborate geometry of it engages the eye. But when a man gets into the machine he gives it quite another meaning. The look of it excites us in a different way, both more intimate, less abstract, and more unexpected. The conventional aesthetic appreciation of machines — the view that the beauty of a machine lies in a harmonious fitness for its function — does not prepare us for this new excitement. . . . The photographs in fact discover man in a new relationship. It is a relationship as cherished and as full of feeling as that earlier relation, familiar in art, between a horse and its rider. The relationship is now different, and more profound. The new rider has not merely exchanged the potentialities of one creature for those of another. He has realised an

aspiration which lies deeper than thought, the longing for a power with no natural limits; he finds himself in real life the super-human inhabitant of his dearest fantasy. That the fantasy is dear to us we cannot doubt. . . . The aeroplane, which evolved with the illogical wastefulness of a biological evolution, was born of a myth. It was a fantasy for centuries before any man flew. Even now, in the interstellar spaces, the myth, the fiction, is again ahead. . . . This exhibition is chiefly concerned with a fantasy still hardly articulate in the dream-life in which men & machines live together, the life which is with us now. . . . The new union of man and machine possesses as positive a composite character [as that of the centaur] and liberates a deeper, more fearsome human impulse. . . . It creates, as we watch, its own myth. The myth, the poetry, is needed: man has no other means of assimilating disruptive experience to the balanced fabric of thought and feeling. It is the purpose of this exhibition to examine the beginnings of just this process, and to isolate some of the visual material on which new myths are based." Thus, it was less the technical applications of these new inventions that concerned Hamilton and Gowing than how the perceptions and social identities of contemporary consumers were transformed.

31. Note that this assumption of an active engagement by the spectator was also fundamental to Hamilton's early paintings, which were always motivated by specific ideas later investigated in the process of picture-making.

32. Richard Hamilton, "Comments on John McHale and His Work," in *The Expendable Ikon: Works by John McHale,* catalogue of an exhibition at the Albright-Knox Art Gallery, Buffalo, N.Y., 1984, p. 89.

33. Banham's model in this regard was Erwin Panofsky, to whom he paid tribute when he wrote: "We are faced with the unprecedented situation of the mass distribution of sophistication. It may not be profound art appreciation, it may not be profound learning in music, but it is an ability to discriminate. . . . [It entails] a degree of sophistication which is a genuine cultural innovation, and we really don't know a damn thing about it yet . . . For guidance on how to do it one is driven back (as so often) to quotation from Panofsky's famous but alas very little read essay on the movies"; "Atavism of the Short-Distance Mini-Cyclist," p. 89.

34. For Banham and many of the IG, "Borax," which he defined as "an anti-Purist, but eyecatching vocabulary of design," was not in bad taste but simply in "a design language which can be used badly or well"; Reyner Banham, "Machine Aesthetic," *Architectural Review,* April 1955, p. 228.

35. Banham discusses the professionalism and expertise of the Pop practitioner in "Design by Choice" (1961; reprinted in Penny Sparke, ed., *Reyner Banham,* p. 106) and the sophistication of audiences in "Atavism of the Short-Distance Mini-Cyclist," p. 88. In "Long Front Of Culture" (pp. 41–43), Alloway argues that individuals in a consumer society, armed with their high level of decoding skills, preserve their integrity within the group. See also John McHale's "The Fine Arts in the Mass Media" (reprinted in *Pop Art Redefined,* p. 44–47), which stresses both the diversity of the mass audience and the fact that there is no need to choose between instances of high and low culture—that it is possible to appreciate both simultaneously.

36. Paolozzi was, for example, one of eight young British sculptors who represented Great Britain at the Venice Biennale of 1952. Herbert Read coined the term "Geometry of Fear" to characterize their work, which he admired. For a fuller discussion of the antipathy the IG felt towards Read's aesthetic, see Massey and Sparke, "Towards a Redefinition." Paolozzi was also included in New Images of Man, an exhibition at the Museum of Modern Art, New York, in 1957, curated by Peter Selz, who was soon to become a virulent critic of American Pop Art.

37. Banham's thesis, "Theory and Design in the First Machine Age," was published in 1960 in London by the Architectural Press and in New York by Praeger Publishers. (Certain of Banham's later studies of architecture, that is, architecture conceived in the widest sense, such as his book devoted to Los Angeles, are more radical in their methodology.) Note that this is true, too, of the Smithsons, as Patricia Phillips attests when she states, "The Smithsons chose to work within the established territory of architectural convention. . . . [They] took ideas from popular phe-

nomena in order to empower the users of architecture"; Patricia Phillips, "Why Is Pop So Unpopular?" in *Modern Dreams,* p. 123.

38. Exception should be made here for Lawrence Alloway. What is notable about these early modernists and others admired by certain members of the group, such as Paul Klee and Jean Dubuffet, are the ways in which their work reinvented or otherwise renewed itself by identifying with what Thomas Crow aptly calls "marginal, 'nonartistic' forms of expressivity and display." This is an approach with a long lineage in modernist art; see Thomas Crow, "Modernism and Mass Culture in the Visual Arts" (1983), reprinted in Francis Frascina, ed., *Pollock and After: The Critical Debate* (New York, 1985), p. 233. James Joyce was the subject of the first exhibition organized on the permanent premises of the I.C.A. in Dover Street, London, in 1950—James Joyce. His Life and Work—for which Richard Hamilton designed the exhibition catalogue. *Ulysses* is the subject of a series of etchings that Hamilton began in the 1940s and is continuing; see *Richard Hamilton,* catalogue of an exhibition at the Orchard Gallery, Londonderry, 1988.

39. For a fuller discussion of the critics of American Pop Art, see Carol Anne Mahsun, *Pop Art and the Critics* (1981), dissertation, Ann Arbor, Mich., and London, 1987.

40. The British 1960s Pop artists, whose effect upon the aesthetic status quo was little more than stylistic, were so rapidly assimilated that comparisons have been drawn with the Pre-Raphaelite Brotherhood. These are apt in a number of respects: as regards the speed with which each group became celebrated; as regards their mutual interest in what might be called exotic subject matter; and as regards the fundamentally provincial character of their concerns, at least as realized in their art.

41. Opponents ranged from those on (or formerly on) the Left, such as Clement Greenberg, Irving Howe, and Dwight MacDonald, to conservatives such as José Ortega y Gasset and T. S. Eliot. Greenberg's most notable essay on the subject of "high/low" was "Avant-Garde and Kitsch," first published in 1939, and reprinted many times. But see also Greenberg's "The Present Prospects of American Painting and Sculpture," *Horizon,* nos. 93–94, October 1947. See also Dwight MacDonald, "A Theory of Mass Culture," *Diogenes,* vol. 3 (1953). Typical of these defenders of high culture (though he tended to overstate his arguments) was Erle Loran, who castigated the Pop artists (especially Roy Lichtenstein, who borrowed from his Cézanne compositional diagrams), while viewing Abstract Expressionism as a demonstration of the "true meaning of free democracy . . . in America." For Loran, the New York School paintings were the "most advanced products of the human mind, comparable in some ways to achievements in physics and chemistry." For Erle Loran, see "Cézanne and Lichtenstein: Problems of Transformation," *Artforum,* vol. 2 (September 1963), pp. 34–35; "Pop Artists or Copy Cats," *Art News,* September 1963, pp. 48–49, 61. The statements by Loran quoted in this note are from "Cézanne and Lichtenstein," p. 35. There was a general difference in approach to much mass culture between writers in the United States and the IG. Among the first American books to survey the subject in any detail was an anthology entitled *Mass Culture: The Popular Arts in America,* edited by Bernard Rosenberg and David Manning White and published in 1957. It contained the work of fifty-one writers concerned with the social effects of the media on American life. In their introduction to the texts, the editors commented that when they were seeking representative viewpoints they found many more excoriators than defenders of mass culture. Moreover, most of the defenders, including White himself, argued in favor of mass culture on the grounds it spread high culture to new audiences, instancing the presentation of Shakespeare, ballet, and opera on TV and the boom in paperback publishing, which had led to the reprinting of Dostoevsky as well as pulp writers. Unlike the IG, they did not value it in itself, on its own account. That the IG was aware of at least some of these debates is indicated by the fact that in a 1958 article, "The Arts and the Mass Media," Lawrence Alloway attacked Greenberg's essay "Avant-Garde and Kitsch," objecting to his reduction of the mass media to "ersatz culture . . . destined for those who are insensible to the value of genuine culture"; reprinted in Michael Compton, *Pop Art,* London, New York, Sydney, and Toronto, 1970, p. 154. Marshall McLuhan's *The Mechanical Bride,* published in 1951, was also discussed at IG

meetings. More than half the book was given over to reproductions of advertisements and other manifestations of popular culture; the other half was devoted to a commentary on their significance.

42. De Kooning's interest in, say, the pinup and Mom-ism was only first studied in 1972, in Thomas B. Hess's "Pinup and Icon," *Art News Annual*, vol. 38 (1972), pp. 223–37. Note that De Kooning had been trained in commercial-art techniques in Rotterdam, had worked in that field in New York in the interwar years, and maintained a lifelong interest in popular art forms — an interest expressed in his art in diverse ways.

43. The New Realists show at the Sidney Janis Gallery, New York, contained the works of Warhol, Lichtenstein, Oldenburg, and Rosenquist, among the fourteen artists exhibited. For a range of early responses to (American) Pop Art, see the symposium held at the Museum of Modern Art, New York, on December 13, 1962, in which the participants included Peter Selz, Henry Geldzahler, Hilton Kramer, Dore Ashton, Leo Steinberg, and Stanley Kunitz. This was later published in *Arts Magazine*, April 1963, pp. 36–45.

44. Because they were graphic in nature, Lichtenstein's sources at this moment did not even have the degree of respectability that certain types of photographic reproduction had. They were consequently considered that much more shocking at first. Similarly, in his paintings Andy Warhol simulated a style of advertising copy very different from the chic high-style advertisements he made as an award-winning designer for such up-market clients as I. Miller and *Vogue*.

45. Among the more substantial early publications on Pop Art, a considerable number were by English authors. See, in addition to Alloway, for example, "The Development of British Pop," in Lucy Lippard, ed., *Pop Art* (New York, 1966), pp. 27–68; John Russell, "British Art," in *Pop Art Redefined*; and Compton, *Pop Art*. One of the first and most important shows curated by Alloway was Six Painters and the Object, which included work by Jim Dine, Lichtenstein, Jasper Johns, Robert Rauschenberg, James Rosenquist, and Warhol. It opened at the Solomon R. Guggenheim Museum in New York in 1963 and then traveled to the Los Angeles County Museum of Art, where Alloway added a companion, West-Coast–based show, Six More.

46. Alloway published his history on several occasions; the most influential account appeared in Lippard, ed., *Pop Art*.

47. See Anne Massey and Penny Sparke, "The Myth of the Independent Group," *Block*, no.10, 1985, p. 48. They point out that Banham, whose writing was also being published widely at this time, did not mention the IG in print until the winter of 1962–63, in an article published in *Motif*, entitled "Who Is This Pop?" in which he argued that all subsequent manifestations of Pop sensibility were indebted to the IG.

48. See, for example, Robert Hughes, *The Shock of the New* (New York, 1980). Norbert Lynton, in his *The Story of Modern Art* (Oxford, 1980), mentions briefly the This is Tomorrow exhibition without, however, naming the IG. John Russell omitted all mention of the IG, Pop, and British Pop from his account of twentieth-century art, *The Meanings of Modern Art* (New York, 1981).

49. Gerhard Richter and Richard Hamilton, in particular, would repay closer comparison, given that both are modernist artists committed to bringing a critical, articulate, contestatory address to painting. Although their interests in the usage of various types of popular-culture imagery and styles converge, neither has confined himself to a conventional Pop Art approach. For example, during the 1960s, Hamilton executed a series of works inspired by the "classical Braun products" designed by Dieter Rams, which, according to the artist, "attempted to introduce a contradiction into the lexicon of source material of Pop. They posed the question: does the subject-matter in most American Pop Art significantly exclude those products of mass culture which might be the choice of a New York Museum of Modern Art 'Good Design' committee from our scrutiny?" ("concept/technology>artwork," in *Richard Hamilton*, catalogue of an exhibition at the Moderna Museet, Stockholm, 1989, p. 22). Recently Richter has drawn on news photographs from the popular press for his series of works based on the Baader-Meinhof gang, a series that raises the possibility of a contemporary history painting.

50. Robert Rosenblum, for example ("Pop Art and Non-Pop Art," *Art and Literature*, vol. 5 [Summer 1964], reprinted in *Pop Art Redefined*, pp. 53–56), argued that "the initially unsettling imagery of Pop Art will quickly be dispelled by the numbing effects of iconographic familiarity and ephemeral or enduring pictorial values will become explicit . . . this boundary between Pop and abstract art is an illusory one," an argument that John Russell and Suzi Gablik sought to second in *Pop Art Redefined*. In doing so, they reinforced statements that many of the artists, most notably Lichtenstein, were then making about their work. But, as Lisa Tickner has pointed out in a discussion of Allen Jones's art ("Allen Jones in Retrospect: A Serpentine Review," *Block*, no. 1 (1979), the problem with trying to focus on form and formal issues alone is that images are not nonhierarchical, interchangeable, and equitable. She continues (p. 41), "It has seemed crudely philistine to talk about the social and psychological relevance of the material – but any understanding of art as a signifying practice must break with the form/content distinction (with the accompanying implication that the 'art' lies in the 'form'), and must attempt to comprehend both the specificities of art as a particular kind of activity, and the way in which this activity transforms or endorses meanings that lie both within and beyond it." It is just this which certain of the more doctrinaire analysts of Pop signally fail to do; see, for example, Donald Kuspit, "Pop Art: A Reactionary Realism," *Art Journal*, Fall 1976, pp. 31–38.

51. Typical of these analyses, which focus on the commodity character of art in capitalist societies, is the argument advanced by Donald Kuspit, in "Pop Art: A Reactionary Realism."

52. Andreas Huyssen has analysed the reasons why in West Germany Pop was taken to be a subcultural, indigenous underground statement, at once critical of capitalist consumer society and yet emancipatory in its effects; see Andreas Huyssen, "The Cultural Politics of Pop" (1975), reprinted in Taylor, *Post-Pop Art* (MIT Press, Cambridge, Mass.: 1989) pp. 45–78.

53. The most prolific and well known of the theorists who, informed by Marxist and linguistic theories, have examined late capitalism as a society of consumption, Jean Baudrillard ("Pop: An Art of Consumption?" [1970], reprinted in Taylor) argues that the (American) Pop artists cannot be "reproached for their commercial success, and for accepting it without shame. . . . It is logical for an art that does not oppose the world of objects but explores its system, to enter itself into the system. It is even the end of a certain hypocrisy and radical illogicality. . . . Yet it is difficult to accuse either Warhol or the Pop artists of bad faith: their exacting logic collides with a certain sociological and cultural status of art, about which they can do nothing. It is this powerlessness which their ideology conveys. When they try to desacrilize their practice, society sacrilizes them all the more. Added to which is the fact that their attempt – however radical it might be – to secularize art, in its themes and its practice, leads to an exaltation and an unprecedented manifestation of the sacred in art. . . . [T]he author's content or intentions are not enough: it is the structures of culture production which are decisive . . . in Pop Art. . . . [I]ts smile epitomizes its whole ambiguity: it is not the smile of critical distance, it is the smile of *collusion*." (Taylor, pp. 36, 40–41, 44) For recent exhibitions that feature art indebted to Baudrillard's and related ideas, see *A Forest of Signs*, catalogue of an exhibition at the Museum of Contemporary Art, Los Angeles, 1989; and *Image World: Art and Media Culture*, catalogue of an exhibition at the Whitney Museum of American Art, New York, 1989.

54. Benjamin H. D. Buchloh, "The Andy Warhol Line," in *The Work of Andy Warhol*, ed. Gary Garrels (Seattle, 1989), p. 55.

55. Introduction to Paul Taylor, op.cit., p. 11.

56. The principal agent of retrieval was the 1988 exhibition and accompanying anthology-catalogue, *Modern Dreams*. This is Tomorrow Today, a reconstruction of the two key IG contributions to This is Tomorrow, was one of a series of four exhibitions on the theme held at the Clocktower Gallery, New York, between October 22, 1987, and June 12, 1988. Two further exhibitions devoted to the IG are scheduled to be held in 1990, at the I.C.A., London, and the Museum of Contemporary Art, Los Angeles. That Alloway and – still more surprising – Banham have not received the recognition that they deserve is demonstrated by the following statement by Steven Connor. (*Postmodern Culture: An Introduction to Theories of the Contemporary*

[Oxford, 1989], p. 184): "Recent years have seen an explosion of interest in a whole range of cultural texts and practices which had previously been scorned by, or remained invisible to, academic criticism. Contemporary cultural critics, following the inspiring lead of Richard Hoggart, Raymond Williams, Roland Barthes and Stuart Hall, take as their subjects sport, hairstyles, shopping, games and social rituals, and unabashedly bring to bear on these areas the same degree of theoretical sophistication as they would to any high cultural artifact." Both Alloway and Banham were initially far more receptive than was Hoggart to the new forms of mass culture, and more engaged by them than was Williams.

57. For a fuller account, see Connor, *Postmodern Culture*, pp. 43–50.

58. This should be seen in relation to the growing attention now being paid not only to the field of popular culture but to the escalating relationship between high and mass culture in the twentieth century. See, for example, James Sloan Allen, *The Romance of Commerce and Culture: Capitalism, Modernism and the Chicago-Aspen Crusade for Cultural Reform* (Chicago and London, 1983).

59. See Marvin Heiferman, "Everywhere, All the Time, for Everybody," in *Image World*, p. 32.

60. Dick Hebdige in particular has pursued this line through numerous studies. See his collected essays, *Hiding in the Light*. See also Dan Graham, "Punk: Political Pop," reprinted in Taylor, ftn. 52, pp. 111–137.

61. See Huyssen, "Cultural Politics," p. 62.

62. The apt phrase is Banham's (*New Brutalism*, p. 62). In September 1985 *Artforum* appeared in a new format and with a new design. In addition to its continuing features and reviews on (mainly) fine art, regular columns were established, devoted to TV, advertising, fashion, architecture, film, and rock music. Articles by such writers as Glenn O'Brien, who analysed contemporary advertising campaigns, recall Banham's essays on car styling. The similarity lies in their witty, incisive, and informed approaches and styles, which wear their intelligence easily. Cf. Reyner Banham, "Vehicles of Desire," *Art*, September 1, 1955; Reyner Banham, "Machine Aesthetic", *Architectural Review*, April 1955; and Glenn O'Brien, "Like Art: The New Ads and Their Gift of Art. Easel Does It," *Artforum*, vol. 24, no. 1 (September 1985), p. 9. The journals to which the IG contributed occasionally — *Cambridge Opinion, Architectural Design*, and *Arts Magazine*, for example — were specialist, not general in orientation.

■ GOLDEN DAYS ■

W hat is now just an afternoon's glide from the rusting culture capitals of the East Coast to the beige carpet hovering above the L.A. Basin can still, in the absence of regulated airfare, revert to what it was from VJ Day to the moment the first sprigs of weed cropped up in the cracks of President Eisenhower's beloved Interstate Highway system: a grinding five-day drive through two distinct and interdicting cultures (plump, pie-fed Midwestern and lean, beef-ranch Southwestern) before you hit the pene-plain leading down from San Bernardino, ultimately to arrive at the acid-cliffed coastline at Santa Monica, and hear the breeze whistling through all those fluorescent joggers' shorts.

That's as it's experienced, of course, from an undeconstructed Eastern point of view, which sees Southern California — no matter how many tens of millions of people it shelters — as an *outpost,* as the farthest westward reach (unless you count Hawaii, in which case you might as well count Wake Island) of the sooty, coal-based, faux-Greek architecture of the mind that consti-tutes, for lack of a more euphonious term, modern American civilization. But before the snowbirds started perching on westbound trains and heading for the tourist hotels and real estate booms (1887, 1906, 1923, and World War II), Southern California was peopled by Native Americans, Spaniards, Mexi-cans, a sprinkling of Brits, and the occasional timber-forted Russian. Seen from another perspective, Southern California is the *northern* reach of the complex, songful civilizations to the south. And it's the *eastern* reach — if not an almost wholly owned subsidiary — of something even more formidable across an ocean which, even in minds educated by flat maps pulled down in grade school class like movie screens, is always dreamt accurately, curving magnificently a quarter-way around the globe, making the Atlantic look like a puddle. Only briefly, in the larger scheme of things, was the displaced Connecticut coziness of Ozzie's film-set abode a reasonable metaphor for the collective aspirations of the newest dwellers in this former desert; and in only a flicker-fraction of that moment did the question that arose among a tiny few of them matter a tinker's damn: "Is this painting [let's say a hard-edged, bright yellow canvas, adorned with a bold, red-and-black "Annie" right off the old comic strip, and executed with a cold-blooded sign painter's neatness] a pure, unadulterated, good-in-its-own-right, museum-bound, high-culture 'achievement,' or has it been polluted beyond redemption by all-too-visible, low-rent, and smart-ass references to newspapers and billboards?"

To be sure, the answer did matter supremely for a few Los Angeles artists, in a few galleries, with a few critics, and to a few curators — almost all of whom were middle-class white guys. (Once, I gave a slide lecture at an Eastern university within the intellectual orbit of New York and was asked afterward what excuse I could offer for being cited — with an asterisk for extra villainy, no less — on a Guerilla Girls poster fingering chauvinst critics

who'd reviewed only a paltry percentage of women artists. I answered that I did most of my reviewing for *Artforum* in the late 1960s and early 1970s, at a time when most of the significant art that appeared in the galleries was produced by a kind of "boys club." As we headed for the door, I heard the voice of my interrogator speaking to a friend. "Boys club?" she spat. "Fuck *him*.")

Unfair, insensitive, overblown, and self-important pebble it may be under the crush of the inexorable glacier of the greater history of everything else, the question (about the bright yellow painting) *was* asked and it's *still* history; it *did* bend a bit the course of a tributary of the now-affluvial mainstream of modern art (admittedly only a watery trickle off the sunlit surface of the glacier), *did* convince a generation of artists to pay attention to certain issues and styles, *did* convince another generation that it had Oedipal business to take care of before it could proceed (slay the fathers who slew the fathers who slew . . .), and *did*, finally, confuse the business of what art was fine, what art was coarse, what art was noble, what art was snide, what art descended from high-minded gene splicing with the tissue of the formalist past, and what art merely bubbled up from the gurgling tar pits of everyday commerce.

■ "It is as if you tipped the United States up," said that noted hob-nobber with nobility, Frank Lloyd Wright, "so all the commonplace people slid down there into Southern California."[1]

"Where else could they go but California, land of sunshine and oranges?" asked Nathanael West, that noted tour guide through the lost souls of these commonplace people. "Once there, they discover that sunshine isn't enough. They get tired of oranges, even of avocado pears and passion fruit."[2]

They — these commonplace people — longed for an egalitarian paradise in the orange groves they were slowly paving over. (The Utopian Society drew 25,000 to a meeting in the Hollywood Bowl in 1934, and the Ham and Eggs movement, with its slogan of "Thirty dollars every Thursday," got 45 percent of the vote on a referendum item in 1938.) The last thing these refugees from America's dry breadbaskets and eroded dustbowls wanted in their midst was a stucco replica of Eastern highbrow culture, with its cold removal of art from the oasis-dreams of everyday life. Fortunately (for them), they didn't have much of an entrenched adversary. Los Angeles's tradition of fine-art painting and sculpture was pretty thin, geographically removed as it was from the constant transatlantic dustings of the European stuff that the East Coast got. Isolated as well from the Spanish and Mexican cultures that it attempted to overrun, settler civilization was also bunkered against the barrage of modern art revolutions that convulsed the first third of the

twentieth century. The occasional émigré modernist (Thomas Mann, Archipenko, or the double agent Man Ray) and a squadron of significant architects (Irving Gill, Greene & Greene, Richard Neutra, Raymond Schindler, and, intermittently, Frank Lloyd Wright) couldn't bring Southern California's visual arts out from the shadow of movieland.

Ah yes, the movies. Thomas Edison tried them for a while on Long Island, but the weather finally got to him, or rather the lack of weather beckoned his successors west. (Some Southern Californians still say, "We're having weather today" over the phone to the East. They mean that the endless roll of days bathed in hazy dry sun has been temporarily broken by a freak rainstorm.) Shooting westerns in which the tall and strangely lipsticked cowboy unmasked (and beat to a pulp) the corrupt saloon owner and thereby won the heart of the tightly curled and strangely chubby ranch daughter was much easier around weatherless Vasquez Rocks and Corriganville. The milling, tuxedo'd smoker/dancers seeking divorces or solving murders in Arctic white angora "New York" hotel rooms were more easily got on film in cavernous soundstages needing no insulation from northern winters. If a little high culture talent was called for (to grind as tracelessly as possible into the final product), the moguls could easily rent it: Salvador Dali for *Fantasia,* William Faulkner for *The Big Sleep.* And for high-class looks, movie-set architecture could be trucked out into the interrupted farmland that was beginning to think of itself as a city: fake Mayan, fake Gothic, fake Normandy, fake Tudor, fake Victorian. The cliché is real: a metropolis built on the illusions that nobody and nothing was here before the common white folk slid in from points east, and that—given enough lightbulbs—the "empty" Basin could be turned into Oz. Hortense Powdermaker (a name so apt one suspects an investigator from the Hays Office) labeled it precisely: *The Dream Factory.*

In dreams, nothing stands still, and dreamers in a land of dreams desperately need to move. After the wars (that *second* global holocaust, Korea, the Barry Sadler chapter of Vietnam), the movement became dizzying: "Valley housewives in Chrysler wagons filled with bobbing towheads sliding across three lanes full bore at 80 mph to make the off-ramp nearest the Safeway; dented, matte-finished VW buses crammed with stoned hippies and ecology flag stickers doing 25 mph up the Cahuenga Pass in the center lane; balding copper tubing salesmen with sex problems taking it out in ludicrous stock fake-racing cars named 'Cuda,' 'Mach 1,' 'Heavy Chevy,' and '240Z'; eight Chicano low-riders hunched in a chartreuse '64 Chevy riding three inches off the pavement with dark brown windows all around, 'Hold on, I'm coming' scripted flossily on the rear side glass, no shocks at all, and beating you to the divider in a rumble of accelerating macho; contented, hog-jowled execs wallowing in Mark IVs or Cadillacs oblivious to everything outside the ice-cold air conditioner and

blue windows; precarious, tilting campers christened 'Hal's Corral' wobbling on the hazard strips, threatening to drop the superfluous Honda bike on your hood; and other smug, self-congratulatory, 'conscientious,' darting drivers of inconspicuous small sedans, like myself."[3]

Artists in the "boys club" had been corn fed on automobile dreams, which, as much as anything else, lured them to California; they admired the Old and Modern Masters less than they did George Barris, who by the 1950s had raised the kustom kar to the status of Catherine IV in Rubens's atelier. "Cherried out," the term of most delicious approval for a perfectly whited and window-frosted storefront studio in Venice, east Hollywood, Pico-Arlington, or Temple Street, was borrowed from flat-toppers kandy-appling their chopped and channeled Mercs.

The brotherhood of the fast lane is a necessarily adolescent community. It defies responsibility (which is based on obligations, which won't stick to you if you manage to keep moving) and loathes settling (which is caused by getting one of life's flat tires and having to pull to the curb); it desires — as do adolescent males — the privileges of a physically mature body and the exemptions of a child's heart. It's Ed (Kookie) Byrnes popping gum and tilt-head combing his Brylcreemed strands in the gaze of a rear-view mirror, packing occasional heat and deputized now and then by Efrem Zimbalist, Jr., to punch people and catch criminals, but economically betrothed only to a cushy non-job parking hipsters' cars on the Sunset Strip at Dino's. It is, in short, high school. What a seat on the museum board and a corporate airplane are to the ossified prosperity of proper middle-aged culture, so are a seat at the movies and a car to its high school embryo. Even more so thirty years ago when the "boys club" was forming: the older guys — Billy Al Bengston (see fig. 222), Ed Moses, Craig Kauffman (see fig. 223), Robert Irwin — already a raucous stable at the Ferus Gallery, the younger guns — Ed Ruscha (see fig. 224), Joe Goode, DeWaine Valentine — only recently arrived from the Plains States. In the rosiest subsequent times, Ruscha would come to date actresses (Samantha Eggar, Candy Clark, Lauren Hutton) and Bengston would drive a Cadillac. Once, this writer would find himself squeezing around said bronze vehicle, parked gleaming in the driveway of Riko Mizuno's gallery, and would say, by way of the smallest talk to the artist, who appeared suddenly at the door, that he admired the labor required to keep such a sheen on the beast. "They have men," Bengston replied, "who do that sort of thing."

Sure they did, and sure they still do, but not as many as worked for the fine old families of the East, against whom artists (back there) lined up with the rest of the woolly-coated radical intellectuals. In Southern California, artists like Bengston didn't see themselves as soldiers in the war of spirit against the Old (as in Master) and rich; if they rebelled against anything, 'twas effete modernism, that cake of big, stiff, didactic Mexican muralist

heroics frosted with sweeping Rico Lebrun charcoal strokes and deft, inky brushlicks. They saw the artist as a light-blue collar worker—not an unsophisticated factory hand, but not smooth-skinned, hands-off middle management, either. They saw him rather like the generally (if not universally) competent owner-operator of a small auto body shop, the kind of guy who—pulling his gleaming pickup truck into the reserved parking slot in front of the leased light-industrial space between the stereo distributor's and the custom surfboard maker's, ready for a day's work—could not only handle the Bondite and belt sander himself, but could also keep the books and hustle business at (outdoor) cocktail parties. An artist, they envisioned, worked not in some creaky downtown loft under third-degree-ish yellow bulbs, but in daylight, or under good fluorescents, in an airy, swept space. He labored not with the barnacled, Beaux-Arts implements of Bohemia, but with the crisp, honest tools of Manifest Destiny realized: metal rulers, masking tape, enamel paints, stainless steel, glass, Plexi, drywall, and chrome.

Almost as much work went into the workplace as into the work itself: lighting, faring, truing, coving, frosting, polishing. In the beginning of it, Bengston made his locally famous statement about artists needing to shake off the old Northern California sensibility (meaning cold-water-flat Abstract Expressionism, as witnessed in the Bay Area by the likes of Mark Rothko and Clyfford Still), putting on clean clothes and getting down to being *artists*, instead of professional existential sufferers. In the afterglow (that is, after these NASA-writ-small clean rooms ceased to be means to the objects and became ends in themselves, resembling the reception area at Sandoz HQ in Switzerland), a hired female voice could be heard to answer the (probably white) phone in one of them, "Larry Bell Enterprises," and Bengston wrote an art-magazine article rating his colleagues' workspaces by such indices as street noise.

It's the immigrant story told once again, only lighter and cheerier, with a safety net this time; instead of the dispossessed of Eastern Europe huddling in the steerage bowels of dank freighters, riding out the storms for the chance to get to the Lower East Side to grasp the first grimy rung, as ragpickers and cobblers, on the ladder up and out of servitude, these were guys speeding in cars across the desert from the midwest (Bengston from Kansas, Ruscha and Joe Goode from Oklahoma) for a chance to reinvent the artist as a kind of handsome, daredevil dentist. And like most immigrants in a new land, they were grateful. Gratitude shows up as a subtext in the art, particularly the Pop stuff: beneath the putative criticism of popular culture (which is, after all, somewhat perfunctory—just repeating its devices out of context), there's a vein of thankfulness: Happy to be here, working in the sun, starting a business of my own. Only in America. Only in California. Only in L.A.

■ Because it sprung, practically full-born and with very little midwifery, from the head of Marcel Duchamp, Pop Art in New York had a museum-baiting edge to it; the entirety of its being seemed concerned with sabotaging the idea of the specially crafted, finely adjusted, and individually touched art object. Jasper Johns and Robert Rauschenberg realized early on (publicly in the mid-1950s, but certainly sooner in their heads) that Duchamp's prescience about the endgame of modern art was actually more inspiring than defeating. Just because Duchamp had said, in effect, "Forget the ultimate futility of trying to checkmate the Renaissance king with an attack of Cubist knights; just stick a urinal in a museum and call it a draw," didn't mean that the jig was finally up. Modern art in the shadow of Duchamp could, they found, actually glow with the tension of its own imminent demise. The trick was to balance the mandatory radicality of iconography (targets, maps, stenciled words, stuffed crows and goats, cardboard boxes) with recognizably fine art riffs (encaustic brushstrokes, graceful composition). The hard-core Pop artists who quickly followed sought to heighten the tension by lowering further the ambience: they removed most of the remnants of academic painting (mutated through Willem de Kooning from Dutch realism into American Abstract Expressionism) and reinstalled Duchamp's potty as silk-screened soup cans and plaster cheeseburgers. Harold Rosenberg called Pop Art "advertising art advertising itself as art that hates advertising."[4] Although Rosenberg would hardly have liked to find himself aesthetically bedded down with Clement Greenberg, another critical sensibility whose subjects did (forgotten by most) range beyond the narrow bounds of Gotham, his *pronunciamiento* is a specific application of Greenberg's opposition of avant-garde and kitsch (popular culture knock-offs of fine art mannerisms) in the bellwether 1939 essay entitled — what else? — "Avant-Garde and Kitsch." Pop Art, for both critics, tried to be avant-garde by looking like kitsch (for example, Roy Lichtenstein's inflating to the status of painting a kind of "realistic" comic-book drawing previously deflated from academic art) and ended up being simply a nasty kitsch for hipsters instead of a warm and fuzzy one for squares. However nose-thumbingly clever it might be (both Rosenberg and Greenberg believed), Pop Art wasn't quite real art, the sort that belonged in high culture's museums.

Although, in Los Angeles, Pop Art was partly perceived as an upstart plaintiff attacking a stuffy, hidebound defendant, the antiart stakes were considerably smaller. Instead of fine art itself in the docket, 'twas only a few moribund stylistic accomplices. As Nancy Marmer put it: "On the West Coast, and this is especially true for the fluid Southern California scene, Pop Art has rightly been considered the active ingredient in a general housecleaning that during the past three or four years has all but exterminated the last traces of prestige for local and imitative versions of Abstract Expressionism, for second-generation Bay Area figurative, and for stillborn Lebrun-

Mexican-Expressionism; in other words, it has functioned most significantly as a transition, an opening wedge."[5]

In Southern California, Pop Art was received as something almost natural. What L.A. liked about Pop Art was not that it was rebellious, but that it was clean and colorful, and that it made it possible for the art cognoscenti to enjoy the stupidly enjoyable popular culture that dominated everybody else's lives without feeling intellectually guilty about it. When Pop Art's Eastern exemplar, Andy Warhol, showed in Los Angeles (his first gallery exhibition of Pop Art—soup can paintings—was held, incidentally, not in New York, but at the Ferus Gallery in Los Angeles in 1962), he was welcomed not as a Duchampian punk, but as a Norman Rockwell for the smart set. He reminded Henry Hopkins, for instance, of warm, childhood lunchtimes: "To those of us who grew up during the cream-colored thirties . . . when good, hot soup sustained us between digging caves in the vacant lot and having 'clod' fights without fear of being tabbed as juvenile delinquents . . . this show has special significance."[6] Pop Art in Los Angeles, especially the homegrown kind, had a kind of natural integrity; it wasn't just another modernist so-bad-it's-good test of the bourgeoisie's ability to take a satirical punch, but rather a slightly askew view of the cosmos in which God probably *did* look and talk like George Burns sitting down to the breakfast special at one of those glass-and-gravel-roof blast-off coffee shops with a parking lot bigger than all of heaven. In those halcyon days when thirty serious galleries dotted that decorator's ganglium of the Sunset Strip known as La Cienega Boulevard, when the sweet, rubbery smell of flat white latex wall paint and the hot, chic brightness of skeletal track lighting inside austere westside cubes made an outing in the L.A. art world as antiseptically dutiful as giving the Karmann Ghia a light wax on a Saturday morning, Pop Art was the brisk, pervasive breeze that put a little existential tang into the trip:

Joni Carson at the burlesque palace—the days when the last of the strippers had limp parodies of macho show-biz names, like Fran Sinatra . . . the last time you were able to mix public sex with polite nightclub going . . . The Russians Are Coming, The Russians Are Coming, that godawful loud movie from the days of big-budget laffs and revisionist sentiment about the Commies . . . 'Vincent Edwards at the Copa,' the Peter Principle of TV actors putting on tuxes and using their full first names to rise to incompetence as pseudo-classy lounge acts, when you could still manufacture crooners from Daily Variety ads . . . advertisements for mortuaries, Kahlua, and drag races . . . The Sol Hurok Building, a pitiful stucco pomposity whose address looked good only on stationery . . . Viki Carr opening for somebody in Las Vegas, then she became a star, then she sang for a discount department store—life in the fast lane . . . The Righteous Brothers (white fake soul) and Schwab's drugstore (where nobody waited to be discovered anymore), and all those cars getting eight miles to the gallon . . . all gone, and none of it missed in the sunny ever-present.[7]

■ No doubt about it, the light in Los Angeles is different, and all the artists— from the earliest nineteenth-century knapsack landscape painters to the most militantly nonvisual neophyte post-whatevers mustering out of Cal Arts—have noticed it. From a Greek-like high sun, whose baking rays speed unfettered through a dry sky and glance off hostile hills and a moodless Pacific, the light infuses everything. The smog, some of whose relentlessly cooked photochemicals are as poisonous in Beverly Hills as in El Monte, cuts the shadows and evens the glare. From the dust of the art world's continuous city-mongering, the light raises kernels of truth: New York *is* (by comparison, of course) vertical, cold, dark, and therefore rude, expensive, and criminal, whereas L.A. is horizontal, warm, light, and therefore (relatively, of course) friendly, cheap, and safe. Or it was a while ago:

"In my absence I had forgotten 'L.A. Space'—its horizonless murk. Cropped off on the inland side by the crisp silhouette of mountains and dissolving in all other directions into the Pacific, it had no middle distance. There was only a gritty, fly-specked *near* and a hazy, enigmatic *far,* and nothing in between. There was a democratic magic about it, though. It accommodated both the realist and the romantic in its sudden bifocal vistas, and it 'belonged' to Ed Ruscha—as certainly as the mountain villages of Spain 'belonged' to the Cubists."[8]

Rather more Ruscha (see fig. 222) "belonged" to the light, because it democratized art for him. How can a royalist hierarchy of the visual arts (and the timeless beauties therein and the revered masters thereof) maintain its hold on the imagination, except in a tragedian's murk slashed occasionally (but gracefully) by sabers of candescence? In the hazed overall brilliance of L.A., a bus-bench ad is the equal of a landscape in oils. What the former lacks in touch it recovers in resolution; what the latter gains in nuance it loses in languor. Ruscha could thus find the perfect intersection of the two: the bus-bench ad transferred to canvas, fared and trued to hold its own against a bare white gallery wall, and the landscape in oils relieved of its shadows, dullness, and rural fuzz.

But the light also levitated the art—if not in what conventional critics would call "quality," at least in metaphysical ambition. Like other émigrés suffering alienation and displacement, Southern Californians (more so in their naïveté then than in their sophistication now) long for a rescue from materialism, from the hard physical facts of scarcity and surplus, from having to make a living among the millions of other seekers of fortune and ease who've turned hard-eyed on the trail, from the reality of the semi-tropics offering doom as well as opportunity. They see that the sunset's ruby warmth is more embracing in the sky than it is on the ground; they conclude that Utopia is freedom from not only hunger and thirst, but gravity and mass as well. Their litany of spiritualist movements have been prayer chimes for the end of the rainbow: The Purple Mother, The Man from Lemuria, Krotona,

Mankind United, Stereometry, New Thought, Mighty I AM. With the artists in the 1960s — for the most part a secular, level-headed bunch — the longing for transcendence has lodged itself in a car-customizer's craftsmanship, and in a particular, distinctly non-bozearts family of materials: plastic. DeWain Valentine and Peter Alexander cast it into (respectively) man-size transparent discs and tall, evanescent wedges; Ed Moses slathered the flexible variety on canvas as encompassing painterly halos; Craig Kauffman vacuum-formed and spray painted it into pearlescent ovoids from Mars; Ron Davis turned it into a psychedelic domesticator of Abstract Expressionism; and Robert Irwin, with a little help from inventive lighting, allowed it to vaporize optically into something approaching the spiritual. In sum, the artists took a label, "plastic" — usually indicating the cheap, pretentious, and fake — that had oft been applied to their city and gave it back some measure of dignity. If not Mondrian's, at least the aerospace industry's.

When Robert Irwin was still a paint-on-canvas abstract artist (before the bars became floating discs and the discs became cleansed and rarified interior spaces), he forbade his work be reproduced in magazines and catalogues because, he reasoned, a work of art which staked a good deal of its worth on its autonomous nonrepresentation of anything outside itself shouldn't turn right around and allow something else — especially a tiny, half-toned photographic plate — to represent *it*. To allow an illustration to stand in for the painting would imply that the painting stood in for something else and, probably, that the something else stood in for something else, and so on, up the line to God. In art, the Mighty I AM could flow into Mankind United only directly, immediately, democratically, nonhierarchically — not through some succession of aesthetic melting pots, big common ones pouring their evaporated and filtered contents into successively smaller and more precious vessels.

■ During the 1950s and part of the 1960s much contemporary art in L.A. was but a pale reflection of New York's: Abstract Expressionism, "new images of man," the sleazier variety of Pop Art, and the rest of it. But something *else* did happen that was strictly unto L.A. Climate, rootlessness, residual and misguided optimism, technology, and a halo of spiritualism all came together, somehow, into a friendly, antiseptic Pop Art pursued by Ruscha, and the "light and space" art pioneered by Irwin. To be sure, a lot of lesser artists filed in behind and began turning out — like Benetton manufactures fancy sweatshirts — the elegant odes to commonplace culture, the paeans to dry-cleaned interiors, and the admixtures of both that signified "L.A. art." But for a while, L.A. gave you something you couldn't get anywhere else.

If any artist, from the safety of a generation's retrospect, could be said to

have been the fusion, then perhaps it was John McCracken (see fig. 225). His "plank" sculptures were as obdurate and beguilingly ordinary as a Bengston emblem or a Ruscha word, but, with their practically mirrored surfaces and delicate lean against the gallery wall, as atmospheric as an Irwin disc. With none of the preachiness of a Carl Andre and better looking than most Donald Judds, they were, for a brief and art historically neglected moment, unselfconsciously sure of themselves. In the alchemy of the not-quite-seamless blend of Pop and Light & Space ubiquitous in real life, they could be had just for the astute looking. The photographer Lewis Baltz captured it a little later: the seemingly dematerialized side of a one-story stucco building (transcendent, à la Robert Irwin), a sliver of curb or parking lot or telephone line (Pop), and the little stains and cracks that are remindful of the inevitable human imperfection of it all. The Big DoNut Drive-In meets the horizon of the sea and (years later, after a blinding flash) begets The Roden Crater, an Edenesque recreation of the L.A. Basin, before the avocado was eaten from the tree of knowledge, before the Great Corruption, before, in effect, art came to town.

And a real democratization there was in the best art in L.A. in the 1960s. None of this phony romancing about the People, either musclebound or gaunt, and none of this self-congratulatory declension of materials and methods as in New York Pop . . . but rather an honest affection for motorcy-cle logos, sergeant's stripes, gas-station architecture, and sign painting. And who could have asked for anything more unhierarchical than the cool rooms of Light & Space? No object-versus-ground, no thing-versus-context, no major-versus-minor passages (making Frank Stella's solution to the "nurse-maid painting" he despised seem a little halfhearted: what you see in his mid-1960s paintings is not so much an egalitarian surface as just another big jewel — more simply cut than most, perhaps — set against a gallery wall), no goods for sale. The arty borrowings from street signage and the transforma-tions of galleries into less-is-more monk's grottos were never part of an elitist plot to exclude anybody. Au contraire, it was hoped that by both parodying and evaporating the reliance on mass-produced objects that imprisoned us all, one generation of artists could finally find the paradise that had eluded everyone else. Come with open eyes and an open heart, the art seemed to say, and the most wondrous perceptions of all are available to anyone just willing to look. (Robert Irwin, in lectures, used to hold up his open palm with fingers splayed vertically, with the thumb on top, to signify the hierarchical way things were in the world. He'd flip it, thumb to bottom, and say this is what alleged revolutionaries were after. Then he'd smile and flatten his hand out, palm hovering parallel to the floor, no finger higher than the other, and say this is the way *he* wanted things to be.)

These days, looking back, it all seems a little quaint. The ground-view magnificence of a Standard station embellished by searchlights against an

otherwise clear and empty sky, has disappeared behind the pile-driven foundations for a *Bladerunner* metropolis rising in its place. The airy universality of a floating disc has been impeached by a pluralism that, perhaps rightly, sees the longing for a purgative one-ness as a cultural yoke, insensitive to the rich brew of ethnic, sexual, political, and philosophical flavors that is Southern California at the end of the century. Paradise, of necessity, has been once again postponed.

NOTES

1. Frank Lloyd Wright, quoted in Carey McWilliams, *Southern California: An Island upon the Land* (Santa Barbara, 1971), p. 181.

2. Nathanael West, *The Day of the Locust* (1939; reprinted New York, 1983), p. 192.

3. Peter Plagens, "Los Angeles: The Ecology of Evil," from *Moonlight Blues: An Artist's Art Criticism* (Ann Arbor, 1986), pp. 215–16.

4. Harold Rosenberg, *The Anxious Object* (New York, 1964), p. 74.

5. Nancy Marmer, "West Coast Pop," in Lucy Lippard, ed., *Pop Art* (New York, 1966), p. 147.

6. Henry T. Hopkins, review of an Andy Warhol exhibition at the Ferus Gallery, Los Angeles, (*Artform*, vol. I, 1962), in Amy Baker, ed., *Artforum: 20 Years of Looking* (Ann Arbor, Mich., 1984), p. 274.

7. Peter Plagens, "Ed Ruscha, Seriously," in *The Works of Edward Ruscha* (New York, 1982), p. 35.

8. Dave Hickey, "Available Light" in *ibid.*, p. 22.

■ *THE LAST CAUSE*:

AT THE BETHANY THEATER

UNTIL JUNE 23 ■

A play" they call it. No need to look for better billing. "Musical" would be claiming too much. *The Last Cause* plays off everything, including theater, art history, the culture itself, above all the audience. For now, I'll call it an absurdist history play that sets out to explore the neglected wellsprings of modern art. Without inventing a single person or place, Phyllis DeForest has written a three-act semidocumentary with a new set of characters for each act. Aristotle's dramatic unities do not preside here. For all its grab-bag ingredients, this episodic musical play provides generous entertainment, especially if you know a few random facts about modern art after Impressionism and have undertaken an annual pilgrimage to your regional museum of modern art. In case you don't or haven't, I supply program notes from the *Playbill* at the end of this review.

Don't expect artists' studios and attics. *La Bohème* lies far away across several mountain ranges. *The Last Cause* chooses public places in which to present a culture inversion — a phrase I model on "temperature inversion" in meteorology. While following the circus-like action, you keep wondering precisely what elements have reversed themselves in this world turned upside down. I cannot summarize the story, not having found one. Here's what happens on the stage of the Bethany.

Act I. It is summer 1912 inside the Simplicissimus Cabaret in Schwabing, the artists' suburb of Munich. The high walls are crowded with paintings in all modern manners from Impressionism to Expressionism. Before the evening's entertainment begins, two young men are excitedly comparing notes about how much is happening all over Europe. In Paris, Cubism and Primitivism and Simultanism and a new group called the Section d'Or. Then there's The Donkey's Tail exhibit of all the crazies in Moscow. Marinetti touring his Futurist circus to one capital after another with thunderous advance publicity. Rumors of a committee of American artists scouring Europe in search of works to include in a major show in New York next year. Above all, both young men are excited and puzzled about developments right here in Schwabing. One name keeps coming up: the Russian Kandinsky, who has lived and worked here for fifteen years. The thin, handsome one with a French accent and slick hair says that even Apollinaire praised Kandinsky's *Improvisation* at the Salon des Indépendants in Paris this spring — called it "Matisse's theory of instinct carried to the point of pure chance." The other young man with soft features and a soft voice quotes from the book Kandinsky has just published called *Concerning the Spiritual in Art*. Every artist in Europe is talking about it. Since the wave theory of the electron has annihilated matter, objects can no longer be represented as solid. We have come to the turning point, Kandinsky claims. Painting will be like music, like the poetry of pure sound.

Meanwhile, on the tiny stage of the Simplicissimus a slender young woman has started singing dark songs about whores and criminals. A cousin

ROGER SHATTUCK
■

of Frankenstein's monster accompanies her on the piano. A third young man rides right into the cabaret on his bicycle to join the others, one of whom he met here yesterday. They sing elaborate bantering introductions that provide the information we need. The jaunty cyclist in his thirties is Paul Klee, a Schwabing regular from Switzerland. On a recent trip to Paris, where he visited Delaunay's studio, Klee heard about the young Frenchman Marcel Duchamp, whose painting *Nude Descending a Staircase* had just been excluded from the Indépendants. They now shake hands. Asked to explain what he's doing in Munich, Duchamp sings an aria about the fourth dimension, alchemy, circular motion, and getting away from Paris. The third young man, Hans or Jean Arp, recites strangely shaped lines of poetry about clouds and goblins and produces weightless stone sculpture from under the table. Klee introduces the visitors to the singer in her page-boy bob, Emmy Hennings, and to the dour pianist, Hugo Ball, avid anarchist and dramaturge of the municipal theater.

At this point the action develops some momentum as the cabaret fills up. The famous playwright Wedekind wanders in with his guitar and accompanies Emmy in a set of his sexy-sentimental torch songs. Quantities of beer and wine disappear. Duchamp dances with several girls. Klee laughingly tells his friends two anecdotes. At an exhibit of French Impressionist art in Moscow several years ago, Kandinsky looked at a painting and saw not a recognizable object or place or person but just forms, pure painting. The power of the canvas was all the greater for this disappearance of the subject. (The catalogue stated that it was a haystack by Monet.) Later, here in Munich, Kandinsky came into his studio one day and couldn't recognize, couldn't identify one of his own works. (It was standing on its side.) Same reaction: the subject can be dispensed with. Pure spiritual forces and forms will take its place.

Klee seems impatient with these claims and points out one of his own paintings hanging on the wall of the Simplicissimus. Immediately we see it blown up on a scrim hanging in front of the set. Works by Arp and Duchamp follow Klee's. Arp talks softly and passionately about concrete art, like pieces of fruit, like pebbles in a brook. The scrim fades out. A portly man in a well-cut suit, smoking a cigar, comes in and sits with the three younger artists: it is Kandinsky. He talks like a book, like his book. "Our most ordinary actions become solemn and portentous if we don't understand what's going on. Imagine several men preparing to lift a heavy weight. Their movements appear mysterious and dramatic—until you have the explanation. Then the charm disappears. Functional meaning negates abstract, spiritual meaning. Just look at this scene. If you didn't know we were in a cabaret, you might think it was a church service. Or the end of the world."

The celebration becomes frenetic. Before long only Klee, Duchamp, and Arp are left, slightly tipsy. They make a solemn three-sided wager. Arp bets

that he will make art objects so self-contained and pure that they can be placed out in the woods or in a field without frame or pedestal. Concrete art, natural art. Klee cannot stop talking about his illustrations for Voltaire's *Candide*. He will make it impossible to tell the difference between children's drawings and the most avant-garde painting. Duchamp does a ritual dance in front of Klee's bicycle still leaning against the wall. "I'll put a stool under one of those wheels and pass it off as a work of art. The claim will be enough. It's impossible to make something that is *not* a work of art." The three artists are resolute and exultant at the same time. Their handshake seals an historic pact, which they swear to reveal to no one. Their conspiracy will change the path of painting. As the curtain goes down they are laughing wildly with their arms around one another.

Act II. Set in a New York hotel dining room during the twenties, DeForest's second act does not allow the energy released in the first to subside for long. Gradually the places at a round table center stage fill up with actors wearing names on their backs like football players. Ordinary diners at the surrounding tables form a gawking audience. Dorothy Parker chassés in on point singing "I'm always chasing Rimbauds." Amiable and worried, Marc Connelly has barely sat down before George Kaufman ambles by and rubs Connelly's bald pate. "That feels just like my wife's bottom." Connelly reaches up to touch the same spot and performs a mock Eureka. "It does, by golly, it does!"

H. L. Mencken introduces a French artist on his third trip to New York. Marcel Duchamp testily corrects Mencken and identifies himself as a professional chess player. Out of his sleeve he pulls a folding chess board.

"I'll give you a sentence with horticulture," Parker announces to no one in particular. Everyone freezes. She savors the silence before going on. "You can lead a whore to culture . . ."

A stout pixie with glasses and a sign saying Alexander Woollcott arrives in time to cut her off at the pass. ". . . but you can't make her think. You must work on your timing, darling. This is my new friend, Harpo Marx from the vaudeville *I'll Say She Is*. It opened last night on Broadway and fills my column today in the *Times*. You all have orders to go see it. Orders."

Harpo, fully accoutered, simply beams at everyone.

Now launched on a course it never followed in history, the Algonquin Round Table careers from prank to wisecrack to slapstick. Woollcott orders every item on the menu not containing the letter "e." Duchamp charms Parker into a chess game. The diners at the other tables have given up all pretense of eating in order to gape and applaud. Harpo and Kaufman smile at one another across the table like two conspirators. "How do you manifest yourself on stage, Mr. Marx?" Kaufman asks. Harpo holds up a warning finger, honks a horn hidden under his garments, and summons his three brothers from the wings. Groucho swings in on a chandelier. Their attempt to save Harpo from the denizens of Broadway and the high priests of the *New*

Yorker is foiled by a Gargantuan figure who holds everyone at bay by just windmilling his arms. "I saw them first, in Rhode Island," he sings. "They're mine." The sign on his back says Herman Mankiewicz.

When an unsteady order has returned with the four Marxes standing like captive slaves on the table, Woollcott and Mankiewicz auction them off to Kaufman and S. J. Perelman, who has sneaked in while no one was looking. The two writers declaim in unison that they will transform vaudeville into a film medium that will lift American culture to new heights of the ridiculous. The four brothers perform a ritual slow-motion hat-changing routine — it could be *Cocoanuts* or *Waiting for Godot.* Woollcott starts a toast. "This is more than a gala day for us all." Groucho squelches any effusion. "A gal a day is enough for me. I can't handle any more." His volcanic clouds of cigar smoke put everyone to sleep, including himself, to close the act.

Having laughed uproariously, the audience looked puzzled during the second intermission. Almost everyone came back to see where it was all going. What can you extrapolate from two such widely separated points?

Act III. After the high-jinks of the Algonquin Round Table occupied by the Marx Brothers, the third act starts off as a solemn courtroom hearing. In the Café Cyrano in Paris, the Surrealist André Breton sits as a red-robed judge to settle several disputes. It must be about 1929 or 1930. This time there's a tourist guide with a megaphone strapped to his face to identify the players. He seems to be bringing a Hirschfeld caricature to life. In one corner Jacques Prévert is singing protest songs and accompanying himself on a concertina. A dandified Aragon holds a book by Lautréamont in his right hand, and one by Lenin in his left, and narrates a long, elaborate dream about the top deck of a bus to Marcel Duchamp, who is bolting a crank to his bicycle wheel while he plays chess with Man Ray. Hans Arp, the perfect egghead sculpted by his own fine hand, is arm wrestling without much conviction with Dali, costumed as himself. The handsome version of Dr. Caligari prowling upstage is Antonin Artaud. The walls are covered with generic Surrealist paintings. Throughout the act young ladies in the café play musical chairs to soft tango music.

After Breton has gaveled the meeting to doubtful order, the poet Paul Eluard stands up to give the report from the Committee on Proverbs. Suitably scrambled, they come out along the lines of "One good mistress deserves another." Politics raises its head. Several members vehemently protest their leaders' having recently joined the Party, thus surrendering the Surrealist revolution to the Communist revolution and Party directives. Aragon defends the Soviet experiment as a glorious anticapitalist vision that will transform the world. From the rear Artaud growls that no illusory change in the class system will contribute one iota to the spiritual salvation of a single individual in the room. Breton announces his decision by quoting scripture.

" 'Transform the world,' Marx said; 'Change life,' Rimbaud said. These two watchwords are one and the same." Mixed cheers and boos.

The next order of business is the role of art. An earnest young Surrealist, Max Morise, gives a historical report. Breton himself originally attacked all forms of art. He called art a "lamentable expedient," an "alibi" distracting us from more important activities like transforming everyday life and liberating love. The term "artist" can be attached to no true Surrealist. Duchamp abandoned all forms of art years ago for chess. Pierre Naville, another Surrealist, said it most trenchantly, "Everyone knows by now that there is no such thing as Surrealist painting." Cheers. Morise sits down.

Man Ray—for some obscure reason displaying a French accent—rises to croon a laconic blues song called "The Objects of My Affection." Paintings, photographs, sculptures, mere things—they amuse, annoy, bemuse, bewilder, mystify, demystify. It turns into a jingle with "Art without art" as the refrain. Duchamp joins in with a single repeated obbligato, "Object o' fart. Object o' fart." It's not clear that anyone has paid much attention. Chess, arm wrestling, and some heavy flirting have been going on throughout.

Artaud, a professional ham actor, strides forward now and brushes everything aside with a Mephistophelian sweep of his cloak. Forget about art. The greatest work of the Surrealist revolution, a veritable hymn to anarchy and intellectual liberation, is not any book or painting or even any work produced by this bunch of café lizards in Paris. Artaud's voice has developed great power. The Marx brothers films *Monkey Business* and *Horse Feathers* elevate sight gags and word games to a level of magic that becomes both terrifying and beautiful. How is it that the American sense of humor can send us the most extreme and original works of our era? The Marx brothers have tapped the poetry of our insanity the way Dan mask carvers express the terror and beauty of African magic. We're never going to find the Surrealist spirit in a café any more than in the École des Beaux Arts or in the weekly meeting of a Communist cell. "I move that the meeting be adjourned!" Artaud shouts. "I move that Surrealism be adjourned! I move that Paris be adjourned so that we can go see the Marx brothers!

Klaver Striva
Cavour Tavina
Scaver Kavina
Okar Triva.

Artaud's chant of bruitist poetry accompanied by African drums gathers momentum and goes out of control. Morise and Aragon escort him out of the café.

With noble gestures Breton sings a powerful baritone aria to calm the

waters, while off to one side a series of disturbing Surrealist paintings appear on the scrim. "Literature and art accompany us into adult life like toys we cannot give up. All around us as we speak, reality itself is at stake. The great modern painters — Chirico and Ernst, Arp and Masson, Miró and Man Ray, even Braque and Picasso without their Cubist price tags — have taught us to abandon the bird in hand for anything stirring in the bush, to elect shadow over substance every time. That way lies black humor, lies the marvelous."

Amid acclamations Breton proposes a toast to the marvelous. Helped by Man Ray, Duchamp pedals his captive celestial bicycle wheel to unprecedented speeds. The whole café and its occupants disappear behind the scrim showing a clip of comic-apocalyptic war footage from the end of *Duck Soup.* Final curtain.

By canny costume changes, the fourteen actors in *The Last Cause* create the impression of a cast of hundreds. The director falls back on the same crescendo effect in each act and succeeds in keeping our attention. The Marxian invasion in the second act provides the only burst of dramatic action. No one seems to take the occasional musical numbers very seriously. Spoof is king. Nor did the producer budget much for sets. The most stunning visual effects occur when the projection of immensely enlarged modern paintings on the scrim engulfs the stage. For a short interval the actors' voices emanate from behind a delicately trembling veil of images — fantastic yet familiar. These moments create the kind of spectacle dreamed of by German Expressionists and Russian Futurists, and by the French Symbolists before them. On this huge scale lyricism and farce cohabit without tensions.

■ What then shall we do with this drunken sailor of a play? Where did it come from? Where is it going? What does it mean? In great and small museums all over the Western world, carefully worded placards accompany traveling exhibits in order to explain to an obedient public shifts in style and recognized stages in artists' lives. Phyllis DeForest has copied down some of the wall signs and rewritten them for the stage. In the process she has woven a message into the play, a view of events approaching an art-historical agenda. Behind the entertainment lies a fairly simple thesis about the flow of the arts since what we like to call the "turn" of our century. Her thesis goes something like this: "A widespread outbreak of wit, children's art, chance, and primitive forms squeezed high seriousness out of painting without removing the spiritual element. Some groups became impatient with the whole privileged category of art." A manifesto? An entertainment for savvy intellectuals? Writing about his collaboration with Picabia and Satie in 1924 on the film *Entr'acte,* René Clair lifts a corner of the curtain draped over a large segment of twentieth-century art. "I hope that one day a future

doctoral candidate will write a thesis on the role of mystification in contemporary art." By having so many jesters around, DeForest seems to be signaling us that she is really in earnest. We shall have to scrutinize how she put this pageant together.

Is DeForest our Vasari writing another *Lives of the Artists?* Better question: can she get away with shuffling and dealing her file cards so whimsically? For she has read modern art history like a buccaneer seizing treasure on the high seas. Duchamp did travel to Munich in the summer of 1912 and produced there the major early studies for the *Great Glass* in his new mechanical visceral style. We do not know what else happened to him there — whom he met and where he stayed. But Paul Klee, a Munich resident since 1906, had gone back to Switzerland that summer, and Arp's Munich visit had come the year before. Hugo Ball worked in Munich in 1912 but not as house piano player at the Simplicissimus. Though he reigned during the twenties and thirties over a large province of American letters, H. L. Mencken never attended an Algonquin Round Table luncheon and regarded New York as a suburb of Baltimore. When in New York during the twenties, Duchamp played his practical jokes with the Arensberg crowd, not in the Algonquin, and made visits on the side to Man Ray's place in New Jersey. On the other hand, Harpo Marx (not his brothers) did play poker and vigorous croquet with the Algonquin group and even turned up for lunch. Don't ask me to straighten out Surrealist membership in the early thirties in Paris, a period of constant turnover and bickering about politics and women. The Café Cyrano served as a Surrealist headquarters for many years, but at a slightly earlier period. So far as I can tell the dialogue in all three acts is based on available sources — once or twice removed. DeForest has invented nothing and altered everything. It's quite a feat.

There's one act missing from *The Last Cause*. All prewar European art movements flowed into Zurich during World War I as into the neck of a great funnel. In 1916 at the Cabaret Voltaire, Hugo Ball and Jean Arp and (later) Tristan Tzara submitted all these movements to the fusion process they named Dada. Later, Dada flowed out again into the European bloodstream. There may be good reason why DeForest didn't write this act. In an oblique, differently weighted play called *Travesties* using Joyce and Tzara, Tom Stoppard has "done" Zurich. But Stoppard explores only that one moment, not a hypothetical culture curve covering two decades.

The Last Cause has the skewed documentary quality of good caricature. The telescopings and displacements do not distort the truth. They reveal a flow of events that we might not otherwise perceive. DeForest brings to life for us three successive artists' hangouts where discussion leads toward a displacement of art toward verbal wit and language games. She picks two strands to hold her package together: Duchamp and the Marx brothers. Where does the supremely unflappable Duchamp, who never succeeded in

turning his back on art, intersect the unstoppable Marx brothers? Even in "real life" the brothers began emptying the contents of the inkwells when they visited their own bank on East 60th Street in Manhattan. To find the link, you don't have to seek out a big word like surrealism. Duchamp and the Marxes spot the visual and verbal anomalies of life as they go by and capture them in displays of unmatched waggishness.

The first act leaves things somewhat unclear. It is true that Duchamp, Klee, and Arp refused to follow Kandinsky into the new high seriousness of pure abstraction. But they did not for that reason reject spiritual content. For all his jokes about "ironic causation" and his elaborate hoaxes, Duchamp never gave up alchemy and a special relation to the fourth dimension. Klee's high-wire act between cartoon and abstraction never carries him away from a region of the imagination devoted to sacredness, mystery, and childhood. Arp, perhaps the greatest artist of the three by traditional standards of form and execution, was also an original and influential poet writing in both German and French. Like his sculpture, his poems create a fairy-tale universe, which hovers between the pastoral and the preposterous. In all three artists the pervasive deployment of *blague,* of joke, leaves intact the spiritual and the aesthetic dimensions of art. They bring it down to earth without lowering it.

Nothing new here. I remember that my college art-history textbook by E. H. Gombrich carried a schematically posed illustration of *Christ in the Temple* from a medieval English Psalter. After looking at it for a moment, you notice in the wide lower margin a beautifully rendered graffiti of a hunting scene with horses and a trained hawk catching a duck. The naturalistic drawing—lower on the page, and lower in the artistic hierarchy established by religion in that era—is wonderfully joyous. That joy keeps peeping through the details of Renaissance painting as facetiae and bizzarria until it surfaces fully in Brueghel and Rabelais. Crowds of people and objects overflow their works, the way multiplying things fill a Marx brothers film and an Ionesco play.

By now we should be able to tell what, if anything, is going on in the three acts of *The Last Cause,* and whether it all arises from more than mere mystification. I suggested at the opening of this review that DeForest is examining a culture inversion, a world turned upside down. But what has been reversed? A century and a half ago by writing a preface to his romantic drama, *Cromwell,* Victor Hugo produced one of the early manifestoes of the modern. In that preface he identified the two elements that have been reversed in our culture inversion.

It is the fertile union of the grotesque with the sublime that gives birth to the genius of the modern, so complex and varied in its forms, so inexhaustible in its creations, and in that respect clearly opposed to the uniform simplicity of ancient genius.

In the ancient epic, Hugo argues a little perilously, the ideal and the sublime leave little room for comedy and buffoonery. Falstaff, Harlequin, Scaramouche, and Goethe's Mephistopheles have brought us myriad new forms of humanity tending more toward the grotesque than toward the sublime. Hugo sees this reversal as the essence of the modern spirit.

A generation later, developing his ideas on the "Grand Style" of painting in Volume III of *Modern Painters,* John Ruskin seized on the same term that Victor Hugo made much of:

A fine grotesque is the expression, in a moment, by a series of symbols thrown together in bold and fearless connection, of truths which it would have taken a long time to express in any verbal way, and of which the connection is left for the beholder to work out for himself; the gaps, left or overleaped by the haste of the imagination, forming the grotesque character.

In these two quotations Hugo and Ruskin offer us a way of understanding both the episodic structure of *The Last Cause* and its message about the grotesque and the comic infiltrating the realm of the sublime in modern art. High and low have changed places.

DeForest has assembled into a play three widely separated, half-imaginary incidents in the story of the modern arts in order to suggest a new dispensation between sublime and grotesque. It all turns, she implies, on free-wheeling wit and unhousebroken imagination. Despite his moments of thralldom at Kairouan in deepest Tunisia, Klee refused to give up the vocabulary of children's art. The Marx brothers — above all, Groucho, backed by the impressive battery of Algonquin writers who thought up his rapid-fire one-liners — anchored themselves firmly to the age (eight to ten?) when nothing trembles a child's reality and tickles its funny bone so seismically as a stupid pun. "What's that in the road? A head?" The Marx brothers thrived on such fare. Correspondingly, DeForest didn't have to invent the doctored proverbs the Surrealists throw at one another in her third act. In 1920 the poet Eluard put out a little magazine called *Proverbe* to which every loyal Dadaist contributed travestied proverbs. Then they all tried to figure out the originals. Even the first sentence of Breton's long sermon known as the Surrealist Manifesto transposes a well-known proverb.

I find myself welcoming the fantasy conspiracy hatched in the first act of this roller-coaster play. Three young artists turn up one night in 1912 in a Munich cabaret and make a tipsy compact that will change the course of modern art. Yes, Vasari and Apollinaire would have approved of DeForest's principle of dramatic composition: one good mystification deserves another. The following two acts, while hilarious in spots, do not attain an equally convincing level of art-historical whimsy. I assume that DeForest's title refers to the vital role of comedians and artists in an unsettled world. While all

around us compulsively interviewed pundits propose wildly contradictory solutions to our crises, *The Last Cause* suggests that only artful comedy can save us from ourselves. Good tonic.

PROGRAM NOTES FOR *THE LAST CAUSE*

Apollinaire, Guillaume, d. 1918. French modernist poet, journalist, critic, early champion of Cubism.

Aragon, Louis, d. 1982. French poet and novelist, founder with Breton of Surrealism in 1924, abandoned it for Communist party.

Arensberg, Walter and Louise, d. 1953–54. Major American collectors and patrons of Duchamp, Picabia, American Dada group.

Artaud, Antonin, d. 1948. French actor, director, poet, active in Surrealist group during early years.

Ball, Hugo, d. 1927. German writer, dramaturge, cabaret musician, poet. Founded Cabaret Voltaire in 1916 with Arp.

Clair, René, d. 1981. French film director and writer. Close to Dada and Surrealism in early years.

Connelly, Marc, d. 1981. American playwright and Hollywood scriptwriter. Early collaborator of George Kaufman.

Delaunay, Robert, d. 1941. French painter, launched Simultanism with Apollinaire.

Donkey's Tail. Large Moscow exhibit of Russian avant-garde art organized in 1912 by Larionov, Goncharova, Malevich, Tatlin.

Eluard, Paul, d. 1952. French Surrealist poet, wrote often on painting.

Hennings, Emmy, d. 1948. German cabaret singer and occasional poet. Accompanied Ball to Zurich.

Hugo, Victor, d. 1885. French romantic poet, dramatist, novelist.

Kaufman, George S., d. 1961. American playwright, screenwriter, leading Broadway figure for thirty years.

Mankiewicz, Herman, d. 1953. American screenwriter and Hollywood producer, began as journalist in New York.

Man Ray, d. 1976. American photographer and artist. Moved to Paris in 1921 and worked closely with Dada and Surrealist groups.

Marinetti, Filippo, d. 1944. Italian poet and writer. Organizer and champion of Italian Futurism.

Mencken, H. L., d. 1956. American journalist, critic, lexicographer.

Morise, Max. Minor early Surrealist.

Naville, Pierre. Surrealist and political journalist.

Parker, Dorothy, d. 1967. American poet, fiction writer, and acerbic journalist.

Perelman, S. J., d. 1979. American journalist, short story writer, Hollywood script writer.

Picabia, Francis, d. 1953. French painter and author, a founder of French Dada.

Prévert, Jacques, d. 1977. French poet, song- and screenwriter, early Surrealist.

Rimbaud, Arthur, d. 1891. French prodigy-poet. Author of "A Season in Hell" and "Illuminations."

Ruskin, John, d. 1900. English writer on art, architecture, and literature. Champion of Turner.

Satie, Erik, d. 1925. French composer and musical wit.

Section d'or. An eclectic group show in October 1912 of painters who dissented from the Braque-Picasso version of Cubism. Included Gleizes, Metzinger, the Duchamp brothers, and Kupka.

Tzara, Tristan, d. 1963. Roumanian writer, carried Zurich Dada to Paris.

Wedekind, Frank, d. 1918. German dramatist in Munich, forerunner of Expressionism.

Woollcott, Alexander, d. 1943. American journalist and powerful New York drama critic in 1920s and 1930s.

BIBLIOGRAPHY

Artaud, Antonin. "Les Frères Marx au cinéma du Panthéon." *Nouvelle Revue Française,* ler janvier 1932.

Adamson, Joe. *Groucho, Harpo, Chico and Sometimes Zeppo.* NY: Simon & Schuster, 1973.

Appignanesi, Lisa. *The Cabaret.* NY: Universe, 1976.

Arp, [Jean]. *On My Way.* NY: Wittenborn, 1948.

Der Blaue Reiter, ed. Klaus Lankheit. Munich: Piper, 1965.

Breton, André. *La Clé des champs.* Paris: Pauvert, 1967.

———. "Le surréaliste et la peinture." *La Révolution Surréaliste,* 1925–27.

Case, Frank. *Tales of a Wayward Inn.* NY: Frederick A. Stokes, 1938.

Clair, René. "En guise d'épigraphe." *Cinéma d'hier, cinéma d'aujoud'hui.* Paris: NRF, 1970.

Gehring, Des D. *The Marx Brothers: A Bio-Bibliography.* NY: Greenwood, 1987.

Goldstein, Malcolm. *George S. Kaufman, His Life, His Theater.* NY: Oxford, 1979.

Gombrich, E. H. *The Story of Art.* London: Phaidon, 1951.

Harriman, Margaret Case. *The Vicious Circle.* NY: Rinehart, 1951.

Hugo, Victor. "Préface de *Cromwell.*" 1927.

Kandinsky, Wassily. *Concerning the Spiritual in Art.* NY: Wittenborn, 1947. Also "The Problem of Form" (1912) and "Reminiscences" (1913).

Klee, Paul. *Diaries 1898–1918.* Berkeley: U. of California, 1964.

Lanchner, Carolyn, ed. *Paul Klee.* NY: Museum of Modern Art, 1987.

Lebel, Robert. *Sur Marcel Duchamp.* Paris: Trianon, 1959.

Man Ray. "Preface." In *The Art of Assemblage,* ed. William Seitz. NY: Museum of Modern Art, 1961

Marcel Duchamp, ed. Anne d'Harnoncourt and Kynaston McShine. NY: Museum of Modern Art, 1973.

Matthews, J. H. *Surrealism and Film.* Ann Arbor: U. of Michigan, 1971.

Mencken, H. L. *The American Scene: A Reader,* ed. H. F. Cairns. NY: Knopf, 1969.

Mencken, H. L. *Selected Prejudices.* NY: Knopf, 1927.

Meredith, Scott. *George S. Kaufman and His Friends.* NY: Doubleday, 1974.

Nadeau, Maurice. *The History of Surrealism.* NY: Macmillan, 1965.

Read, Herbert. *Arp.* London: Thames and Hudson, 1968.

Ruskin, John. *Modern Painters,* vol. III, part IV. NY: Wiley & Halsted, 1856.

Shattuck, Roger. *The Banquet Years.* NY: Harcourt, Brace, 1959.

Stoppard, Tom. *Travesties.* NY: Grove, 1975.

Willett, John. *Expressionism.* NY: MacGraw-Hill, 1970.

INDEX

INDEX

■ ILLUSTRATIONS ■

IN THE CAPTIONS,
DIMENSIONS ARE GIVEN HEIGHT FIRST.

DIMENSIONS FOR WORKS ON PAPER ARE FOR
THE ENTIRE SHEET, UNLESS OTHERWISE NOTED.

DRAWINGS AND PAPIER COLLÉS ARE ON PAPER
UNLESS ANOTHER SUPPORT IS SPECIFIED.

WHEN DATES FOR WORKS OF ART ARE IN DOUBT,
THE INFORMATION IS IN BRACKETS.

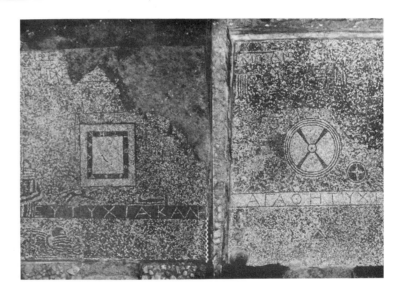

1 . Villa of Good Fortune, Olynthus. Early 4th century B.C. Pebble mosaic with a representation of Achilles, Thetis and Nereids. c. 19′ 8″ × 9′ 10″ (c. 600 × 300 cm)

2 . Villa of Good Fortune, Olynthus. Eutychia mosaic. Early 4th century B.C. Pebble mosaics with inscriptions and symbols, including double axe, swastika, and wheel of fortune. Dimensions unavailable

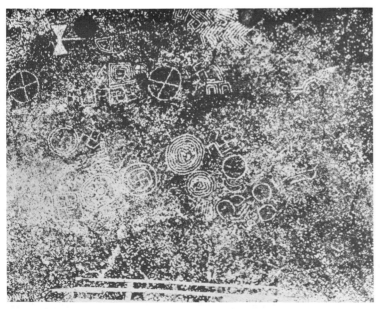

3 . House A xi 9, Olynthus. Early 4th century B.C. Pebble mosaics with various symbols, including swastika and double axe. 19′ 8¼″ × 9′ 10⅛″ (600 × 800 cm)

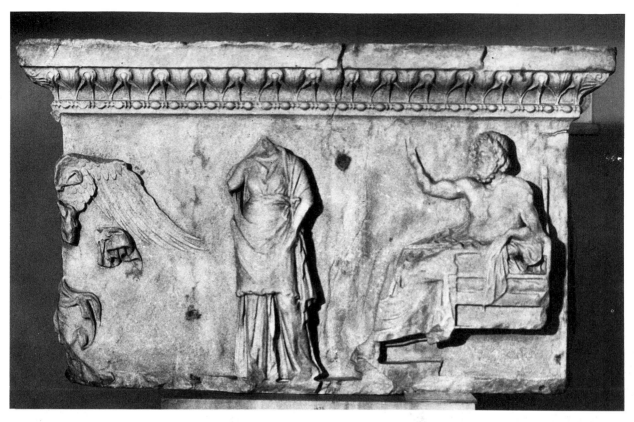

4., 5. Front and side views of an altar from Epidaurus. Late 4th century B.C. National Archeological Museum, Athens

6. Arch of Constantine, Rome. 315. Medallions and frieze on north side, with medallions of Hadrian (117–138)

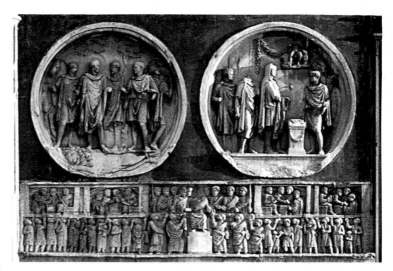

7. South portal, La Celle-Bruère. 12th century. Two fighting figures; relief signed by Frotoardus

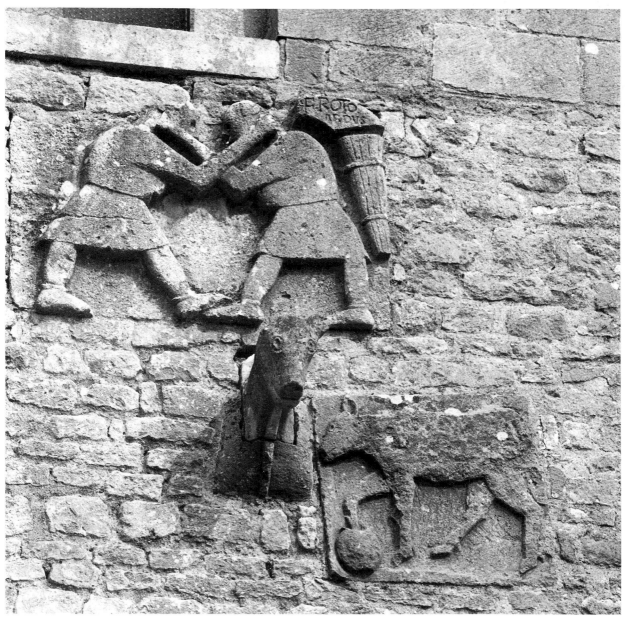

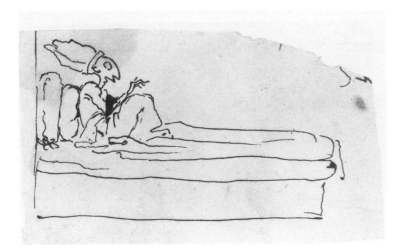

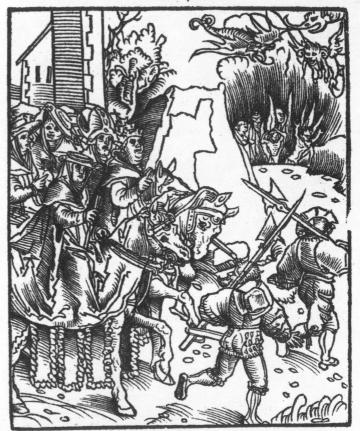

8. Gian Lorenzo Bernini. *Caricature of Pope Innocent XI.* c. 1676–80. Pen and ink, 4½ × 7³⁄₁₆″ (11.4 × 18.2 cm). Museum der bildenden Künste, Leipzig

9. Attributed to Annibale Carracci. *Heads and a Figure.* c. 1595. Pen and brown ink over some black chalk, with brown wash, 6¾ × 4⅝″ (17.2 × 11.7 cm). Windsor Castle, Royal Library, no. 1928

10. Lucas Cranach. *Pope Leo X as the Antichrist.* Woodcut. From *Passional Christi und Antichristi,* 1521. Reprinted, D. G. Kaweran, ed. (Berlin, 1885), ill. 19. Princeton University Libraries, Princeton, New Jersey

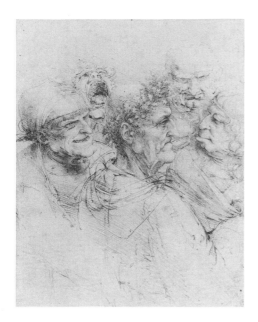

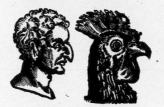

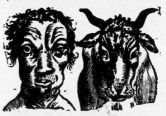

1 1. Leonardo da Vinci. *A Group of Five Grotesque Heads.* c.1494. Pen and ink, 10¼ × 8¹⁄₁₆″ (26 × 20.5 cm). Windsor Castle, Royal Library, no. 12495r

1 2. Physiognomical types. Woodcuts. From Giambattista della Porta, *De humana physiognomia* (Vico Equense, 1586; reprinted, Rouen, 1650), pp.116f. Princeton University Libraries, Princeton, New Jersey

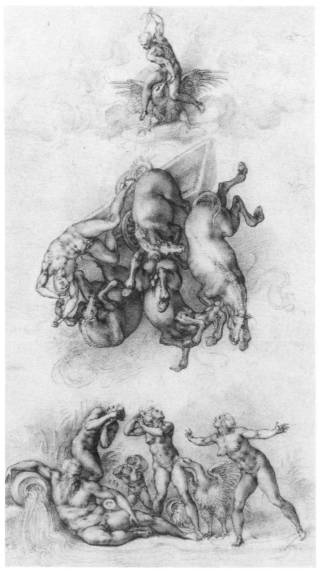

1 3. Michelangelo. *The Fall of Phaeton.* 1533. Black chalk, 16¼ × 9³⁄₁₆″ (41.3 × 23.4 cm). Windsor Castle, Royal Library, no. 12766

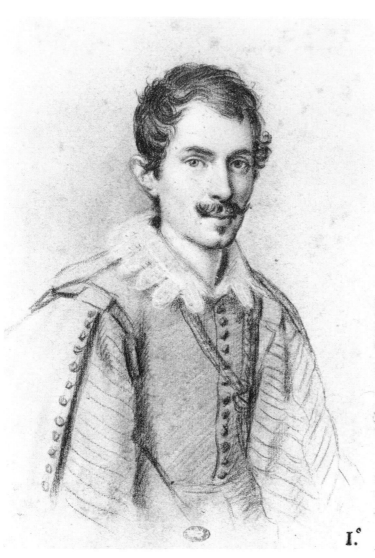

1 4 . Ottavio Leoni. *Portrait of Gian Lorenzo Bernini*. 1622. Red and black chalk heightened with white, 9¼ × 6¹¹⁄₁₆″ (23.5 × 17 cm). Biblioteca Marucelliana, Florence, vol. H.I, fol. 15

1 5 . Gian Lorenzo Bernini. *Caricature of Cardinal Scipione Borghese*. 1632. Pen and ink on paper, 10³⁄₁₆ × 7⅞″ (27.4 × 20 cm). Biblioteca Apostolica Vaticana, Vatican City, MS Chigi P. VI. 4, fol. 15

1 6 . Left: Anonymous. *Caricature of Don Virginio Orsini* (copy of an original by Gian Lorenzo Bernini) n.d. Right: Gian Lorenzo Bernini. *Portrait of the Captain of the Papal Guard of Pope Urban VIII*. Before 1644. Pen and ink, 7⅜ × 10¹⁄₁₆″ (18.8 × 25.6 cm). Istituto Nazionale per la Grafica, Rome. Fondo Corsini 127521 (579)

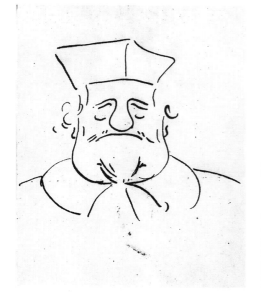

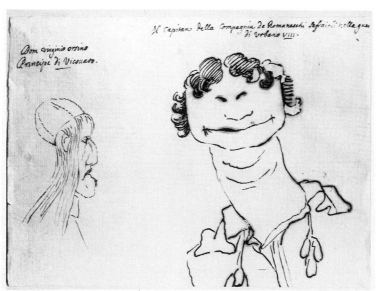

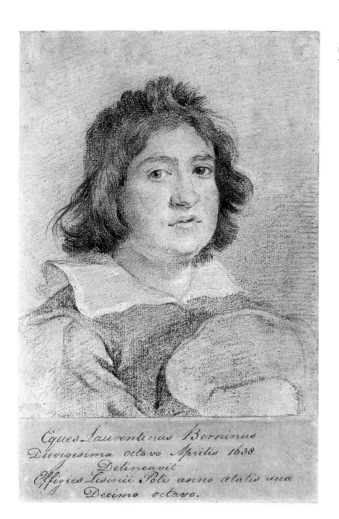

Eques Laurentinus Berninus
Dievigesima octavo Aprilis 1638
Delineavit
Effigies Sisinii Poli anno ætatis suæ
Decimo octavo.

17. Gian Lorenzo Bernini. *Portrait of Sisinio Poli.* 1638. Black and red chalk with white heightening, 10⁵⁄₁₆ × 8⁷⁄₁₆″ (26.2 × 21.5 cm). The Pierpont Morgan Library, New York, no. IV, 174

18. Gian Lorenzo Bernini. *Portrait of Cardinal Scipione Borghese.* 1632. Red chalk and graphite, 9⁷⁄₈ × 7¼″ (25.2 × 18.4 cm). The Pierpont Morgan Library, New York, no. IV, 176

19. Albrecht Dürer. Drawing in letter to Willibald Pirckheimer (detail). 1506. Stadtbibliothek, Nuremberg, Pirckh, 394,7

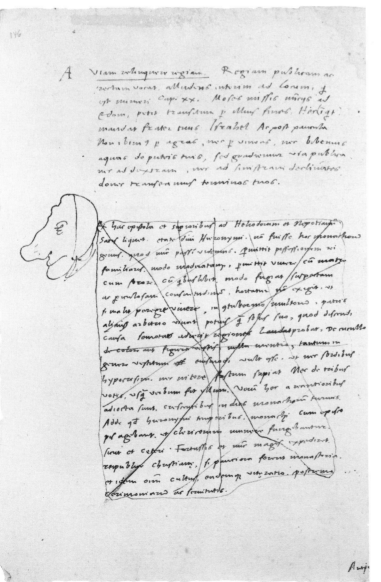

20. Erasmus of Rotterdam. Manuscript page. Before 1524. Universitätsbibliothek, Basel, Mscr. C VIa 68, p.146

21. Leonardo da Vinci (?). Drawing of heads and profiles. c. 1507. Red and black chalk, 11¼ × 7¹⁄₁₆" (28.6 × 18 cm). Royal Library, Windsor Castle, no. 12673v

22. Giovanni Francesco Caroto. *Boy with Drawing.* c. 1540. Oil on panel, 14⁹⁄₁₆ × 11⁷⁄₁₆" (37 × 29 cm). Museo del Castelvecchio, Verona

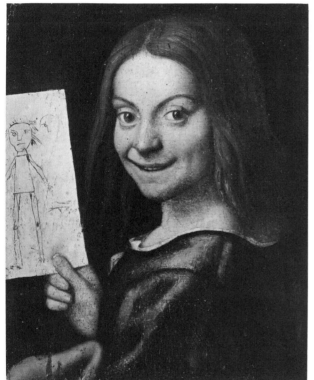

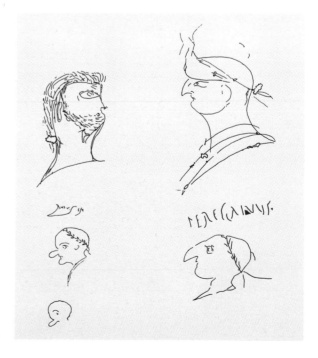

23. Ancient graffiti on the walls of buildings at Rome and Pompeii

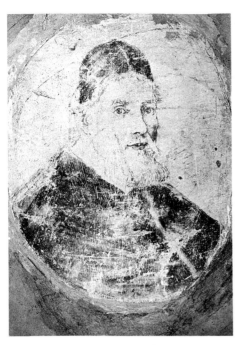

24. Gian Lorenzo Bernini. *Urban VIII.* c. 1630. Black and red chalk wall drawing (much restored), 24 × 14⁹⁄₁₆″ (61 × 37 cm). Villa della Maddalena, Muccia

25. Sgraffito decorations. Courtyard, Palazzo Bartolini-Salimbeni, Florence

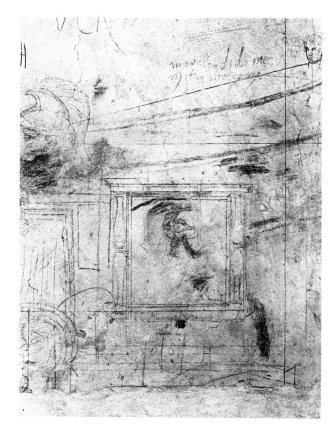

26. Michelangelo and assistants. *Wall Drawings.* c. 1530. Charcoal on plaster. New Sacristy, San Lorenzo, Florence

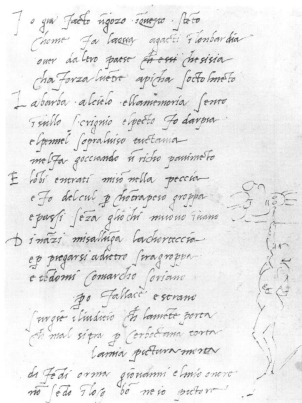

27. Michelangelo. Sonnet about the Sistine Ceiling. 1511–17. Pen and ink. Archivio Buonarotti, Florence, vol. XIII, fol. 111

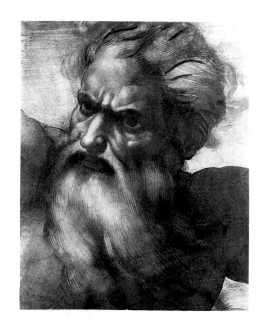

28. Michelangelo. *Creation of the Sun and Moon* (detail). 1508–12. Fresco. Vatican Palace, Sistine Chapel, Vatican City

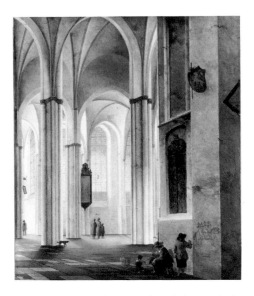

2 9 . Pieter Saenredam. *Interior of the Buurkerk at Utrecht.* 1644. Oil on oak panel, 23¹¹/₁₆ × 19¾″ (60.1 × 50.1 cm). The National Gallery, London

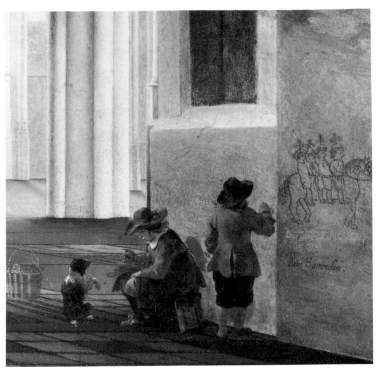

3 0 . Pieter Saenredam. *Interior of the Buurkerk at Utrecht.* (detail)

3 1 . Pieter van Laer. *Artists' Tavern in Rome.* c. 1630. Pen with brown ink and brown wash, 8 × 10³/₁₆″ (20.3 × 25.8 cm). Staatliche Museen Preussischer Kulturbesitz, Kupferstichkabinett, East Berlin, no. Kd2 5239

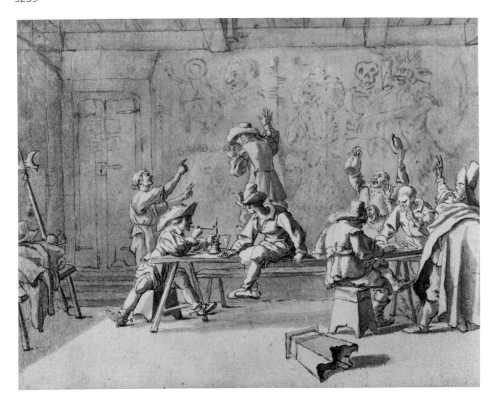

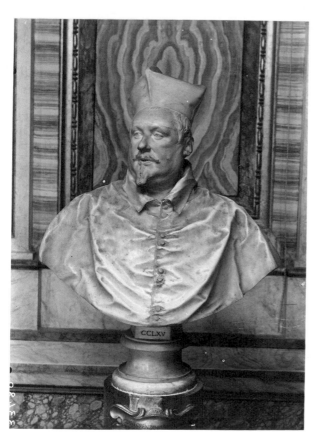

32. Gian Lorenzo Bernini. *Bust of Cardinal Scipione Borghese.* 1632. Marble, 30¹¹⁄₁₆″ (78 cm) high. Borghese Gallery, Rome

33. *Pasquino.* Copy of a mid-3rd century B.C. original. Marble, 6′ 3⁹⁄₁₆″ (192 cm) high. Piazza di Pasquino, Rome

34. Antonio Lafreri. *Pasquino.* 1550. Engraving. From *Speculum romanae magnificentiae.* The Beinecke Rare Book and Manuscript Library, Yale University, New Haven, Conn.

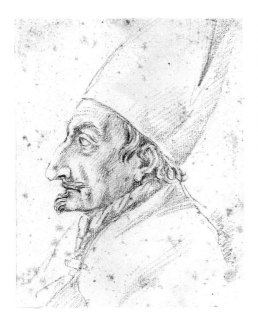

35. Gian Lorenzo Bernini (?). *Profile of Innocent XI.* 1676–80. Red chalk, 7½ × 5¹³⁄₁₆" (19.1 × 14.8 cm). Istituto Nazionale per la Grafica, Rome, Fondo Corsini 127535 (578)

36. Romeyn de Hooghe. *The Death of Moriens.* Engraving. From David De la Vigne, *Spiegel Van Een Saalighe Doodt* (Antwerp, 1673?), p. 39. The New York Public Library. Astor, Lenox and Tilden Foundations. Spencer Collection

37. Gian Lorenzo Bernini. *Beata Ludovica Albertoni.* 1671–74. Marble, over life-size. San Francisco a Ripa, Altieri Chapel, Rome

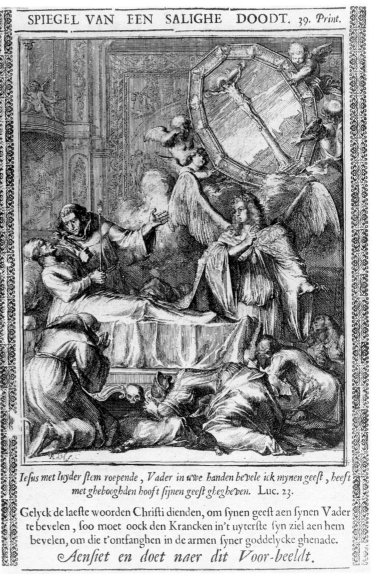

SPIEGEL VAN EEN SALIGHE DOODT. 39. *Print.*

Iesus met luyder stem roepende, *Vader in uwe handen bevele ick mynen geest*, heeft met gebooghden hooft sijnen geest gegheven. Luc. 23.

Gelyck de laeste woorden Christi dienden, om synen geest aen synen Vader te bevelen, soo moet oock den Krancken in't uyterste syn ziel aen hem bevelen, om die t'ontfanghen in de armen syner goddelycke ghenade.

Aensiet en doet naer dit Voor-beeldt.

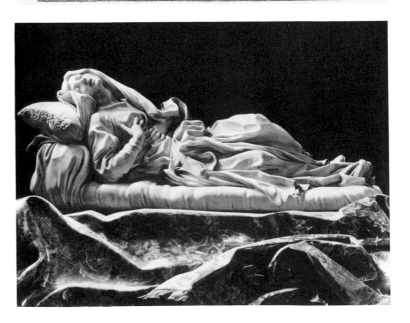

38. Tomb of Erard de la Marck (formerly in Liège, Cathedral). 1528. Engraving. From J. J. Boissard, *Romanae urbis topographiae et antiquitatum,* part IV, tome II (Frankfurt, 1597–1602), title page

39. Medal of Innocent XI with Pius V on the reverse. 1676–89. 1⁹⁄₁₆" (3.9 cm). Trustees of the British Museum, London

40. Medal of Pius V. 1571. 1⁹⁄₁₆" (4 cm). Trustees of the British Museum, London

41. Hieronymus Bosch (shop of Hieronymus Cock). c. 1150–70. *Drollery.* Engraving, 11⅝ × 8½″ (29.5 × 21.6 cm). The Metropolitan Museum of Art, New York. Elisha Whittelsey Collection; Elisha Whittelsey Fund, 1960, no. 60.576.6

42. Title page, *Carmina apposita Grillo Mono-culo: ad Pasquillû* (Rome, 1526)

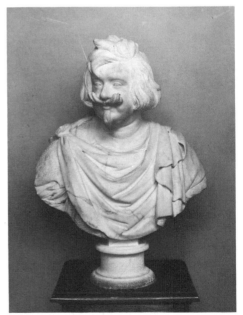

43. Anonymous. *Bust of Paolo Giordano II, Duke of Bracciano* (copy after a model of 1632 by Gian Lorenzo Bernini). c.1635. Marble, 34⅝″ (88 cm) high. Castle Orsini-Odescalchi, Bracciano

44. Théodore Géricault. Sketch for *The Charging Chasseur.* 1812. Oil on paper, mounted on canvas, 20¹¹⁄₁₆ × 15¾" (52.5 × 40 cm). Musée du Louvre, Paris

45. Anonymous. *Charging Chasseur.* c. 1810. Colored etching, image 7 × 4⅞" (18 × 12.3 cm). Private collection

46. Théodore Géricault. *Signboard of a Farrier.* c. 1814. Oil on wooden panel, 48¹⁄₁₆ × 40³⁄₁₆" (122 × 102 cm). Kunsthaus Zürich

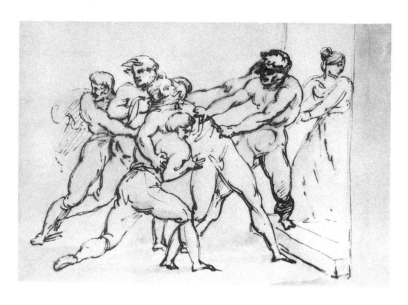

47. Théodore Géricault. *Fualdès Dragged into the Murder House.* 1818. Pen and wash, 7³⁄₁₆ × 9⁵⁄₁₆" (18.3 × 25.2 cm). Present whereabouts unknown. Formerly collection Duc de Trévise, Paris

48. Sébastien Coeuré. *Fualdès Dragged into the Murder House.* 1818. Lithograph, dimensions unavailable. Private collection

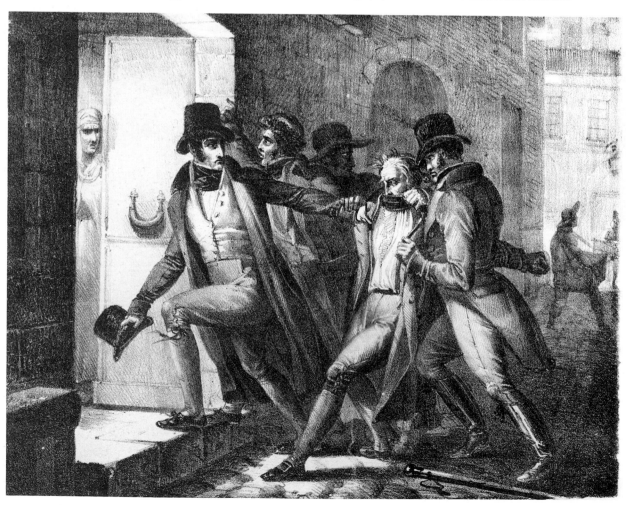

49. Théodore Géricault. *Return from Russia.* c. 1818. Lithograph printed in two tones, image 13³⁄₁₆ × 10³⁄₁₆" (33.5 × 25.9 cm). Delteil 13. Stanford University Museum of Art. Gift of the Committee for Art at Stanford

50. Théodore Géricault. *The Piper.* 1821. Lithograph, image 12³⁄₈ × 9³⁄₁₆" (31.5 × 23.3 cm). Delteil 30. Stanford University Museum of Art. Mortimer c. Leventritt Fund

5 1 . Théodore Géricault. *The Epsom Downs Derby.* 1821. Oil on canvas, 36¼ × 48¼" (92 × 122.5 cm). Musée du Louvre, Paris

5 2 . Anonymous. *Teaboy Beating Hephestion and Grey Falcon at Epsom.* 1801. Colored etching, image 3½ × 6" (8.8 × 15.4 cm). Private collection

5 3 . Théodore Géricault. *The Start of the Barberi Race.* 1817. Oil on paper, mounted on canvas, 17¼ × 23½" (45 × 60 cm). Musée du Louvre, Paris

5 4 . Gustave Courbet. *A Burial at Ornans.* 1850. Oil on canvas, 10' 4" × 21' 11" (315 × 668 cm). Musée d'Orsay, Paris

5 5 . F. Georgin. *Les Degres des Ages.* 1826. Hand-colored woodcut, dimensions unavailable. Pellerin Collection, Épinal

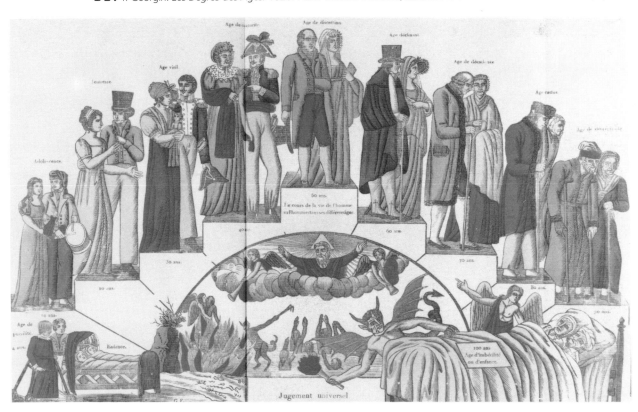

56. Gustave Courbet. *The Apostle Jean Journet Setting Out on the Conquest of Universal Harmony.* 1850. Lithograph, image 9⁷⁄₁₆ × 6¹¹⁄₁₆" (24 × 17 cm). Stanford University Museum of Art. Museum Purchase Fund

57. Charles-Joseph Traviès de Villers. *Liard, The Philosophical Rag-Picker.* 1834. Lithograph, image 9¹³⁄₁₆ × 9¹⁄₁₆" (25 × 23 cm). Stanford University Museum of Art. Museum Purchase Fund

58. Anonymous. *The Wandering Jew.* c. 1820. Hand-colored woodcut. Reproduced as the frontispiece to Champfleury (Jules Fleury), *Histoire de l'imagerie populaire,* Paris, 1869

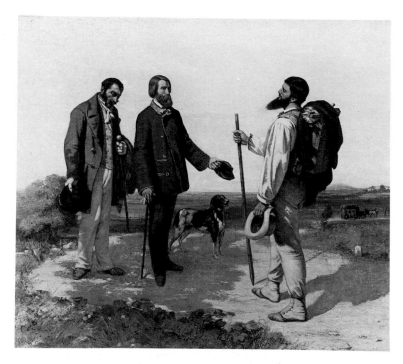

59. Gustave Courbet. *The Meeting.* 1854. Oil on canvas, 50¹³⁄₁₆ × 58¹¹⁄₁₆" (129 × 149 cm). Musée Fabre, Montpellier

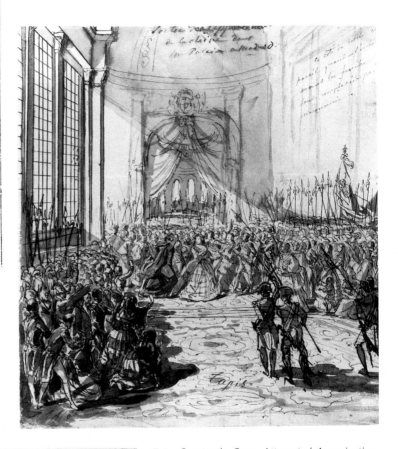

Il ne néglige pas d'ajouter, auprès des paysans, que les républicains sont tous des *partageux*, qui veulent tout en commun, même les pay-sannes.

60. Nadar (Gaspar Félix Tournachon). "Mossieu Réac." Wood engraving. From *La Revue Comique,* May 1849

61. Constantin Guys. *Attempted Assassination of the Queen of Spain in the Long Gallery of the Royal Palace, Madrid, February 2, 1852.* 1852. Pen with ink and wash. 9⅞ × 9¼″ (25 × 23.5 cm). Stanford University Museum of Art. Mortimer c. Leventritt Fund

62. Carle Vernet. *The Lithographic Print Shop of F. Delpech.* 1818. Lithograph, image 6¼ × 9½″ (17 × 24.5 cm). Stanford University Museum of Art. Museum Purchase Fund

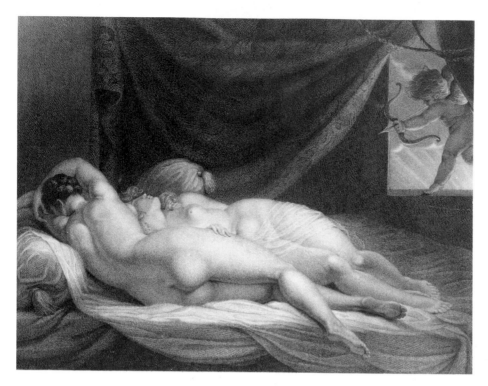

63. Anonymous. *Two Nude Women Asleep.* c. 1840. Etching, 6⅞ × 9" (17 × 22.7 cm). Private collection

64. Gustave Courbet. *The Sleepers.* 1866. Oil on canvas, 53⅛" × 6' 6¾" (135 × 200 cm). Ville de Paris, Musée du Petit Palais, Paris

65. Gustave Doré. *Afternoon in the Garden of the Tuileries* (originally titled *Promenades aux Tuileries, la grande allée de deux heures à quatre*). Wood engraving. From *Le Journal pour rire*, April 1849

La grande allée, de deux heures à quatre.

66. Edouard Manet. *Music in the Tuileries.* 1862. Oil on canvas, 30 × 46½″ (76.2 × 118.1 cm). The National Gallery, London

67. Anonymous. *Caricature of Paintings in the Salon of 1848.* Wood engraving. From *Le Journal pour rire*, April 1848

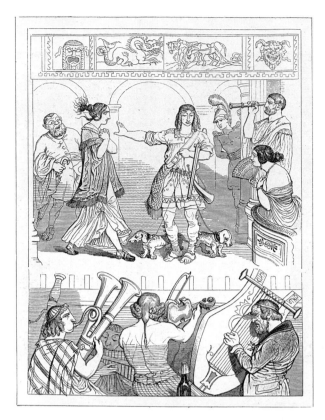

68. Grandville (J.-I.-I. Gérard). *Mlle Leucothoé in the Role of Phaedra.* Hand-colored wood engraving. From *Un Autre Monde,* 1844

70. Honoré Daumier. *The Nights of Penelope,* (from *Histoire Ancienne).* 1842. Lithograph, image 9⁵⁄₁₆ × 7⁷⁄₁₆″ (23.7 × 18.9 cm). Delteil 930. Stanford University Museum of Art. Museum Purchase Fund

69. Honoré Daumier. *Pygmalion (*from *Histoire Ancienne).* 1841. Lithograph, image 9⅞ × 8⅜″ (25 × 21.2 cm). Delteil 971. Stanford University Art Museum. Museum Purchase Fund

71. Honoré Daumier. *Clytemnestra.* 1850. Lithograph, image 9¾ × 8½" (24.8 × 21.7 cm). Delteil 1980. Private collection

72. Pierre Guérin. *Clytemnestra Contemplating the Murder of Agamemnon.* 1817. Oil on canvas, 11′ 2⅝″ × 10′ 7¹⁵⁄₁₆″ (342 × 325 cm). Musée du Louvre, Paris

73. Edgar Degas. *Spartan Boys and Girls Exercising.* c.1860–62; reworked until 1880. Oil on canvas, 42⅞ × 61″ (109 × 155 cm). The National Gallery, London

74. Jacques-Louis David. *The Intervention of the Sabine Women.* 1799. Oil on canvas, 12′ 7¹⁵⁄₁₆″ × 17′1¾″ (386 × 520 cm). Musée du Louvre, Paris

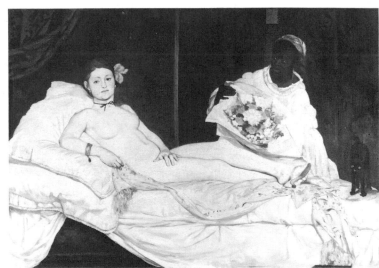

75. Edouard Manet. *Olympia.* 1863. Oil on canvas, 51⅜″ × 6′ 2¹³⁄₁₆″ (130.5 × 190 cm). Musée d'Orsay, Paris

76. Titian. *Venus of Urbino.* 1538. Oil on canvas, 47 × 65″ (119.4 × 165.1 cm). Uffizi Gallery, Florence

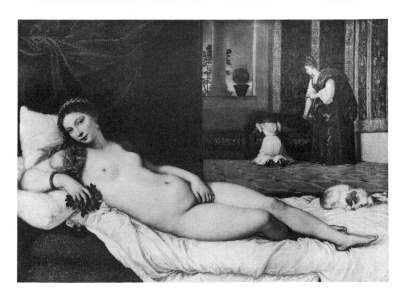

77. Armand Berthez as a Cubist painter in the revue *Et Voilà!* by Robert Dieudonné, performed at the Théâtre des Capucines in fall 1911. From *Le Théâtre,* December [I], 1911, p. 24. Bibliothèque Nationale, Paris

78. Sonia Delaunay in a "simultaneous dress" of her own design, which she wore to the Bal Bulier. 1913. From *Montjoie!,* April-June, 1914, p. 24

79. Pablo Picasso. *Ma Jolie (Woman with a Zither or Guitar)*. Paris, winter, 1911–12. Oil on canvas, 39⅜ × 25¾" (100 × 65.4 cm). Daix 430. The Museum of Modern Art, New York. Acquired through the Lillie P. Bliss Bequest

80. Harry Fragson on the occasion of his engagement at the Alhambra music hall in October 1911. From *Comoedia illustré*, October 1, 1911, p. 27. The New York Public Library at Lincoln Center. Astor, Lenox and Tilden Foundations. Billy Rose Theatre Collection

— EXCELSIOR —
Attractions •

Une des chansons de Fragson à l'Alhambra

Un air délicieusement prenant dont les orchestres de tziganes ont fait la vogue et que tout Paris fredonne, d'exquises paroles pouvant être chantées par tout le monde, un ar-

Ô Ma-non, ma jo - li - e, Mon cœur te dit bon-jour! Pour nous, les tzi - ga - nes jouent ma mie Leur chan-son d'a - mour Leur chan-son d'a - mour Et cet-te mé-lo - di - e Me don-ne le fris - son É cou-te la donc É cou-te là donc C'est no - tre pre - miè - re chan - son

tiste merveilleux qui la détaille avec un art unique : voilà ce qui explique le succès qu'obtient *Fragson* tous les soirs à l'Alhambra dans la romance *Dernière chanson*. La musique est

81. The *ma jolie* refrain from "Dernière chanson" by Harry Fragson, as it appeared in *Excelsior*, October 5, 1911, p. 9. Bibliothèque Historique de la Ville de Paris

82. Pablo Picasso. Sketchbook drawing. 1901–02. Pencil on paper, 5⅛ × 8¼″ (13 × 21 cm). Carnet 102, p. 19V. Musée Picasso, Paris

83. Pablo Picasso. Sketchbook drawing. 1901–02. Pencil on paper, 5⅛ × 8¼″ (13 × 21 cm). Carnet 102, p. 41V. Musée Picasso, Paris

84. Ludovic Galice. Poster for Jeanne Bloch at La Scala music hall. 1890s. Musée de la Publicité, Paris

85. Pablo Picasso. *Sheet of Music and Guitar.* Paris, autumn 1912. Pasted papers. Dimensions unavailable. Daix 521. Succession Picasso

87. Pablo Picasso. *Guitar, Sheet Music, and Glass.* Paris, after November 18, 1912. Pasted paper, gouache, and charcoal, 18⅞ × 14⅜" (47.9 × 36.5 cm). Daix 513. Marion Koogler McNay Art Museum, San Antonio. Bequest of Marion Koogler McNay

88. Pablo Picasso. *Still Life with Chair Caning.* Paris, [May] 1912. Collage of oil, oilcloth, and pasted paper on canvas (oval), surrounded by rope, 10⅝ × 13¾" (27 × 35 cm). Daix 466. Musée Picasso, Paris

86. Pablo Picasso. *Violin and Sheet Music.* Autumn 1912. Papers pasted on the lid of a cardboard box, 30¹¹⁄₁₆ × 24¹³⁄₁₆" (78 × 63 cm). Daix 519. Musée Picasso, Paris

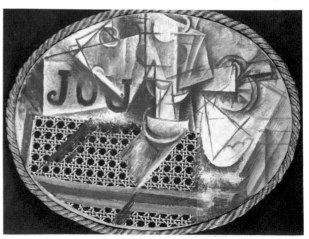

89. Poster for the revue *Le Petit Journal* by A. de Jallais and Nazé, performed at the Théâtre-Déjazet in October 1864. From Robert Dreyfus, *Petite Histoire de la revue de fin d'année* (Paris, 1909), p. XXVII. Bibliothèque de l'Arsenal, Paris

90. Poster for the revue *Le Royaume du Calembour* by Théodore Coginard and Clairville, performed at the Théâtre des Variétés in 1855. From Robert Dreyfus, *Petite Histoire de la revue de fin d'année* (Paris, 1909), p. XV. Bibliothèque de l'Arsenal, Paris

91. d'Ostoya. Cover of *L'Assiette au beurre,* December 31, 1910. Bibliothèque Nationale, Paris

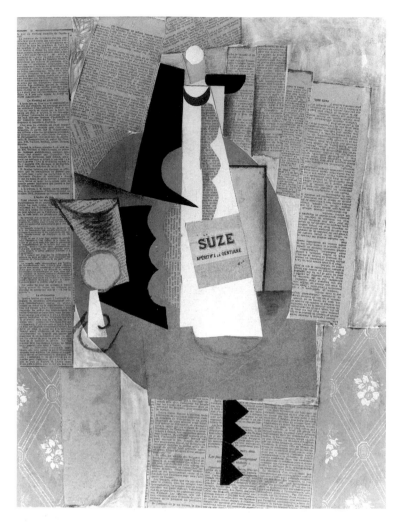

9 2 . Pablo Picasso. *Glass and Bottle of Suze*. Paris, after November 18, 1912. Pasted paper, gouache, and charcoal, 25¾ × 19¾" (65.4 × 50.1 cm). Daix 523. Washington University Gallery of Art, St. Louis. University purchase, Kende Sale Fund, 1946

ÉMILE VILTARD, compère de revues.

9 3 . Emile Viltard, "Compère de revues," in 1855. From Robert Dreyfus, *Petite Histoire de la revue de fin d'année* (Paris, 1909), frontispiece. Bibliothèque de l'Arsenal, Paris

Mlle J. DEMONY

Photo Henri Manuel

94. J. Demony as the magazine *Comoedia illustré* at the Olympia music hall in winter 1908–09. From *Comoedia illustré,* January 15, 1909, p. 76. Bibliothèque Nationale, Paris

95. Blondinette d'Alaza as the newspaper *Le Nouveau Siècle* in *La Grande Revue* by M. Millot and L. Boyer, performed at the Olympia music hall in spring 1910. From *Le Nouveau Siècle,* June 26, 1910, p. 1. Bibliothèque Nationale, Paris

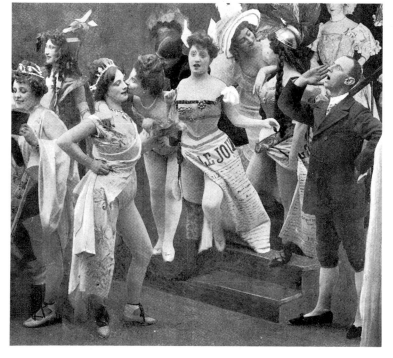

96. *Le Journal* newspaper costume. From *Le Panorama,* "Paris la nuit," no.1, c. 1900. Bibliothèque de l'Arsenal, Paris

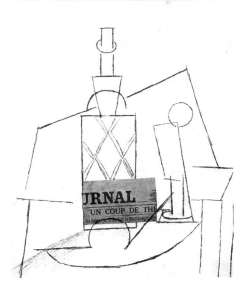

97. Pablo Picasso. *Table with Bottle, Wineglass, and Newspaper.* Paris, after December 4, 1912. Pasted paper, charcoal, and gouache on paper, 24⅜ × 18⅞" (62 × 48 cm). Musée National d'Art Moderne, Centre Georges Pompidou, Paris. Gift of Henri Laugier

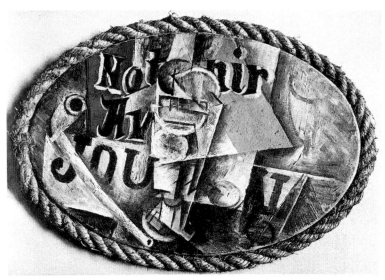

98. Pablo Picasso. *Notre Avenir est dans l'Air.* Paris, spring 1912. Oil on oval canvas framed with rope, 8¹¹⁄₁₆ × 13" (22 × 33 cm). Daix 465. Succession Picasso

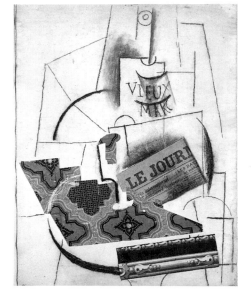

99. Pablo Picasso. *Bottle of Vieux Marc, Glass, and Newspaper.* After March 15, 1913. Charcoal and pasted and pinned paper, 24¾ × 19¼" (63 × 49 cm). Musée National d'Art Moderne, Centre Georges Pompidou, Paris. Gift of Henri Laugier

100. Pablo Picasso. *Au Bon Marché*. Paris, after January 25–26, 1913. Oil and pasted papers on cardboard, 9¼ × 12³⁄₁₆″ (23.5 × 31 cm). Daix 557. Ludwig Collection, Aachen

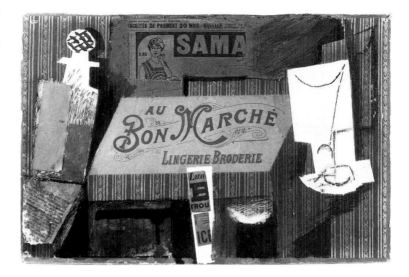

101. Pablo Picasso. *Bottle and Glass*. Autumn-winter, 1912. Charcoal, graphite, and newsprint on paper, 24³⁄₈ × 18½″ (62 × 47.1 cm). Daix 543. The Menil Collection, Houston

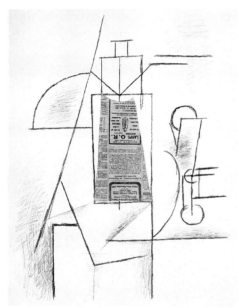

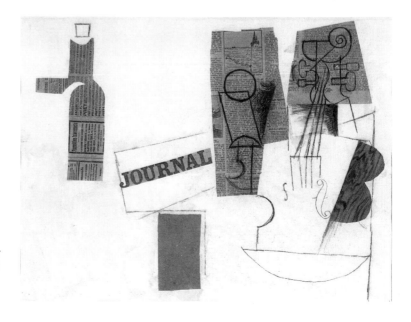

102. Pablo Picasso. *Syphon, Glass, Newspaper and Violin*. Paris, after December 3, 1912. Pasted papers and charcoal on paper, 18½ × 24⁵⁄₈″ (47 × 62.5 cm). Daix 528. Moderna Museet, Stockholm

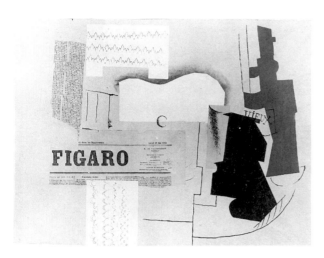

103. Pablo Picasso. *Bottle of Vieux Marc, Glass, Guitar and Newspaper.* Céret, spring 1913. Pasted papers and pen and ink drawing, 18⅜ × 24⅝" (46.7 × 62.5 cm). Daix 604. Tate Gallery, London

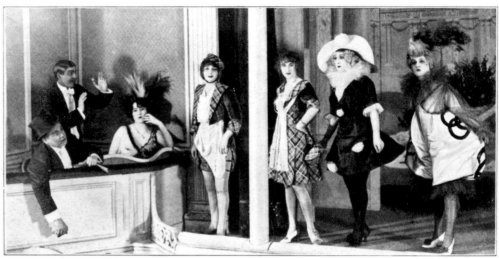

104. Performers impersonating spectators in the revue *Paris Fin de Règne* by Rip and Bosquet, performed at the Théâtre des Capucines in winter 1912–13. From *Comoedia illustré*, January 20, 1913, p. 360. Bibliothèque Nationale, Paris

105. Jacques Villon. Cover illustration for the sheet music of the song "Collages" by Gil and Gaston Maquis, 1898

106. The actor Mounet-Sully and the comic Dranem impersonated in *La Revue de l'Ambigu* by Dominique Bonnaud, Numa Blès and Lucien Boyer, performed at the Théâtre de l'Ambigu-Comique in winter 1911–12. From *Comoedia illustré*, December 15, 1911, p. 190. The New York Public Library at Lincoln Center. Astor, Lenox and Tilden Foundations. Billy Rose Theatre Collection

Ph. Famechon et Lejards.

CHARLEY ET BUSSY

107. "Madame Job" and "Louis XIV" in *La R'vu . . . u . . . e!* by Léon Daniel, performed at the Boîte à Fursy in February 1913. From *Le Music-Hall*, February 15, 1913, p. 7. Bibliothèque Nationale, Paris

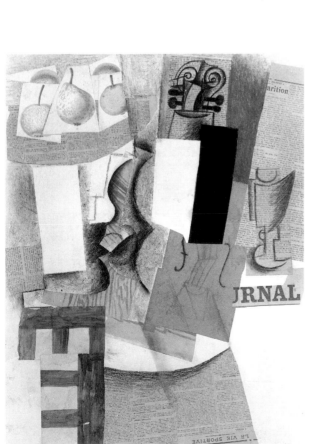

108. Pablo Picasso. *Bowl with Fruit, Violin, and Wineglass.* Paris, begun after December 2, 1912; completed after January 21, 1913. Pasted paper, watercolor, chalk, oil, and charcoal on cardboard, 25½ × 19½" (64.8 × 49.5 cm). Daix 530. Philadelphia Museum of Art. A. E. Gallatin Collection, no. 52–61–106

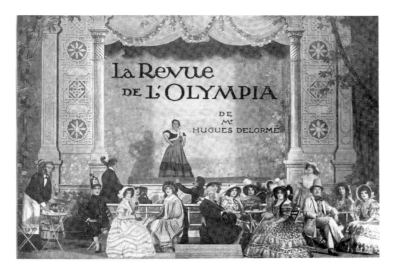

109. The café-concert l'Alcazar d'été as it looked during the 1860s, in *La Revue de l'Olympia* by Hugues Delorme, performed at the Olympia music hall in fall 1913. From *Comoedia illustré,* October 20, 1913, p. 80. Bibliothèque Nationale, Paris

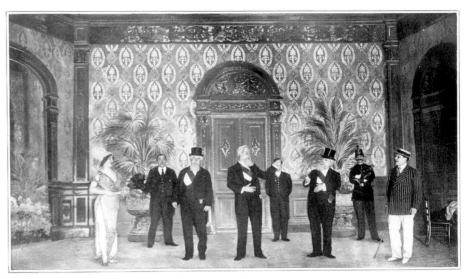

110. "A l'Elysée," a tableau from *La Revue de l'Ambigu* by Dominique Bonnaud, Numa Blès and Lucien Boyer, performed at the Théâtre de l'Ambigu-Comique. From *Le Théâtre,* January [I] 1912, p. 17. Library of Congress, Washington, D.C.

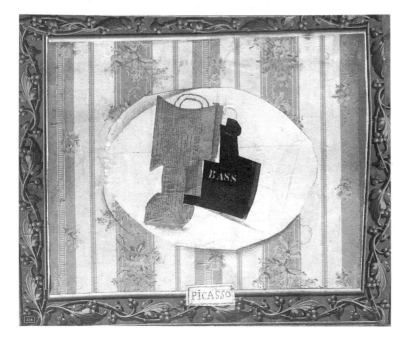

111. Pablo Picasso. *Glass and Bottle of Bass.* Paris, spring 1914. Pasted papers and charcoal on cardboard, 20½ × 26⅜" (52 × 67 cm). Daix 684. Private collection

112. Georges Braque. *Still Life on a Table: Gillette.* [Paris, early 1914] Charcoal, pasted paper, and gouache, 18⅞ × 24⅜″ (48 × 62 cm). Musée National d'Art Moderne, Centre Georges Pompidou, Paris

113. Gerald Murphy. *Razor.* 1924. Oil on canvas, 32⅝ × 36½″ (82.9 × 91.4 cm). Dallas Museum of Art. Foundation for the Arts Collection; gift of the artist

114. Diego Rivera. *Still Life with Carafe*. 1914. Collage and gouache on paper, 14 × 7½" (35.5 × 29 cm). Property of the Governor of the State of Veracruz

115. Diego Rivera. *The Alarm Clock*. 1914. Oil on canvas, 20¹⁄₁₆ × 25⁹⁄₁₆" (51 × 65 cm). Frida Kahlo Museum Collection, Coyoacán, Mexico

116. Juan Gris. *Syphon and Bottles*. 1910. Oil on cardboard, transferred to canvas, 22⁷⁄₁₆ × 18⁷⁄₈" (57 × 48 cm). Mr. and Mrs. Gonzalez, Paris

117. Fernand Léger. *The Syphon.* 1924. Oil on canvas, 25⅝ × 18⅛" (65.1 × 46 cm). Albright-Knox Art Gallery, Buffalo. Gift of Mr. and Mrs. Gordon Bunshaft, 1977

118. Advertisement for Campari. From *Le Matin,* September 12, 1924, p. 3

119. Juan Gris. *The Crossword Puzzles.* 1925. Oil on canvas, 13 × 16⅛" (33 × 41 cm). Private collection

120. Juan Gris. *The Package of Quaker Oats.* 1915. Oil on canvas, 17½ × 14⅝" (44.5 × 37 cm). Present whereabouts unknown

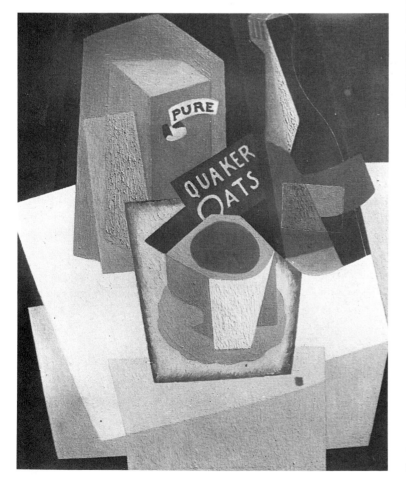

121. Gino Severini. *Still Life: Quaker Oats.* 1917. Oil on canvas, 23⅝ × 20 1/16" (60 × 51 cm). Collection Eric Estorick

1 2 2 . Pablo Picasso. *Still Life with Biscuits.* Avignon, summer 1914. Pencil, 12⅛ × 19″ (20.1 × 48.2 cm). Musée Picasso, Paris

1 2 3 . Pablo Picasso. *Head of a Man with a Moustache.* [Céret] after May 6, 1913. Ink on newspaper, 21⅞ × 14¾″ (55.5 × 37.4 cm). Private collection

1 2 4 . Georges Braque. *Glass and Bottle: Fourrures.* [Paris, winter] 1913–14. Charcoal and pasted paper, 18⅞ × 24⅜″ (48 × 62 cm). Private collection, Switzerland

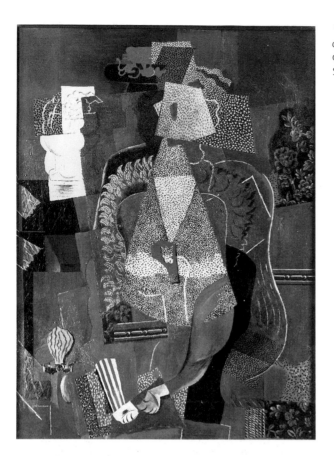

125. Pablo Picasso. *Portrait of a Girl.* Avignon, summer 1914. Oil on canvas, 51⅛ × 38" (130 × 96.5 cm). Daix 784. Musée National d'Art Moderne, Centre Georges Pompidou, Paris. Bequest of George Salles

126. Pablo Picasso. *The Restaurant.* Paris [spring 1914]. Oil on cut-out canvas, 14⁹⁄₁₆ × 19⁵⁄₁₆" (37 × 49 cm). Daix 703. Succession Picasso

127. Pablo Picasso. *4 Gats: Plat del Día* (design for a menu). c. 1900. Colored chalk, watercolor, and wash, dimensions unavailable. Private collection

128. Juan Gris. *Les Aéroplanes.* Cover page from *L'Assiette au beurre,* November 14, 1908

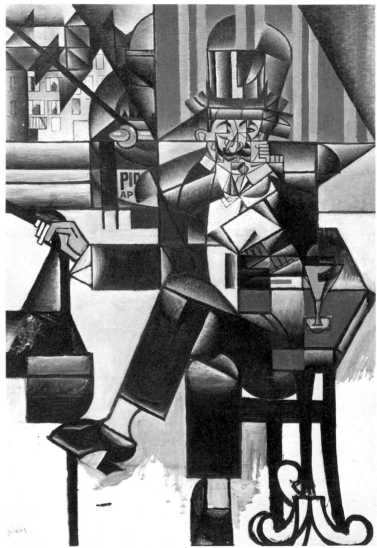

130. Juan Gris. Illustration from "Bruits de guerre et bruits de paix," *L'Assiette au beurre,* October 3, 1908, p. 439

129. Juan Gris. *The Man in the Café.* 1912. Oil on canvas, 50½ × 34⅝" (128 × 87.9 cm). Philadelphia Museum of Art. Louise and Walter Arensberg Collection

1 3 1 . Juan Gris. *The Smoker.* 1913. Oil on canvas, 16¾ × 21¼" (73 × 54 cm). Thyssen-Bornemisza Collection, Lugano

1 3 2 . Juan Gris. *The Bullfighter.* 1913. Oil on canvas, 36¼ × 23⅝" (92 × 60 cm). Private collection

1 3 3 . Juan Gris. *Anis del Mono.* 1914. Oil, crayon, and collaged paper on canvas, 16½ × 9½" (41.8 × 24 cm). Private collection

134. Pablo Picasso. *Spanish Still Life.* Paris, spring 1912. Oil on canvas (oval), 18⅛ × 13″ (46 × 33 cm). Daix 476. Musée d'Art Moderne, Villeneuve-d'Ascq. Gift of Geneviève and Jean Masurel

135. Juan Gris. *Still Life with Plaque.* December 1917. Oil on canvas, 25¾ × 32″ (65.5 × 81 cm). Oeffentliche Kunstsammlung Basel, Kunstmuseum

136. Nautical rope and mirror. Photographed in Toulon, 1977

137. Pablo Picasso. *Souvenir du Havre*. Paris [May] 1912. Oil and enamel on canvas (oval), 36¼ × 25⅝″ (92 × 65 cm). Daix 458. Private collection

138. Picture postcard of Le Havre; sent by Braque to D.-H. Kahnweiler, November 27, 1912

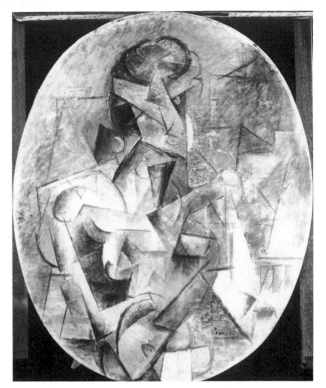

1 4 0 . Pablo Picasso. *Woman with a Mandolin.* Paris, spring 1910. Oil on canvas (oval), 31½ × 25½" (80 × 64 cm). Daix 341. Private collection, Switzerland

1 4 1 . Pablo Picasso. *Guitar.* Paris [winter 1912–13]. Construction of sheet metal, string, and wire, 30½ × 13¾ × 7⅝" (77.5 × 35 × 19.3 cm). The Museum of Modern Art, New York. Gift of the artist

1 4 2 . Tin cake mold (Mexico). 12½" (31.8 cm) high. Collection Ariane and Alain Kirili

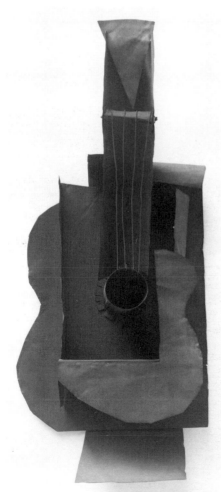

143. Georges Braque. *Still Life with Tenora* (formerly called *Clarinet*). [Sorgues, summer 1913] Pasted paper, oil, charcoal, chalk, and pencil on canvas, 37½ × 47⅜" (95.2 × 120.3 cm). The Museum of Modern Art, New York. Nelson A. Rockefeller Bequest

144. Juan Gris. *Fantômas (Pipe and Newspaper).* 1915. Oil on canvas, 23½ × 28⅞" (59.8 × 73.3 cm). National Gallery of Art, Washington, D.C. Chester Dale Fund

145. Georges Braque. *Checkerboard: Tivoli-Cinéma.* Sorgues, after October 31, 1913. Gesso, pasted paper, charcoal, and oil on canvas, 25¾ × 36¼" (65.5 × 92 cm). Collection A. Rosengart, Lucerne

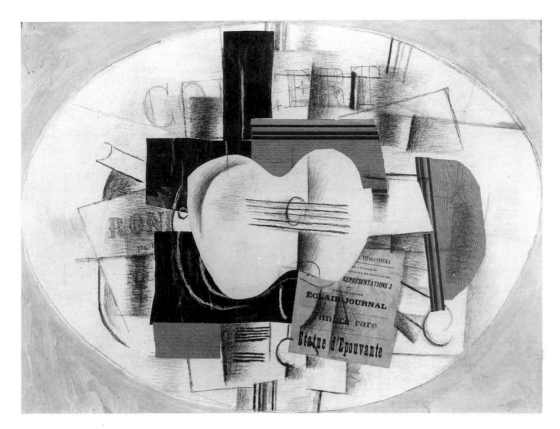

146. Georges Braque. *Guitar and Program: Statue d'épouvante.* Sorgues, November 1913. Charcoal, gouache, and pasted paper on paper, 28¾ × 39⅜" (73 × 100 cm). Musée Picasso, Paris

147. Stuart Davis. Mural in Gar Sparks's Nut Shop, Newark, New Jersey. 1921. Destroyed

148. Aristarkh Lentulov. *Moscow.* 1913. Oil on canvas with collage, 6' 5⁹⁄₁₆" × 6' 2⁷⁄₁₆" (197 × 189 cm). State Tretiakov Gallery, Moscow

149. Ilia Mashkov. *Self-Portrait with Petr Konchalovsky.* 1910. Oil on canvas, 6' 9⁷⁄₈" × 8' 10⁵⁄₁₆" (208 × 270 cm). State Russian Museum, Leningrad

150. Kasimir Malevich. *Composition with Mona Lisa.* 1914. Oil on canvas with collage, 24⁷⁄₁₆" × 19½" (62 × 49.5 cm). Private collection

ДУДИЛЬЩИК

151. Vladimir Tatlin. Costume for a Pipe Player in *The Emperor Maximilian and His Disobedient Son Adolf.* 1911. Watercolor and ink, 12⅝ × 7¹¹⁄₁₆″ (32 × 19.5 cm). Collection Nina and Nikita D. Lobanov-Rostovsky, London

152. Lubok of Farnos. *The Jester.* 18th century. Colored woodcut, 14⅜ × 11⁷⁄₁₆″ (36.5 × 29 cm). Pushkin Museum of Fine Arts, Moscow

153. Natalie Gontcharova, her face decorated with Rayist designs. 1913. From the journal *Teatr v Karrikaturakh* ("Theater in Caricatures"), Moscow, September 21, 1913, p. 9

154. Mikhail Larionov. *Venus.* 1912. Oil on canvas, 26 × 33¹¹⁄₁₆" (66 × 85.5 cm). State Russian Museum, Leningrad

155. Aleksandr Shevchenko. *Venus.* 1915. Gouache, 7½ × 9¹⁄₁₆" (19 × 23 cm). Collection Tatiana Rubinshtein, Moscow

156. Kasimir Malevich. *Woman at a Poster Column.* 1914. Oil on canvas with collage, 15¹⁵⁄₁₆ × 25³⁄₁₆″ (71 × 64 cm). Stedelijk Museum, Amsterdam

157. Elsa Krüger and Mak dancing the Tango of Death. c. 1912.

158. Mikhail Larionov. *Gypsy in Tiraspol*. c. 1907. Oil on canvas, 37⅜ × 31⅞" (95 × 81 cm). Present whereabouts unknown. Formerly State Tretiakov Gallery, Moscow

159. Advertisement for Anatolii Durov and his pig. c. 1907

160. Niko Pirosmanashvili. *Sow and Piglets*. c. 1910. Oil on cardboard, 31½ × 39⅜" (80 × 100 cm). State Museum of Arts, Tbilisi

161. Kuzma Petrov-Vodkin. *Still Life with Herring.* 1918. 22³⁄₁₆ × 34¹³⁄₁₆" (58 × 88.5 cm). State Russian Museum, Leningrad

162. Mikhail Larionov. *Sausage and Mackrel.* 1912. Oil on canvas, 18⅛ × 24" (46 × 61 cm). Ludwig Museum, Cologne

163. Vladimir Tatlin. Illustration for Vladimir Mayakovsky's poem "Vyveskam" ("To Signboards"). Published in *Trebnikh troikh* ("Prayer-Book of Three"), Moscow, 1913

164. Aleksandr Shevchenko. *Signboard Still Life: Wine and Fruit.* 1913. Oil on canvas, 32¹/₁₆ × 34¼″ (81.5 × 87 cm). State Tretiakov Gallery, Moscow

165. Suspended signboard in wood representing a ham. c. 1900. State Museum of the History of the City of Leningrad

167. Baker's signboard. c. 1900

166. Natalie Gontcharova. *Still Life with Ham,* 1912. Oil on canvas, 27³/₁₆ × 21⅝″ (69 × 55 cm). State Russian Museum, Leningrad

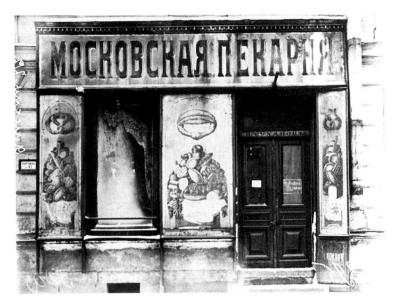

168. Photograph of a Moscow bakery. c. 1900

169. Signboard representing a woman ironing. Late 19th century

170. Aleksandr Shevchenko. *Woman Ironing.* 1920. Oil on canvas, 37 × 32½" (94 × 82.5 cm). State Russian Museum, Leningrad

171. Ivan Puni. *Washing Windows.* 1915. Oil on canvas, 33⁷⁄₁₆ × 26³⁄₈" (85 × 67 cm). Private collection

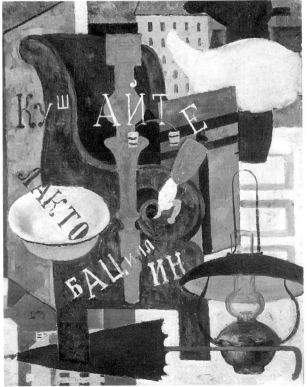

172. Signboard advertising live fish. Early 1900s

173. Kasimir Malevich. *Tailor.* 1914. Pencil, 6⅜ × 4⁵⁄₁₆″ (16.2 × 11 cm). Museum Ludwig, Cologne

174. Olga Rozanova (?). Untitled. 1916. Collage on paper, 8⅜ × 6⅝″ (21.2 × 16.9 cm). © 1981 George Costakis. The George Costakis Collection (owned by Art Co., Ltd.)

A version of this image appears in a book called *1918* (Tiflis, 1917) by Vasilii Kamensky, Alexi Kruchenykh, et al.

175. Olga Rozanova. *Workbox.* 1915. Oil on canvas with collage, 22¹³/₁₆ × 25″ (58 × 33 cm). State Tretiakov Gallery, Moscow

176. Advertisement for photography on zinc undertaken by the Mettsger Corporation, Moscow, 1898. From Al Suvorin, ed., *Vsia Miskva na 1898 god* (Moscow: Chicherin, 1898), p. 9 of commercial white pages

177. Nikolai Suetin. Design for a tram panel in Vitebsk. c. 1920. Reproduced as a postcard in 1932. Collection Alex Rabinovich, New York

179. Ilia Zdanevich. Page from *Li-Dantiu Faram* (Paris: 41 dégres, 1923)

178. Georgii Leonov. Untitled. 1889. Watercolor and India ink with collage, dimensions unavailable. State Tretiakov Gallery, Moscow

180. Page from a Russian alphabet book. 1900

181. Varvara Stepanova. *Gaust-Chaba*. Moscow. 1919. Watercolor on newspaper, 6⅞ × 10¹³⁄₁₆″ (17.5 × 27.5 cm). Private collection

183. Advertisement for galoshes produced by the Conductor Corporation, Riga. c. 1910

182. Aleksandr Rodchenko. *Ticket No. 1.* 1919. Collage with colored papers and postcards, 14 × 8⁷⁄₁₆″ (35.5 × 21.5 cm). Rodchenko and Stepanova Archive

184. Aleksandr Rodchenko. Advertisement for galoshes. 1923

185. Advertisement for Teikhman's insulation materials, St. Petersburg. c. 1906. From *Ezhegodnik . . .* (St. Petersburg, 1906)

187. Poster advertising the film *Eagle.* c. 1915. From *Vestnik kinematografii* (Moscow, 1915), no. 115, p. 88

186. Poster advertising the film *State Councillor's Love.* c. 1915. From *Vestnik kinematografii* (Moscow, 1915), no. 115, p. 17

188. Gustav Klutsis. Photomontage printed in colors on postcard for the All-Union Spartakiada, Moscow. 1928. 5¹⁵⁄₁₆ × 4³⁄₁₆" (15.1 × 10.6 cm). © 1981 George Costakis. The George Costakis Collection (owned by Art Co., Ltd.)

189. Cover of *Partisan Review,* Fall 1939

190. Gisèle Freund. *Walter Benjamin.* Paris, 1937. Photograph

191. André Breton, Diego Rivera, Leon Trotsky. Mexico, 1938. From *Minotaure,* May 1939, p. 48

192. Title page of *Marxist Quarterly,* January–March 1937

MARXIST QUARTERLY

Vol. I No. 1

JANUARY-MARCH
1937

CONTENTS

Challenge	3
By the Editors	
Science and Socialism	5
By Benjamin Ginzburg	
Farm Labor in Fascist Italy	11
By Carl T. Schmidt	
Marxism and Values	38
By Sidney Hook	
The American Revolution:	46
Economic Aspects *By Louis M. Hacker*	
Materialism and Spooks	68
By Friedrich Engels	
Nature of Abstract Art	77
By Meyer Schapiro	
New Aspects of Cyclical Crises	99
By Bertram D. Wolfe	
Social Origins of Nominalism	115
By Edward Conze	
Metaphysics of Reaction	125
By Bern Brandon	
American Class Relations	134
By Lewis Corey	

REVIEWS OF BOOKS

Dialectical Materialism *By Theodore B. Brameld*	144
Discussion by George Simpson	
Militarism and Democracy *By Herbert Zam*	150
American Trade Unionism *By Sterling D. Spero*	155
Religion and Revolution *By Corliss Lamont*	159
Veblen and Marxism *By Lewis Corey*	162
The New Era in a Novel *By James Rorty*	168

Board of Editors
James Burnham
Lewis Corey
Louis M. Hacker
Francis A. Henson
Will Herberg
Sidney Hook
Corliss Lamont
George Novack
Meyer Schapiro
Sterling D. Spero
Bertram D. Wolfe
Herbert Zam
•
Lewis Corey
Managing Editor
•
Published by
American Marxist
Association
Louis M. Hacker
President
Sterling D. Spero
Sec'y-Treas.
•
Francis A. Henson
Business Manager

Copyright 1916 by AMERICAN MARXIST ASSOCIATION. Subscription rates: $2.00 a year, $2.50 for foreign countries. Application for entry as second class matter is pending. Address all communications to MARXIST QUARTERLY, 20 Vesey Street, New York City.
Printed at the LIBERAL PRESS, 80 Fourth Avenue, New York City

193. Arnold Friedman. *Interior with Daisies.* c. 1942–46. Oil on canvas. 20 × 24" (50.8 × 60.9 cm). Private collection. Courtesy of Salander-O'Reilly Galleries, Inc., New York

194. Kasimir Malevich. *Suprematist Composition: Red Square and Black Square.* 1915. Oil on canvas, 28 × 17½" (71.1 × 44.5 cm). The Museum of Modern Art, New York

195. Piet Mondrian. *Broadway Boogie Woogie.* 1942–43. Oil on canvas, 50 × 50" (127 × 127 cm). The Museum of Modern Art, New York. Given anonymously

196. Alfred H. Barr, Jr. "The Development of Abstract Art." Chart prepared for the exhibition "Cubism and Abstract Art," The Museum of Modern Art, New York, 1936

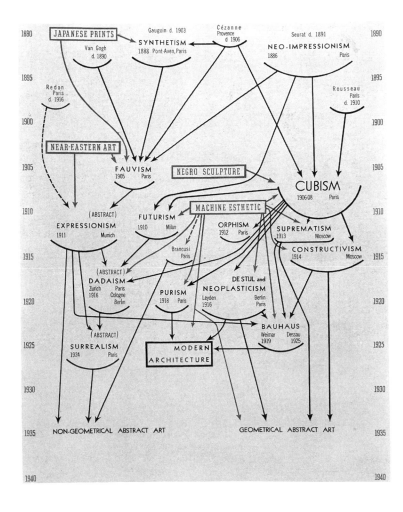

197. Kurt Schwitters. *Mz 151. Wenzel Kind (Knave Child).* 1921. Collage, 6¾ × 5⅛" (17.1 × 12.9 cm). Sprengel Museum, Hannover. Extended loan from Marlborough Fine Art (London) Ltd.

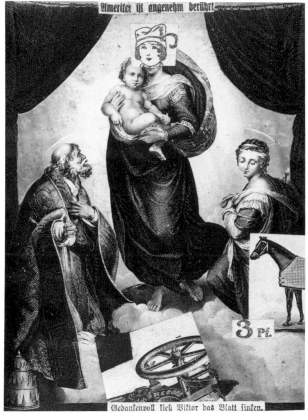

198. Joan Miró. *Untitled (Composition).* 1933. Drawing/collage with sandpaper, postcards, découpage, pencil on brown prepared paper, 41⅝ × 27⅝" (105.7 × 70.2 cm). Mrs. E. A. Bergman Collection, Chicago

199. Georges Seurat. *Le Chahut.* 1889–90. Oil on canvas. 66⁹/₁₆ × 54¾" (169 × 139 cm). Rijksmuseum Kröller-Müller, Otterlo

202. Philip Guston. *East Coker—T. S. E.* 1979. Oil on canvas. 40 × 48" (101.6 × 122 cm). Private collection, Woodstock. Courtesy David McKee Gallery, New York

The "T. S. E." in the title of this imaginary portrait refers to T. S. Eliot, author of *Four Quartets,* of which "East Coker" is one.

200. William Steig. "Whoever Wants the Answer Must Come to Me." From William Steig, *The Lonely Ones,* Duell, Sloan and Pearce, New York, 1942, p. 43, n. 42

201. William Steig. "Who Am I?." From William Steig, *All Embarrassed,* Duell, Sloan and Pearce, New York, 1944, p. 71

203. Ad Reinhardt. "How to Look at a Cubist Painting." From *P.M.,* January 27, 1946. © Copyright 1990 Anna Reinhardt

204. Ad Reinhardt. "How to Look Out" (detail). From *P.M.*, June 23, 1946. © Coppyright 1990 Anna Reinhardt

206. Andy Warhol. *Gold Marilyn Monroe*. 1962. Synthetic polymer paint, silkscreened, and oil on canvas, 6' 11" × 57" (211.4 × 144.7 cm). The Museum of Modern Art, New York. Gift of Philip Johnson

205. Willem de Kooning. *Marilyn Monroe*. 1954. Oil on canvas. 50 × 30" (127 × 76.2 cm). Neuberger Museum, State University of New York at Purchase. Gift of Roy R. Neuberger

207. Edouard Manet. *Charles Baudelaire*. 1868. Etching, third plate, 4th state, 3⅞ × 3¼" (9.7 × 8.3 cm)

208. Richard Hamilton, John McHale, and John Voelcker. Sequence of views around Hamilton-McHale-Voelcker pavilion at "This Is Tomorrow" exhibition. 1956. Whitechapel Art Gallery, London

209. Nigel Henderson, Eduardo Paolozzi, Alison and Peter Smithson. Installation view of *Patio and Pavilion* at "This Is Tomorrow" exhibition. 1956. Whitechapel Art Gallery, London

210. Richard Hamilton. *Just What Is It That Makes Today's Homes So Different, So Appealing?* 1956. Collage, 12 × 18½" (30.5 × 47 cm). Kunsthalle, Tübingen. Sammlung Zundel

211. Richard Hamilton. *Hommage à Chrysler Corps.* 1957. Oil, metal foil, and collage on panel, 48 × 32" (121.9 × 81.3 cm). Private collection, London

212. Eduardo Paolozzi. *Yours Till the Boys Come Home.* 1951. Collage on paper, 14¼ × 9¾" (36.2 × 24.8 cm). Tate Gallery, London

213. Eduardo Paolozzi. *St. Sebastian No. 2.* 1957. Bronze, 7'3¾" (215 cm) high. The Solomon R. Guggenheim Museum, New York

214. John McHale. *Icehead.* 1957. Collage, 39½ × 28½" (100 × 72.4 cm). Collection Magda Cordell McHale, Buffalo

215. John McHale. *Machine-Made America II.* 1956. Collage, 23 × 17" (58.4 × 43.2 cm). Private collection

216. Nigel Henderson, Eduardo Paolozzi, and Alison and Peter Smithson. Installation view of "Parallel of Life and Art" exhibition. 1953. Institute of Contemporary Arts, London

217. Richard Hamilton. Installation view of "Man, Machine and Motion" exhibition. 1955. Hatton Gallery, Newcastle upon Tyne

218. Andy Warhol. Advertisement for I. Miller Shoes. From *The New York Times,* September 25, 1955, p. 85

219. Andy Warhol. *Large Coca-Cola.* 1962. Synthetic polymer paint on canvas, 6' 10" × 57" (208 × 145 cm). Private collection

220. Roy Lichtenstein. *Girl with Ball.* 1961. Oil and synthetic polymer paint on canvas, 60¼ × 36¼" (153 × 91.9 cm). The Museum of Modern Art, New York. Gift of Philip Johnson

221. Advertisement for Mount Airy Lodge. 1961

PETER PLAGENS

GOLDEN DAYS

222. Billy Al Bengston. *Chaney.* 1965. Oil and lacquer on masonite, 61 × 47" (155 × 119.4 cm). Private collection

223. Craig Kauffman. *Untitled Wall Relief.* 1967. Vacuum-formed Plexiglas, 6' × 52" × 15" (182.9 × 132 × 38.1 cm). Los Angeles County Museum of Art. Gift of the Kleiner Foundation

224. Edward Ruscha. *Annie*. 1962. Oil on canvas, 6′ × 67″ (182.9 × 170.2 cm). Private collection

225. John McCracken. *Don't Tell Me When to Stop*. 1966–67. Lacquer, fiberglass, plywood, 10′ × 20½″ × 3½″ (304.8 × 52.1 × 8.9 cm). Los Angeles County Museum of Art. Gift of the Kleiner Foundation through the Contemporary Art Council

PHOTOGRAPH CREDITS

Photographs reproduced in this volume have been provided, in the majority of cases, by the owners or custodians of the works, indicated in the captions. Individual works of art appearing here may be additionally protected by copyright in the United States of America or abroad, and may not be reproduced in any form without the permission of the copyright owners.

© Succession Picasso, for each work appearing with the following credit: Musée d'Art Moderne de la Ville de Paris; Musée National d'Art Moderne, Centre National d'Art et de Culture Georges Pompidou, Paris; Musée Picasso, Paris; and the following illustrations: 85, 98, and 126. S.P.A.D.E.M., Paris, is the exclusive French agent for reproduction rights for Picasso and Gris, and A.D.A.G.P. for Braque and Villon. S.I.A.E., Rome, is the exclusive Italian agent for reproduction rights for Severini. Cosmopress, Geneva, is the exclusive European agent for reproduction rights for Schwitters. A.R.S., New York, is the exclusive United States agent for S.P.A.D.E.M. and A.D.A.G.P., and V.A.G.A., New York, is the exclusive United States agent for Cosmopress. Additional picture reproduction rights, where relevant, reserved by S.P.A.D.E.M., A.D.A.G.P., S.I.A.E., and Cosmopress.

The following list applies to photographs for which a separate acknowledgment is due. Numbers refer to figures. 4, 5: Evangelia Zaukare, Athens; 6: Alinari, Rome; 7: Zodiaque, St. Léger Vauban; 9, 11, 13: © Her Majesty the Queen; 14: Isabella Sansoni, Florence; 22: Courtesy L. Canali, Rome; 21: © Her Majesty the Queen; 24: Raponi Angelo, Muccia; 26: Scala/Art Resource, New York; 27: Gabinetto Fotografico Soprintendenza Beni Artistici e Storici di Firenze; 28: Alinari/Art Resource, New York; 31: Jörg P. Anders, East Berlin; 32: Gabinetto Fotografico, Rome; 33: Alinari/Art Resource, New York; 35: Oscar Savio, Rome; 37: Anderson/Art Resource, New York; 39, 40: Warburg Institute, London; 43: Gabinetto Fotografico Nazionale, Rome; 46: Walter Dräyer, Zurich; 48: Cabinet des Estampes, Paris; 51: Cliché des Réunion des Musées Nationaux de France, Paris, © R.M.N.–S.P.A.D.E.M. Paris; 53: Bulloz, Paris; 55: Cliché des Réunion des Musées Nationaux de France, Paris, © R.M.N.–S.P.A.D.E.M.; 59: Claude O'Sughrue, Montpellier; 64: Bulloz, Paris; 74, 75: Cliché des Réunion des Musées Nationaux de France, Paris, © R.M.N.–S.P.A.D.E.M.; 76: Alinari, Rome; 81: Jeffrey Weiss, New York; 82, 83, 88: Cliché des Réunion des Musées Nationaux de France, Paris, © R.M.N.–S.P.A.D.E.M.; 99: Lauros-Giraudon, Paris; 101: Paul Hester, Houston; 102: Statens Konstmuseer, Stockholm; 116: Galerie Louise Leiris, Paris; 118: Jim Strong, Hempstead, N.Y.; 123: André Koti, Paris; 125: Cliché des Réunion des Musées Nationaux de France, Paris, © R.M.N.–S.P.A.D.E.M.; 128: Ann Norton, New York; 130: The Solomon R. Guggenheim Museum, New York; 133: Paulus Leeser, New York; 136: Robert Rosenblum, New York; 138, 139: Archives Galerie Louise Leiris, Paris; 142: Ariane Lopez-Huici, New York; 162: Rheinisches Bildarchiv, Cologne; 166, 167, 168: Photo courtesy of Alla Povelikhina, Leningrad; 173: Rheinisches Bildarchiv, Cologne; 189: Photo Bryan Berkey, New York, © Partisan Review, Inc.; 190: © Gisèle Freund/Photoresearchers, Inc., New York; 192: Bryan Burkey, New York; 197: © Cosmopress, Geneva; 202: Bevan Davies, New York; 205: Jim Frank, New York; 208: Richard Hamilton; 209: John Maltby, London; 211: Robert E. Mates and Susan Lazarus, New York; 213: Robert E. Mates, New York; 214: Peter Muscato, New York; 216: Nigel Henderson, London (both); 217: Richard Hamilton; fig. 221: Bryan Burkey, New York.

PHOTOGRAPH SOURCES

The following citations, specifying secondary sources of some illustrations published herein, are intended as scholarly supplements to the caption information for each image. Numbers refer to figures. 1: David Moore Robinson, "The Villa of Good Fortune at Olynthus," *American Journal of Archaeology*, v. 38, 1934, pl. XXX; 2: Robinson, p. 504, fig. 2; 3: Robinson, pl. XXXI; 23: V. Väänänen, ed., *Graffiti del Palatino. II. Domus Tiberiana* (Helsinki, 1970), pp. 121, 213 and J.-P. Cèbe, *La Caricature et la parodie dans le monde romain antique des origins a Juvénal* (Paris, 1966), p. XIX, 3, 6; 25: Günther and Christel Thiem, *Toskanische Fassaden-Dekoration* (Munich: Bruckmann Verlag, 1964), pl. 101; 42: Fernando and Renato Silenzi, *Pasquino. Cinquecento Pasquinate* (Milan, 1933), ill. opp. p. 100; 105: Colette de Ginestet and Catherine Pouillon, *Jacques Villon. Les Estampes et les Illustrations, catalogue raisonné* (Paris, 1979), no. E.20; 114: Ramón Favela, *Diego Rivera. The Cubist Years*, exh. cat. (Phoenix Art Museum, 1984), cat. n. 123; 115: *The Frida Kahlo Museum* (México, 1970), p. 25, lower right; 119: Douglas Cooper, *Juan Gris: Catalogue raisonné* (Paris, 1977), p. 345, n. 521; 120: Cooper, p. 191, n. 125; 121: Daniela Fonti, *Gino Severini. Catalogo ragionato* (Milan, 1988), p. 259, n. 283; 127: Robert Rosenblum, "The Typography of Cubism" in *Picasso in Retrospect*, eds. R. Penrose and J. Golding (New York, 1973), p. 74, fig. 125; 129: Mark Rosenthal, *Juan Gris*, exh. cat. (New York, 1983), p. 10; 132: Cooper, p. 87, n. 50; 147: Diane Kelder, ed., *Stuart Davis* (New York, 1971), fig. 17; 157: Natalia Sheremetievskaia, *Tanets na estrate* (Moscow, 1985), p. 24; 159: Anatolii Durov, *Vzhizni i na arene* (Moscow, 1984), between pp. 64 and 65; 169: *Panorama iskusstv 78* (Moscow, 1979), p. 253; 172: *Panorama iskusstv 78* (Moscow, 1979), p. 247; 178: Yurii Gerchuk, *Zhivye veschi* (Moscow, 1977), p. 67; fig. 183: Nina Baurina, *Russkii plakat, vtoraia polovina XIX-nachalo XX veka* (Leningrad, 1988), p. 107; 184: German Karginov, *Rodchenko* (Budapest, 1975; London, 1979), p. 108; 191: © Photo, Fritz Bach, from *Minotaure*, No. 12–13, May 1939, p. 48 (Geneva, Switzerland: Editions d'art Albert Skira; Reprint, New York: Arno, 1968); 203, 204: Thomas B. Hess, *The Art Comics and Satires of Ad Reinhardt*, exh. cat. (Düsseldorf: Kunsthalle; Rome: Marlborough, 1975), n.p.; 207: Marcel Guérin. *L'Oeuvre gravé de Manet.* (Paris, 1944); 215: Photo Theo Crosby. From *Architectural Review*, vol. 121, May 1957, cover; 219: *"Success is a job in New York . . ." The Early Art and Business of Andy Warhol*, exh. cat. (New York: Grey Art Gallery and Study Center, New York University, and Pittsburgh: The Carnegie Museum of Art, 1989), p. 13, fig. 13, cat. 140.